SEEN | UNSEEN

SEEN | UNSEEN

Art, Science, and Intuition
from Leonardo to the
Hubble Telescope

MARTIN KEMP

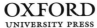

OXFORD
UNIVERSITY PRESS

Great Clarendon Street, Oxford OX2 6DP

Oxford University Press is a department of the University of Oxford.
It furthers the University's objective of excellence in research, scholarship,
and education by publishing worldwide in

Oxford New York

Auckland Cape Town Dar es Salaam Hong Kong Karachi
Kuala Lumpur Madrid Melbourne Mexico City Nairobi
New Delhi Shanghai Taipei Toronto

With offices in

Argentina Austria Brazil Chile Czech Republic France Greece
Guatemala Hungary Italy Japan Poland Portugal Singapore
South Korea Switzerland Thailand Turkey Ukraine Vietnam

Oxford is a registered trade mark of Oxford University Press
in the UK and in certain other countries

Published in the United States
by Oxford University Press Inc., New York

British Library Cataloguing in Publication Data

Data available

Library of Congress Cataloging in Publication Data
Kemp, Martin.
 Seen/unseen : art, science, and intuition from Leonardo
to the Hubble telescope / Martin Kemp.
 Includes bibliographical references and index.
 ISBN-13: 978–0–19–929572–2 (alk. paper)
 ISBN-10: 0–19–929572–7 (alk. paper)
 1. Art and science. I. Title.
 N72.S3K39 2006
 701.05—dc22 2006016459

Typeset by RefineCatch Limited, Bungay, Suffolk
Printed in Great Britain by
Biddles Ltd., Kings Lynn, Norfolk

ISBN 0–19–929572–7 978–0–19–929572–2

10 9 8 7 6 5 4 3 2 1

PREFACE AND ACKNOWLEDGEMENTS

This book stands on twin pillars, built by others. The pillar marked 'material circumstance' was provided by the Wolfson Foundation, in the form of one of two five-year British Academy Research Professorships in the Humanities, established with the worthy aim of relieving senior academics of 'routine administration' and of the less worthy but nowadays necessary release of lecturers from undergraduate teaching, which has come to carry such absurd burdens of managerialism. The Professorship was awarded as the result of my application being selected for the national competition by the University of St Andrews, where the Principal, Struther Arnott, provided unreserved support. In October 1995, after a little over two years of the Wolfson Professorship, I was appointed to the Chair in the History of Art at the University of Oxford, on the same terms as had been agreed with St Andrews. To undertake the equivalent of the duties from which I was released, Oxford appointed Paul Crowther, my former colleague in St Andrews, who provided exemplary personal commitment and inspiration in promoting a vigorous post-graduate community in the Department of the History of Art. His assistance, together with that of Mrs Sheila Ballard, whose loyal secretarial and administrative services had brought some order to my personal chaos, has been vital to whatever I accomplished in my first three years in Oxford. Pamela Romano, her successor, has been unfailingly solicitous and supportive in the long haul to bring the text into production. Latterly, in our new premises, Nicola Henderson and Rachel Woodruff have been unfailingly willing, efficient, and cheerful in administering the Department and helping me deal with an ever-escalating series of internal and external demands. My colleagues in the Department, Geraldine Johnson and Marius Kwint, have shared

irksome burdens of adminstration with a generosity that has made my life workable. In the Academy, Ken Emond was unfailingly helpful in facilitating the paths of funding.

Not the least of the benefits of the generosity of the Wolfson Foundation has been the annual sum allocated for research expenses, the largest single item of which has been the employment of a Research Assistant. These duties have been performed in Oxford by Ioanna Christoforaki, who is completing a doctorate in late Byzantine Art in Cyprus, and who has proved superbly adaptable and creative in assuming increasing responsibility for many of the more time-consuming aspects of my work, from the initial obtaining of primary sources to the final procedures leading to publication. Grants from the History Faculty at Oxford have enabled me to deploy the excellent services of Alessandra Lopez y Royo Iyer, who undertook vital work on the references, Morag McCormick, and Matt Landrus. Matt has provided sterling help in compiling the final set of illustrations and assembling them in digital form. I am also grateful for the support of the History Faculty, not least in providing a series of grants to top up research assistance.

In the spring of 2002 I was fortunate to be invited as a Visiting Scholar at the Getty Research Institute in Los Angeles, where Tom Crowe and his staff provided unstinting support and warm welcome. Glenn Phillips acted with unfussy efficiency as my research assistant. Uta Kornmeier has contributed importantly in the final stages of the book's production.

The pillar marked 'personal inspiration' requires a brief narrative explanation and some preliminary remarks. It was my original intention to produce the second panel of a diptych on *The Science of Art*, looking this time at a series of themes in the natural and human sciences from the Renaissance to about 1880, having written on *Optical Themes in Western Art from Brunelleschi to Seurat* in the volume first published by Yale University Press in 1989. That this intention, with its requirement of long hours of uninterrupted primary source research in many locations, has not been realized is the result of positive and negative factors. The largest negative factor has been the huge personal and academic disruption in my life caused by my move to Oxford. As the only tenured member of staff in the Department of the History of Art in Oxford when I arrived, many of the convolutedly bureaucratic tasks which in theory were excluded from my remit have landed on my desk. That there were no obvious mechanisms for controlling the erosion of my time is less any individual's fault than the result of a system that was for long characterized by diffused, pluralistic responsi-

bility, lack of delegated powers, and cumbersome decision-making structures. Happily, things are now changing for the better, both with respect to the administration of the University and within the Department, which now has four members of staff and thriving bodies of undergraduate and postgraduate students. But there is no escaping the fact that everything has taken too long, and it has only been through the support and enthusiasm of Latha Menon and James Thompson of Oxford University Press that the final text has been realized for publication.

The positive factor—which I hope provides the dominant tone of the book—has been my growing conviction that there is an exciting job to be done by a historian of the visual at the present time in the development of historical disciplines and in the light of the late twentieth-century explosion of visual imagery. The nature of that job, rather different from that of the more 'academic' book first envisaged, is outlined in the introduction. The specific moment at which the positive agenda for this book was crystallized from a set of more generally amorphous intuitions can be identified with the devising and delivery of a talk on 'Journey into Space: from Painters' Perspective to Visions of the Atom and Cosmos' at a conference organized by Richard Bright, Director of the Interalia Centre, in the lecture theatre at the Royal Botanic Garden in Edinburgh on 22 March 1997. Later that same day I spoke at the invitation of Graeme Murray in the Fruitmarket Gallery on some of the themes of natural design which now feature in chapters 5 and 6—in an unsatisfactory lecture that showed all the signs of unresolved ideas. Following the lectures, both their relative successes and definite failures, it was Marina Wallace who identified the outward-looking agenda which lies behind the present publication and which provides the second of the pillars. She has subsequently become the 'audience' for the evolving chapters, providing a continuing commentary which has sustained my confidence and motivation through periods of corrosive uncertainty. As the core of this second pillar, she bears no responsibility for the book's shortcomings, but can take credit both for its existence and for it being better than it might otherwise have been.

Another significant positive factor has been the invitation from Philip Campbell, the editor of *Nature*, the weekly journal of science, to write a column on 'Art and Science', each centred on a single work of art. His enthusiasm, which has supported me in the discipline of producing a sometimes eccentric weekly essay in which I have tried to say something of potential worth in around 500 words, has encouraged me in my ambition to speak to new audiences. This series, together with

PREFACE AND
ACKNOWLEDGE-
MENTS

a parallel set of essays on the 'artefacts' of science and 'science and culture' in *Nature* are also being published as a book. The ideas which have surfaced during the course of the *Nature* series, particularly the notion of 'structural intuitions', have insinuated themselves into the present fabric. The response of those surprisingly numerous readers who have taken the trouble to write to me has provided additional encouragement and stimulation.

Along the way, my son and daughter, Joanna and Jonathan, have produced neat insights, the former from her perspective as a river ecologist, and the latter from his standpoint as a physicist specializing in musical acoustics. The book of my collected *Nature* articles, *Visualizations*, was dedicated to them, as this one could well be.

MK

CONTENTS

10. Invisible Worlds

Seeing the un-seeable. Instantaneous photography and
X-rays. Bubble chambers and particles, Feynman diagrams
and graphic modes. X-ray diffraction and big molecules.
Images and models generated by computer. Sonar and
medical scans as modes of seeing and representing.
Problems of perception and representation by machines
in modern imagery.

Looking Backwards and Forwards

A speculative conclusion.

LIST OF ILLUSTRATIONS

PHOTOGRAPHIC ACKNOWLEDGEMENTS

INTRODUCTION

S omeone who inhabits any territory of specialized knowledge will inevitably and properly entertain opinions on matters at lesser or greater degrees of remove from that territory. A bricklayer has as much right to express deeply held views about the goodness or venality of his or her fellow human beings as the most erudite of moral philosophers. The philosopher should be able to draw on a range of references and articulate arguments about what is considered good in a way that the bricklayer could not and would not need to do. The apparent intellectual superiority of an academic's philosophical discourse over the robust assertions of a worker in the building trade does not mean that the latter cannot pose a challenge to the former. A hands-on worker may address something from a practical perspective which the most sophisticated philosopher can ignore only at his or her peril. During the course of this book we will see a number of historical instances in which a resolute character who stands outside a professional discipline, or who has the courage to reach outwards, is able to bring a fresh perspective to bear in such a way as to readdress long-accepted views of an inward-looking kind. A recurrent historical theme will be the bringing of practical experience to bear on what was seen as bookish theory.

In all too many of the sections in the chapters that follow, I am like a bricklayer who leaves the plot of land on which a modest house is being built and enters building sites on which towering structures are rising, some in cast concrete, others with steel frames. I am taking the risk not only of commenting on shared features, such as the necessity of a secure load-bearing beam above a window aperture, but also expressing opinions on constructional techniques in concrete and steel. To state

the position less metaphorically, I am a historian of the visual, and I aspire to extend the modes of analysis normally reserved for works of art into the artefacts of science and technology. This involves not only crossing boundaries in the search for common themes, but also arguing that any insights that might emerge can be brought to bear on enduring questions on how visual representations are used in fundamental ways to gain our human purchase on the world about us. I realize that I can do little more than open some personal doors into such grand issues, but I hope my visual perspectives will contribute to the continuing debates about seeing, knowing, and representing.

The educative dimension in my agenda brings with it an undertow of ethical value. Such an agenda for history was more common in the past than it is today. I make no apology for reviving it; I believe that the historian's voice is too rarely heard in debates about current issues, particularly about significant questions in the visual cultures of science and technology, the cultures which loom so large in our society. My approach here is quite different from deconstructive criticism of historical culture to serve current political agendas in the way that has become fashionable in the closet politics of academia. Rather, in a more historically generous spirit, I am reconstructing some continuities and discontinuities between past and present which serve to put current trends in perspective, without treating the past as a sour land over which to exercise present concerns and anxieties.

Two intersecting perspectives are involved in this agenda: that of the past as reconstructed from visual and written evidence; and, inevitably, that of the present. And a very extraordinary present it is, above all in visual terms. I believe that the current explosion of imagery on a worldwide basis, driven not least though not exclusively by computers, is as significant as the visual revolution of the Renaissance, which achieved its international transmission through the media of prints and the printed book. The way that computers record, manipulate, and generate images has frequently been seen as introducing something radically new, whether viewed from within by missionary advocates involved with the 'revolution' or externally from more anxious perspectives. It is, to my mind, essential that we gain a grip on what is happening now in relation to what happened in the past—and perhaps to see that there are more similarities than may be immediately apparent. We are living at a time when it seems that many of the old assumptions about science and its time-honoured disciplines are breaking down and when artistic practice is occupying territories in which the old notions of the fixed 'work of art' and enduring 'artefact' are being disrupted. The book takes advantage of the freedom of the

disruptions to look back afresh at age-old issues in the seeing and depiction of nature, and to look critically at the present from the perspective of someone professionally concerned with the past.

We are witnessing attacks on the arrogance of scientific knowledge and a public loss of absolute confidence in scientific progress, whilst at the same time the professional mainstream of science has been seen as doggedly pursuing its professional programmes largely in defiance of public concerns. Recently there have been encouraging signs, seen most notably in the growth of a market for books of popular science, that there is a growing professional and public awareness of the need to communicate and debate the agendas of science on a broader basis. In the context of the concerns of the present book, Steven Jay Gould, Ian Stewart, Stuart Kauffman, Michio Kaku, Stephen Hawking, Philip Ball, Brian Goodwin, Steven Rose, Frank Close, Gordon Fraser, John Barrow, David Peat, and Richard Dawkins—to name only a few authors who have recently impinged upon me personally—have produced lively and largely accessible books that act as bridges between technical science and its public (mis)understanding. It may be significant that a proportion of the most-read books of 'popular science' are written by those who espouse partly or largely unorthodox stances and who feel that their natural audience lies outside the restrictive practices of established professional disciplines. In this popular forum, the 'visual' has played and continues to play a key role, both because of its inherent importance in terms of observation and representation, and because 'pictures' provide highly effective ways of communicating to non-specialist audiences. At the same time, the practice of art has become bewilderingly plural and often detached from the public concept of 'Art'. Artistic representation generally seems to have surrendered its traditional and assumed roles of narrative, naturalistic portrayal, direct meaning, and aesthetic contemplation, as it has become so involved with process, performance, and spectacle. As such, it has been the subject of some public bewilderment, centred on the question, 'Is is Art?'

Against these backgrounds, I will be analysing some recurrent types of image of natural order in art and science to show how their historical understanding can shed new and unexpected light on the ways we have tackled and continue to tackle such issues as the visualizing of space, the relationships of wholes to parts, the generation of form in nature, the mathematics of complexity as popularized and represented in chaos theory and fractals, and the machine-made image. I am not trying to portray some kind of 'spirit of the age' or 'collective unconscious' at any point in the story. Rather, in what is a series of essays with linked visual motifs, I am intending to trace some persistent currents. They

3

have run more strongly at some times than others. In this quest, my roll-call of witnesses runs from Leonardo, Dürer and selected artistic successors, through Kepler, Galileo, Goethe, Darwin, Galton, and D'Arcy Thompson, to some of today's scientific pundits and practising artists.

I will be focusing on what I am identifying as a series of nodal points in the history of the imagery of the seen and unseen worlds of nature in art and science, rather than writing a 'joined-up' chronological and / or synchronic history. The book comprises, therefore, complimentary essays with an underlying historical shape rather than a sequential 'story'. The first of the nodal points is the visual revolution of the Renaissance in terms of the rise of the naturalistic image through techniques for the construction of perspectival space and the imitation of nature. This rise will be witnessed across the fifteenth, sixteenth, and early seventeenth centuries. The second concerns the so-called Romantic era, in which depictions of nature became increasingly concerned with visions of dynamic interaction and aspired to reach out into realms of sublimity in time and space. This period runs from the precursors of Romanticism in the eighteenth century to the middle years of the next. Thirdly comes the period of classic modernism in the first three-quarters of the last century, in which the emphasis was upon hidden, abstract forms and forces, often of increasing minuteness and immensity. Finally, in our current age of plurality and process, we are faced with an extraordinary proliferation of the means of generating a wide range of images of varied types, and with a huge increase in our ability to broadcast them (in terms of numbers, speed, and geographical spread). I am convinced that we can gain a better and less awed critical purchase on current developments if we take the long view. Taking such a perspective, I believe it is possible to produce an effective commentary on a number of continuing themes in art and science, in such a way that both the present and past begin to look rather different.

The book represents a sampling of these themes via topics selected from research I have conducted over some 35 years. It brings together a series of my persistent concerns within a more general framework. Although the common threads were not invariably apparent at the time when I wrote some of the earlier studies, they have now been drawn together in the service of a larger whole. Inevitably, given the scope of the present enterprise, I have needed to mingle highly-focused case studies with gross generalizations. I am aware of some problematic shifts of gear, as detailed scrutiny of a small segment of territory at a steady pace is interspersed with generalizations that rush breathlessly across sketchily portrayed landscapes. I am not offering a survey, and I

4

am being consciously partial, in both senses of that term. The best I can hope is that the topics subjected to detailed focus have been selected in such a way as to be exemplary, so that the parts can be seen as belonging to a discernible whole, without using what would normally be seen as a consistent historical 'argument'. The consistency resides in the style of approach to images and the recurrent patterns established by the illustrations rather than that of a single historical thesis. I am therefore conscious that the book is not unified in the conventional way through the pursuit of a single argument, the inhabiting of a clearly bounded territory, or any kind of narrative (chronological or otherwise). It is, rather, constructed around a series of 'movements', roughly analogous to the kinds of structure employed by composers in symphonies, in which themes are suggested only to disappear, before re-emerging in transfigured forms. The illustrations are also used consciously to create echoes and resonances in such a way as to make their own suggestive points, rather than acting in a more limited way as literal illustrations of the text. As they came together, telling juxtapositions arose, beyond those I originally anticipated.

My choice of historical characters has been motivated by a sense of when someone seems, knowingly or inadvertently, to embody an exceptional range of those concerns which went into the compound that made the visual culture of his or her age distinctive. I have been drawn towards a series of remarkable characters who are at once representative and exceptional—representative with respect to their conceptual and visual styles, and exceptional in their ability to act as representatives of a remarkably wide range of what is conceptually and visually possible in a given period. My aspiration to see continuities is reflected in the grouping of the ten chapters into four parts. To highlight some of the threads that run across the chapters, I have sometimes returned to the same episodes, albeit in somewhat different ways. If the reader senses that something is handled in an even more than customarily summary manner than is usual, it might be worth waiting to see if it returns.

The first chapter is concerned with perspective, about which I have already written at some length in *The Science of Art*. Inevitably, some of the evidence is shared, but my intention here is to characterize in a broader way the consequences of the 'perspectival vision' in some key incidents in the sciences as well as in the visual arts. The second chapter carries an understanding of these consequences into selected areas of twentieth-century imagery. I am conscious that the leap from incidents drawn from the period 1400–1610 to the modern era is very sharp, on the surface at least. However, the virtue is that the commonalities that

can be discerned are all the more striking. The underlying refrain of these two chapters in part I concerns how mechanisms of perception (innate and acquired) found expression in systems of spatial representation, which acted as powerful tools in visualization and communication. This theme of looking at things from and with a particular spatial perspective resurfaces in one guise or another throughout subsequent chapters, particularly in part IV, which looks at the use of devices for seeing and representing.

The five chapters that comprise parts II and III are also concerned with perspectives, albeit in the more metaphorical sense. I am looking at the way in which a series of thinkers on visual matters—some not unreasonably described as 'visionaries'—have allied detailed scrutiny of parts, sometimes very minute, with a sense of how the details fit into whole systems. Stated this way, the use of parts as a gateway to wholes may sound uncontroversial, but it carries serious implications for what we believe to be the fundamental levels at which nature's organization operates. If we accept what is often called 'reductionism', the way to understand nature is to dismantle it into its smallest effect parts. In physics, these parts correspond to the smallest discernible particles, while in biology the crucial unit has latterly been characterized as the 'selfish gene'. If we adhere to a more holistic view, we will seek insights into greater patterns of organization (often self-organization) behind the teeming variousness of nature. Traditionally such a holistic quest has been motivated by religious beliefs or mystical philosophies, but the advent of the new mathematics of complexity (most famously through chaos theory) has provided new tools with which to supply quantitative mechanisms for earlier qualitative insights. Parts II and III centre respectively upon qualitative and quantitative themes in the natural sciences, that is to say on analytical descriptions and mathematical precisions, with an emphasis upon geometrical patterns in part III; but the division of labour is not absolute. Qualitative science always carries implications that there are systematic mechanisms at work, even if these are not the overt focus of quantitative analysis, while even the hardest acts of quantification and mechanistic reductionism rest on often unstated assumptions that rely on qualitative judgements. The most austere judgement that all there is in nature is 'bottom-up' mechanism is a philosophical stance, a kind of negative faith, not a demonstrable certainty.

Each of the central chapters picks out 'heroes' for greater or lesser degrees of special attention. These include Leonardo, Dürer, Bernard Palissy, Robert Thornton, Robert Hooke, D'Arcy Thompson, and Francis Galton, a list that reflects how the sciences and arts became self-

consciously defined through the heroic (predominantly male) pioneers in the Renaissance and its successor periods. This individualizing impetus is one of the dominant conceptual and social realities of the world I am traversing. However, not all my leading characters are household names, and some of them would generally be regarded as coming into the category of the eccentric. Even so, I am confident that they can sustain the exemplary roles I am asking then to perform.

The final part acts a kind of framing device, returning to questions of optical representation. It is concerned with strategies, above all instrumental, to create objective mechanisms of representation which could militate against the intrusion of the artist's eye and hand. The long-standing nature of this ambition has been consistently downplayed by writers on photography and later systems of technological representation. Any historian studying a specific topic within a particular period is inevitably drawn to what appears to be new—to differentiate the topic and indeed to justify looking at it at all—but this can all too easily lead to the apparent innovations being used to over-characterize what is taken to be a radically new feature in a later society. The result is the historical equivalent of a self-fulfilling prophecy. My intention is not to deny that some very remarkable and decisive things have happened since the Renaissance, but to avoid jumping to easy conclusions about change. The intention is to recognize continuities and developments, as illustrative of enduring traits in human perceptual means and cognitive ends—even when the means are as novel as X-rays.

To follow the chapters with a decisive conclusion would be contrary to my desire to keep issues open. But it would be unhelpful not to make some effort to look back over the landscape after asking the reader to undertake such a lengthy journey.

I am conscious that the book does not fit readily into an existing genre. For my part, I am intending to explore the possibility of looking at issues in the public and professional debates in ways that at least raise interesting questions. Inevitably it will be characterized as being about 'art and science', an area of cross-disciplinary debate that has become something of a growth industry. However, I would wish it not to be seen as art and science, but rather as about the 'history of the visual' as a discipline in its own right. I am operating on the assumption that if we do not begin by classifying each visual product as either a work of art or a scientific product then some very interesting things begin to happen. This is not to say that art and science are invalid or misleading classifications, and much activity (certainly during the nineteenth and twentieth centuries) has been undertaken within institutional and intellectual frameworks in which varied notions of the arts and science

enjoyed almost unquestioned rule. I am not looking primarily to chart the influence of one on the other, and even less am I intending to resort to generalized notions of creativity, inspiration, and imagination in order to say that art and science are at heart much the same kind of thing. Rather I am attempting to discern what I have elsewhere called 'structural intuitions' which are expressed in various ways in a recurrent basis in the arts and sciences. These intuitions may play prominent roles in different areas of activity at various times, and may even be driven underground for greater or lesser periods. The vehicles in which they are brought to public attention will often be so different that they may escape notice if we allow the vehicles always to drive down separate highways. What I mean by 'structural intuitions', with respect to inner and outer worlds, is best left for definition in the main body of the book, and has been explored in my book *Visualizations*, in which some of my *Nature* essays are collected.

I have already indicated that I am not trying to maintain that there are some underlying 'big ideas' that define the spirit of an age. Indeed, I share the late Sir Ernst Gombrich's huge distrust of such great definitions. If anything, I hope that the underlying ideas that I am exploring indicate that many of our visual instincts as expressed in images recur across different ages, however different the vehicles may be. Perhaps the most central of the ideas is that certain styles or modes of scientific and artistic visualization have been shared across many periods, assuming different degrees of prominence for different innovators. Should any reader ask 'Is there is any evidence that scientists do or ever did think visually?' (a question that has been posed to me), I hope that this book does demonstrate that some very significant figures did operate in particularly visual manners. Other major thinkers in the same age—in any age—will not be much engaged with visual tools. There is not a value judgement to be made here. One approach is not better than the other; different kinds of thought each have their role to play. If my arguments about some specially visual styles of science fail, I am sure that many living scientists of note, such as Sir Harry Kroto, a leading member of the team that discovered Buckminster Fullerine, would testify more effectively than I to the role of visual thinking in scientific invention. The solving of the 'architectural' structure of C_{60} as a truncated dodecahedron was inspired, not least, by the geodesic domes of Buckminster Fuller, the American visionary architect and inventor, after whom the 'new' carbon molecule was appropriately named. It is interesting that key figures in the early history of the modelling of the polyhedral symmetries of viruses also looked to Fuller for inspiration.

I have no intention of claiming that any century (or other time division) was a predominantly visual culture, but I do believe that at particular times visual images have played particularly dynamic roles in cultural developments. It seems undeniable that the advent of the printed book with illustrations was central to radical transformations in many areas of science and technology, but I am certainly not arguing that the use of illustrations in a book means that its author was, himself, visually acute or even visually aware. Illustrations appear in books for many different reasons—sometimes in response to the publisher's sense of what will sell—and they need not be structurally related to the main purpose of the text. However, many of the authors who feature in this book insisted on the value of illustrative material and took great trouble to forge the most effective pictorial means as to convince me that their high levels of visual awareness cannot be doubted.

In writing a book about ideas to which I am committed, I realize that there is a risk of the tone sounding over-assertive. My intention is to propose ideas with conviction, in the belief that ideas as such are worth conviction and that they can best play their role in discussions if they are advocated positively. It does not mean that they are right, but it does mean that the issues seem to me to be of sufficient importance to justify a committed effort in formulating arguments—both pro and con.

A NOTE ABOUT ILLUSTRATIONS

Ideally, this book should have many hundreds of illustrations, painting a picture that runs parallel to the text. However, practical matters dictate otherwise. With the assistance of readers for the Press, I have aspired to provide enough illustrations (particularly of unfamiliar material) to support the argument and sufficient references to guide the reader to complimentary caches of images.

PART I

JOURNEY INTO SPACE

1

LOOKING INTO THE BOX

The way we think about space, consciously and unconsciously, is profoundly associated at the deepest structural level with the way that space has come to be represented in Western art from the time of the invention of linear perspective in the Renaissance. The dominant schema of visualization is what might be called the cubic unit, potentially extensible to infinity, but for the most part related to the finite spaces we inhabit inside the predominantly urban environments that house increasing numbers of the world's population. It is a form of ordering that we also show a marked propensity to impose on more rural topographies for a variety of visual, psychological, and functional reasons. It is a schema which has pervasively entered world cultures which traditionally have represented space in very different ways, if at all. The entry has been affected partly by the spread of perspectival depiction within the realm of art, much as it diffused in an apparently inexorable manner from fifteenth-century Florence into virtually every European state in the early modern era. But its dominance has been more pervasively and insistently affected by photography, the universal art, and subsequently by film, television and, most recently, by computer imaging. The basic parameters for the construction of space in a computer, utilizing the X, Y, and Z axes to define the three dimensional coordinates, are precisely those established by the Renaissance perspectivists: up and down, in and out, and from side to side. The boundaries of the screen of a computer, displaying the results of a computer-aided design programme, are in effect transformed into a kind of frame or window through which we view an illusionistic slice of measurable space. As such, the resulting 'pictures' on the screens conform to the spatial format that was first

provided by the stock organizational tool for the Renaissance paintings.

I should say at the outset that I am not automatically positing a causal relationship between the mechanisms of perspectival representation and our process of visualization—saying, as has been done, that the system of *depiction* is responsible for the imposition of a system of spatial *visualization* characteristic of Western and Westernized cultures. Nor am I assuming the converse—that such a form of representation is somehow the inevitable consequence of the perceptual structures we use to see and move in space. My concern here is to see how, from my perspective as a historian of the visual, a historical study can contribute to some of the main questions about the perception, cognition, and representation of space and form from the Renaissance to now. My engagement with these issues is founded not only on the belief that the historian can play a vital role in the debates, above all in the understanding of the cultural values which shape the evidence and methods we use, but also on the conviction that the historian's own analyses are posited upon implicit or explicit points of view which need to be openly acknowledged and interrogated.

The theme I will be tackling in this chapter involves the relationship between the mode of spatial depiction that was invented and perfected in Renaissance painting and the way in which space was re-envisaged in scientific representation, particularly in astronomy. My study of this theme falls broadly into three parts. The first looks at what might be called the 'architectural aesthetics' of the Copernican revolution, in the hands of Nicolaus Copernicus and his successors, particularly Johannes Kepler. The second deals with the question of the points from which things are viewed—'perspectives' on things, in the literal sense—and how it relates to the sun-centred system which became established in the wake of Copernicus's book on the revolution of the heavens in 1543. I then offer some thoughts upon modes of metaphor and representation in the 'Scientific Revolution'. The following chapter will deal with the implications of the old perspectives of the Renaissance for new systems of representation from the twentieth century onwards, and I will suggest how my historical standpoint might contribute to the cross-disciplinary issues of seeing and representing space in our visual world.

The twin motifs running through the older historical themes are the mathematical aesthetics of space—notions of the perfection of geometry, proportional harmonies, and divine design—and the definition of the position of the observer as the key to the perception of the underlying regularities of both God's creation and those human

14

artefacts which mirrored his created order. Indeed, as we will see, it was God's bringing into existence an attuned observer which was for long regarded as the immediate purpose of our visual world, a world made either *for us* or *by us* as observing beings.

These motifs, somewhat difficult and abstract in their verbal formulation, can be brought into immediate visual reality by looking at key inventions by two of the pioneers of the Renaissance revolution in the visual arts, the Church of S. Lorenzo by Filippo Brunelleschi, seen in a view down one of the aisles (fig. 1) and the fresco of the *Trinity* by Masaccio in a bay on the side wall of the left-hand aisle of S. Maria Novella (fig. 2). They are both located in Florence, where the ground-work for the new vision was laid down. One is an actual building designed to be seen perspectively in terms of invariant, proportional beauties in space, while the other is a painting of a comparable piece of harmonic architecture according to the perspectival perception of a spectator located at a specific point of view.

The link between Brunelleschi's style of building and perspective is, at one level, wholly obvious. Probably before he began his career as an architect, he had invented the modern form of linear perspective. He

Fig. 1

Filippo Brunelleschi, *S. Lorenzo*, second quarter of the fifteenth century, Florence

is credited with this achievement in the biography probably written by Antonio Manetti, who knew his subject personally.[1] We learn that Filippo made two demonstration panels, one of the Florentine Baptistery and the other of the government palace (now the Palazzo Vecchio (fig. 3), both of which are now lost. The aim of such perspectives was to show 'buildings in proportion, as the eye gauges them, and so true that when one stands away from them they seem to be in three dimensions'—to quote the sculptor, Ghiberti, one of the earliest and most avid converts to perspective.[2] Both panels are now lost. In the case of the latter, the larger of the two according to Manetti's description, the artist cut out the sky in such a way that the profile of the buildings could be matched with their painted equivalents. For the Baptistery panel, he arranged a portable peep-show. A conical hole was drilled in the panel, and the spectator looked through from the back at a hand-held mirror, in

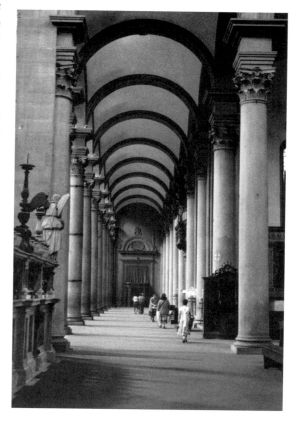

Fig. 2

Masaccio, Trinity, in its setting, c.1426, S. Maria Novella, Florence

which the reflection of the painted surface could be seen. Not only did this viewing system allow the spectator to establish a viewpoint for the panel roughly equivalent to that from which the depiction had been contrived, but it also gave him or her the potential, while standing at the actual location, to match the painted scene in reflection with the actual view when the mirror was alternately raised into position and then lowered.

Already the basic proposition is in place. The image of a regular shape is transformed according to the point of view of the spectator, and it is the systematic nature of that transformation according to the inherent geometry of optical rule that allows us to comprehend the nature of the shape in terms of its apparent spatial form in the painted representation. What Manetti, for all his careful description of the panels, does not tell us is how his subject achieved these results. Fortunately in our present context, we need not concern ourselves with a problem which is not susceptible to definite resolution. We simply need to stress for present purposes that the relationship between the spectator and the object was expressed systematically in the image, in such a way that the actual shape of the object, its spatial location, and point of view are logically interdependent in the depiction. One consequence is that the image provides all the data we need to reconstruct the proper viewing position, whether by visual instinct or precise calculation.

The notion of an observer looking at architectural structures from precise 'station points' is thoroughly urban in nature, and it is no coincidence that Brunelleschi should have invented this method of perspectival representation at a particular time and place in a society which was pioneering new systems for the design of urban environments as geometrical machines for the social life of the modern citizen. Florence was an old city, and any substantial schemes of town planning needed to be carved from the existing fabric with considerable difficulty, given the often entrenched interests of existing property holders. But the effort was made, often with notable results. The Piazza della Signoria, the grand space which presented Brunelleschi with the

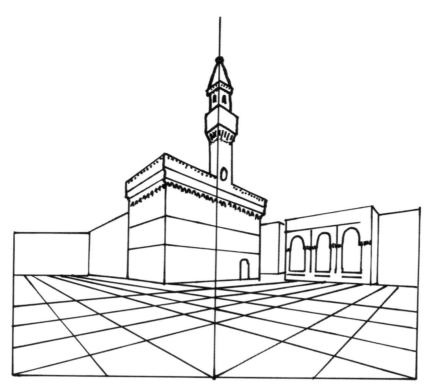

Fig. 3

Reconstruction of Filippo
Brunelleschi's lost
*Demonstration panel of
the Florentine Baptistery,*
*c.*1413

kind of open vista necessary to portray such a large structure, had itself
been laboriously excavated from a densely-built area over a number of
years, not least as the result of the confiscation of properties owned
by exiled families. Even more immediately germane to our present
concerns is the way that the Via Calzaiuoli had been straightened and
regularized in the years 1389–91. A spectator who had walked along
the ceremonial route down the wide street from the Cathedral and
past the important Guild Hall of Or San Michele, which was then in
the early stages of adornment with the great series of standing figures
by Donatello, Ghiberti, and other leading masters, would emerge at
the corner of the Piazza into the grand scenographic space, within
which the bulk of the Palazzo made its splendid impact. The dramatic
moment of emergence was heralded by a parade of matching facades
at the northern end of the Via (fig. 4), the very point at which the
spectator spills into the bright panorama of the square that provided
Brunelleschi's location point for his perspective panel.

Given the piecemeal opportunism which lay behind the making of
the Piazza, and indeed the building of the Palazzo itself, it is difficult to
know how far precise measures or regular geometry could be imposed in
the devising of the spaces—though it is certain that the geometry of

17

Fig. 4

*Facades at the northern
end of the Via Calzaiuoli
leading to Or San
Michele, c.1390 and
later*

surveying, in which Brunelleschi was well schooled, was involved in
the practical procedures at every stage. However, we do know of the
geometrical aspirations of the Florentine town planners when they had
the opportunity to work without the constraints of existing structures.
During the fourteenth century, a series of new towns was inaugurated
by the Florentine government in the surrounding Tuscan territory, as
part of the systematic extension of their rule in accordance with their
conceptions of political and urban order.[3] The town of S. Giovanni Val
d'Arno (Valdarno) (fig. 5) exemplifies their aspirations. At the centre of

Fig. 5

S. Giovanni Val d'Arno,
from 1298, view of the
Palazzo del Pretorio

a superb double square stands the imposing building which housed the council, at the intersection of the widest street on the cross axis of the town. The whole plan is a testimony to the principles of geometric order in the service of social imperatives. Spaces, streets, and properties are assigned dimensions proportionate to their importance in the hierarchies of their public and private functions. When a tourist photographer in the present-day town, which has survived in remarkably complete condition, selects a suitably scenic point from which to photograph the square, he or she is responding instinctively to the spatial control exercised by the original planners. When Brunelleschi stationed himself at the mouth of the Via Calzaiuoli in Florence, and within the central door of the Cathedral in front of the Baptistery, he was partaking even more knowingly in the measured urban experience to which he was to contribute so purposefully as an architect and planner.

The nature of his contribution was very special. The nave of S. Lorenzo shows the way that he was using components of set geometrical form and proportion. The round arches are supported by columns in such a way that the arch is twice as tall as it is wide, and located in a nave which is double the width of the distances between the columns. He has adopted a vocabulary of regular forms, such as the classicizing capitals, which served to establish his reputation as the reviver of the good, ancient style. 'He has the greatest intellect and imagination; the Roman manner of building was rediscovered by him', as Giovanni Ruccellai (an important patron of Alberti) recorded in his common-place book.[4] These basic and traditional formulations need to be qualified by the responsible historian in the light of the complex building history of S. Lorenzo and the close affinities between his architectural style and Tuscan Romanesque architecture of the tenth and eleventh centuries. However, the core of his visual achievement—the invention of a harmonic architecture which embeds references to ancient Roman ideals—remains clear. Considered spatially, the importance of his system of design was that it retained its proportional lucidity regardless of the spectator's viewpoint. A square retains its lucid identity when viewed from a varied angle with a greater degree of robustness than a rhombus or parallelogram. The proportional system also means that the relationship of the parts remains invariant and apparent regardless of the extent that they may be perspectively diminished as they move further from the spectator's station point. This is what I meant when I said that Brunelleschi designed buildings to be seen perspectively—or perhaps it would be better to say that his insistence on spatial lucidity and proportional regularity ran through

his invention of perspective, as a way to record the ordering of forms in space, no less than through his production of an architecture which declared its regular spatial measure in both its whole and in its parts. Proportion is the rule.

It is also important to realize that the spatial organization within S. Lorenzo also related to hierarchical order, not only such ecclesiastical hierarchies of the high and lateral altars but also the social orders of those patrons who were conceded rights over particular parts of the interior. As the leading family behind the financing of the rebuilding of their local church, the Medici assumed control over the sacristy, a prestigiously domed structure which doubled as their burial chapel, and a large side chapel. Even more notably, as the other sponsors found the financial commitments beyond their means, Cosimo de' Medici acquired the rights to the absolutely crucial space immediately under the dome of the main crossing. Cosimo was to be celebrated in precisely this location by the beautiful inlaid geometry of the tomb marker designed by Andrea Verrocchio (fig. 6), the teacher of Leonardo. Symmetry and status were as intimately linked within the consecrated space of the church as in the secular marking out of the dimensions of a Tuscan new town.

When we turn to the first painting which fully reflects Brunelleschian linear perspective, Masaccio's *Trinity* (fig. 2), it is not surprising to find that it portrays structures which embody the architect's principles of spatial measure and classicizing grammar. The setting of the arch supported by columns within the pilasters which support the straight cornice locks it into a set relationship to the whole ensemble. Everything

Fig. 6

Andrea Verrocchio,
*Tomb marker for Cosimo
de' Medici*, 1465–7,
Florence, S. Lorenzo

would need to change if just one dimension was modified. The coffered vault is locked into the mould dictated by its framing elements, in a way that seemingly brooks no compromise. Had Masaccio adopted a pointed Gothic arch, he could have flexibly altered its height or width without radical implications for the whole. Looking at the set, inviolable composition of the architecture of the *Trinity*, the definition of beauty formulated by Leon Battista Alberti comes to mind: 'Beauty is a reasoned harmony of all the parts within a body, so that nothing may be added, taken away or altered, but for the worse'.[5] It is this apparently regular, internally consistent structure that is then depicted from a specific point of view—with radical consequences for its appearance as an image but without losing its assertive regularity as a design.

The fresco immediately declares to the spectator that he or she is seeing a particular structure from a particular place, and that the painted space has a reality contemporaneous with ours—we are looking at it here and now, standing at this spot on the pavement of the church at an existential moment. For instance, on a summer day it seems that the air of the nave—offering cool and moistly tangible solace after the baking dryness of the Piazza in front of the facade—is the same as that which surrounds the kneeling donors as well as the sacred persons deeper in the space of the painted 'chapel'. We look upwards, into the vault at the rows of receding coffers. We see the head of God the Father pressing optically into the arch of the vault—from our low viewpoint—and silhouetted regally against its concave grandeur. We look across at the kneeling husband and wife, on a level with us (physically and symbolically) and located in front of the pilasters which mark the spatial boundaries between the mortal and divine spaces. Even more unequivocally in our space is the skeleton on its bier. We look down in an optical and metaphorical sense on the merely mortal remains, yet the inscription sternly reminds us that 'What you are I once was. What I am you will become'. Perhaps we are nor surprised to find that space has profound spiritual meaning and hierarchical import in painting— but we should also be prepared for the fact that space in what we call science will prove to be as deeply loaded with meaning.

Masaccio has accomplished his ends through a measured exploitation of Brunelleschi's invention, and it is by no means out of the question that the architect was directly involved in the design of Masaccio's painted structure. Although, as close analyses have shown, the painter has by no means followed all the optical implications of his perspective scheme with complete rigour—adjusting the geometry where his instincts told him that it was not compatible with the visual effects he was seeking—and although our low viewpoint obscures

the floor on which the Virgin and St John stand, the visual effect is one of measured lucidity which defines the relative positions of the observer and the fictive scene. The optimal viewing position, as both calculation and on-site intuition suggest, is around the normal head height of someone standing directly in front of the fresco and at a point between the piers which mark the division between the nave and aisles.

It also seems, very remarkably, that the slight setting of God the Father off the central axis is a response to the position of what then was the regular entrance to S. Maria Novella. This was situated in the lateral wall, opposite the fresco—outside of which ran the cloister located on the right of the church as we approach the façade. Entering via that door, we see the *Trinity* on the other (left) side of the nave and aisles, but it is not directly ahead of us. We approach it somewhat to the right of its central axis. Masaccio is so attuned to the responsiveness of things in space as the spectator's viewpoint moves that he has used the phenomenon of parallax as happens when we move our head from one side to the other or alternately close one eye and open the other. He suggests that God's head seems not to be aligned with the central axis of the vault. The visual effect is as if we look down the nave of a Brunelleschian church from a slightly off-centre position.

In our conjoining of the *Trinity* with Brunelleschian architecture, we can see how it is impossible to separate the harmonic ideal of proportional design and the perspectival premise of the readily legible shapes of geometrical forms seen from a specific viewpoint. This conjunction pervades the act of visualization that underlays Copernicus's re-envisaging of the cosmos.

The Copernican System as Aesthetic Architecture

The dominant motivation in Copernicus's revision of the entrenched scheme of Ptolemy seems to have been discontent with the ugly elaborations which had become necessary over the years to make an earth-centred system fit the observed motions of the planets and sun. The basic system of circular orbits around the earth had become heavily qualified by epicycles (secondary orbits born around the major orbits) and eccentrics (off-centre and mobile centres of revolution). The essential beauty of the Ptolemeic system had become progressively obscured by manoeuvres designed to 'save appearances'. In retrospect, in seems that the system was ripe for collapse under the weight of its own elaboration. Copernicus instinctively sensed that an unacceptable point of

corruption had been reached, and the schema had become grotesque. The latter-day proponents of the Ptolemeic universe has failed to:

> elicit or deduce from the eccentrics the principal consideration, that is the true structure of the universe and the true symmetry of the parts. On the contrary, their experience was just like some one taking from various places hands, feet, a head and other pieces. Very well depicted they may be, but not for the representation of a single person. Since these fragments would not belong to one another at all, a monster rather than a man would be assembled. Hence in the process of demonstration or 'method' as it is called, those who have employed eccentrics are found either to have omitted something essential or to have added something extraneous and wholly irrelevant.[6]

The harmonic body, the well-proportioned figure, had been dismembered in traditional astronomy. By contrast, he sensed that the body of the universe should yield nothing in perfection to the body of the ideal human being as created by God. Theorists of visual beauty in the Renaissance had paid a good deal of attention to the way in which the beauty of the human frame—the microcosm of the universal of macrocosm—could be defined. The formulation of the ancient Roman architect, Vitruvius, that the body could be inscribed within a square and a circle, the two most perfect figures, assumed canonical status, and received its definitive visual formulation at the hands of Leonardo, who also searched within the overall schema for the more detailed, internal harmonics of the members of the body, features of the face and so on. As he declared:

> Music . . . composes harmony from the conjunction of her proportional parts, which make their effect instantaneously, being constrained to arise and die in one of more harmonic intervals. These intervals may be said to circumscribe the proportionality of the component parts of which such harmony is composed, no differently from the linear contours of the limbs from which human beauty is generated.[7]

If human beauty could be so confirmed, surely the prime job of the astronomer was to reinstate the fundamentally simple perfection of the body of the universe. His job, in a sense, was to be more true to Ptolemy's principles of harmonic simplicity than his Ptolemeic successors had succeeded in being. Copernicus's act of genius was to see that the only way to accomplish the reinstatement of perfection was to discard the premise around which the older system was based—to discard the fixed idea that everything necessarily turned around the fulcrum of the privileged earth. We know that his new system actually presented his immediate followers with at least as many difficulties with respect to the observational data as had that of Ptolemy, but the principle of

23

'aesthetic cleansing' which drove him to invert the established order is clear.

The vision of bodily geometry inspired by Vitruvius had provided an essential underpinning for the evolving principles of architecture in the Renaissance. Beneath the centralized ground plans of Leonardo's designs for 'temples' we can sense the eternal pattern of the Vitruvian man, tracing the circular and rectilinear elements with the tips of his fingers and the soles of his feet. It was a vision that was to be realized in monumental stone not by Leonardo himself but very directly by Donato Bramante, his one-time colleague in Milan. Bramante's scheme for St Peter's in Rome, only approximately discernible under later revisions, and, in more perfect realization, his actual building of the Tempietto at S. Pietro in Montorio show that the 'body' of the Christian 'temple' yields nothing in perfection to the underlying principles of the Vitruvian man. With this in mind, we can make sense of the ecstatic metaphor that Copernicus uses to justify and (in the text) literally to frame his conclusive diagram of the heliocentric system (fig. 7):

> At rest . . . in the middle of everything is the sun. For in this most beautiful temple, who would place this lamp in another or better position than that from which it can light up the whole thing at the same time? For the sun is

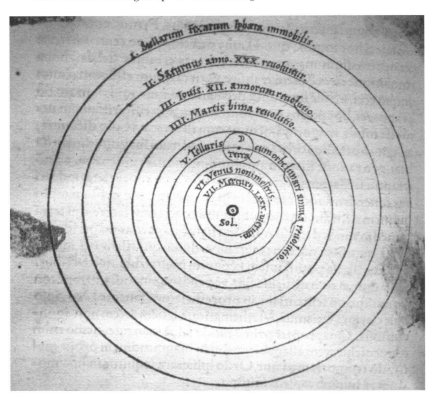

Fig. 7

Nicola Copernicus,
Orbits of the Heavenly Bodies, from *De Revolutionibus*, 1543

24

not inappropriately called by some people the lantern of the universe, its mind by others, and its ruler still by others. The Thrice greatest [Hermes Trismegestius] labels it as a visible god, and Sophocles Electra, the all-seeing. Thus indeed, as though seated on a royal throne, the sun governs the family of the planets revolving around it.[8]

The vision, no less tightly conceived than Alberti's definition of inviolable beauty, seamlessly blends the principles of Renaissance design, the social hierarchies of spatial disposition, and the definition of divine purposefulness in a way that we recognize as already present in Brunelleschi's pursuits. The hierarchies of the governors and the governed, from the supreme Deity, through those who rule with his sanction on earth, to the humble subjects of the predetermined order, are as implicit in Copernicus's scheme, no less than in the design of buildings in a Renaissance state.

The analogy between the heavens and the temple—it is more than a parallel because it is based on the underlying laws of God's universe—becomes even more compelling in visual terms when we discover that Bramante had devised a plan to set the Tempietto within a circular *cortile*. Such a prestigious, centred setting would have been entirely appropriate for a temple that marks the point of the martyrdom of St Peter, the Pope's predecessor as God's supreme representative on earth. However, a moment's hesitation may be in order, since the basis of the Ptolemeic system, as conventionally illustrated works no less well with the scheme for the Tempietto within its orbiting colonnade than the Copernican version. And the specific analogy between the design of the world system and a temple had been prominently mooted in Cicero's *Dream of Scipio* without carrying even the slightest heliocentric implications. But, as we have seen, the basic representation of the traditional schema was now so removed from what was needed to reconcile it with astronomical observations that the force of the comparison was now a matter of theory rather than scientific practice. Copernicus could have claimed that his system was now the only one that could perform the essential function of revealing the temple of the heavens as a 'body' created by God.

The beauty of the Copernican system undoubtedly played a significant role in firing the imagination of its later supporters, though the insertion of the 'base' earth into the orbiting heavens also drew disgusted reactions from some of his opponents. As Christopher Clavius wrote in his commentary of Sacrobosco's *De sphaera*, 'such a worthless and crude body ought to be uniformly separated from all parts of the heavens, which is a body of the highest excellence'.[9] Beauty seemed then as now to reside, as they say, in the eye of the beholder.

No one was more positively appreciative of the aesthetic significance of Copernicus's temple than Johannes Kepler. All his work is suffused by his search for the Platonic harmonics in God's sublime design, and his *Harmonices mundi* ('On the Harmony of the World') in 1619 expounds an all-embracing theory of the music of the cosmos, as a mirror of the arithmetical and geometrical perfection that is in the divine mind. As he states in his introduction:

> Shapes are in the archetype prior to their being in the product, in the divine mind prior to being in creatures, differently indeed in respect of their subject, but the same in the form of their essence.[10]

The authority to whom he repeatedly refers the reader is Proculus Diadochus, whose commentary on Euclid identified geometry as the supremely Platonic mental exercise and as the foundation of all proper understanding of form.

The harmonic proportionality of heavenly mathematics, not last in the guise of the 'music of the spheres' was a long-standing belief. Pliny's *Natural History* will serve to set the tone. In his encyclopaedic compilation, Pliny recalls that:

> Pythagoras . . . designates the distance between the earth and the moon as a whole tone, that between the moon and Mercury a semitone, between Mercury and Venus the same, between her and the sun a tone-and-a-half, between the sun and Mars a tone, . . . between Mars and Jupiter half a tone, between Jupiter and Saturn half a tone, between Saturn and the zodiac a tone-and-a-half: the seven (?) tones thus producing the so-called diapason, i.e. a universal harmony; in this Saturn moves in the Dorian mode, Jupiter in the Phrygian, and similarly with the other planets.[11]

Although the sceptical Pliny considered such celestial harmonics 'more entertaining than convincing', many later theorists with a taste for Pythagorean metaphysics were much taken with the idea. In the Renaissance, for example, Franchino Gaffurio, a leading musician and pioneering theorist in Leonardo's Milan, commenced his series with the Moon and Mercury, giving a succession of 1, 1/2, 1, 1, 1/2, 1, and 1 in such a way that the whole system comprises an octave or diapason. Gaffurio was a pioneer in the codification and representation of harmonic systems, including diagrams proportional relationships.[12]

The pervasiveness of such proportional harmonics for Kepler was such that it not only explained the music of the heavens, but also gave a model for forms of government. Taking his cue from Jean Bodin's *Les six livres de la republique* (1576), he set out broad equations between aristocratic republics and arithmetical proportions, and between royal governance and geometrical proportions. Such is the rule of proportion

that it permeates every relationship in society from the formulation of laws to the weighting of punishment and from the delights of friendship to the division of inheritances. Tempered proportion and apportionment is the rule in all things. Copernicus's allusion to the centrality of the royal throne has found its natural extension in Kepler's adapting of Bodin's social mathematics to his own cosmological ends. Something of this all-embracing usage survives in our expression, 'a sense of proportion', used when we want to espouse a balanced viewpoint.

The immediate reception of Copernicus's heliocentric system amongst astronomers in the generation before Kepler centred upon its role as possible *model* of the heavens in mathematical-cum-aesthetic terms, rather than as a literal physical description of the form and action of the universe. All the radical implications which arose from the repositioning of the earth and its inhabitants did not immediately impress themselves widely on the philosophical and theological communities. The preface provided by Ossiander cast Copernicus's model in the light of a mathematical hypothesis which achieved superior results, rather than as an account of a material mechanism—though it seems fairly clear that Copernicus believed that he was describing the 'real' state of affairs. Only gradually did the full and potentially heretical implications of his displacement of the earth become overtly apparent in the foreground of the theology of the heavens. The controversy came to centre on what Copernicus had done to the position of the observer on the celestial vehicle which God had designed for our journey through life.

The Copernican System and the Perspectival Observer

Copernicus himself was well aware of how radical was his displacement of the observing being—God's supreme creation—from a position of cosmological centrality. Residing on our mobile planet, which now orbits the sun, all the positions and motions of the celestial bodies can only be understood relative to our motion. In his typically humanist fashion, to help us envisage the relativity of the mobile observer, he quoted a sentence from Virgil's *Aeneid*: 'forth from this harbour we sail, and the land and cities slip backwards'.[13] The sometimes odd effects of such relative motions is something that we have probably all experienced—looking at the moon rushing along beside us as we drive

through a tree-lined landscape, or when we see a plane apparently frozen in the air relative to static objects in the landscape during our rapid motion along a motorway or railway line. And, of course, we still see the sun 'rising' and the sun 'setting' in the old Ptolemeic manner, in spite of knowing that it is not the sun that is moving with respect to the static earth.

The idea that perception of reality is defined in terms of where the observer is situated is a perspectival notion in a very literal sense. It also corresponds in a broader way to a prominent Renaissance philosophy which was founded upon ancient Stoic concepts, particularly as gleaned from the widely-studied writings of the Roman authors, Cicero and Seneca. At the heart of Stoic philosophy was an emphasis upon empirical knowledge, in which nature and reason were allied in the service of understanding. Renaissance Neo-Stoicism characterized the sensory world as made for and validated by 'Man', the sentient being placed by God at the pinnacle of Creation. The central idea was encapsulated in a much-quoted tag, attributed to Protagoras, that 'Man is the measure of all things'.[14] It is not surprising to find Alberti, whose ideas were saturated by Neo-Stoic thought, citing the Protagoran formula in 1435 in his short Latin treatise *On Painting*—dedicated a year later to Brunelleschi in its Italian version. *De Pictura* was the first book to give an account of the rationale and construction of linear perspective. Outlining the geometry of perspective in the first of the three books in his treatise, Alberti tells us that he is showing 'how this noble and beautiful art arises from roots within Nature herself'.[15] In his basic formula for the construction of a squared ground plan in perspective, as the foundation for the proportional distribution of forms in space, his preferred module is one *braccio*, one arm's length, which he takes as equivalent to one third of man's normal height (fig. 8). This module provides the basis for a 4-step procedure for the production of a tiled ground plan in strict foreshortening. Man is thus the Protagoran measure of all things in space.

The key feature of Albertian perspective was that it defined the appearance of things, most notably their relative size with respect to the observer, in accordance with an optical theory of vision. The apparent size of an object as registered on the surface of a picture painted according to perspective was proportional to the distance of the object from the spectator—as if seen in a 'real life' situation, given a fixed viewing position and defined location for the 'window' or 'picture frame' through which the object is seen. Move the viewer, object or frame, and the appearance changes correspondingly according to the rule of parallax.

Fig. 8

Leon Battista Alberti,
*Construction of a
Squared Ground
Plan in Perspective,*
based on *De
pictura,* 1435

Whereas Alberti posited only a static viewer in each case, Leonardo noted what happened when the spectator was actually in continuous motion. The vanishing point seems to move in accordance with our change in position:

> the extent to which the point of diminution travels with you will be apparent when you walk beside a ploughed plot of land with straight furrows, the ends of which reach down to the road on which you are walking. You will always see each pair of furrows in such a way that it seems to you that they are trying to press inwards and join together at their distant ends.[16]

A related intuition with respect to the relativities in perspectival vision in Leonardo's analysis of the rules for light concerns the exchangeable or reversible 'seeing' of one thing by another. When he is discussing the passage of light onto and past solid bodies, defining, for example, the nature of the shadows cast on a background by a solid object illuminated from a particular source he says that the surface either 'sees' (*vede*) or does not 'see' the light according to whether it passes freely or is intercepted by an intervening body on its way from the source to the background. What he means is that the source is 'visible from' the background—and *vice versa*. One effectively 'sees' the other in a reciprocal relationship.

A nice pictorial conceit which precisely exploits this mutual visibility of the spectator and the seen thing is provided by Andrea Mantegna in the illusionistic oculus which he painted on the ceiling of the room known as the 'Camera degli Sposi' in the Ducal Palace at Mantua (fig. 9). Standing in the centre of the relatively small room, which served as a an audience chamber for the Marquis of Mantua, Ludovico Gonzaga, we look directly upwards at the curved vault, which is apparently transformed into a structure decorated with motifs in relief and punctuated by an open drum. High above our architecturally confined space, birds fly in the blue sky. Foreshortened infants populate the drum, while amused women regard us in a spirit of courtly fun from its rim. We are both viewer and viewed. The implication is that our space and indeed our persons could be characterized perspectively from the viewpoint of one of the ladies, in a way no less valid and systematic than Mantegna's definition of their location on our behalf. How surprising and radical these new viewpoints could be is vividly realized in Mantegna's *Dead Christ*, shockingly foreshortened on the mortuary slab on which his body was anointed. Compared to the traditional depiction, side-on, Christ is literally seen from a different perspective, arresting our vision with the daring novelty of a view in which feet are more prominent

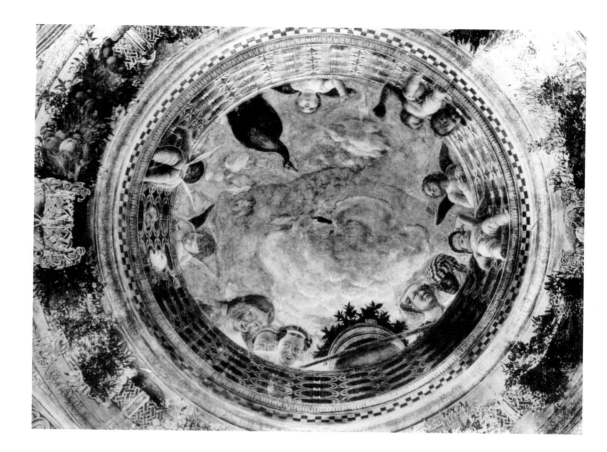

than the face—though the artist has compromised the rules of perspective by decorously showing Christ's head as larger than it should strictly have been from his chosen viewpoint.

As with Masaccio, the new space serves meaning. Whereas the smiling women in the oculus occupy a light-hearted realm of feminine recreation, the message in the *Dead Christ* is deadly serious. We are confronted with the sacrificial reality of Christ's body—the corporeal presence embodied in the Mass—and brought face-to-face with the nature of his physical suffering on the cross, prominently denoted by the jagged stigmata in the soles of his feet. Like Masaccio, and in keeping with Brunelleschi's demonstration panels and Alberti's construction, Mantegna's use of perspective assumes a single observer located statically at a fixed viewing point—and, ideally, a spectator looking with only one eye. We know that the efficacy of a perspectival image is more robust than this formulation suggests— that it continues to make coherent sense from viewpoints quite removed from the ideal position—but the monocular principle is inviolable.

Fig. 9

Andrea Mantegna, *Oculus in the 'Camera degli Sposi'*, c.1465–74, Palazzo Ducale Mantua, Castello di S. Giorgio

There are some equivalents in earlier astronomy to the concept that the spatial disposition of the visible world can be viewed validly from different points within it, and indeed from outside the system itself. The representation of the cosmos as an armillary sphere (fig. 10) permitted the viewer—godlike—to stand outside our terrestrial domain and to see the perfection of the universe from the astronomical equivalent of an Olympian perspective. The wonderful machinery of the heavens could be viewed in all its spatial lucidity, and a perspectival rendering in a picture, such as was standard in personifications of *Astronomy*, would declare the basic disposition of its prime components in a highly intelligible manner. When the orbital patterns of the heavens came to be projected on to a flat surface, as in the planispheric projection on an astrolabe (fig. 11), a skill in which Islamic instrument-makers excelled in advance of their European counterparts, a perspectival viewpoint needed to be chosen. More than one alternative was available, both within and outside the circles of the spheres. The planishpere can be characterized as a perspectival rendering for the purposes of mathematical observation and measurement rather than illusionistic representation—or alternatively like the shadow cast by an armillary sphere illuminated by a single light source. There is, therefore, much common ground between a standard perspective picture and the standard astronomical images of the universe in the forms of the armillary sphere and the astrolabe. Where Copernicus set a new challenge to these standard perspectives was that he placed the human observer on the earth in an irredeemably *mobile* position, like Leonardo's spectator walking beside the ploughed field.

During the course of the first half of the sixteenth century, as we move towards the date of Copernicus's publication, a number of artists began to experiment with perspectival schemes that do indeed work with a mobile spectator, or at least with one who is seen as occupying more than one position. Perhaps the most remarkable of these is the fresco that Antonio Correggio began painting in the dome of the church of S. Giovanni Evangelista in Parma in the 1520s (fig. 12). The main image is dominated by the airborne Christ, surrounded by a ring of disciples who

Fig. 10

Adam Heroldt,
Armillary sphere,
1648. Science
Museum, London

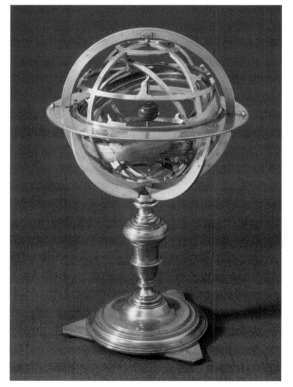

32

are seated on clouds around the rim of the dome. The prime viewpoint for this image is no longer centrally under the vaulted space, as it had been in Mantegna's Camera degli Sposi, but is located at the junction of the nave and the crossing. In other words, a visitor to S. Giovanni, walking along the nave, would be presented with the vision in its full glory at the very point at which he or she first entered the central square covered by the dome. Christ's orientation, seen as it were at an angle from below, makes best sense from this position, as we look upwards and across. But there is another viewpoint needed if we are to make complete sense of the meaning of the fresco. The subject is indeed a vision, the vision of St John on Mount Patmos, as told in the Book of Revelations: 'And behold He cometh on clouds, and every eye shall see Him' (Rev.1: 7). This only becomes explicit if the hollow space of the dome is viewed from the other side of the crossing, that is from the space of the monk's choir. Only then do we become properly aware of the cowering figure of the Evangelist (fig. 13), who stares from the lowest region of the dome in awed astonishment at the miraculous revelation. That this privileged insight is reserved for the worshipping monks is unlikely to have been a matter of chance. Like Copernicus's orbiting observers, the viewer experiences new meanings from the acts of displacement and becomes aware of alternative ways in which our experience may be ordered and comprehended.

There is no suggestion here that Copernicus was affected by Correggio's vision, or by something equivalent to it. Nor am I positing some kind of unconscious diffusing of ideas 'in the air'. Rather, I wish to see the acts of Correggio and Copernicus as predicated on a shared notion of the plural positions of the spectator in relation to our perception of reality, with corresponding consequences for the appearance of things as seen and their images in representation. Their schemes of observed space are comparably dependent upon the potential inherent in the perspectival system for the visualization and depiction of space. If we should seem to be imputing too much sophistication of visual understanding to Copernicus, whose own methods of representation remained resolutely traditional, it is worth recalling that his authorized likeness was said to have been based upon a self-portrait, and that he

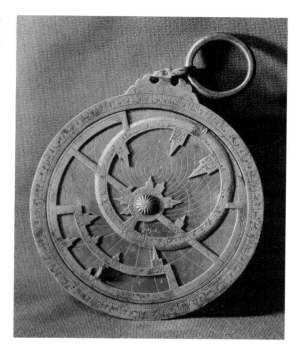

Fig. 11

Ahmad Ibn Khalaf,
Astrolabe, 9th century.
Bibliothèque
Nationale de Cartes
et Plans, Paris

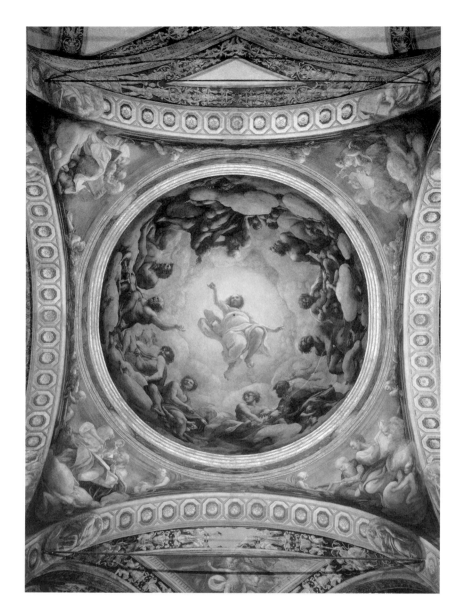

Fig. 12

Antonio Correggio,
*Ascension of Christ
(Vision of St. John on
Mount Patmos)*,
*c.*1520–2, dome
fresco, Parma, S.
Giovanni Evangelista

undoubtedly knew his way around the ancient texts on issues of artistic
representation, including those in Greek. I should be surprised if he
had not encountered Alberti's book on architecture, and he could have
gained access to the first printed edition of *On Painting*, published in
Basel in 1540.

The fully conscious manifestation and manipulation of the new
relativity of the observer comes with Johannes Kepler's astonishing
Somnium ('Dream') composed in 1609 and published posthumously in

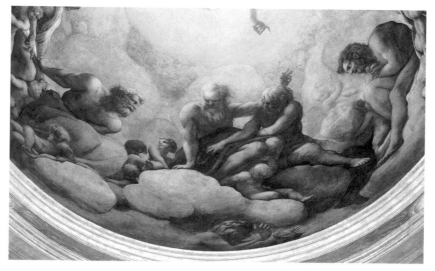

Fig. 13

Correggio, *St. John the
Evangelist and Apostles*,
1520–4, detail of

1634. Kepler envisages how the system of orbiting planets would have been seen by an inhabitant on Levania (equivalent to the moon). The appearance of the system is radically different, yet the rational observer is able to understand how to analyse the data in terms of relative motions in such a way as to arrive at a lucid understanding of the order of the heavens. This remarkable act of spatial visualization confirms what we can sense generally in Kepler's work, namely that his ability to manipulate three-dimensional models in his mind was of the highest order—yielding nothing to the abilities of the greatest painters, sculptors, and architects to envisage forms in space. The remarkable scheme he invented to account for the distances between the orbits of the planets in his *Mysterium cosmographicum* in 1596 is another spectacular case in point. He tells how, when he was teaching his 'students the way Great Conjunctions jump eight signs at a time' he drew 'many triangles, or quasi triangles, in the same circle', and it began to dawn on him that the distances could be explained if the ratios between the successive orbits were designed to be equivalent to the spheres successively circumscribed around and inscribed within the five 'Platonic solids' (the regular polyhedra) when nested one inside the other (fig.14).[17] At the centre was the octahedron, followed by the icosahedron, the dodecahedron, the tetrahedron, and the cube.

The great folding plate depicts the resulting structure from a perspectival vantage point outside the system, from a perspective accessible only to God as the supreme designer of such a wondrous piece of machinery. Or, rather, we should say that Kepler has depicted his scheme for the construction of his own cosmological model, in a

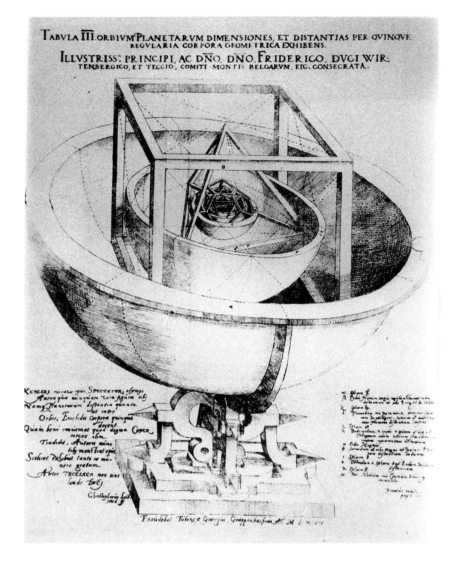

Fig. 14

Johannes Kepler,
*Model of the
Planetary System,*
from *Mysterium
cosmographicum,*
1596

manner analogous to an armillary sphere—as if he were acting as a microcosmic emulator of God. In its most ambitious form, Kepler envisaged that his cosmological device would be driven by clockwork and that its hollow armature would be filled by alcoholic beverages of a suitable kind. (It was, after all, a courtly creation, dedicated to Duke Frederick of Wittenberg, who literally acted as a protector for Kepler as a Copernican 'heretic'.) The model, whether God's or made by human agency, is by implication something which can potentially be viewed and envisaged perspectively from any point within or outside the system. The form of visualization and representation in the model stood in direct line of succession from the form of spatial illustration

invented by Leonardo for the treatise of the five regular polyhedra, *De divina proportione*, written in 1496 by his colleague in Milan, Luca Pacioli. It was the set of five solids that had been characterized by the building blocks of the universe in Plato's *Timaeus*—as the four elements and the cosmos—and it may not be unfair (however much Plato would have disliked it) to characterize Kepler's vision as 'Plato in perspective'—particularized in terms of the appearance of the universe as an artefact viewed from an individual standpoint.

It seems to me that the relativities which we have seen emerging in the Renaissance can be placed in productive dialogue with major aspects of twentieth century philosophy and physics in two particular respects. The first involves the individual viewer as the centre of a customized experience of what we take to be reality. If, to state the problem at it starkest, all we have access to is our own experience, we can neither identify it convincingly with someone else's, since we can never be 'inside' someone else's head, nor be confident that there is a reality out there independent of the mental constructs in our mind, since we are trapped by what our cognitive system can do. Although the notion of perspectival relativity we have seen emerging might seem logically to be leading in this direction, this is very far from being the case. Although appearance was transformed in relation to the situation of each viewer, the results were not arbitrarily individual to each percipient being. Firstly, there was an absolute order underlying God's creation, and this order was apparent in the whole and the parts from every angle. And secondly, the prime purpose of the system of perception and cognition with which we have been endowed was to deduce the underlying rules with a certainty that aspired to the condition of a mathematical proof. Two people might, say, see a cube from different positions and have a different image in their eyes, but they could both say with comparable confidence that they were seeing a cube. Or, to express it in less anachronistic terms, a square building represented in a picture would be registered as square regardless of whether it is seen at one angle or another.

The second involves the potential indeterminacy of the viewer in a changing situation, in which we can never be certain whether it is us or something else that is moving and whether we can rely upon any stable frame of reference for a system of measurement. The famous metaphor for modern notions of indeterminacy is Schrödinger's cat. To characterize the indeterminacy of quantum physics, Erwin Schrödinger asked us to envisage a cat in a box with a phial of poison. The trigger for the release of the poison is provided by the decay of an atom in some radioactive material. The probability of decay is known to be 50%.

When we open the box there is a fifty-fifty chance of the cat being either dead or alive. While the box is closed we cannot assume either that the cat is living or that it has perished, and quantum theory requires us to conceive of the cat being in an indeterminate state, such that it only becomes alive or dead with our act of observation. In other words, the act of the observer—the intrusion of the experimenter—is inseparable from the realization of one of the probabilities. In a sense, this is an extreme consequence of the Neo-Stoic position— that the system exists only in relation to the observer. But this would be to take what we have seen in Correggio, Copernicus, and Kepler in an unwarranted direction. However complex the situation might become with a mobile observer, the system could still be characterized with respect to an absolutely stable and predictable frame of spatial and temporal reference. The clockwork of the heavens could be seen as the same piece of regular machinery from whichever direction it was viewed, and it paced out the same intervals of time for all of us, whether on the earth or the moon.

Although we are no longer a party to the philosophical and theological beliefs which fed the Renaissance sense of the rationality of the system and our perception of it, our pragmatic navigation through time and space in our daily world depends intuitively upon the kind of regular space-time framework which the perspectival vision of Kepler had brought to such a high degree of sophistication. For practical purposes we remain untouched by relativities and indeterminacies of modern physics and cosmology. We remain operatives of a form of perspectival perception at an intuitive level—not, in any straightforward way, according to the perspective of Brunelleschi, but in relation to a set of perceptual protocols and processes that exhibit powerful affinities to it. This is not to say that our ability to see in such ways only arose after the invention of painters' perspective, since I believe that such perceptual modes pre-date the Renaissance formulation. Indeed, I am convinced that they are a fundamental proclivity of the perceptual apparatus with which we have been endowed since the origin of our species. Potentially, the Renaissance perspectival trick was always there to be discovered, but it could only be codified and exploited as a fully conscious mode of visualization and representation when cultural conditions, particularly those relating to the role of images, were propitious. We will later return to these complicated issues in more detail.

More Architecture and Some Real Seeing: Kepler, Tycho, and Galileo

Given Kepler's extraordinary gifts of spatial visualization and his dedication to the disclosing of visual harmonies, it is almost to be expected that he would adopt the kind of architectural metaphor which lay at the heart of Copernicus's rapturous account of the heliocentric system. For the frontispiece to his publication of the *Rudolphine Tables* in 1627—the great collection of observational data assembled by Tycho Brahe for the Emperor Rudolph II—he designed an octagonal temple (fig.15) as a place of spiritual habitation by the shades of the great astronomers of antiquity, Islam, and the Renaissance. The triumphant succession passes round the temple from the rear in two sequences, anti-clockwise on the left and clockwise on the right. At the rear stands a shadowy Chaldean, whilst at the front Hipparchus (the precocious Greek heliocentrist) stands behind Copernicus, and Ptolemy is succeeded by Tycho. The edifice is definitively Renaissance in style, centralized and decorated in the ancient manner, but it is not unified in its architectural modes. The supporting

Fig. 15

Johannes Kepler, *Frontispiece with the Temple of the Astronomers*, from *Tabulae Rudolphinae*, 1627

columns undergo a progression from the rudest to the most sophisticated of the architectural orders. Kepler has ingeniously exploited the way that the orders were characterized in the Renaissance, not only as alternative styles to be used in ways appropriate to each building but as also corresponding to a long historical succession, beginning with the rustic components of a rude hut, passing through progressively less severe and more elegant modes, and culminating in the suave and decorated beauty of the Corinthian order. Thus Hipparchus and Ptolemy are placed beside a roughish version of Doric columns, while Copernicus sits by a sophisticated and developed version of the Tuscan order. Tycho's supremacy at the head of the astronomical succession is proclaimed by the Corinthian column, with its highly-developed capital of acanthus leaves and volutes. The centralized scheme is reminiscent of that devised by the painter-theorist

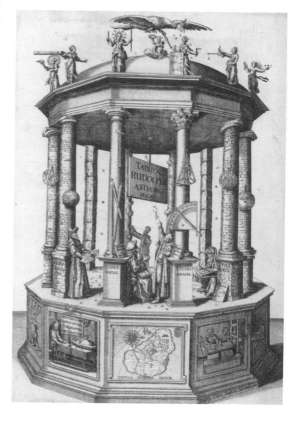

Giovanni Paolo Lomazzo in his *Idea del tempio della pittura* in 1590, in which a circular temple dedicated to the art of painting, very similar in form to Bramante's Tempietto, is supported by caryatid columns in the form of seven great painters: Michelangelo, Gaudenzio Ferrari, Polidoro da Caravaggio, Leonardo da Vinci, Raphael, Mantegna, and Titian. But not even Lomazzo, for all his ingenuity, built a temporal succession into his metaphorical temple.

The temples of Kepler and Lomazzo are of course intellectual conceits rather than real structures. Lomazzo, who wrote his treatise after he had lost his eyesight, does not even provide an illustration of his imagined building. Tycho Brahe, the Danish astronomer who was the supreme observationalist of his time, went one better than Kepler in giving concrete form to the Copernican metaphor. A 'temple-palace' of astronomy was constructed at his behest on the island of Hven, which had been granted to him by the Danish King, Frederick II. No longer extant, its basic design can be seen in the engravings which he published in a number of his own books. Designed by the architect, Johannes Steenwinckel, it consisted of a residence, observatories and garden constructed according to principles of symmetry in relation to cruciform axes. Tycho stressed that all was 'strictly symmetrically arranged, as required with architecture if the work is to be executed in the proper manner according to the rules of art'.[18] The details of the architectural style of the central 'castle', which he named Uraniborg, were hardly in the latest *all'antica* mode by Italian standards, but his Renaissance insistence on *symmetria* dominates the underlying plan. Set within formal gardens, the axes of which correspond to the directions of the compass, it echoed at a microcosmic level those principles of design underlying the universe which he was to observe with such mathematical precision. The observatory housed the large, meticulously engineered and often elaborately decorated instruments in which he took justifiable pride. Within one of these, his great mural quadrant, or *Tychonicus* (fig. 16), the astronomer himself (metal nose and all) was painted by Tobias Gemperlin, seated magisterially at the centre of his own mini-cosmos.

The Neo-Stoic observer in Tycho's image has become the hero of the human quest to know. The quest is for the creature made in God's image to know of his Maker through the mathematical order of divine creation. Tycho's self-image not only encapsulates the exciting and emerging heroism of the scientific 'genius'—the striving for mastery in an overtly 'manly' sense—but it also potentially embodies the arrogance which has often been manifested in our scientific culture. The image of the heroic man pushing on undaunted

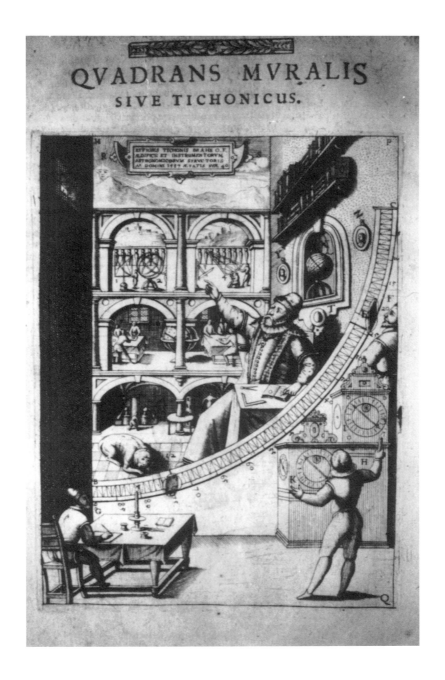

QVADRANS MVRALIS
SIVE TICHONICUS.

Fig. 16

Tycho Brahe, *The
Great Quadrant or
Tychonicus* from
*Astronomiae
instauratae
mechanica*, 1598

into new territories and probing into zones of the cosmos previously
unpenetrated by human vision plays a central role in the iconography
of the scientist. It both immortalizes real achievements, about which
we need not feel guilty, and enshrines values that can all to easily lead
to domineering attitude towards nature, towards other cultures and to
all those not privy to the great truths.

41

Tycho was himself part of a political landscape. For instance, he made sure that his great instruments could be dismantled and moved to other locations, at times when the vagaries of human conduct and the chronic instabilities of European regimes placed his patronage in peril. And he also knew that the nexus of learning and mastery of instruments of which he was part was also an important servant of trade and war. Precise instrumentation was essential to imperial explorers, and the understanding of the motion of solid bodies through the air served military ballistics as much as astronomy, attracting the patronage of militaristic princes in due measure. Not for nothing did Galileo perfect a military compass as well as using the appropriately named 'spyglass' to discover the divine symmetries of the cosmos.

With such a developed mission on the parts of Copernicus, Tycho, Kepler, and Galileo to discover divine symmetries, there was bound to have been a strong tendency to press the analysis of the observational data and even to force the acts of observation themselves to deliver the desired model. However, rigorous observation, both in itself and on account of the inevitable imperfections of instrumental measurements, tends to throw grit into the smoothly lubricated gears of any idealizing theory. For Copernicus, the real and the ideal were one, since his harmonic simplification had been designed to accommodate the realities which the Ptolemeic system could no longer comfortably embrace. But Tycho's measurements had introduced new grit, and the wheels were again beginning to grate. He had himself invented a composite system, part Ptolemeic, part Copernican to cope with the problems of fitting geometry to data, and it was this scheme that was illustrated on the roof of the temple Kepler had devised for his *Tables*. Kepler's instincts were to retain Copernican simplicity, and his poly-hedral model was dedicated to this end. However, Tycho's grit entered Kepler's system as well. Kepler's solution was to develop a model which characterized the orbit of a planet as an actual physical system, subject to a turning moment in a circular direction and a magnetic pull in a lateral direction. The result was an ellipse. The illustrated analogy he devised to explain this—and it is a physical analogy rather than a metaphysical metaphor—was of a boat being steered in a circle in a running stream of water and actually pursuing an elliptical path.

Kepler's marriage of mathematics with mechanical realities, even if the reality of the magnetic pull later proved not be such, was very much in keeping with what had been matching trends in the practical and philosophical professions in the Renaissance. Arts, crafts and technologies, ranging from painting to gunnery and from dance to engineering, had progressively laid claim to mathematical bases, not

least in campaigns to enhance their intellectual and social status. The frontispiece of Niccoló Tartaglia's *Nova Scientia* in 1537 (fig. 17) embodies all the aspirations. He sets the 'new science' of ballistics in two round enclosures, the outer gate of which is opened by Euclid. The inner sanctum, within which Philosophy is enthroned, is guarded by Plato, who brandishes his austere tag, 'Let no-one who is ignorant of geometry enter here'—which Leonardo had paraphrased in connection with his anatomical researches.[19] For their part, the philosophically orientated sciences, such as medicine and physics, had begun to

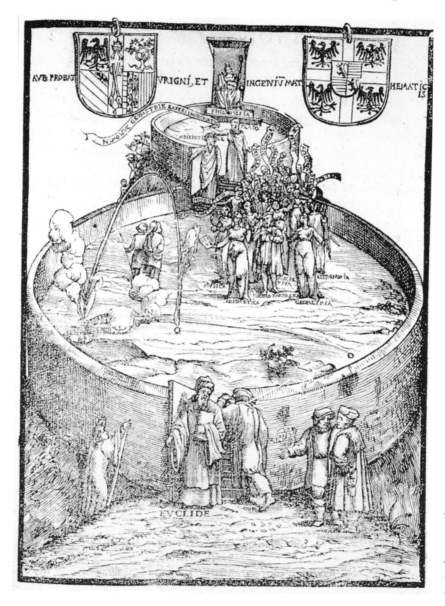

Fig. 17

Niccoló Tartaglia, *Frontispiece of the Mathematical Sciences*, from *Nova Scientia*, 1537

concern themselves in an increasingly direct and insistent way with the actual behaviour of things in the material world. Leonardo's insistence on 'experience' in determining the laws of nature was a precocious part of this trend, as was the rise of experiment and direct observation in Galileo. What Kepler had done with his elliptical orbits was, by metaphorical implication, to say that the planetary deities were now captains of ships who were assigned the practical, hands-on task of navigation through the cosmic sea—if the divine mathematics of the universe was not to break down.

However, from Galileo's standpoint, Kepler had gone too far and had indeed broken down the level of perfection required by God as supreme geometer. Galileo could not accept, on what we might anachronistically call 'aesthetic grounds', that the orbits had been denied the unitary perfection of the circle in favour of the compound symmetries of the ellipse with its two foci. Given his huge and effective commitment to the definition of phenomena in 'real' terms and to experimental demonstration of causes in so many areas of his work, the gravitational force exercised by his instinct for perfect design in the motion of the heavens is all the more notable.

In many other respects, however, Galileo ceded nothing to Kepler in his rigorous and knowing visual scrutiny and mental modelling of the three-dimensional world with the goal of realism in mind. We would hope for nothing less from a founder of the Accademia dei Lincei (Academy of the Lynxes), the members of which professed allegiance to the sharp-eyed seeing for which the lynx was renowned. Three examples, amongst a remarkable set of important acts of critical seeing and articulate representation by Galileo, will suffice to demonstrate how his looking was informed by a sharp understanding of how puzzling appearances might be translated into lucid explanation once we analyse the optical basis for appearance, all concerning the new wonders seen through the telescope.

It now seems obvious what the telescope can accomplish as an extension of human sight into otherwise inaccessible realms of the universe. But, like all radically new inventions, the telescope took time to 'bed in' as a generally accepted tool. There were two key problems. The first was that it was vulnerable to the charge that what was seen through it was in whole or in part produced by the instrument itself; that is to say it was making its own visual artefacts rather than showing in an accurate manner what was out there. Such vulnerability is invariably greatest during the earliest phases of the introduction of a new visual tool, both because of innate suspicion of a new-fangled device and because the earliest instruments tend not to deliver images of high

clarity. The second problem was that strange things were becoming visible for which no ready frame of interpretative seeing existed. It was not always clear whether certain features of the seen image corresponded in reality to one thing or another, particularly when they did not fit neatly into the modes of seeing and representation that had been established for unaided vision.

The new pictures of the surface of the moon are the first case in point. There had been a long-term dispute about the causes of the patchy appearance of the moon. Some had argued that it arose from the uneven composition of the moon's substance, as if it were a variegated ball of opaque and less opaque materials. Leonardo believed that the unevenness was caused by the presence of seas, like those on earth. The dispute was not just a matter of theoretical astronomy. If one or more of the heavenly bodies was like our earth—less than immaculately perfect—revisions were required to current theological stances about the perfection of the cosmos. What the telescope now showed was not merely an indefinable patchiness but an undeniable series of pronounced marks—what Thomas Harriot, the English philosopher, called the 'strange Spottednesse of the Moon'.[20] The *maculae* were visibly definite features of the moon's non-immaculate surface and they demanded a new manner of explanation.

What complicated the issue was that there was no straightforward agreement about what astronomers were actually seeing down their primitive telescopes. And if something is seen uncertainly, it can neither be represented with conviction nor adequately modelled in the mind for the purposes of explanation. Harriot's own drawings showed exactly the lack of clarity resulting from a combination of perceptual uncertainty and limited graphic means—even allowing for the modest performance of his own telescope.[21] Galileo, by contrast, arrived at a firm conviction about what he was seeing and had the skills at hand to convey his vision. He came to the unshakeable conclusion that the dark and light patches were not discolorations of the surface of the moon but corresponded to patterns of light and shade which arose as light from the sun pursued a raking path across the rough topography of the planet. The irregularity of the border between the lit and shaded portions of the moon was caused by the higher features

Fig. 18

Galileo Galilei, *Telescopic Studies of the Moon*, from *Sidereus Nuncius*, 1610

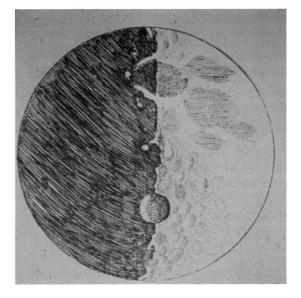

catching the glancing rays of the sun, while the adjacent valleys were in shadow. His representations, published in 1610 in his *Siderius Nuncius (Starry Messenger)*, are accordingly articulated in accordance with the knowledge of what kind of thing was being seen (fig. 18).

There is no single explanation of Galileo's successful act of perception, visualization, and representation. At the outset, we need to acknowledge that the characteristics of the telescopes he was using played a significant role in showing the lunar landscape. He had, after all, striven mightily to produce instruments which delivered higher magnification and clearer images than those available to Harriot. We also need to take into account that here, too, is a strong sense that we all see what we *want* to see, Galileo no less than ourselves. For his part, Galileo was predisposed to think that the moon and earth were related planets, rather than holding to the conviction that the earth was literally central and the moon literally immaculate (i.e. without stain) like the Virgin Mary. But his understanding of the nature of cast shadows on three-dimensional bodies clearly was a crucial factor in his dialogue between seeing and representing. There can be no doubt that he knew the shaded, perspectival illustration of polyhedra and other geometrical solids in the tradition of Leonardo's illustrations for Pacioli. Faces at different angles were shaded with a density according to the quality of light falling upon them. Leonardo had formulated the rule that the relative degrees of light and shade, on say the human face, would be proportional to the angle of their impact. When light struck perpendicularly, it would illuminate the surface most brightly, whereas a glancing blow would leave it largely in shade. We now know, courtesy of the great eighteenth-century physicist, Johann Lambert, that the intensity of diffuse reflection is proportional to the cosine of the angle of incidence. Renaissance authors of perspective treatises, such as Wenzel Jamnitzer in Nuremberg and Daniele Barbaro in Venice, had enhanced their representations of quite complex bodies with carefully graded intensities of light and shade, in keeping with Leonardo's illustrations for Pacioli, while Guidolabldo del Monte, in the treatise on perspective that Galileo saw before it was published in 1600, had formulated rules for the geometry of cast shadows. Galileo had, early in his career, been instructed in perspective by Ostilio Ricci, who was elected as a member of the Florentine Accademia del Disegno in 1593. The irregular surface of the moon did not lend itself to precisely geometrical analysis in the manner of the treatises, but the mode of viewing and representation is essentially the same.

Galileo's own account in *Siderius nuncius* specifically talks in terms of the tips of the mountains becoming progressively visible at the

shaded margin of the moon like the shining ridges of mountain ranges that are revealed on earth at dawn with the rising sun. This observation of the behaviour of light in nature was precisely of the kind to which Leonardo had devoted so much attention in his planned 'Treatise on Painting'. Leonardo strove to define the rules by which the artist could plot the relationship between topographical features, the angle of the sun, the role of the intervening atmosphere, and the relative position of the observer. Although Leonardo's writings were still unpublished, they were avidly studied in manuscript form in Florence and Rome, not least by Ludovico Cigoli, Galileo's friend and correspondent.

As a reasonably skilled draftsman, friend of artists in Medicean Florence, and 'honorary' member of the Florentine Accademia del Disegno (the pioneer academy of artists), Galileo was well placed to make a crucial visual contribution to the reshaping of our picture of the moon in terms of a rugged planet. His leading follower, Vincenzo Viviani reported that Galileo exhibited a 'natural and personal inclination for the art of drawing',[22] and the astronomer's original drawings for the mountainous moon demonstrate a consummate handling of the media of line and wash to convey the graduations of chiaroscuro. The published engravings, though less compelling, are highly effective in supporting Galileo's new perception of the earth-like planet. And, with the advice of Cigoli, he took pains to ensure that the engraved images delivered the quality necessary to sustain his visual argument.

Galileo's second act of looking very directly and articulately involves what he called the '*virtù de prospettiva*'. If it was unsettling to think that the moon should apparently be much like our earth, it was even more disconcerting to find that the sun was subject to outbreaks of mobile spots. The recording of sunspots was not so much a matter of looking directly at the sun with a telescope, which is strictly not recommended, but of using a telescope to project the image of the sun perpendicularly on to a sheet of paper. What was observed was a series of irregular patches or blemishes which changed in shape as they progressed across the orb of the sun. Seeing what these might be was even more problematic than the interpretation of the 'spottednesse' of the moon, since they were not stable in place or configuration and did not readily align themselves with familiar phenomena on earth. One observer, Lodovico Cigoli, the painter who was a friend of the astronomer, and who was then working in Rome, wrote to Galileo in 1612 comparing the spots to the kinds of flaws one might see in a less than perfectly blown glass carafe.

Probably the obvious move was to regard the patches as clouds that were passing between us and the sun, presumably much nearer the sun than the earth. This was precisely the manner of interpretation adopted by Christoph Scheiner, the Swiss Jesuit philosopher working in Papal circles in Rome. This theory had the considerable advantage theologically of leaving the body of the sun unscarred by blemishes. But Galileo argued that the only interpretation that was visually consistent was to regard them as integral parts of the surface of the sun. A series of images of the spots convinced him that they became progressively 'wider' as they progressed towards the centre of the sun from the first point at which they had appeared. They then diminished in width as they moved towards the opposite edge of the sun. Although their shape was not constant, the net effect was that they appeared to be fore-shortened at the edges of the sun and seen at their fullest extent when they were directly in front of us as observers. The sense of the visual turning of the spots was compelling to Galileo when he considered them '*in virtù di prospettiva*' (according to the power of perspective). It is important to realize that in this instance, compared to his characterization of the mountainous moon, his visual interpretation was not locked into a convincing account of what the sun spots might be as physical objects. It seems that it was the cogency of his visual analysis that decisively set the tone for his interpretation.

The prime disputants were fully aware that the crux of the argument involved the issues of looking and representing which had been brought to the fore by the theory and practice of Renaissance art. Attacking Galileo's sullying of the sun's image, Scheiner published under the pseudonym, *Apelles latens post tabulam* (Apelles hidden behind the picture), alluding to the story told by the Roman author, Pliny, that the great Greek master used to hide behind his paintings to hear what was being said about them. When Apelles heard a cobbler criticize a sandal he had painted, he promptly corrected it, but when the same cobbler next criticized a leg the painter roundly told him to 'stick to his last'—in the now famous expression. By aligning himself with Apelles, Scheiner was laying claim to honesty, openness, and high professionalism in visual matters. In much the same humanistically knowing vein, Galileo compared his openness to visual doubt and susceptibility to visual error to the bewilderment of a monkey who dashes to look behind a mirror to see who is there: 'I am . . . like the monkey who firmly believed that he saw another monkey in the mirror . . . and discovered his error only after running behind the glass several times'.[23] The monkey was traditionally the symbol for simple and potentially mindless imitation of nature in art—'nature's ape' in both

senses. It is significant in this climate of artistic allusion that one of Galileo's most informative correspondents in Papal Rome was Lodovico Cigoli, who was writing his own technically accomplished book on perspective while undertaking various Roman commissions.

Galileo specifically cited Cigoli in his polemics with his Aristotelian adversaries in Rome. The convoluted arguments and collages of citations which characterized the responses of his disputants are compared to the kinds of aggregate portraits of greengrocery and machinery popularized by Arcimboldo. A typical Archimboldo image is a profile head with bust made up from an assemblage of related objects, such as books, weapons or vegetables. Galileo describes practitioners of this genre as 'certain capricious painters who occasionally constrain themselves, for sport, to represent a human face or something else by throwing together sometimes some agricultural implements, at other fruits and perhaps the flowers of this or that season'.[24] Such *capricci* are fine for courtly entertainment, but they are not what real art is about: 'If anyone were to pursue all his studies in such a school of painting and should conclude in general that every other manner of representation was blameworthy and imperfect, it is certain that Cigoli and other illustrious painters would laugh him to scorn'. Direct and coherent representation of nature, in the classic manner, was to be favoured over the invention of mannered convolutions, however clever they may be.

Returning the compliment, as it were, the moon on which the Virgin stands in Cigoli's fresco in the dome of the Pauline Chapel in S. Maria Maggiore is of the pock-marked Galilean kind (fig. 19) rather than the spotless crescent which would seem more fitting for the Virgin of the Immaculate Conception. And, as what appears to be his visual contribution to the increasingly bitter disputes that were to culminate in Galileo's humiliating renunciation of his Copernicanism, the painter produced an elaborate image of *Virtue and Envy*, known in two drawings. Addressed to 'Your Lordship' (*Vostra Signora*)—the term of courtesy that Cigoli accorded to Galileo—an inscription on one of the drawings asserts that 'if work does not fear Jove's thunderbolts, then it will never be conquered by envy, since it seems to me that Virtue has its roots in struggle'.[25] The reference to 'Jove' probably alludes to another of the controversial telescopic observations, namely Galileo's description of the satellites in orbit around Jupiter. In the drawing, Virtue is shown 'slowly making her way through rocks and thorns', while her arms are metamorphosing into laurel branches, in the manner of the virtuous Daphne of mythological legend. Envy, with snake-hair, wizened body, and livid expression, lurks darkly in an opening amongst the rocks. The acrimony and increasing polarization

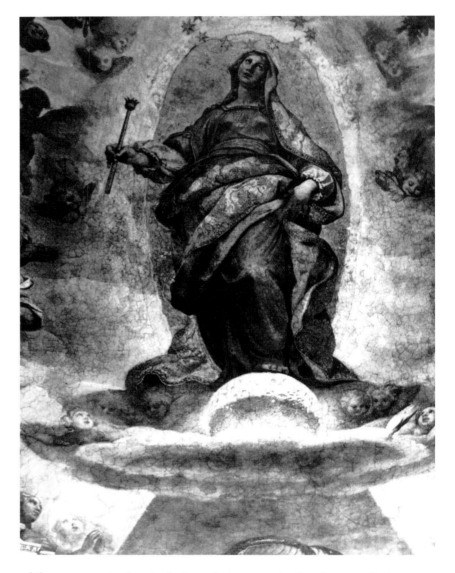

Fig. 19

Ludovico Cigoli,
*Madonna of the
Immaculate
Conception*, c.1610,
detail of dome fresco,
Rome, S. Maria
Maggiore,
Capella Paolina

of the arguments about what was being seen in the observers' telescopes
is not overstated by the stark contrasts between the female protagonists
in Cigoli's allegory.

Even for someone of Galileo's visual acumen, there were some new
telescopic observations that proved to be very resistant to clear seeing
and visual modelling. The monkey sensed that there was an error, but
could not make out what it was. When Galileo looked at Saturn, he saw
something very puzzling. The planet appeared to be accompanied by
protrusions or horns. How this could be interpreted was unclear. The
problem is much like those 'what-is-it?' visual puzzles in children's
comics where an object is drawn or photographed from a strange angle.

Once the puzzle is cracked, either by agile looking or by giving up and reading the solution, it can 'of course' be seen for what it is without difficulty. In this case the written solution was not provided until 1656, when Christian Huygens—hardly daring to parade his conclusions—hid it within another puzzle, a cipher in which the explanatory sentence was written as sequences of the same letter, beginning, 'aaaaaaa ccccc . . .'.[26] Only three years later in his *System Saturnium* (*System of Saturn*) had Huygens arrived at such firmness of conviction that he could publish the plain truth of Saturn's rings in words and image.

What is apparent in these episodes is not just that very sophisticated acts of visual interpretation were involved if the new world was to be mapped in two and three dimensions, but also that the leading participants were very alert to the roles that could be performed by different modes of illustration, ranging from the fully pictorial to the conventionally diagrammatic. Scheiner and Galileo were alike in this respect. As an example of the two modes used in the same episode, we can compare the 'pictures' of the sunspots transcribed from the projected images with the kind of diagram used by Galileo to demonstrate the geometrical basis for his argument about the foreshortening of the spots on the actual surface of the sphere of the sun. The linear diagram plots the relationship between the parallel rays of the sun and the sunspots as they move round the circumference of the sun. Virtually all the conceivable modes had been signalled in Leonardo's drawings: fully rendered pictures of forms, sometimes in sequential views; solid and flat sections; see-through images; 'exploded' views, in which joined forms are moved apart to show how their junctions are articulated; plans and elevations; and schematic images, ranging from simplified depictions to analytical diagrams in which lines can represent such invisible things as lines of force. Sometimes various modes are apparent on one sheet. No one emulated Leonardo's variety in the Renaissance, but there was a widespread consciousness that various kinds of visual mapping were needed if a range of information was to be conveyed about what was seen and how to look at it.

A nice example is the notable gallery of frescoed maps executed under the direction of Egnatio Danti in the Vatican between 1580 and 1583. Danti, from a notable Perugian family of authors and artists, had spent some years in the Medicean court at Florence, where he had been responsible for a grand series of maps painted on leather in the Sala delle Carte Geografiche of the Palazzo Vecchio, and large-scale instruments that utilized the church of S. Maria Novella (of Masaccio fame) as a site for astronomical observations. His brother, Vincenzo, was a

notable sculptor in Florence and elsewhere, and was himself planning an ambitious book on the theory of art, of which only the first part, the *Treatise on Perfect Proportions*, was completed. For his part, Egnatio produced an extensive and sophisticated commentary for the version of the treatise on perspective by the Bolognese architect, Jacopo Barozzi da Vignola, published in 1583.[27] He had come to Rome in 1580 to participate in Pope Gregory XIII's project to reform the calendar, which had over the centuries become out of step with the equinoxes by some eleven days. Danti's maps, devoted to the states over which the Pope claimed dominion, adopt a quasi-pictorial mode appropriate to their role, rather than a flat, chart-like convention. Inserted views depict such details as fortifications in the perspective mode that was apposite for such geometrically designed structures (fig. 20), while decorative tablets not only provide rhetorical flourishes but also parade the flat scales with which distances can be estimated. The mixture of registers of 'reality' is consistent with the elaborate games of illusion played by artists of this period in the decoration of interior spaces, which might contain mixtures of painted paintings (set fictively in painted frames), fictive renderings of tapestries, mosaics, reliefs, and architectural structures, along with examples of the real things. The virtuosity which Danti's maps share with such decorations was clearly enjoyed in its own right, but each of the modes can potentially do a serious job in bearing different kinds of information and messages.

What this and the other incidents of picturing we have studied show is that the legacy of Brunelleschi and the fifteenth-century painters had extended a long way. Indeed, the effect of their visual revolution continued to be felt in artistic illusions and naturalistic illustrations throughout the eighteenth and nineteenth centuries. By contrast, the visual world constructed by art and science in the twentieth and twenty-first centuries seems to look very different. But, as we will see in the next chapter, it depends on where and how we look.

NOTES

1. Antonio Manetti, *Life of Brunelleschi*, Howard Salmon, ed. (University Park and London: Pennsylvania State University Press, 1970)
2. Lorenzo Ghiberti, *I Commentarii*, Lorenzo Bartoli ed. (Firenze: Giunti, 1998), p. 95
3. David Friedman, *Florentine New Towns: Urban Design in the Late Middle Ages*, (Cambridge, Massachusetts, 1988)
4. Giovanni Ruccellai, *Il Zibaldone*, in Martin Kemp, *Behind the Picture* (New Haven and London: Yale University Press), p. 151

5. Leon Battista Alberti, *On the art of building in ten books*, Joseph Rykwert, Neil Leach, Robert Tavernor trs. (London and Cambridge, Massachusetts: The MIT Press 1998) vol. 1, 1

6. Copernicus, *De Revolutionibus orbium celestium*, (Nuremberg: I. Petrus, 1543)

7. Martin Kemp and Margaret Walker eds, *Leonardo on Painting*, (London and New Haven: Yale University Press, 1989), p. 59

8. Copernicus as quoted in Martin Kemp 'Temples of the Body and Temples of the Cosmos: Vision and Visualization in the Vesalian and Copernican Revolutions' in *Picturing Knowledge: Historical and Philosophical Problems Concerning the Use of Art in Science*, Brian S. Baigre ed. (Toronto/Buffalo/London: University of Toronto Press, 1996) p. 62

9. Christopher Clavius, *In Sphaeram Ioannis de Sacrobosco commentarius*, (Rome: Petrus Cholinus, 1610) pp. 69–70

10. Johannes Kepler *Harmonices Mundi*, (1619) *The Harmony of the World* E. J. Aiton, A. M. Duncan and J. V. Field, eds, (Philadelphia: American Philosophical Society, 1997)

11. Pliny, *Historia Naturalis*, II, xx

12. Franchino Gaffurio, *Theorica musicae*, (Milan: Ioannes Petrus de Lomatio, 1492)

13. Martin Kemp 'Temples of the Body and Temples of the Cosmos', *Picturing Knowledge*, p. 64

14. Leon Battista Alberti, *On Painting*, Martin Kemp ed, Cecil Grayson tr. (London: Penguin Books, 1991), p. 53

15. Leon Battista Alberti, *On Painting*, p. 35

16. Leonardo *On Painting*, Kemp and Walker eds, p. 115

17. Judith V. Field, *Kepler's Geometrical Cosmology*, (Chicago: The University of Chicago Press, 1988) p. 47

Fig. 20

Egnatio Danti, detail of inset heraldic device, view of fortifications, and cartouche from the Sala delle Carte Geografiche, c.1580–3

18. Tycho as quoted in Martin Kemp 'Temples of the Body and Temples of the Cosmos', *Picturing Knowledge*, p. 75

19. Martin Kemp, Leonardo da Vinci. *The Marvellous Works of Nature and Man*, (London: J. M. Dent & Sons Ltd, 1989) p. 293

20. Harriot as quoted in Samuel Y. Edgerton *The Heritage of Giotto's Geometry. Art and Science on the eve of the scientific revolution*, (Ithaca and London: Cornell University Press 1991), p. 234

21. Illustrated by Edgerton, pl. 7.8

22. Viviani in Antonio Favaro and Isodoro del Lungo eds *Le opere di Galileo*, (Florence: Giunti Barbera, 1890–1909), vol. 19, p. 602

23. Galileo as quoted in Martin Kemp, *The Science of Art. Optical themes in western art from Brunelleschi to Seurat*, (New Haven and London: Yale University Press, 1990), p. 96

24. Galileo as quoted in Martin Kemp, *The Science of Art*, p. 98

25. Cigoli as quoted in Eileen Reeves, *Painting the Heavens. Art and Science in the age of Galileo*, (Princeton: Princeton University Press, 1997), p. 172

26. Christian Huygens *Horologium Oscillatorum*, (Paris: Muguly, 1623)

27. Jacopo da Vignola *Le due regole della prospettiva pratica*, Egnatio Danti ed. (Rome, Francesco Zanetti, 1583)

2 | THE PERSISTENT BOX

To leap, as we are about to do, from the sixteenth and early seventeenth centuries to the twentieth does not imply that nothing much happened to the representation of space in art and science during the intervening centuries. But what happened in between belongs in a different story, which I have in part attempted to explore elsewhere.[1] In this context, I am highlighting how the basic parameters of spatial representation that gained such a firm grip during the Renaissance can be seen as still operative in very powerful ways, even in the newest fields of depiction. I can make this point most simply, by a visual juxtaposition.

If we look at a quintessentially twentieth-century image, a physiographic chart resulting from the pioneering sonar scans of the sea-bed and produced by Bruce Heezen and Marie Tharp in the 1950s (fig. 21), it is difficult not to be struck by the extraordinary visual resemblance to Danti's Roman wall-maps.[2] Is the resemblance merely a superficial matter or even a question of coincidence in which quite different means just happen to result in apparently similar results? Or is there some more significant point to be made about continuities in perception and visual modelling? Are we, perhaps, stuck with the old schemata, locked by visual inertia into old modes at a time when the new realms of modern science suggest that we should be extending our consciousness into new realms of visualization? Or, to view the matter more positively, is there a special and enduring power in the apparently shared ways that three-dimensional configurations are depicted?

I described the sonar image as 'quintessentially twentieth-century' because it deals with something that cannot be seen and relies upon a transmission other than the visible wavelengths of light that we

Fig. 21

Bruce Heezen and
Marie Tharp,
*Physiographic Map of
the North Atlantic
Ridge*, 1952

normally use for looking at the world. Sonar scanning in underwater
geology developed from techniques used in the Second World War to
detect hostile submarines. Like a number of other crucial instances of
scientific innovation—we may think of Galileo's studies of ballistics—
new understanding is inseparable from the writing of a fresh chapter in
the old story of human combat. High frequency sound waves, in the
range of trilling bird-song, are generated and transmitted through the
waters, and where they encounter a surface they are reflected according
to rules that are analogous to those of light. The shared behaviour of
light, sound, bouncing balls, and columns of water as they encounter
obstacles had been a cornerstone of Leonardo's universal laws of
dynamics. Some of the sound waves rebound to the 'observer'—in this
case a receiver tuned to the frequency of the sound. The reflected waves,
like light rays, provide data that can be analysed in various ways to
construct charts of how close and how far away the surfaces are from
which the sound is reflected. It is as if we could see bird song as it
rebounds from walls and tree trunks. The earliest maps produced by
Heezen and Tharp involved the sketching-in of hypothetical relief
features between the survey lines, using principles which will be out-
lined in chapter 9. Such was the pictorial impulse in the representation
of the underwater highlands and lowlands that a specialist painter of

Alpine panoramas, Heinrich Berann, was employed to bring advanced artistic skills to the modelling of forms in light and shade for the more developed panoramas of the sea bed.

In keeping with this modelling impulse, a system of 'side-scan sonar' was subsequently devised. The sound is transmitted to the ocean floor at an angle so that 'shadows' are created. This is exactly the principle Galileo observed on the moon and Leonardo described in his image of light on the human head. Any object, however rugged, if flooded with full frontal illumination, will not adequately reveal its surface configurations to a frontally placed observer. However, the sonar equivalent of raking light provides data which can be directly used to model a shaded picture of the sea bed.

The full implications of the use of machines to generate non-visible emissions as a form of 'light', to receive the modified emissions as forms of 'visual stimuli', to analyse the incoming data as a form of 'cognition', and to depict the results through a form of 'drawing' will be explored in the last section of this book. For the moment we are concerned with what this and other twentieth- and twenty-first century images tell us about our journey into the world of represented space.

New Inputs and Old Outputs

The need for cast 'shadows' in the composition of a picture using non-visible phenomena is far from unique to side-scan sonar. When a visual image is required of the minutest details of surfaces examined with an electron microscope at magnifications up to the order of 1,000,000 times, a related but different means is needed. Even the most refined versions of optical microscopy, which are effectively limited to about 2,000 times magnification, are constrained by the fact that the wavelength of light is larger than an atom and cannot therefore be used to resolve details at atomic level. Invented in the 1930s, the technique of microscopy using electrons rather than visible light is able to reveal the surface configurations of atoms in different substances. The 'light' in the original transmission electron microscope consists of electrons emitted from a filament which pass down the evacuated interior of the instrument and through 'lenses' formed by electrical or magnetic fields. The resulting beams are transmitted through the thin samples or, in the case of the scanning microscope, are reflected off their surface. The scattering of the beam, in a way analogous to light passing through a thin section or bouncing off a rough surface, allows a 'picture' to be imprinted on a fine-grain photographic plate. To provide a visual image

of materials of low mass density which do not scatter electrons in a way that can be differentiated from the film on which the specimen must be mounted, a strategy has been developed through which the 'shadows' can be physically 'painted' on to the sides of the microscopic 'hills'. A thin metal layer is vacuum deposited at an oblique angle on to the surface, selectively coating it, much as light coats the directly exposed features of Leonardo's drawn head or the sides of Danti's cartographic mountains.

Particularly striking examples are the photographs of freeze-fracture replicas of plasma membranes, such as those of eucaryotic cells from invertebrates, mainly arthropods, taken by the Cambridge cell biologist, Nancy Lane (fig. 22). As Lane justifiably says, the images 'provide stunning evidence, if such were required, of the beauty of the cell'.

The technique, developed during the late 1950s and 1960s involves the fast freezing of contiguous membranes, which have been treated with 'antifreeze' to avoid crystal formation. The two adhering membranes are cleaved with a knife in an evacuated chamber, the fracture plane running medially through either membrane. The resulting relief surfaces, each of which may carry some residues from the other half of the membrane, are then shadowed with a heavy metal 'sprayed'

Fig. 22

Nancy Lane, *Freeze-Fracture Replica of Plasma Membranes,* 1998

at an angle on to the sides of the hills and valleys. The surface is next 'faced up' with a thin film of carbon—non-opaque to electrons—and the biological tissue removed when the preparation has been thawed. The metallic 'death mask' (Lane's term) is then examined under a transmission electron microscope.[3]

What we see are the configurations of particles that form the intercellular junctions. In some places we see the prominences of the proteins anchored in their 'sea' of lipid. In others we see the depressions which retain, in negative, the imprint of the projecting features from the half-membrane that has been severed. Reading the complex and subtle configurations of convexities and hollows involves considerable knowledge and visual agility, accentuating the positive and, unlike the popular song, *not* eliminating but asserting the negative. Navigating through such a landscape, devoid of the

recognizable features of our human terrain, requires disciplined scrutiny by an experienced observer, the cultivation of visual memory, and considerable perceptual control—*and* the 'correct' orientation of the highlights and metallic shadows as if lit, ideally, from the upper left, if prominence and hollow are not to be misleadingly reversed.

A key refinement in electron microscopy, the scanning tunnelling microscope, was devised in Switzerland by Gerd Binning and Heinrich Rohrer and announced in 1982, using a probe tip which tapers to one atom at its point to detect changes in surface configuration through variations in an electric current which passes between the tip and the surface. The technique exhibits greater delicacy and higher sensitivity than the relatively brutal bombardment of surfaces in standard electron microscopy. The variations in the electric current corresponding to the distance between the probe and the surface acts as a tactile register of shape, like a kind of electronic Braille reader. The immediate goal of Binning and Rohrer was to provide an accurate picture of the multiple diamond pattern of the surface of silicon 7×7, which has since become a classic subject for the technique. Like other micoscopic images of crystals, the geometrical regularity surpasses anything seen in the macroscopic world. If we think that the resulting images have a special kind of beauty, we are not simply giving a retrospectively romantic gloss to a passionless achievement in 'hard' science. Binning's language captures the reactions of the inventors. He talks of 'feeling the "colour" of those atoms' and speaks rhapsodically of the sense of aesthetic revelation: 'here one saw little hills, and the hills formed a complicated pattern with this symmetry. We like symmetry. If something is symmetrical, it is very pretty. This was complicated but regular, extremely surprising and pretty'.[4] The 'landscapes' disclosed by both kinds of electron microscopy often resonate visually, on their tiny scales, with the largest features of our terrestrial landscapes, and evoke similar sensations of beauty. Binning's microscopic hills and Danti's terrestrial mountains echo to similar refrains. This issue of scale will recur in subsequent chapters.

Spectacular examples of the construction of what appear to be landscapes, as seen in our normal way are provided by the views of Venus generated from the huge quantities of digital data transmitted from the Magellan space craft in 1991–4 (fig. 23). Such is the nature of the atmosphere of Venus that it cannot be penetrated by rays within the normal visible spectrum. The much longer wavelengths of radar-imaging devices are needed if we are to 'see' anything at all. The 'visual' technique involved synthetic aperture radar scanning, in which a radar beam is directed diagonally downwards and sideways at an angle from

Fig. 23

Venusian Landscape
from the spacecraft
Magellan by NASA,
1991

the path of Magellan's flight, using computer analysis to correlate the data with the Doppler effect which arises with a rapidly moving body. The sideways look was complemented by radar altimetry, which utilizes a beam that points directly downwards. Each circuit of Venus by the craft resulted in some 18.2 billion bits of information being transmitted back to earth, and, during the first 243-day Venusian year, no less than 1,852 data-collection and play-back passes of the planet were accomplished. Such digitally transmitted and recorded data is not visual in any normal sense of the term, and some of the effects of 'seeing' by radar are anomalous. For example, highly reflective surfaces will return little or no reflections directly back to the laterally positioned transmitter/receiver, and will therefore register as 'black'—in contrast to their reflective lustre when viewed by the eye in normal lighting conditions. Only through enormously complicated processes of computer analysis and synthesis can an image be produced which functions within the visual realms with which we are familiar.

To achieve the beautiful landscapes, which place us in the position of privileged observers high on Venusian terrain, those designing the images need to make a series of overtly pictorial choices which affect every aspect of the rendering. These range from the basic decision to map the data in terms of the customary form of perspectival scaling of near and distant features, to detailed choices of what 'false colours' should be used and how they are modified as they are seen in

progressively more distant zones of the view. As well as generating specific views of Venusian landscapes, the data has also been mapped onto the surface of a sphere to produce an image of the whole planet akin to the telescopic representations of the moon. The colours were derived from observations made by Russian spacecraft, Venera 13 and 14. The result involves a remarkable, compound act of international seeing according to shared perceptual and aesthetic preferences.

The pictures of Venusian scenes present us with masterpieces of a new form of topographical art by largely anonymous masters (or teams of masters) of galactic landscape painting. The picturesque and sublime beauties of our 'sister' planets are revealed according to the same kinds of pictorial rendering as have come to certify the visual delights of our terrestrial habitat. When images of the atmosphere of Jupiter, beamed back from a 'suicide probe' which had been dispatched from the spacecraft Galileo, were published in *The Independent* newspaper in Britain on 7 June 1997 (fig. 24), the text by Charles Arthur began, 'It may look like a Turner painting ...' He was referring to the 'false colour' image printed as a panorama rather than the inset illustration of how 'it would appear to the human eye'. When we realize that the 'picture covered about 143 million square miles', the Turneresque qualities both become more contrived and more suggestive: 'contrived' because the visual qualities of the image are set up to work with our normal register of scale on this earth; and suggestive because Turner was himself striving for that expression of the awesome infinity of a scale-less cosmos which characterizes certain strands of Romantic science, art, and literature. Given Turner's intense, if idiosyncratic, interest in what science was revealing about the powers of nature, particularly in terms of light, it is not difficult to imagine his enthusiasm for the panorama of Jupiter's wondrous clouds.

When we also discover ten days later in the same newspaper that pictures generated from the transmissions of the Hubble Space Telescope are being exhibited at the Blue Gallery in London, which specializes in art with a scientific dimension, as well as at the Science Museum, the picture of astronomy-into-art appears to be complete. The visitors to the art gallery were expected to be attracted as much if not more by the 'abstract form' of the pictures as 'their scientific

Fig. 24

The Atmosphere of Jupiter from the spacecraft Galileo, as illustrated in *The Independent*, 7 June 1997

content'. The renowned science fiction writer and pundit of the future, Arthur C. Clarke, encouraged the spectators to 'first look and enjoy; later think about the implications'.[5] Slightly nervous that scientists will regard this aesthetic approach as a traduction of the true purpose of the images, the article in the newspaper provides the encouraging forecasts that 'the Blue Gallery's exhibition expects to draw 10 times more people than usual every day'.

An obvious question arises, not least in view of the huge effort required to synthesize landscapes from the trillions of bits of data which the probes and telescopes transmit to earth. Why should anyone have bothered to paint the landscapes of Venus, Jupiter, and other features of the solar system by computer when 'scientific' understanding of the planet does not appear to be significantly advanced by the production of visually seductive images. I think there are three main explanations. One resides in the human impulses of those who undertake the incredible journeys of exploration. Strong clues are provided by the naming of one craft 'Magellan', after the great Renaissance voyager from Portugal whose expedition circumnavigated the globe during 1519–21, another after Galileo, renowned explorer of telescopic space, and even one named after a painter, Giotto. The greatest explorer of techniques for naturalistic depiction in early fourteenth century Italy, Giotto had previously depicted a convincing comet in his painting of the *Adoration of the Kings* in the Scrovegni Chapel in Padua. It was on this basis that he lent his name to the spacecraft launched in 1986 to investigate Halley's comet, which was probably the particular comet witnessed by Giotto when it appeared in 1301.[6]

The desire of intrepid explorers, ancient and modern, to see the wonders of the newly discovered terrains with their own eyes appears to be irresistible. It is a form of geographical voyeurism in which all modern tourists participate. If we cannot do it in person, like Magellan, we do it by instrumental proxy, like Galileo. The second reason lies in the satisfying of a seemingly voracious public need for pictures of new discoveries within a culture which ceaselessly demands cascades of visual novelty. The third explanation, locked into the other two, is that the huge budgets needed to sustain space exploration have to be justified by space agencies and by their political masters. The deployment of vast resources needs to be seen to be yielding results. Some kind of spectacular public output is desirable and maybe even necessary if the enterprises are to continue. The beautiful and exhilarating landscapes help no end in the enlisting of our collective support. The success of the designers of such landscapes in attuning them to traditional pictorial criteria is confirmed by the Hubble images being

exhibited as 'Art' in an art gallery with high price tags. The professional explorers and the public audience share a series of assumptions built into our visual culture, and, as members of the public, we become by electronic proxy armchair tourists and aesthetic voyeurs in extraordinary voyages of stellar exploration. The complex webs of patronage, economics, aesthetics, and public reception are not essentially different from those that give rise to masterpieces of Renaissance and Baroque art.

The use of rays or emissions outside our sensory range to generate visual images opens up the possibility of mapping phenomena which do not lie within the physical aspects of 'seeable' form and space. If we can set up devices to perceive levels of energy, as signalled by heat or electrical activity, we can create maps which may relate to forms and structures but which are not, strictly speaking, records of them. The images of the surface of the earth generated by the Landsat satellites, the first of which was launched in 1972, are a nice case in point. Although we tend to view the maps as if they are aerial photographs snapped from high above our planet, they are not optical records in any normal sense. The scanner in the satellites uses light from selected slots within the visible spectrum and within the infrared band. Using a mirror which oscillates thirteen times a second, and detectors sensitive to different wavelengths, the scanner transmits millions of bits of digital data per second. This data does not just embrace some of the features that we would normally see, but it also embodies information about such factors as the moisture content of the soil and the vigour of growing vegetation. One band of wavelengths, for instance, provides a measure of chlorophyll absorption. Fully-grown plants feature most vividly in the infrared band and are appropriately represented as red rather than green. The picture thus operates in ways which are both consistent and inconsistent with our normal ways of viewing things within the parameters of the Newtonian spectrum of visible light.

The colour of Landsat maps and other forms of scanning that we will encounter in chapter 9 is particularly problematic. The fact that the specific colour designated to correspond to a particular kind of phenomenon does not match that experienced in our normal vision has led to the maps being termed 'false-colour' images. In as much as green vegetation may be represented as red, and the 'grey matter' of our brains as red and blue, the pictures deviate from our normal experience and give a 'false' impression. But in that the surfaces we normally see as coloured are not actually coloured in terms of some kind of inbuilt 'stain', but are perceived as coloured only through our ability to encode certain wavelengths of light in terms of discernibly different hues, the

depiction of grass as red is in theory no more and no less artificial than showing it as green. It is simply a question of understanding the code being used. The scanner conventionally 'sees' the grass as red because that is how its mental processes have been designed to operate. Yet the way the scientists have rigged the systems to register different levels of activity or energy output is far from arbitrary. The assigning of the warm colours to 'hot' zones of high energy and the cool colours to quiet areas exploits our psychological-cum-physiological responses to colour. We are accustomed to thinking of yellow and red as corresponding to heat and fire, as in the sun or flames, while 'cool blue' evokes a chilly world of ice and shaded snows. Thus the Newtonian spectrum can be used as a kind of colour thermometer for the visual registering of brain or crop activity—or electrical charge on the surface of a molecule. Even if the false-colour image does not correspond precisely to the optical world with which we are familiar, it is still nevertheless anchored firmly in our sensory, phenomenological experience. Our visual-tactile world is still mapped strictly within our sensory parameters.

But what of sets of data resulting from techniques of surveying that resolutely resist straight seeing as equivalent to retinal images? I am thinking of techniques like X-ray diffraction crystallography which provide a 'picture', but a picture which cannot be perceptually registered in terms of the three-dimensional structures it records.

Perhaps the greatest visual problem shared by modern physics, chemistry, and biology has been to find ways of seeing atomic and molecular structure, particularly the large organic molecules of proteins and nucleic acids that comprise the building-blocks of life. The crucial step came in 1912 when Max von Laue investigated the possibility of using crystals as gratings for the study of X-rays. When he passed X-rays through the crystals he generated interference patterns which could be recorded on a photographic plate. The images formed by this method, resembling galaxies of orbiting points, have played vital roles in some of the major discoveries in molecular science. They do not function as photographs (in the normal sense) of the interior architecture of crystals but as a kind of flat chart or graphical record of the impacts of X-rays diffracted by the electron 'clouds' around the nuclei of the atoms. Compared to the images we have encountered so far, the flat image shares most in common with the astrolabe, on which the three-dimensional configuration of the orbiting bodies is projected as a tracery of overlaid circles and arcs. The pattern in each case results from flat traces of three-dimensional structures and provides key evidence of these structures—if we know how to read them—but neither is a spatial representation in the illusionistic sense. To translate the X-ray

diffraction print into a picture of the three-dimensional structure requires the combining of the two-dimensional map with a series of measurements of the intensities of each spot (which carry additional spatial information) in order to envisage a model of the likely structure. Such spatial models are not simply a matter of satisfying our visual curiosity, but covey vital information about the properties and behaviour of the molecules both on their own and in various compounds.

The most famous instance of the translation of X-ray diffraction maps into a molecular sculpture was provided by the disclosing of the double helix of deoxyribose nucleic acid—the DNA from which genes are composed and which has subsequently provided the focus for the huge quantities of research that have been devoted to the unravelling of genetic codes. The vital data and photograph were provided by Raymond Gosling and Rosalind Franklin. But what was the structure that generated such a configuration? The problem of visualization is not unlike that required to translate the apparent motions of the heavenly bodies into a working model—or to deduce the three dimensional configuration of the heavens from the projection of the stars on the flat rete (plate of the orbits) of an astrolabe. The resolution of the structure of DNA from its 'star map' proved no less demanding than the task facing Ptolemy and Copernicus—even if arriving at a definitive model for DNA was accomplished in a rapid ferment of international debate over the course of years rather than over centuries of speculation. The prize in the race, both metaphorically and in the literal terms of the Nobel award, went to James Watson and Francis Crick working at Cambridge and Maurice Wilkins in London. It was in the Cambridge partnership that the solution of the now-famous double helix was devised, in 1953, creating the iconic image which has become the 'Mona Lisa' of modern science.[7]

Watson, in his 'Personal Account', provides a vivid and revealing narrative, which, whatever its reliability as disinterested history, gives a good feeling of the mental processes and attitudes of the collaborators as viewed from his individualistic standpoint. They took their cue from Linus Pauling, whose 'main working tools were a set of molecular models superficially resembling the toys of pre-school children', rather than Franklin, to whom 'model building did not appeal'.[8] Watson's narrative conveys a strong impression that Franklin regarded the young men as flashy and seeking shortcuts, while they regarded her as sharp, stubborn, and purist in a schoolmistress way. In any event, their modelling took the form of a complex visual brain-teaser, in which the component parts could only be bonded in a perfect spatial array within

65

one definitive structure. The procedure was less a matter of steady, linear progress according to remorseless logic than of obsessive 'fiddling' with alternative, ramshackle assemblages of shapes in which mathematical theory and X-ray data provided the rules within which the constructional game could be played. Nothing could be omitted and nothing could remain superfluous, in keeping with the Albertian and Copernican principles of architectural integrity. A key moment came when Crick's intuitions lead Watson to take 'apart a particularly repulsive backbone centred molecule', in favour of working on 'backbone-out models':

> This meant temporarily ignoring the bases, but in any case this had to happen since now another week was required before the shop could hand over the flat tin plates cut in the shapes of purines and pyrimidines.[9]

When, after setbacks and detours, the rationale of the molecular architecture eventually and thrillingly crystallized in the model, it exuded such an air of rightness that Franklin, 'like almost everyone else . . . accepted the fact that the structure was too pretty not to be true'.[10] Their resulting paper, 'Molecular Structure of Nucleic Acids', published in short and emotionally laconic order in *Nature* in 1953, eventually founded what is now a huge industry, academic and commercial, in molecular genetics.

The public parade of their momentous act of modelling involved a seemingly fragile and home-made construction in which the actual structures of the physical model serve to mark out locations of atoms as bonded in space rather than representing the appearance of DNA as if seen under huge magnification. What we are, in effect, seeing is the scaffolding to hold up the relevant bits of space which are believed to be occupied by the nuclei of the atoms. Looking at the now famous photograph of the young American and English scientists posed with their creation—taken by Barrington Brown for *Time* magazine but not published until later—it is difficult not to be struck with how much both the model and the photograph (with haircuts and suits) are 'of their period'—that is to say that they breathe a style which anchors them in time. Our sense of the period style of the Watson–Crick model—linear, wiry, openly mechanical, unadorned, and rhetorically 'functional'—is necessarily framed by reference to earlier and later systems of representation. Their precarious spatial lattice stands very much within the design parameters of the 1951 Festival of Britain, the event which decisively marked the pragmatically British embrace of a modern style for a new age. In contrast, the 'Glyptic Formula' kits for modelling molecules in the nineteenth century, with their polished balls, firm

rods, and turned mahogany stands, exude the air of a gentleman's billiard room; while recent computer images ostentatiously parade the high-tech rhetoric of electronic graphics. The haemoglobin model later perfected by Max Perutz, in whose laboratory Watson and Crick were inspired to undertake their quest, has its own 60s look—assertive and futuristic like a visionary model for a concrete block of layered residences. As in any work of design, more is involved than structure and function. Whether we call the visual ingredient 'style' or 'aesthetic', we can intuitively sense its presence—in both conventional and ground breaking artefacts.

The issue of what the electronic polish of modern computer graphics actually depict will engage us again in the final chapter. For the moment we may note that alternative modes of computer depiction which have evolved out of the hand-made models and drawings perform different roles in spatial depiction. Space-filling models give some sense of the relative spaces which the individual atoms are thought to occupy, while the more linear or skeletal representations of 'ribbons' allow us to see inside the molecule so that we may understand the spatial array more fully. The two main methods do different visual jobs in clarifying properties of the structures. They also, through inclusion and omission, play towards properties of the configurations that potentially can be used to address different questions about the chemical behaviour of the molecules.

Testing the Limits

What is striking about all these images of huge and minute worlds that were unimaginable to the inventors of pictorial space in the Renaissance is the extent to which the nature of the representations operates with criteria of legibility that Alberti and his contemporaries would have readily recognized. The space is perspectival. The patterns of light and shade obey the principles of *chiaroscuro* recorded by Leonardo. The textural and colouristic renderings do not in essence differ from those achieved by Jan van Eyck and successive generations of artists who have mastered the naturalistic rendering of the visible world. The clusters of spheres and notions of packing are not so very remote from the late sixteenth-century schemas for 'atoms' envisaged by Giordano Bruno, who was notoriously executed for his Copernican beliefs. We seem to be trapped in our geometrical perspective box of coloured tricks. This constancy of visual means is all the more striking when we recall that a number of the techniques rely upon the revolutionary

tenets of quantum physics which were of course unknown to Alberti et al. The tunnelling microscope is a case in point, since it works from the concept that the 'shells' of electrons around atomic nuclei are atmospheres of 'probability' rather than the miniature planetary systems of particles in defined orbits that are familiar in the conventionally popular view. In many ways, the ball-like model of atoms works well with the kinds of behaviour that scientists investigate, but the conventionality is undeniable, and we may wonder if the convention does not in part determine the kinds of behaviour that scientists conceive as susceptible to investigation.

There are a number of possible explanations of the enduring schemas. Perhaps the constancy is mere conservatism in mode of representation. Maybe the inherent limitations of what can be represented with the very limited means of hues, tones, and lines on flat surfaces simply leave a huge gap between what modern science might like to depict and what can actually be done. Or perhaps there is something more profound, more structural in the continuities.

The gravitational force of representational conservatism is almost certainly a factor. Any form of communication relies upon accepted conventions, in which a representational schema effectively conveys information both through its repetition and through recognized variations in its properties. Thus a spherical object is recognized by the graduations of light and shade across its surface according to transitions of tone around its rotundity. To be legible as a sphere this basic formula needs to be discernible, but it can be overlaid with a remarkable range of disrupting signals—such as reflected light on the shaded portions, and detailed variations of surface colour and texture—without loosing overall coherence (fig. 25). The sight of the underlying sphere exhibits very considerable robustness. It is remarkable how many variations can be introduced without destroying our ability to compute the basic sphericity of the form. Depending on our cognitive interest at any particular time, we can selectively pick out one or more of the 'interferences' which affect the basic 'signal'. We can, for instance, mentally filter the image to concentrate on variations in surface colour or tone. Indeed, coherent viewing of the surface characteristics is dependent upon the underlying perception of the basic shape. This is true of Galileo's perception of the moon's surface irregularities. Given the centuries over which the representational schemata have been perfected, it is not surprising that the shapes and terrains of distant planets should be depicted in the accepted manner. The portrayals play to well-honed skills in extracting complex information from sophisticated representations.

We also need to acknowledge that the depiction of something with paints or inks or some other colouring matter on a flat surface has built-in limitations. The traditional illustration on paper, whether hand-made or instrumentally generated, works with a very limited range of light compared to that available to our eyes in the normal world around us. Yet, in spite of forecasts to the contrary, words and images on paper as means of communication exhibit a huge reluctance to be wholly displaced by new and less apparently limited media. A pictorial representation can work very subtly with our incredible ability to discriminate between minute variations in tone in the middle register of our eyes' range. A shaded depiction uses a kind of proportional 'homology' in a very condensed range to create an analogue of the actual scene. Thus white paint can successfully represent the blinding light of a lamp, while black can depict utter darkness, although neither reflects or absorbs light to an extent that comes physically near the presence and absence of real light. However, the gap remains, and provides an ultimate limitation which cannot be overcome.

Fig. 25

Variegated Rubber Ball

The rendering of space on a two-dimensional surface is comparably constrained perceptually to act within definite parameters. We have seen that the third dimension can be 'described' to a degree that is scarcely credible. Yet the illusion is limited to the third dimension. Repeated attempts from the early twentieth century onwards have been made to disrupt or extend the traditional means of constructing pictorial space to evoke the fourth dimension, but they have perpetually struggled to break free of the limitations set by our perceptual mechanisms. Typically, the attempts rely either upon our accepting the representational suppression of one of the conventional three dimensions, which is 'taken as read', in order to insert a fourth, or upon some kind of overlaid ambiguity in which we are invited to tease spatial order out of dizzying patterns.

The most beguiling method to assist our visualization was invented by Edwin Abbott in his fantasy novel, *Flatland: A Romance of Many Dimensions by a Square* in 1884. He asks us to imagine beings who live and perceive in only two dimensions.[11] To them, a cube is unseeable,

even in their mind's eye. And a sphere can only be perceived as a circle of varied circumference, corresponding to the plane intersecting the sphere as it passes through their 'flatland'. However, it might be possible for 'flatlanders' to formulate the intellectual notion of a three-dimensional cube and to devise a graphic equivalent two-dimensionally in terms of an 'unfolded' cube or other polyhedron of the type devised by Leonardo and Dürer (fig. 26), in which all the faces are 'hinged' outwards to provided a flat net. This kind of graphic manoeuvre was systematically exploited around 1900 by the eccentric mathematician, Charles Hinton, in his sustained programme to represent the fourth dimension within the framework of our three-dimensional proclivities. His most famous device was the hypercube or 'tesseract', which 'unfolded' a four-dimensional cube into a cruciform figure, in which stacked cubes sit on the faces of a normal cube. Hinton's tesseracts became fashionable icons of multi-dimensional mysticism, featuring opportunistically in Salvador Dali's visually glutinous painting of a four-dimensional crucifixion.[12] Hinton's other main strategy, now more widely adopted, was to envisage the shows cast by a body at one dimensional level below its level of existence.

To define the hypercube more precisely, let us begin with a 2-D square. If a square is translated in a direction perpendicular to the plane in which the square was originally situated, then the region swept out by the square is a 3-D figure. If the distance of the translation is equal to the length of the sides of the square, the resulting 3-D figure is a cube. Similarly, if a cube were to be translated in a direction perpendicular to the 3-D space in which it is contained, then the 4-D region that would be swept out would be a hypercube. One technique that can be used to represent a 4-D figure is to show its 3-D shadow. As the 4-D figure is rotated in 4-D space, so the shape of its 3-D shadow will change. In such an animation (of which a still is shown here as fig. 26), the 3-D figure is the 3-D shadow of the edges of a 4-D hypercube.[13] The shadow on the ground is the 2-D shadow of the 3-D figure that we can see in our ordinary world. The hypercube has here been oriented in 4-D space so that it displays a symmetrical 2-D shadow (fig. 27). This disclosure of symmetries in 2-D operates in the same way as happens when we view the plan and elevation of the hexahedron drawn by Dürer. The plan and elevation can be envisaged as the cast shadows of the body at a particular orientation made by a very distant source, such as the sun, in which the rays are effectively parallel. Another analogy is with the projection of the celestial sphere on an astrolabe (fig. 11), though in this case the 'shadow' is formed by a point source of light

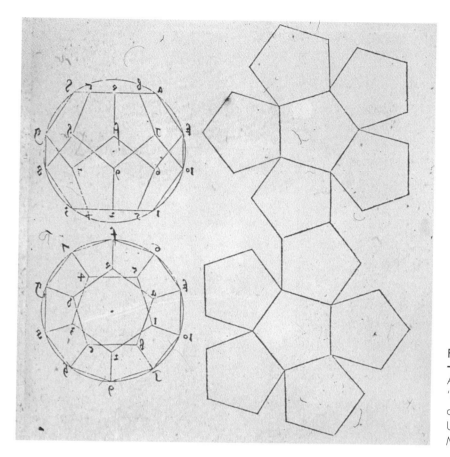

Fig. 26

Albrecht Dürer,
'Unfolded'
dodecahedron, from
Unterweissung der
Messung, 1525

very adjacent to the projected features. The kind of graphic manoeuvre performed by Mee means that we can begin to 'see' how the fourth dimension exists in our inner eye, but we never quite grasp it in terms of our external experience.

The worlds of science and art post-Hinton and post-Dali have witnessed a variety of beguiling solutions to the perceptual dilemma posed by dimensions in excess of three. Particularly effective examples in scientific illustration are those provided by Malcolm Godwin for Stephen Hawking's best-selling books on time and space (fig. 28).[14] As it happens, Godwin's attractive image of 'brane worlds' (one of the latest devices in theoretical astronomy) relies on the same kind of perceptual intricacies as came into play when looking at the variegated ball (fig. 25). Amongst artistic essays in the fourth dimension, the paintings and sculptures by the New York artist, Tony Robbin, stand out.[15] Yet for all their conceptual and visual ingenuity, I do not find any of the possible strategies really assuage our prosaic demand for reality in presenting the fourth dimension. Either the apparent reality fails the

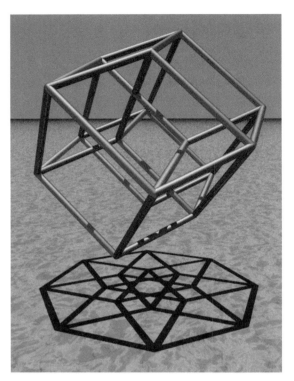

fourth dimension or the fourth dimension eludes the tools of illusionistic representation. The tubes, vessels, and 'doughnuts', 'saddles', and 'sinks' beloved of science popularizers either reduce the concepts to a level at which their nature remains elusive or introduce an abstract level of intellectual convention which violates optical coherence. It seems to me that no degree of graphic ingenuity can or could literally let us 'see' in more than three dimensions, in the perceptual sense of 'seeing'. The impossibility of visualizing the fourth dimension in terms of an 'optical-tactile' model was recognized in the nineteenth century by Helmholtz, who compared this incapacity with the inaccessibility of the visual sensation of colour to a blind person. Professional mathematicians and theoretical physicists have developed techniques of extraordinary conceptual sophistication for handling multi-dimensional spaces as mental abstractions and they have clearly achieved what might be called 'modes of visualization' which are beyond anything I can hold on to satisfactorily. These modes of visualization involve levels of logical, algebraic abstraction that carry them into realms which can be conceived and manipulated, but which lie outside literal 'visual-ization', in as much as they are not working within any inherently visual register. They may be better described as encoded conceptualizations rather than tangible visualizations.

It may be that the artist is at an advantage here. Works of art are not restricted to literal description and logical demonstration, and can use techniques of implication, suggestion, and allusion to supplement the obvious tricks of illusion. A nice and very early example, which paradoxically succeeds in insinuating spatial dynamism into the incontrovertibly solid medium of bronze sculpture, is Umberto Boccioni's *Development of a Bottle in Space* from 1912, in which the outer contours of the bottle spirals inwards and outwards in a complex spatial dance. The Italian Futurist exploits the fractured and spinning planes of his 'exploded' bottle to evoke the interpenetrating energies of light, form, space and time—exploiting in a visually poetic manner ideas that he had gleaned from the public transmission of the new physics, particularly via the French philosopher, Henri Bergson.

However, the frame of reference for his dynamic evocations irrevocably remains the standard coordinates, combined with our knowledge of what a normal bottle actually looks like.

We can now, of course, introduce actual motion even into flat images, using cine-matographic techniques and computer simulation to add a temporal dimension, and we can use various methods to create the parallax effects of two-eyed viewing. The introduction of time into an image does genuinely supply another dimension, but it does not as such introduce an additional *spatial* axis. The results may be described as the animation of the traditional pictorial format, circumventing some of its limits as a surrogate or analogue for real seeing, rather than creating a radically new alternative. It is probably only when time is used in a way analogous to the sphere passing successively through Abbott's *Flatland* that motion can insinuate a further spatial dimension—or at least insinuate the fourth dimension to a suggestive degree in our inner eye.

Fig. 28
———
Malcolm Godwin, *Brane World Scenario*, illustration devised for Stephen Hawking, *The Universe in a Nutshell*, 2001

The birth of cinematography from traditional photography serves to emphasize the comparability and optical continuity of the moving and static image. The cinema screen, or that of a computer, remains a flat surface on which illusion is inscribed according to standard rules of scale, hue, and tone. Virtual reality, it might seem, suffers from no such limitations. However, I believe that virtual reality as a system of representation of extraordinary potential can best be characterized as the ultimate—or at least the most recent and most extreme—of the systems to create an analogue for our normal experience of space, an experience which is defined by the boundaries of our tactile and visual reach. Indeed, I think it is apparent that the mainstream of European image-making from the Renaissance to the mid-nineteenth century continued in photography and its derivatives rather than in what are now characterized as the 'Fine Arts'.

But does the much-vaunted concept of cyberspace now present the revolutionary alternative that has so far proved elusive? The space of networked transmission by computer seems no longer to be con-strained by the old dictates of geography and time. Nor is the new space of digital information, in theory at least, constrained by standard modes for the accessing of data through the linear scrutiny of material

in a predetermined and inviolable manner. The new modes of communication have undoubtedly warped traditional measures of how long it takes to access visual material through personal travel or through linear searches through standard systems of reference (such as photographic archives). Yet the visual spaces within which the images and representations operate, and which we see on our screens, are articulated within the familiar frameworks. In the 'pictures' which fly through cyberspace, no less than the dizzying illusions of virtual reality, the old up-and-down, side-to-side, and in-and-out are still indelibly present. It is this apparent indelibility that brings us to what I regard as the crux of the problem—to the deepest structural issues of how we see.

These issues have attracted huge amounts of attention from philosophers, psychologists, and neurologists, particularly those psychologists who have devised experimental methods to understand the amazingly responsive mechanisms of vision. The research extends from the details of the physiology of the retina to the mental procedures through which coherence (and sometimes incoherence) is extracted from the cacophonous array of stimuli with which we are constantly presented. Giving an adequate review of the range of views that have been advanced is clearly beyond the scope of the relatively brief final section of this chapter, and indeed beyond the scope even of a full chapter. Furthermore, I cannot lay claim to extensive knowledge of the literature that continues to pour forth across the range of disciplines concerned with seeing and knowing. However, since the prime role of this book is to give a sense of how some key issues look from my perspective as a historian of the visual, I can claim some justification for saying how things look from my viewpoint. And, since what I have been saying so far is inevitably coloured by my attitudes towards the processes of seeing, it is only fair that I give the reader a chance to assess them in their own right.

Perspective and Perception: Some Cultural Reflections

It will have become apparent from the drift of my arguments that I uncontroversially regard perspectival representation and its photographic descendent as having gained a powerful grip on how we visualize and depict space in a number of arenas. But illustrating the power of standard spatial representation does not in itself prove that

perspective has some special status in relation to how our sight actually works, now and in the past. I am, by the way, assuming that the basic optical and neurological processes which have arisen during the course of the evolution of *homo sapiens* have not significantly changed during the relatively short era for which we have records of the production of representations of the seen world. The apparent triumph of perspectival depiction in our modern world does not mean that it can automatically claim a superior status. It could be no more than a convention imposed upon our ways of seeing and thinking, and remorselessly promulgated by the societal, political, and economic forces which oversaw its birth. We have no reason for assuming that it is inherently better than the modes of representation adopted by other civilizations, whether we mean 'better' artistically or with respect to efficacy in depicting what we think we see.

Even considered within the business of naturalistic representation in the western tradition, the limitations of perspective are obvious. It is predicated on the notion of a one-eyed static spectator looking at frozen forms, who is prepared to tolerate all the other shortcomings of the standard means of naturalistic representation—of the extremely limited range of lightness and darkness which can be achieved with pigments, of the limited colouristic effects that pigments can produce compared to coloured lights, of the limits of the pictorial field (often artificially framed), of the continued presence of the flat surface of the image, and so on. Furthermore, if we consider the static eye surveying a wide surface in front of it—say a long wall perpendicular to the central axis of our line of light—why is there no perspectival diminution of the more distant parts of the wall in accordance with the rule that things further away from the eye look smaller? Why are there no lateral vanishing points, as Leonardo once speculated? Or, to take this mode of reasoning to its logical conclusion, why should horizontals and verticals not be shown converging in a curvilinear manner to upper, lower, and lateral vanishing points. Given these problems, it is worth looking briefly at curvilinear perspective as an alternative system, and at an alternative of a different kind from a different culture.

Considered in terms of its own premises, the system of curvilinear perspective is logically consistent—until we consider it within the functional framework of representation. The surface on which we depict something in curvilinear perspective is itself theoretically subject to the same rules of lateral and upwards recession as the subject of the depiction. Or, to put it another way, if the wall orientated per-pendicularly to our line of sight is depicted as a straight band running across a canvas, and the image is viewed from the appropriate station

point in front of the picture, the curvilinear effect should be optically replicated. To show the wall receding in a curvilinear manner would simply be to double the effect. However, this mode of reasoning is to accept the actuality of curvilinear perception, and, as I will be arguing below, this actuality cannot be assumed in spite of its superficial air of logicality.

If we step outside the western tradition, the challenge becomes more insistent and less easily refuted. Amongst all the vast range of modes of representation in diverse cultures over the ages and across the globe, there has been only one which has used single vanishing point perspective. The explanation is clearly not that all the other modes are 'primitive' and merely groping with childish naivety towards a goal which is as yet imperfectly realized. It is easy to demonstrate that many of the alternative visions are the result of long and sophisticated formulations of representational means. I have selected to illustrate this point a sumptuous illumination from early Safavid Iran, dating from about 1540 (fig. 29)—that is to say contemporaneous with the Renaissance, and close in date to the revolutionary publications by Copernicus, Vesalius, and Fuchs. Everything about the courtly illustration, in a manuscript of the *Shanama* commissioned by King Shah Isma'il, breathes sophistication, and, even without sustained analysis, we can sense the meticulous control of how the spaces are registered. It can also be demonstrated historically that it was preceded by centuries of artistic development. Moreover, it comes from a civilization with a highly distinguished tradition in the sciences and technology, not least geometry, astronomy, medicine, and natural history. Indeed, the Islamic tradition was vital to the rise of western science.

The painting, signed by Dust Muhammad, tells in intricate detail an incident in the story of Haftvad and the worm, which, having been spared by Haftvad's daughter when she was eating an apple, brought such prosperity to the village that a fortress was constructed to protect it. Eventually poisoned with boiling lead, the worm's death lead to the fall of the town. The key incident of the discovery of the 'maggot' by the daughter as she was spinning is located in the shade of the tree in the lower left quarter. The reader's eye is invited to wander across a scene replete with detail of town and country life. Amidst the general busy-ness, labourers perform various tasks, a butcher sells from his shop, scholars read books, and a muezzin calls the populace to prayer. Such features as the town gate, flanked by round towers, the extra-mural shop, the mosque with minaret, aristocratic tower, and mountainous backdrop inhabited by goats are all lucidly represented. The controlled orchestration of three simple linear orientations, flatly

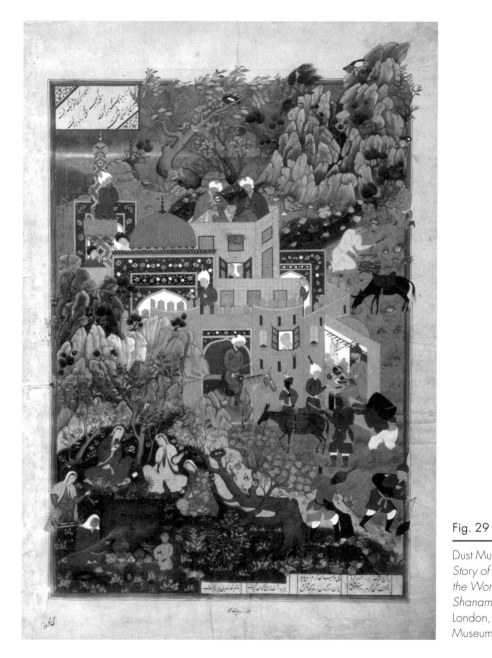

Fig. 29

Dust Muhammad,
*Story of Haftvad and
the Worm, c.*1540,
Shanama manuscript,
London, British
Museum, fol. 521v.

planar, diagonal and curved is adequate to trigger architectural
recognition and allows the 'stamping' of decorative patterns of bricks,
mosaic, and metal interlace to identify the function and status of
the buildings. A neat and self-conscious visual play is made at various

points around the decorative border, where features within the frame protrude over its confines. It is hard to argue that such an image is somehow less developed in its narrative, spatial, stylistic, and technical modes than those of a Renaissance miniature set in orthodox perspectival space.

Such an example demonstrates conclusively that linear perspective is not in itself an inevitable consequence of a developed striving for complex registration of things occurring in space. Linear perspective, it therefore follows, is the product of a specific kind of culture—or, more specifically, of a culture that places very particular requirements on its system of spatial rendering on two-dimensional surfaces. Indeed, the whole thrust of the historical argument in the first chapter has been to place perspective in its broad cultural setting. This is not to say that those who formulated, codified, and developed perspective acted under some kind of inevitable, gravitational force imposed by society. Perspectival rendering is part of the complex web of impulses within which its exponents play an interactive role in fostering values, visualizations, means and ends, to no less a degree than bankers and politicians. If, as seems inescapable, perspective is culturally specific, it might seem to follow that it is a convention specific to that society. In as much as perspective follows certain conventions, the view of perspective as an arbitrary convention seems logical. But in taking this step, we have made an illegitimate move. We cannot assume that because something is specific to one culture that it is conventional in an *arbitrary* sense—cognitively, perceptually, or materially.

The law of gravitation, for example, could only be formulated within a society that had reason to be interested in its formulation and had developed the intellectual and institutional frameworks within which it could be formulated and tested. The law in its Newtonian formulation—each body attracts every other body with a force which is directly proportional to the masses of the bodies multiplied together and inversely proportional to the distance between them—is hardly a natural outcome of applying common sense to observation. It was the result of centuries of theorizing, experiment, and mathematical refinement. In this sense, the law of gravity is a cultural product. But it is not arbitrary. It has a truth content which explains why rocks hurled from the ramparts of medieval fortresses fall at mightier speeds on the assailants below if they are propelled from higher walls, just as much as it provides a formula to explain why Galilean objects dropped (according to legend) from the leaning tower of Pisa hit the ground when they do, or why the apocryphal apple struck Newton's head to such effect. The law holds good within defined parameters, whether or

not those affected by its operation have any interest in its mathematical rationale.

In this way, we can regard any technique or any piece of knowledge as a cultural product and at the same time as potentially non-arbitrary. The knowledge may be expressed within proscribed conventions, but it need not be purely conventional in that sense that any other set of conventions would do as well. The law of gravitation does a job in predicting what happens in terms of distance, velocity, and time when something is in free fall in relation to a solid, extremely heavy body like the earth—but the job requires someone to devise the job description, and it is the job description that arises in a specific cultural context. In the same way, I believe that perspective does a particular kind of job, and that the job description may be described as 'to show what something looks like when viewed from a particular place in particular circumstances, in such a way that it is possible to predict with some success what it would look like if seen from a different place or under different circumstances'. The validity of this description hinges, of course, on the premise that we can actually talk about what something 'looks like' with any degree of security.

By talking of what something 'looks like', I am not referring to the image on the retina of the eye, or even to some kind of image compounded in our brain as a kind of 'photograph' of what is out there. What I am talking about is the collective result of an incredibly complex interaction between the buzzing confusion of visual stimuli, the optics of seeing, the neuro-physics of sensation, the cognitive systems that come into play, and the huge baggage of experience, knowledge, assumption, context, and directed interest that sets structured parameters on how we operate the processes of determining what something 'looks like'. Faced with such complexity, it may seem unlikely that we can identify any universal stability or robustness at the centre of the system. However, I believe it is the very complexity that has been met during the evolutionary process with dominant kinds of response-mechanisms that work towards coherence by dint of robust simplifications. These simplifications are in the nature of perceptual hypotheses that begin by assuming that the most obvious explanations of the visual array are correct. Thus, when we see two lines apparently converging towards a point, there are two obvious hypotheses: one supposes that the two lines are not parallel and exist on a plane perpendicular to our line of sight; the other supposes that the two lines are parallel and are lying in a plane orientated at an angle to our line of vision. Between these two hypotheses lie an infinite number of other possibilities of lines at varied angles on variously orientated planes, and

even that the point at which the lines come closest to each other is nearer to us that the widest aperture. The intermediate hypotheses can be entertained intellectually, and we may even force ourselves to 'see' them, but they do not arise naturally and spontaneously. How, then, do we chose between the two prime hypotheses?

With such a schematic example, there is no clear reason for making one choice rather than the other, but in any normal act of seeing such an arrangement of lines (denoting boundaries, surface marks, or whatever) will arise in conjunction with other clues that automatically favour one hypothesis over the other. A few additional clues, such as an added line converging on the same point will suffice to drag our perception in the direction of the assumption that the lines do correspond to parallels apparently receding in space. We are dealing—since there is no actual space involved—with an illusion, but we are not dealing with an arbitrary delusion. We are, I believe, witnessing a kind of gravitational force in our perceptual procedures which is designed to extract patterns of visual coherence that allow us to operate functionally in the three-dimensional world which we inhabit. Occasionally, this and other gravitational forces, such as those that permit us to read graded textures in spatial terms, may drag us into false positions—as when we view an illusionistic picture—but during the course of countless trillions of our day-to-day experiences the basic reactions serve us well and are richly confirmed virtually every moment of our waking lives.

If this is anywhere near correct, it indicates that a perspective picture subtly (or in some cases not so subtly) plays judiciously with inbuilt propensies in our perceptual system. The more elaborately optical the perspective picture of an object is, and the closer it comes to matching key characteristics in the optical array presented by the real object, the more irresistibly the gravitational forces come into play. Viewed in this light, the perspectival representation is not a literally realistic replication of what we see in terms of how we see it, but it is an ingenious device that acts as an analogue for the seen thing in such a way that its brings sufficient of the key responses into play as to let us see it as an optically convincing picture of the object. This formulation helps explain why some of the greatest masters of naturalism, such as Velàsquez, Vermeer, and Chardin achieve such rich visual effects with the minimum of detailed 'description'. All three painters do just enough to encourage the spectator to complete the visual desciption of the depicted forms. During the course of a sustained refinement of pictorial means, such masters of devious naturalism have empirically alighted upon those central facets of the painted analogue that will

80

irresistibly evoke in our minds certain properties of seen things, in such a compelling way that we are irresistibly incited to put in what the painter has left out in terms of detail and other visual properties.

Everyone or Just Some of Us?

It may still be objected that this evidence is arising within a certain set of cultural assumptions—as indeed it is. What about the apparently strong evidence that seeing in perspective is a culturally acquired habit? The two prime sources of such evidence are studies of people who have acquired the ability to see after living the earlier years of their life in blindness, and investigations of the perceptual proclivities of peoples who live in environments very different from the rectilinear structures which we inhabit and move between.

It is well known that mature or relatively mature individuals who are suddenly enabled to see can experience huge and depressing difficulties in making sense of the world they had previously understood chiefly through touch. If my theory of inbuilt gravitational forces is correct, why do they not instantaneously come into play? Leaving aside such complications as retinal damage or atrophy, I think it is clear that there is a phase in infancy—the phase in which the brain is growing at a huge rate—when the vital groundwork of our cognitive structures is laid down in such a way that we are provided with an extraordinarily complex tool-kit for gravitational detection and hypothesis formation. The potential to acquire the tools is inherent, but they will only be acquired and achieve priority in response to the complex interaction between experiences and needs. Our ability to develop new tools after the prime period of tool acquisition may well be considerably diminished, and the surprise for me is not that newly-sighted adults do not immediately know how to see but that they generally do such a relatively good job in making up the deficit.

I think the explanation for the evidence from inhabitants of non-rectilinear environments is essentially the same. The oft-cited example of a people living in a 'circular culture' is the Zulu nation, who famously live in round huts and plough curved furrows in their fields. It seems that they do not react to linear illusions of the kind favoured by experimental psychologists with anything like the same kind of readiness as those subject to modern urban environments and barrages of western imagery. Again, I do not find this either surprising or inconsistent with what I have been arguing. Their environment does not give priority to the tools which detect rectilinear clues, but highlights other

spatial devices, such as texture gradients and other aspects of scaling. This does not mean that Zulus are 'perspective blind', and that they are incapable of working with a developed example of an image made in the western naturalistic manner, such as a photograph. Rather, their own perceptual habits have arisen in such a way as to exhibit specific priorities in relation to their immediate experiences and most compelling needs. Their acts of visual hypothesis formation are selectively focused in ways that differ from mine, but the difference is a matter of focus and selection rather than fundamentally different in mode of operation. It should also be said that looking at representations is itself a special kind of cultural task, and the Zulu observer of the psychologists' test-pieces bring their own baggage of filtering expectations to the viewing of images on flat surfaces.

Overall, it seems that the jobs done by the tool-kits of the Zulus and 'ourselves' are hugely similar, but that variations in cultural priorities mean that the very particular cultural construction of linear perspective only arises when one of the essentially common gravitational forces exceptionally becomes the subject of sustained experimental attention in art and science. This experimental attention itself arises in relation to the function of images in relation to different kinds of quests for knowledge and meaning. Thus, I am not arguing that there is a universal visual experience such that what I and the Zulus see in our head is the same, but I am arguing for a commonality in perceptual and cognitive potential, and in underlying mechanisms for the extraction of visual coherence.

Whether this set of contentions is true, it is undeniable that the dominant current paradigm of spatial representation, invading even the cultures of the Zulus as Africa 'modernizes', is the perspectival box. Are we now irredeemably stuck inside it?

In as much as modern science has achieved extraordinarily powerful ways of characterizing curved spaces, relativities of time and space, and multi-dimensional geometries, we have clearly been able to burst out of its confines, conceptually at least. The necessary intellectual tools have been forged by those competent at high levels in such modes of conceptualization and description, as we have seen. Although such types of description are hardly new, and have entered the general currency of advanced scientific education, they remain remote from general public understanding and resistant to visualization and representation in terms of our normal and ingrained experience of the phenomenological world. They are intellectual constructs that we have been unable to naturalize in our automatic responses to spatial experience and representation.

Even curvilinear perspective which is hardly an advanced subversion of the perspective box, is condemned to operate with reference to the standard frames of perspectival representation. The curved frame is seen implicitly through the 'window' of the page or framed surface on which it is realized, and declares its curved nature in relation to an implicit grid of rectilinear space behind the surface. When we come to characterize Einstein's theories of relativity, it is always by implicit and often by explicit reference to regular space and regular units of time. N-dimensional geometry rests on the bedrock of our instinctual grasp of three-dimensional space and solid objects. To understand such modern visions, mechanisms of visualization other than our visual tool-kits need to be accessed—if this use of 'visual-ization' is not a contradiction in terms, as suggested earlier. Einstein spoke of the bodily aspects involved in his instinctive realization of relativity, in advance of his characterization of it in analytical formulae. This somatic aspect is not so surprising if we realize that motion is integral to the new vision, and that motion in space is something that can be felt through sets of bodily sensations that are not irredeemably shaped by stock visual formulas. Other forms of visualization are decisively remote from any sensory experiences, and I am tempted to confirm my earlier suggestion that they cannot be considered 'visual-ization' in any meaningful way. I am thinking especially of the use of algebraic formulations, which rely upon a series of logical postulates to be manipulated according to their own conventions independently of any need to convert them into 'pictures'. I personally find the symbolic logic of algebra very difficult to operate with any fluency—as did Leonardo who was much clever than me—and realize that I am not well placed to characterize the frames of spatial reference that might come into play in the hands of an accomplished mathematician. However, it is my instinct that such procedures rely upon a kind of neural architecture which is not integrally related to the experiential equipment which comes into play when we look at space around us.

In the final analysis, I think we are—for the specific purposes of perceiving and depicting the spaces we normally experience—trapped in our metrical box. But, having reached this point, I would no longer use the term 'trapped', which carries too pejorative an implication. Our ability to operate within the standard forms of visualization and representation has given us incredible strengths in our ability to navigate through our physical environment and have endowed us with the potential to represent and manipulate that plastic environment in all manner of ways, both physical and mental. It has also given us a firmly characterized home base from which to leap off into realms of space

and time that permit us to see beyond the inbuilt acts of robust seeing which have been the primary goals of the perceptual habits and mental architecture acquired over our individual lifetimes and during the long ages of human evolution. In short, our journey into space and into new spaces is unthinkable without the three-dimensional proclivities of our ways of seeing. Linear perspective in art, coupled with coherent illusions of light, shade and colour, are just very peculiar symptoms of this condition, which, as I hope to show in what follows, operates across every scale of seeing and visualizing.

NOTES

1. In Martin Kemp, *The Science of Art: Optical themes in Western Art from Brunelleschi to Seurat*, (New Haven and London: Yale University Press, 1990)
2. Marie Tharp 'Mapping the Ocean Floor—1947 to 1977' in R. A. Scrutton and M. Talwani eds. *The Ocean Floor*, (London: John Wiley and Sons, 1982)
3. Lane as quoted in Martin Kemp, *Visualizations: the nature book of art and science*, (Oxford: Oxford University Press, 2000), p. 141
4. Binning as quoted in Stephen S. Hall, *Mapping the next Millennium: How Computer-driven Cartography is Revolutionizing the Face of Science*, (New York: Vintage books, 1993), p. 242
5. Blue Gallery, 1997 (ex. Cat.)
6. For Giotto's image, see Martin Kemp, 'The King's Comet. Giotto, Halley and the Art of Observation', *Nature*, no. 415, 2002, p. 264
7. Martin Kemp, 'The *Mona Lisa* of Modern Science', *Nature*, **421**, 2003 (Supplement), pp. 416–20
8. James D. Watson, *The Double Helix*, (New American Library, New York 1969), pp. 34 and 45
9. *The Double Helix*, p. 103
10. *The Double Helix*, p. 124
11. Edwin Abbott, *A Square*, 1884, published as *Flatland*, (London: Penguin, 1999)
12. Martin Kemp, 'Dali's Dimensions', in *Visualizations: The 'Nature' Book of Art and Science* (Oxford, Oxford University Press, 2000), pp. 102–103
13. See *www.connectionsspace.co.uk*. I am most grateful to Nick Mee for the account that follows
14. For an explanation, see Martin Kemp, 'Godwin's Galaxies. The illustrations in Stephen Hawking's *The Universe in a Nutshell*', Nature, no. 415, 2002, p. 738
15. Tony Robbin, *Fourfield: Computers, Art and the Fourth Dimension*, (Bullfinch Press, Paris, London and Boston, 1992)

PART II

LESSER AND GREATER WORLDS

3

THE ART OF ANALOGY: LEONARDO AND PALISSY

Perspective is about seeing and representing things in scale. Big objects look smaller as they move into the distance, but they are still proportionately larger than small objects at comparable distances. There is another, complimentary sense in which looking at nature is about scales. With our unaided eye we can scrutinize tiny details of natural form from very close range, and we can bear witness to the great motions of the vastly distant heavens. Assisted by the telescope and microscope we can appreciate organizational patterns at ever smaller and larger scales. Over the ages, those who have investigated and represented nature have uncovered and demonstrated varieties of order and disorder that echo across the tiniest and largest worlds. This chapter and the one that follows listen to these echoes from the Renaissance to the present day.

Leonardo and the Ancient Idea

When Leonardo cited 'the ancients' as the source of the idea that man is a 'lesser world', he was acknowledging that the concept of the microcosm, which was so central to his thought, was hallowed by time, most notably by its lineage from ancient Greece and Rome. Leonardo's own formulation is so vivid, that we can do no better than let him speak for himself:

> By the ancients man was termed a lesser world and certainly the according of this name is well conceived, because, in that man is composed of water,

earth, air and fire, his body is an analogue of the world; just as man has in himself bones, the supports and armature of his flesh, the world has the rocks, supports of the soil; just as man has in himself the lake of the blood, in which the lungs increase and decrease in breathing, so the body of the earth has its oceanic sea which likewise increases and decreases every six hours with the breathing of the world; just as in that lake of blood the veins originate, which make ramifications throughout the human body, so the oceanic sea fills the body of the earth with infinite veins of water.[1]

This was written in the early 1490s. Later in the Codex Leicester, written around 1506–9 and now owned by Bill Gates, the computer magnate, he re-formulated the idea:

We may say that the earth has a vegetative soul, and that its flesh is the soil, its bones are the system of the conjunctions of the rocks of which the mountains are composed; its cartilage is the tufa, and its blood the veins of the waters; the lake of blood which lies within the heart is the oceanic sea; its breathing is the increase and decrease of the blood in the pulses, and corresponds in the earth the flux and re-flux of the sea, and the heat of the soul of the world is the fire which is infused throughout the earth, and the residence of the vegetative soul is in the fire, which in diverse places in the earth spout forth in baths, in sulphurous mines and in volcanoes, and in Monte Gibello [Etna] in Sicily, and in several other places.[2]

The antiquity of the concept is not in doubt. It can be traced back at least to the time of Plato in the 5–4th century BC. One of its classic formulations was provided five centuries later in Seneca's *Natural Questions*:

The idea appeals to me that the earth is governed by nature and is much like the system of our own bodies in which there are both veins (vessels for blood) and arteries (vessels for air). In the earth there are some routes through which water runs, some through which air passes. And nature fashions these routes so like the human body that our ancestors even called them 'veins' of water.[3]

It was within the context of such an animate view of the body of the earth that philosophers had sought to explain the puzzle of how springs could have their origins high on mountainsides. An analogy with the way that blood spurts forth from severed vessels in the temples of the head was perhaps inevitable, and was duly considered by Leonardo. His debate with ancient and mediaeval authorities ranged over a wide spectrum of animate and physical explanations, including processes of distillation in high caverns and the siphoning of water from lower reservoirs. In the end, he concluded more prosaically and correctly that the elevated springs resulted from precipitation on even higher

slopes, collected together to generate surprisingly powerful jets of water.

Leonardo contributed in various ways to the standard notions of the microcosm. He quantified aspects of its operation and unsettled some of its assumptions, as we will see. But his greatest contribution was to endow the analogy with an altogether new level of visual conviction and vitality. He pressed his supreme skills as a draftsman into the service of revealing the analagous wonders of the human and terrestrial bodies. Even in a map undertaken with great precision, the 'vene d'acque' of the earth vividly manifest their vitalizing irrigations under the touch of Leonardo's pen, just as the 'tree of the vessels' in the human body is characterized in such a way that we can sense how the ramifications transport the vital and animal spirits to the most geographically remote regions of the limbs. When he shows how the vessels of the old become tortuous and silted like sluggish rivers, while the young benefit from straight canals along which course swift currents, he does so in terms of fundamental process in relation to form rather than convenient analogy.

This recourse to the microcosm, or to the more general grounds of the underlying identity of causes across a wide range of natural effects, can be recognized as exploiting the method of analogy, which was ubiquitous in mediaeval science. But analogy, at least in its modern sense, is too weak a term for the method. We tend to use analogy as a convenient way of envisaging how something might work, by reference to something we know, or to underline an argument in a picturesque way, without necessarily intending to impute anything profound in terms of underlying truths of cosmic organization. For Leonardo, and for his ancient and mediaeval predecessors, analogies were not matters of ingenious intellectual convenience; rather they were expressions of the deepest unities of natural order. Observing parallels in natural processes, most notably between those in the human body and the body of the earth, was a major tool in the quest to understand the working of the universe *in toto*, and provided genuine insight into the order of God's design of the universal machine. In its classic form, the method of analogy is a qualitative device aimed at revealing the wholeness of things—or a holistic view of everything—very different in tenor from most modern science. The main thrust of modern science is quantitative, measuring ever-smaller components with ever greater precision. Its great strengths, until comparatively recently, have been in the atomizing of the parts. Even the great acts of instrumental seeing into the vast depths of interstellar space have been achieved through extreme minuteness of discernment—being able to detect

almost infinitely imperceptible signals from distances we can only enumerate and not envisage.

If the method by analogy is traditionally qualitative, it need not necessarily be so. It could, as Leonardo showed, lead to quantitative laws. One focus of his concern was with branching systems, which he regarded as essentially subject to the same dynamic law across the territories of the vessels of the human body, as across the tributaries of rivers and stems of plants. In order that the same volume of fluid should be transmitted at the end of the system of branching as through its main trunk—which he considered a necessary condition of efficient flow, without unnecessary turbulence—he argued that the sum total of the cross-sectional areas at each level of the branching system must be equal. In other words, if we measure the dimensions of all the smallest twigs around the periphery of a tree (fig. 30), they will equal in total cross-sectional area the dimensions of the main trunk, or the total area of the branches at any level as defined by successive arcs of a circle. It was valid whether the branching was by regular bifurcation, or by asymmetrical divisions, such as a third and two-thirds. The underlying law, as Leonardo realized, is that the volume of flow through a tube in a given amount of time is directly proportional to the cross-sectional area of the interior of the tube. This law, unformulated before him, was much to his liking, given his concern to find proportional harmonies in all the dynamic and static performance of nature's engineering. It also became practically relevant when he endeavoured to devise better ways of measuring water flow, which became a particular concern of his after he had been granted the concession by his French masters to draw a measured amount of water from one of the Milanese canals. These liquid assets were not to provide Leonardo himself with water for drinking and bathing, or even primarily to irrigate his Milanese vineyard, but were given to him for resale as a source of continuing income. As so often, the intellectual quest and the practical advantages are inseparably united.

As he thought more and more about the behaviour of water in the body of the earth, not just on its surface but also through what he believed to be a whole vascular system of inner channels, and as he was increasingly brought face-to-face with how it could be managed through hydraulic engineering, he came to confront realities which sat uneasily with the embrace of microcosmic theory. Although the law of branching potentially held good whether the flow was from the 'trunk' into the 'twigs', or from the 'twigs' into the 'trunk'—or was in both directions during ebb and flow, as in his theory of the motion of blood—he came to realize that the reservoir of water in the seas could

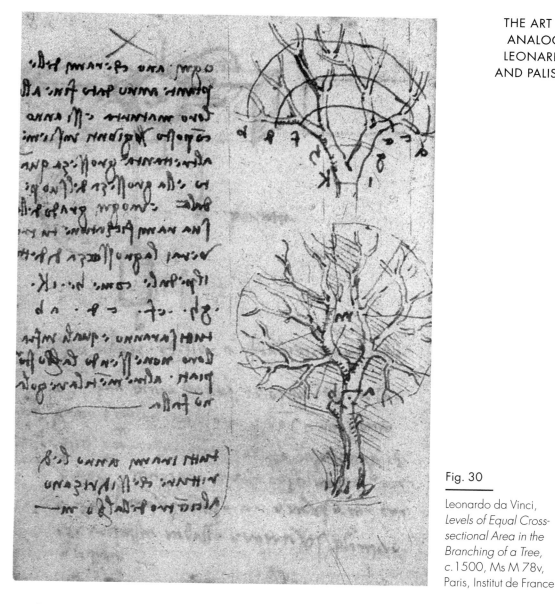

Fig. 30

Leonardo da Vinci,
*Levels of Equal Cross-
sectional Area in the
Branching of a Tree,*
c. 1500, Ms M 78v,
Paris, Institut de France

not be held to be identical to the mass of the blood within the heart.
As he wrote, about 1510:

> The origin of the sea is contrary to the origin of the blood, because the sea
> receives into itself all the rivers which are caused solely by the aqueous
> vapours raised into the air. But the sea of the blood is the cause of all the
> veins.[4]

The cycles of evaporation and precipitation which fed the open
system of the hillsides, streams, valleys, rivers, and seas differed in

fundamental respects from the closed system of the blood vessels fed exclusively by the pumping heart. What did this mean for the microcosm?

It meant that its implications could not be taken for granted for the detailed explanation of specific phenomena, and that the method of analogy could not be automatically sustained at every functional level. If the notion of the microcosm were to survive—and we have no evidence that he abandoned it totally—it would have to exist at the more abstract level of the commonality of universal law, such as the law governing the flow of fluids through channels, rather than in its more animate and qualitative sense. It could survive in spirit, even if its bodily reality needed critical scrutiny in each individual instance.

In another sense, the force of the analogy could survive the erosion of its detailed parts. This sense may be described as ethical or moral. If human beings are irredeemably part of the whole system of the world, if everything that happens inside us is ultimately a manifestation of what lies behind everything that happens outside us, then we cannot abstract ourselves from the world; we cannot place ourselves outside or above nature, since we are locked into its fabric. This means, in essence, that everything we do to nature, we ultimately do to ourselves, above all in the sense that if we brutalize one of Nature's creations, we brutalize ourselves. There are plentiful signs that Leonardo was fully alert to the way that the notion of the microcosm could lead to a definition of our responsibilities within nature. Not least, there is some contemporary evidence that he became a vegetarian. In a letter to Giuliano de' Medici, Andrea Corsali noted that Leonardo does not 'feed upon anything which contains blood, nor . . . anything animate.[5] Leonardo clearly developed a revulsion for the eating of dead creatures:

> Man and animals are essentially the passage and conduit for food, sepulchre for animals, lodgings of the dead, making its own life out of the death of the other, sheath of corruption.[6]

His 'prophetic' riddles contain enough spirited barbs against the destructiveness of human beings and the nastiness of our devouring animals for us to believe that they are more than literary commonplaces. Three examples will give a sense of their tone:

> Innumerable ones will have their little children torn from them and flayed and barbarously quartered [i.e. sheep, cows, goats etc.]
>
> The animals of the waters will die in the boiling waters [i.e. fish].
>
> They will be killed by those whom they nourish and scoured by merciless deaths [i.e. animals that are killed and eaten].[7]

In a different but related way, his sense of how we must retain our oneness with nature permeated his activities as an engineer. At the most fundamental level, he believed that:

> although human ingenuity makes various inventions, corresponding by machines to the same ends, it will never discover any inventions more beautiful, more appropriate or more direct than nature, because in her inventions nothing is lacking and nothing is superfluous'.[8]

This meant that the creations of the natural world were the only proper models, not necessarily to be imitated in the most literal way—since human means and ends have their own characteristic purposes *within* nature—but to be followed in terms of the principles governing the way that nature invents things. Everything is and should be made according to the law of 'Necessity', which decreed that nothing should be superfluous and nothing lacking in the way that form achieves function in the context of natural law. Thus his flying machine—his great *uccello*, to use his own term—drew upon the lessons provided by birds and bats, not only their anatomical mechanics but also the principles by which birds are borne aloft on air currents, spiralling on the warm thermals of summer air in the Florentine hills. His designs for the individual components and the effect of the whole, as far as it can be reconstructed are suggestively analogous to birds and bats, without being slavishly imitative. He was making a bird-cum-bat contraption in terms of the particular necessities imposed by the job of enabling human beings to fly. His vision was that the inanimate frame of his mighty creation would be vitalised by the human spirit:

> A bird is an instrument working according to a mathematical law. It lies within the power of man to make this instrument with all its motions, but without the full scope of its powers; but this limitation only applies with respect to balancing itself. Accordingly we may say that such an instrument fabricated by man lacks nothing but the soul of man.[9]

We now realize the impossibility of achieving man-powered flight with flapping wings, and Leonardo himself became aware that human musculature could not deliver enough power to lift his contraption actively into the air. However, this acknowledgement should not dull our appreciation of the beauty of his vision in striving to create what he called a 'second nature' in the world. And we now know, through full-scale reconstruction and testing, that one of the wing shapes he devised in the later phases of his work on the flying machine does indeed exhibit striking aerodynamic properties in the context of gliding.[10]

Perhaps the nicest evidence of the way that he saw the human con-triver of devices as working collaboratively with nature comes when he was involved with hydraulic engineering, particularly with schemes of canalization around Florence. His own plan was for a great arching canal north of the unnavigable section of the Arno running along a course which seemed 'natural'. His canal follows, coincidentally, the route chosen by the designers of the autostrada between Florence and Pisa. His studies of Florentine topography revealed both prehistoric signs of the distribution of water courses and inland lakes in distant ages, and suggested potential courses that water might be persuaded to take with a certain amount of human encouragement. The scheme with which he is normally associated, promoted by Machiavelli to divert the Arno around Pisa at a time of war against the coastal city, foundered on its signal failure to respect the nature of water in its behaviour in particular situations. Leonardo was one of the 'masters of water' con-sulted by the Florentine authorities, but his does not appear to have been the determining voice behind the doomed project. On a smaller scale, when he explains in the Codex Leicester how to prevent the ruin-ing of the house that is being undermined by a meandering river, he proposes using a weir or series of weirs in a precisely calculated manner to alter the flow in such a way that the river itself does the job of depositing soil to prevent continued erosion: 'I have a house on the bank of the river, and the water is carrying off the soil beneath it and is about to make it collapse; consequently I wish to act in such a way that the river may fill up again for me the cavity it has already made'.[11] The fundamental principle to be borne in mind is that 'the impetus of every moveable thing pursues its course along the line it was created'.[12] Only through subtle mastery of the rules could the impetus be eased away from its ordained course. Leonardo realized that Nature can be a hugely forceful collaborator, but can be an implacable enemy if we try ignorantly and crudely to push her around against her natural desires.

All this is not designed to prove that Leonardo is a proto-ecologist, precocious environmentalist, or visionary 'green'. He was writing at a time when the power of human beings to intervene in the natural process was extremely limited, by today's more massively intrusive standards. The way that we can generate so much carbon dioxide that we can change the climate, or emit so many CFCs as to create a hole in the ozone layer, would have been beyond his wildest fears. Rather, his morality was that of respecting each life. A thousand deaths do not essentially matter more than one death to the individual who dies or to those who are immediately and intimately affected. The failure of the canal around Pisa was on a grand scale, but it was a particular instance

of man's folly rather than a global conspiracy. The lessons of Nature were to be applied in each case. Nature's largeness ensured that her ultimate governance could not be questioned by the puny acts of humans, however grand these acts might be on a human scale. What Nature could do through her great storms and deluges manifested a majesty beside which the wars conducted by human rulers were inconsequential and transitory. Amidst the crashing vortices of the turbulent air in one of the drawings, a series of battle tents can be seen wheeling on the wind like fragile kites. So much for the mighty commanders! As he wrote when Ludovico Sforza, his Milanese patron, was overthrown by the invading French: 'the Duke lost his state, property, and liberty, and none of his works were completed by him'.[13]

Following this piece of Leonardo-esque scene-setting, this chapter is primarily concerned with the qualitative issues that arise from attempts to seek the meaning of the whole through a reverent research into the details of the parts, whether these parts are those of the human body or the apparently humbler creations of nature. The kind if quantification and geometrical definition which we saw Leonardo attempting—particularly the search for mathematical patterns which resonate across the whole and the parts—will be the subject of the two chapters in part III.

In looking at the qualitative issues my approach will again involve drawing upon the insights of exceptional individuals as the key to wider perceptions. However, unlike the first two chapters, the two visual modellers who lie at the heart this and the successive chapter are not generally recognized as 'great men', within either the worlds of science or art. They both come into the category of what I call 'wonderful lunatics'; that is to say those people whose atrophied sense of what most people would consider realistic leads them to set out agendas of an extraordinary and virtually unrealizable kind. Each 'wonderful lunatic', like Leonardo himself, aspired to be a *uomo universale*, aiming to embody in his person a universe of insight. In so doing, he not only embodied the theme of the whole in the parts but also drew into himself an astonishing range of characteristics of his age, in a way that a focused individual who achieves definable greatness in specialist pursuits is unlikely to do. My two 'wonderful lunatics' are the French potter of the second half of the sixteenth century, Bernard Palissy, and the English Botanist, Robert Thornton, who launched his flagship enterprise, *The Temple of Flora*, in 1799. In one way, they are both confirmed specialists, yet in another, as will become evident, they wholly refuse to be constrained by the parameters of their specialisms.

Palissy and the Life Casters; Nature and Artifice

Bernard Palissy is hardly a household name. He has a certain minor fame as the maker of remarkable ceramic dishes, dense in vividly coloured natural forms (fig. 31), but is unlikely to receive much notice beyond the circles of those interested in historic pottery or Mannerist Art. His wares are likely to feature in the glass cases of museums of decorative arts, or those sections of museums or galleries into which objects of 'applied art' are segregated, rather than sharing space with the work of sculptors and painters. He might also be used as a somewhat recherché point of reference within the history of science, as someone who wrote powerfully about fossils and the history of earth in the vernacular. This second Palissy features, if he features at all, as an example of the rise of vernacular science, not least in the hands of those who enter scientific enquiry through acts of practical doing rather than university philosophy. He is a figure who has been dismembered and whose parts have then undergone marginalization. But if we bring his parts together again, seeking the whole man behind his legacy of fired clay and printed books, he is an altogether remarkable figure. When we realize that, on one hand, he achieved huge contemporary renown for incorporating direct casts from the creations of nature in his works—collaborating in the most intimate way with Nature the supreme designer—and, on the other, he believed that the inferno of his pro-

Fig. 31

Bernard Palissy,
Ceramic Dish with Life
*Casts, c.*1560,
London, Wallace
Collection

cesses of firing clay and melting enamels embodies in microcosm the most potent creative forces in the 'womb of the earth', we can immediately begin to sense what he may have to say to us in our present context. When we also discover that he saw his way of working and thinking as representing the true route into communion with God's creative nature, we can tell that we are dealing with someone who set the biggest kinds of unconfined ambitions for his chosen pursuits.

Although Palissy's highly distinctive style as a potter might seem at first sight to have arisen in eccentric isolation—however much it was directly imitated in later ages—he can best be understood within a long tradition of the incorporation of objects fabricated by nature into works of human artifice, and within the fashion for animals and plants cast from life in sixteenth-century metalwork. Let us look at the real objects first.

Items deemed to be worthy of luxurious setting were those curious, rare, wonderful, and exotic creations of nature which graced *Schatzkammern* and *Wunderkammern*—treasuries and cabinets of curiosity. Many of the rarest and most prized items were regarded as bearing profound meaning. An ostrich egg, for example, was regarded as a suitable item as a symbol of generation to hang in a church, and it could also be interpreted more specifically as a symbol of virgin birth, given the bestiary legend that ostrich eggs hatched miraculously when abandoned in the sand. Similarly, 'serpents' tongues' (*Natterzungen*), in reality fossilized sharks' teeth, were accorded magic properties in dispelling poisons. Such items were not merely secular curiosities. We know that Duccio's *Measta* was displayed in Siena Cathedral with two ostrich eggs, and one hangs tantalizingly over the Virgin and Child in Piero della Francesca's *Madonna and Child with Saints and Duke Federigo Montefeltro* in the Bera Gallery in Milan. Eggs and serpents' tongues in settings of considerable richness featured in the famed treasury of the mediaeval Cathedral of Cologne, and are recorded in a print by the elder Cranach. Some spectacular examples survive, much prized and highly valued, and the supreme quality of the workmanship of the mounts testifies to the immense trouble that the patron and designer took to act with due reverence to a wonder of natural design. In one example, *Natterzungen* hanging from a coral 'tree' could be detached from the coral branches to be dipped into suspect beverages or dishes of food.[14] The coral itself was credited with warding off the evil eye and other beneficial actions.

Exotic shells of wondrous shape were particularly favoured subjects of the metalworkers' homage. They were expensive treasures even before they were mounted. Philip Hainhofer, who was an entrepreneur of elaborate *Wunderkammern* in the form of intricately designed chests,

reported that 6000 florins worth of *indianische Schneggen* (Indian shells) had been presented to the French King by the Dutch States. In 1610 the Duke of Wittenberg, a private collector, spent 1200 florins on a collection of shells. Knowing that 150–200 gold florins would allow a family to live very decently for a year, we can understand that the sums were distinctly large. The extravagantly geometrical spirals of nautilus, strombus, and trochus shells evoked handsomely generous flourishes from Mannerist goldsmiths (fig. 32), as they sought to tease their materials into shapes that worked sumptuous variations on what God could do in his role as the ultimate *artifex*. Like Leonardo, the great makers of such *fantasie* on natural themes must have seemed to be acting as the agents of a 'second nature in the world'. A print from Georg Hoefnagel's *Archetypa* in 1592, a series devoted to assemblages of

Fig. 32

Philip Hainhofer,
*Nautilus Cup, Coral
etc.*, detail from the
Kunstschrank, 1632,
Uppsala University

naturalia, praises the 'gloria summi opficis' (the glory of the highest craftsman) in just this sense. Just as the rational measures of space were seen as intended by God for the human observer, in the Neo-Stoic sense, so God has placed these wonders of design on earth to serve our material and cerebral needs. The remarkable products of nature that populate the earth, water, and air demand our homage, and Hofnagel demonstrates his reverence by exploiting his own self-conscious artistry as the 'ape' of nature to display them in all their Mannerist complexity. Seen in such a light, the goldsmiths who placed their artifice in the service of nature were true alchemists of visual form.

In an entirely complementary way, direct casts of animals and plants became valued collectibles in the second half of the sixteenth century. Prodigious skill and patience were required, particularly in casting the softer parts of animals and more delicate forms of plants. Someone who could take a mould from a frog without distorting its fleshy parts or could cast seeding grasses in all their minute delicacy had achieved a feat of rare technical mastery. The great Nuremberg goldsmith, Wenzel Jamnitzer, employed Matthias Zündt, a noted specialist in the finest techniques, when he wanted nature casts of the highest quality for his elaborate table pieces. Life casts were of interest to European patrons of the highest aspirations. Philipp Hainhoffer, writing to Duke Philipp of Pommerania reported that Christoph Lencker, the goldsmith, owned 'a large snake cast entirely of silver and a number of little lizards that were cast by old Lorenz [Dhem, the Augsburg goldsmith]. He paid 8 florins for a lizard and refuses to sell any of them, looking on them as treasures: there is no chased work on them, but they are entirely cast from life'.[15] Such items appealed on various levels: as technical wonders, as examples of perfect mimesis, as works in which the boundaries between the natural and artificial were broken down, and as vivid manifestations of the powers of God as the archetypal Mannerist designer on his own account. They were much to the taste of the kind of aristocratic collectors across Europe who were building up cabinets of curiosities and *Wunderkammern* in which abundant collections of *naturalia* (products of nature), *exotica* (items of wonder from far-away places), *artificialia* (artefacts contrived by human hand), and *scientifica* (instruments and scientific curiosities) were interwoven in various permutations to reveal the marvels of human and natural creativity.

A nice sense of how the walk-in cabinets or proto-museums func-tioned—albeit on a smaller scale—can be gained by looking at one of Philipp Hainhofer's complex chests. The *Kuntschrank* he supplied in 1632 for the Councillors of Augsburg to present to King Gustavus Adolfus of Sweden has survived in Uppsala. Inset into the outside of the

cabinet is a rich array of cameos, reliefs, plaquettes, *pietre dure*, and so on, which rise to a triumphant climax in the mountain of rock crystal and coral, at the summit of which is a ewer formed from a Seychelles nut adorned with a Venus lid. The many compartments and drawers in the cabinet play host to aggregations of secret wonders from the four continents, including silver casts from nature, strange bits of exotic animal, dried skins, scientific instruments, domestic tools, miniature musical instruments, and devices driven by clockwork. It was veritably a world in miniature—openly playing upon the microcosmic concept that also lay behind some of the walk-in *Wunderkammern*.

When Jamnitzer came to exploit the nature casts which gave him such delight, he also exploited microcosmic notions. In 1556, he commenced two great table pieces for the Archduke Ferdinand of Tyrol and Emperor Maximillian II. The first was not completed, but involved the casting of small animals and insects by Matthias Zündt, from whom Ferdinand later obtained two dozen small animals and grasses. The second has not survived, but a student's description indicates that the ten-foot-high creation assumed the overall form of the imperial crown, atop of which was the imperial eagle and a seated figure of Jupiter. It was adorned according to an elaborate philosophical and political programme, involving the four elements, seasons, winds, European rivers, major rulers, etc. Earth was personified as Cybele, water as Neptune, and air as Mercury, while Jupiter's thunderbolts served to stand for fire. Some components were animated by ingenious displays, such as clockwork music for dancers and running water to power miniature watermills. As the description admiringly says, included in its compass were 'Physica, Metaphysica, Politica, and many fine Philosophical and Poetical ideas'. This is the kind of context in which Kepler's projected model of the geomtrical cosmos would have thrived.

Some impression of the visual effect of such creations, albeit on a smaller scale, can be gained from the table-piece commissioned in 1549 by his native city of Nuremberg, at the centre of which a luxuriant figure of Mother Earth supports a splendid bowl. Like all Jamnitzer's works it is characterized by a highly mannered complexity in overall design and impecable naturalism in detail. If we should wonder whether Jamnitzer was just a skilled artisan who had no personal involvement with the microcosmic ideas he was being asked to exploit, we may note that he was the author of a highly sophisticated and intricate book on perspective in 1565, the *Perspectiva corporibus regularibus*, which opens with an exposition of how Plato had identified the five regular solids with the elements and the cosmos. So pleased was the city of Nuremberg with Jamitzer's high technical, artistic, and intellectual

achievement, that they granted him a pension on the strength of his treatise.

The particular aesthetic of nature apparent in the works of Jamnitzer, Hoefnagel, Kepler, and other contemporary designers, draftsmen, painters, sculptors, and instrument makers who supplied the European courts in the second half of the sixteenth century involves interlocking complexities of visual and intellectual kinds. The eyes which looked at nature and its representations were particularly attuned to convoluted organic forms that twisted, spiralled, branched, swelled into bulbous convexity, and sank into sudden concavities, that flowered and seeded with eager fecundity, that spoke of the strange and sometimes monstrous inventions of nature discovered in exotic territories, and that testified to God's inexhaustible creativity as a designer of organic geometry. It is a taste that runs through the books of natural history no less than the goldsmith's fantasies. The hugely influential images in Leonhart Fuchs's *De historia stirpium* of 1542 are laid out first and foremost with lucidity of description firmly in mind, displaying all the parts rather than evoking any natural situation, but the disposing of the image on the white page and within the rectilinear borders exudes a very definite sense of rhythmic design in which the artists demonstrate their conscious awareness of how nature's formal ingenuities can best be realized in the context of a woodcut illustration. The title page exemplifies the sense of intricate design that is underlined by the woodcuts. Conrad Gesner's equally seminal encyclopaedia of animals, the *Historiae animalium*, the first volume of which appeared in 1551, is comparatively sober in its in-text illustrations, but when he portrays a creature for which a natural model is not readily available he resorts to intricate fantasies. Thus his Rhinoceros elaborates on the armour-plated hypernole of Dürer's famous image, while the *Ostrich*, the picturesquely named *Struthocamelo* (fig. 33) is endowed with a splendid profusion of proto-Rococo feathers, worthy of the most exotic fan-dancer.

The formal intricacies are matched by the texts of the great picture books, which pursue an intellectual course very different from what we would now regard as an account of the natural history of the creatures. The text on the *Struthocamelo* typically begins in good humanist fashion with an elaborate review of the etymology of the name in Greek and Latin literature, noting pedantically and arcanely, for example, that Pliny's name for the giant bird, *Struthiocamelum*, has six syllables rather than five. The act of naming was not only of Biblical import— God had charged Adam with the task of assigning names—but also of great consequence if the texts on exotic and familiar creatures described

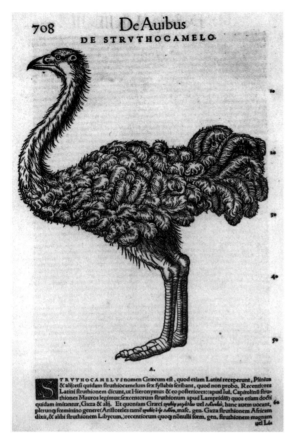

A.

TRVTHOCAMELVS nomen Græcum eſt, quod etiam Latini receperunt, Plinius & alijʒetſi quidam ſtruthiocamelum ſex ſyllabis ſcribant, quod non probo. Recentiores Latini ſtruthionem dicunt, ut Hieronymus & eo poſteriores:(apud Iul. Capitolinũ ſtru-thiones Mauros legimus:ſexcentorum ſtruthionum apud Lampridiũ) quos etiam docti quidam imitantur, Gaza & alij. Et quoniam Græci σφηϝ μηϝλϓϐ uel λϓϐαλϓϐ, hanc auem uocant, plerunϙ fœminino genere(Ariſtoteles ramē σφηϝϐ ϐϓϐ λϓϐϐϐ, maſc. gen. Gaza ſtruthionem Africam dixit, & alibi ſtruthionem Libycum,)recentiorum quoϙ nõnulli fœm. gen. ſtruthionem magnam
uel LL

Fig. 33

Conrad Gessner,
Ostrich, from *Historian
animalium*, 1551

by ancient and modern authorities were to be collated and analysed. Gesner provides indices for names in no less than ten languages. For any animal on which he has adequate documentation, Gesner follows the discussion of its name(s) with sections on its appearance, nutrition, reproduction, and life in nature. He then deals with the animal's utility for such human ends as agriculture and medicine. Finally, and at some length and with elaborate citations, he treats the animal's *significance*, its meaning in the book of nature—symbolically, morally, temperamentally, culturally, poetically, and so on. The animal was not simply a specimen for the natural historian (in the later sense of the term) but a living cultural component in the complex of microcosms and macrocosm that God has provided as the setting for human life and, perhaps, salvation.

The European passion for the more elaborate artifice of form and meaning in created nature, and the matching taste for artefacts in which the skill of the human hand enters into complex visual and intellectual dialogue with the natural sciences, provides the substratum for Palissy's more earthy creations. Visually, it is clear that a plate such as that illustrated in fig. 31 belongs—allowing for the difference in medium—with the kinds of works at which we have just been looking. In quality, his works do not suffer from any comparison. What separates Palissy from all the other makers of objects that play on the artifice of nature is that he published a body of writings that give us the highest level of insight into the technical, stylistic, scientific, philosophical, theological, social, and political parameters within which his extraordinary creations were generated. Not even Jamnizter, who wrote on perspective, has left anything like such a rich legacy. Indeed, we have to look to Leonardo, and to a lesser extent Dürer, to find anything comparable by an artist in the sixteenth century. And, as we will see, his ideas resonate with Leonardo's in notable ways. Who was this remarkable 'craftsman-author'?

He was the famed potter, the 'Maître Palissy', who was granted the titles 'Inventeur des Rustiques Figulines du Roy' in 1563, and 'Inventeur des Rustiques Figulines de la Royne, mère de Roy' in 1588. 'Rustique

Figulines' means, roughly, 'rustic ceramics', with 'Rustique' being used in the sense of 'totally in the natural or country style', rather than meaning crude and rude. He was also renowned as the fabricator of large grottoes in which the major decorative effect was created by ceramic casts. The grottoes, like the plates, attracted the highest levels of patronage. What seems to have been his first grotto was made for the Duc de Montmorency at Ecouen from 1556 onwards. It was celebrated in Palissy's small twelve-folio booklet, but the grotto itself is lost without apparent physical trace.[16] Its greatest successor, also sadly demolished, was created in the area of the Louvre for Queen Catherine de Médicis (Caterina de' Medici of Florence). On 2 January 1570 Bernard is documented with his sons, Nicolas and Mathurin, as 'sculteurs en terre' who were manufacturing 'ouvrages de terre cuicte esmaillée' (enamelled terracotta) for the royal grotto.[17] But these are hardly works of a precocious artist; by 1556 he was already well into his forties. Information about his earlier activities is scant, and is pieced together largely from his own less than complete and, we may suspect, less than completely reliable account.

Palissy was born at Agen, probably in 1510. He began his career as an itinerant glass painter, but slackening demand meant that he could see no secure future in such work. He apparently worked for a time as a surveyor and map-maker, which suggests that he had acquired skills in mensuration and geometry beyond that of a simple glass-painter. The great transformation in his life, he tells us, came in 1540, when he was thirty years old.[18] He saw 'an earthen cup, turned and enamelled with such beauty that I was immediately perplexed. . . . I came to think that if I were able to make enamels I could make pottery vessels and other things of good design, for God had given me the knack of knowing something about drawing'. If, as seems likely from his admiration for its whiteness, his source of inspiration was a piece of Chinese porcelain, he was joining the increasingly widespread European quest to emulate the secrets of the oriental potters. He recounts, in what sounds like an over-dramatized narrative, his desperate struggles in Saintes during sixteen years of obsessional experimentation, which plunged him into poverty and strained his marriage to breaking point. He did not succeed in inventing porcelain, if that was indeed his intention, but he did perfect a way to make a fine white ceramic as the basis for his *rustiques figulines*. What he does not tell us, no doubt for reasons of professional secrecy, is precisely how he achieved his effects, most notably the making and colouring of the vivid life casts.

Given this background of thin documentation and lost grottoes, which the reader is likely to find increasingly discouraging, it is good to

be able to report that a series of nineteenth-century and modern excavations in the area of the Louvre have unearthed much of the basic layout of Palissy's grotto and workshops. The excavations have brought to light a number of his actual moulds and casts for ceramics, not only life casts but also examples of cameos and enamelled metallic plaques. The larger surviving fragments, such as a chorus of spouting frogs on volcanic rocks and a herm figure show that the density of natural form in his dishes was sustained into his large-scale works. The framework was that of 'rustic' architecture which itself inhabits a hinterland between the artificial and natural, as had become popular in Italy and France by this time. The style very much takes its cue from Diana's grotto in Ovid's *Metamorphoses*, which was 'wrought by no artist's hand, but nature by cunning had imitated art, for she had shaped a native arch of the living rock and soft tufa'.[19] Palissy's individual casts of animals, such as the beautiful lizards found in the store excavated in his workshop from 1984 onwards, give a compelling sense of the visual impact of his creatures. They set the standards we should expect of surviving ceramics which we might hope to attribute to him. Only a few surviving items (fig. 31) meet these most exacting criteria, and the great majority of ceramics which look like 'Palissy' are probably best recognized as later workshop productions, admiring imitations, or later forgeries.

Alongside this literally fragmentary picture of Palissy's achievements as an artist, we can set two notable books: his *Recepte véritable par laquelle tous les hommes de France pourrant apprendre à multiplier et augmenter leur thrésors* ('True means by which all Frenchmen may learn to increase and augment their treasures'), published in 1563; and the more developed treatise which was printed in 1580, the *Discours Admirables de la nature des eaux et fonteines, tant naturelles, qu'artificelles, des metaux, des sel & salines, des pierres, des terres, du feu & des emaux . . .* ('Praiseworthy discourses on the nature of waters and spings, both natural and artificial, of metals, salt and salines, stones, earths, fire and enamels.')[20] Written in a robust and impetuous vernacular, they are cast in the form of combative dialogues between two speakers who respectively represent philosophical and practical stances. The protagonists in the *Discours* are named 'Theory' and 'Practice'. 'Theory' is a bookish philosopher of stuffy views, who exhibits dangerous alchemical tendencies, while 'Practice' (effectively the author himself) is paraded as the blunt man of common sense and practical experience. The tone is set by the letter of dedication of the *Discours* to Sir Antoine de Ponts, one of the King's captains and counsellors. It is worth quoting from it at some length:

Many men, under beautiful Latin, or other well polished language have left many pernicious ingenuities to delude youth and waste its time: thus a Geber [Jabir Ibn Hayyan, eighth to ninth-century Islamic alchemist], a *Roman de la Rose* [*c*.1230, by Guillaume de Lorris] and a Ramond Lulle [thirteenth-century theological mystic and supposed alchemist], and some disciples of Paracelsus [Theophrastus von Hohenheim, sixteenth-century theologian, scientist, doctor, renowned alchemist, and occultist], and many other alchemists have left books in the study of which many have both lost their time and wealth. Such pernicious books have led me to scratch the earth during forty years, and to search its womb [*matrice*], in order to know the things it produces within itself, and by these means I have found grace before God, who has revealed to me secrets which until now have remained unknown to men, even the most learned, as may be ascertained from my writings, contained in this book. I well know that some will scoff, saying that it is impossible that a man without Latin could have knowledge of nature; and they will say that it is very bold of me to write against the opinion of so many and famous philosophers, who have written on natural things, and filled the whole earth with wisdom. I also know that others will judge by appearances, saying that I am but a poor workman: and by such statements will try to make my writings appear harmful. In truth, there are things in my book which it will be hard for ignorant people to believe. Not withstanding all these considerations, I have not ceased to pursue my undertaking, and to counter all calumnies and snares. I have set up a cabinet in which I have placed many admirable and monstrous things which I have drawn from the womb of the earth, and which give evidence of what I say, and no one will be found who will not be forced to admit them to be true, after he has seen the things which I have prepared in my cabinet.[21]

As befits a founder of the Reformed Church at Saintes, in his role as a zealous Hugenot, he is more overtly concerned with his status before God than Leonardo appears to have been, but in other respects the tone is notably similar to Leonardo's writings. The open parading of hands-on experience and first-hand looking, as preferable to all the Latin erudition of the University men, is fundamentally the same as Leonardo's willingness to acknowledge that he is a 'man without learning'.[22] This stance is in part defensive, given the vulnerability of Leonardo and Palissy to the charge that they were ill-informed about the richness of Latin learning, but such freedom from dogma could be turned to good account—not only by Leonardo and Palissy but also by practitioners in a number of those 'manual' disciplines that were newly laying down theoretical bases. Increasing attempts to reconcile practical experience with the formulas of Aristotelian science were beginning to reveal the kinds of strain that were to erode the old certainties during the coming century. We find comparable declarations of reliance upon experience

rather than received wisdom in a range of professional activities, not least military and civil engineering. Palissy's awareness of the tenor of the debates in military science is reflected in his statement that 'if the theory imagined by war leaders could be carried out they would never loose a battle'.[23] For his part, Palissy claims that his physical engagement with metal deposits and fossils, literally as a man of the soil, has 'taught me more philosophy than Aristotle. And it is because I cannot read Aristotle that I have read much in these marcasites, and have understood through them that the generative material of metals are fluid, liquid and aqueous, and this I have learned by examining their shape'.[24]

What Palissy also shares with those of his contemporaries who were declaring the superiority of experience over book learning is a far greater covert reliance upon traditional theory than they were openly prepared to admit. Indeed, the declaration itself has an honourable tradition in its own right, even if reliance upon direct experience was more often honoured in the breach rather than the observance. Like Leonardo, he managed to glean a framework of Aristotelian theory from a few vernacular publications, supplemented by keen discussions with well-informed contemporaries, and probably by some limited ability to grapple with Latin texts. On bases that were insecure by the standards of 'men with learning', they exploited their considerable mental agilities to gain an idiosyncratic grip on traditional frameworks for the explanation of natural phenomena. The identity of Palissy's actual sources is difficult to define, not least because he resorts very little to the humanist tradition of learned citation. He probably depended heavily on the increasing if still limited quantity of writing on natural philosophy that was becoming available in French, including Girolamo Cardano's *De subtilitate* ('On Exactitudes', translated from the Latin), Pièrre Belon's *Observations on Several Singular and Memorable Things Found in Greece*, Guillame Rondelet's *Complete History of Fishes*, and Jacques Besson's *The Art and Science of Finding Water and Springs Underground*.[25] It is also highly likely that he was much taken by the repertoire of nature's marvels paraded by Ambrose Paré, who attended his lectures and who openly revelled in the profligacy of natural form in its most bizarre, convoluted, and curious guises, not least amongst the denizens of the deep. In his *Book of Monsters and Prodigies*, Paré maintained that the very first 'reason' for extravagant natural forms was to demonstrate the 'glory of God', whose inventiveness is untramelled.[26]

Palissy was also clearly acquainted with the growing body of alchemical literature available in the vernacular. The alchemists' terms

of reference set important parameters for Palissy's debates, even though he rejected the central tenets of their metaphysical beliefs and had absolutely no faith in their quest for such mystical secrets as the 'philosopher's stone', the elusive agent that effected transformations, and their ambitions to create gold from base materials. We can also gain some idea of the nexus of oral science to which he had access from the impressive cast list of lettered men, including a number of leading physicians, whom he records as paying an *écu* each to attend his lectures as 'witnesses'.[27] What, then, are the observations and ideas that Palissy, the 'humble' potter, had the nerve to parade before his distinguished audience?

His central idea shares Leonardo's vision of the earth as a kind of organism in flux, subject to continual processes of change on every conceivable scale. Although Palissy did not believe that there was any possibility of anything truly new arising, since everything in the world, actually or by pre-determined potential, has been there from the very moment of Creation, he saw that the compounds and their location were in a continual ferment of change. Mountains, for example, provide living testimony to their growth by 'congelation' and their wearing away by erosion. At the heart of the motions within the earth are the actions of two fundamental kinds of water: the 'congelative' waters which (according to one of his typical analogies) tend to solidify like hot wax thrown on to a mound of cold wax; and the 'exhalative', waters which behave like steam issuing from a boiling kettle.[28] The exhalative virtue reacts to heat, as in the internal furnaces of the earth, and in extreme form is responsible for catastrophic eruptions and earthquakes. In this context of fluid flux, all natural substances and organisms arise from fundamental seeds, *semences*, implanted in the moist womb of the earth from the very beginning by God.[29] The job of the human worker, in such a world, is to manipulate, shape, and recombine the materials provided by God, aiding nature to reveal its wonders and potentialities.

Given this dynamic vision, it is not surprising that he should have devoted a good deal of attention to two of the time-honoured questions of process in the body of the earth, the explanation of mountain springs and the cause of fossils. We have already seen that the first of these had occupied Leonardo, who had also been much concerned with the evidence that fossils could not be explained by the Biblical deluge. When Palissy seeks an explanation for springs in high mountains, he characteristically belabours 'Theory' for blind reliance on traditional metaphysics: 'I must argue further with you and your Latin philosophers: because you find nothing good unless it comes from the

Latins. I give you as a general and certain rule that waters never rise higher than the springs whence they come'.[30] His own explanation is down-to-earth. He argues that all springs can be explained in the most straightforward way by the precipitation of water previously exhaled from the earth. Similarly, he seeks to explain fossils by reference to credible processes of a physical nature. By fossils Palissy meant not only stony casts of the whole or parts of organisms but also other mineral objects deposited during igneous processes and early stone tools. Throughout his debates with 'Theory', Palissy continually refers to his own observations of fossilized marine creatures in dense layers at high locations. He cites observations made in such places as Xaintonge (Saintonge) and the Ardennes, drawing not least upon his experiences as a surveyor and map-maker in an earlier phase of his career.[31] He uses his knowledge to issue a specific challenge to supporters of Cardano, who argued that the ancient shells had been washed to high locations by the Biblical Deluge:

> Now I ask anyone who follows Cardano's opinion by what door did the sea enter to bring these shells into the densest rocks? I have explained to you that these fishes were generated in the very place where they have changed their nature, keeping the form that they had when they were alive.[32]

Cardano had actually argued for multiple inundations, but Palissy is by far from being the first or last author to misrepresent his adversary. In any event, his arguments retain their potency even in the face of the more sophisticated version of Cardano's theory.

Again, Palissy's own observations and the uses to which he puts them are very similar to Leonardo's, especially his contention that close scrutiny of the fossils in the original locations reveals that the creatures had lived there for all their lives.[33] Both maintained that vast tracts of land had once been submerged for long periods of time, and that huge changes had taken place in the configurations of earth and water over the ages. The similarities are probably a reflection of shared sources, experiences, and intellectual habits rather than direct or even indirect influence. Palissy himself is clearly drawing on the Mediaeval and Renaissance theories based on the *Congelation and Conglutination of Stone* by the Islamic philosopher, Avicenna, most probably as transmitted by authorities whose writings were available in French, such as Cardano (in spite of Palissy's criticisms) and Besson.[34] Palissy's 'congelative and generative salt', which is responsible for the petrified casts of marine animals, is conceived in exactly this tradition, but his vivid reconstruction of the actual mechanism reflects

his experience of using moulds for casting the bodies of animals in his ceramics.

In his hectoring debates with 'Theory', Palissy as 'Practice' consistently draws attention to the tangible reality of those specimens he had torn from the womb of the earth. Accordingly, the final 'proof' resided in his '*cabinet*', his carefully staged collection of geological marvels. On the surface, his cabinet appears to resemble other examples of *Wunderkammern*, but none of the other assemblages of the curious products of nature and man—even those created by men of learning for relatively specialist purposes—served such a remorselessly polemic function. His cabinet was designed as a didactic tool to bring the viewer face-to-face with empirical reality. He records the 'labels' assigned to the various categories of objects, though they are less what we would call labels than argumentative and discursive 'wall panels'. Two excerpts will give an idea of their tone:

> Just as all kinds of metals, and other fusible materials, take on the shape of the hollows or moulds in which they are placed, or thrown, even when thrown into the earth, take the shape of the place where the material is thrown or poured, so the materials of all kinds of rocks take the shape of the place where the material has congealed. . . .
>
> I have placed here as evidence a great number of stones through which you will easily be able to know that the reasons and proofs of my treatise on stones are true. And if you are not entirely devoid of sense, you will admit it after having the demonstration of these natural stones.[35]

The multitude of 'proofs . . . placed here for you in rows' included: stones formed flat side down; layered rocks like talc; compound rocks containing stones and fossils; petrified wood; petrified shells; rocks and ores in geometrical configurations; rocks formed in spiral shapes; marine creatures from named locations; petrified fruits; agates and chalcedonies; imprints of grasses; fishes' and animals' skulls containing rock; porous rocks; and congealed salts.[36] What all these items had in common was that they were tangible manifestations of the form-producing potentialities of the matrix of the earth as seeded by divine creation.

All this is remarkable enough, coming from a glass painter turned surveyor, turned potter, but even more notable is the way that he models himself in the autobiographical sections of his writings as a second force of nature in the world, mirroring in microcosm the process he observed in the body of the earth. The notion of the unity of the formative powers of nature and the human maker was not new in itself, and it is likely that Palissy was aware of its formulation in Albertus Magnus's thirteenth-century *Book on Minerals*:

> The force capable of forming an animal . . . is in the seed in the same way that the artisan is in the artefact that he makes by his art; so in material suitable for stones, there is a power that forms and produces stones, and develops the form of this stone and that.[37]

What Palissy does with this notion is to embed it in his person in the most extraordinarily personalized way, above all in his accounts of his heroic struggles to create his own products by 'exhalation' and 'congelation'. It is only possible here to give a brief flavour of his vivid narratives:

> Although I spent six days and nights in front of the kiln without ceasing to burn wood at both openings, it was not possible to melt the enamel and I was like a desperate man . . .

> I was forced to burn all the stakes that held up the plants in my garden, and when they were burned up, I was forced to burn the tables and the floor of my house, in order to melt the second mixture. I was in such anguish as I could not describe: for I was quite dried out because of the work and the heat of the kiln; for more than a month my shirt had not dried on me . . .

> The mortar I had used to build my kiln was full of pebbles which when hot and my enamels began to liquefy burst into many pieces, making many loud noises in the kiln. Now as the fragments of these pebbles flew against my work, the enamel, which was already liquefied and sticky, caught these pebbles and stuck them to all parts of my vessels and medals, which without that would have been fine . . .

> Having made a certain number of rustic ewers and fired them, some of my enamels turned out fine and well melted, others were poorly melted, others were burned, because they were made of various materials that were fusible to various degrees; the green of the lizards was burned before the colour of the serpents had melted, also the colour of the serpents, crayfish, turtles and crabs had melted before the white had attained any beauty. All these mistakes have caused me such labour and mental anguish that before I made my enamels fusible at the same degree of fire, I thought I would be at death's door; also as I worked at such things for more than ten years my body was so wasted away that my arms and legs had no form or trace of muscles, but on the contrary my legs were like sticks.[38]

There is a total self-identification with his processes, an identification which extends from visceral and sexual empathies to philosophical ambitions to place his creative energies in the service of the divine potencies of nature. Just as the fossils in his cabinet were wrenched from the womb of the volcanic earth, so his own ceramics were torn violently from the matrix of his infernal kilns. The processes which he mastered as a potter became those of nature herself in microcosm.

As he laboured mightily with his kilns, baking his clays and fusing his enamels, so he felt that he was creating in miniature a crucible for nature herself:

> The kilns in which I bake my work have taught me much concerning the violence of fire; but among other things they have made me know the strength of the elements which generate earthquakes.[39]

He drew upon his experiences both to adduce general principles and to inculcate a proper reverence for the inexhaustible variety of natural things. Only experience can reveal to the maker the precise behaviour of all the myriad types of earth that the potter might encounter.[40] It is this variety that he uses as a justification for his reluctance to disclose all his secrets to 'Theory', since only the true adept who has won his experience over many hard years can embrace in practice and in theory anything like the full range of nature's wonders and know how to deal with the unexpected.[41]

His own plates testify to his understanding of the petrifying principles embodied in the clays and enamels, and to nature's infinite variety of form, texture, and colour. The best of the autograph ceramics bear vivid witness to his ability to act as a kind of second Nature. In every instance, Nature must be the supreme guide for the human *artifex*:

> When I have contemplated the various works and beautiful order that God has made in the earth, I have been astonished at the presumption of man: for I see that there are many shellfish that have such beautiful lustre that no pearl in the world is so beautiful. Among others there is one in M. Rasce's cabinet which has such a lustre that it looks like a carbuncle, because of its polish, and seeing such things I say to myself, why is it that those who say they can make gold [i.e. the alchemists] do not powder some of these shells and make a paste to fashion a fine cup? I am sure that a cup, well made of such materials, would be more precious than gold. Or else why do they not find out what the fish has used to make this fine house, and take such materials to make a fine vessel. The fish that makes his shell is not as glorious as man, being an animal with very little form and yet it can do what man could not.[42]

Those who succeed in aiding God's design by realizing the potential within earthy materials were achieving the highest aspirations available to humans:

> The first inventors of some good thing, to help nature, have been so hon-
> oured by our predecessors that they have thought them to be participants in
> the spirit of God. Ceres, who thought of sowing and cultivating wheat, has
> been called a goddess; Bacchus, a good man (not a drunkard as the painters

portray him) was exalted because he thought of planting and cultivating the grape; Priapus in the same way, for having invented the division of lands so that each man should tend his own share; Neptune for having invented navigation; and hence all inventors of useful things have been thought to partake of the gifts of God.[43]

Palissy himself, as *Inventeur des rustiques figulines* could lay claim to be the potter's equivalent of Vulcan.

There is clearly an element of exaggeration in the heroic way he fashions himself in his writings, but there is no doubt that he was a man of conviction and courage. He was a fervent and active Huguenot, in the face of severe dangers. As with other aspects of his mature activity, his religion is an organic part of the whole man. He embraced the Huguenot movement in its striving for freedom from the stultifying conventions of bookish authority and rigid hierarchies which ruled in the institutionalized church. For Palissy, freedom to read the book of Nature and to imbibe its divine language was essential if humans were to achieve a proper understanding of God's majesty. It is in this spirit that he developed his utopian vision of an ideal refuge for 'Christians exiled in times of persecution'. The designer of the perfect city for the free-minded Christian could, of course, do no other than take inspiration from one of the most beautiful and protective structures devised by God, the spiral shell of *Murex linnaeus* which was perfect in its spiralling beauty no less than in its functional security.

Yet, for someone of such radical views, he inevitably found it necessary to work within a framework of patronage founded on traditional hierarchies. He was able to square this circle, to some extent, by differentiating between proper and improper uses of power. In his letter to the reader in the section on metals and alchemy he exempts from criticism three types of people with power:

> I wish to blame in no way three kinds of persons. To wit, the first are noblemen who occupy their minds by way of recreation, without being influenced by love of illegitimate gain. The second are all kinds of physicians of whom it is required to know natures. The third are those who have the power, and who would at no price abuse it.[44]

The ideal person is one who uses the powers gained by analytical experience of reality to serve God with disinterested virtue.

That this eccentric and opinionated artisan was able to forge a successful career as an admired potter, fabricator of grottoes, and polemicist says much for his two chief patrons, firstly the Constable Anne Duc de Montmorency, who was to die in 1567 during the war against the Huguenots, and latterly the widowed Queen Catherine,

who served as his continued protector in the face of the persecution of the Huguenots. Not surprisingly, Palissy still ran into problems. He was thrown into prison in 1562, owing his release in the following year to the intervention of the Constable Montmorency with the Queen. He was again imprisoned in 1587, and his failure to comply with the terms of his banishment lead to his reincarceration in the Bastille. The death of the Queen in 1589 left him without an obvious protector, and in 1590 it was reported that 'Maistre Bernard Palissi, prisoner for religion, aged eighty years, died in misery'—and, I may add, in growing obscurity.[45]

He is someone who deserved and deserves better. I believe that in our present endeavour, he sustains his exemplary role splendidly, even though he would not figure in any standard histories (whether of art or science) as a 'great man'. Nowhere do we see a more vivid and personalized example of the rise of a new kind of robustly vernacular science, in which the common-sense knowledge of the artisan is brought into fertile dialogue with the erudite theories of natural philosophy. No one better illustrates how the grand processes of nature may be understood by analogy with hands-on experience in the workshop. No philosopher better exemplified how a genuine respect for the ancients and their successors could be translated into a challenging empiricism that could be regarded as truer to the ancients' enterprise than docile acceptance of everything they wrote. No artist, not even Michelangelo, provides a more telling illustration of the integration of the artist's bodily instincts with the forging of artefacts. He perfectly represents the rise of the self-conscious and self-modelling individual in the histories of Renaissance art and science, the wilfully independent hero characterized as the obsessional observer and reconstructor of God's creation. Like Michelangelo and Tycho Brahe, in their different spheres of activity, he becomes a kind of second god in the world, revealing the majesty of divine creation to humankind more surely than the standard dogmas of ritualized religion.

In his life, art and thought Palissy was the architect of his own personal microcosm, within which he aspired to embed the fundamental processes of the whole world. For the historian, he signals with great clarity, albeit in a highly personalized manner, the crucially new perspectives that the men of practice were bringing into the world of the science of visible things.

NOTES

1. Leonardo da Vinci, Manuscript A 55v, (Paris, Institut de France), quoted in Martin Kemp *Leonardo da Vinci: The Marvellous Works of Nature and Man*, (London: J. M. Dent and Sons: 1989), pp. 117–18

2. Leonardo, *Codex Leicester: A masterpiece of science*, Claire Farago ed., with introductory essays by Martin Kemp, Owen Gingerich, and Carlo Pedretti, (New York: American Museum of Natural History, 1996), sheet 3B/folio 34 r

3. Seneca, *Quaestiones naturales*, III 14–15

4. Leonardo, *Corpus of the Anatomical Studies in the Collection of Her Majesty The Queen at Windsor Castle*, Kenneth D. Keele and Carlo Pedretti eds, (London : Johnson Reprint Company Ltd., Harcourt Brace Janovitch Publishers, 1979), 137v (RL 19003r)

5. Jean Paul Richter ed., *The Literary Works of Leonardo da Vinci*, (London and New York: Phaison, 1970) vol. II, p. 103, note 844

6. Jean Paul Richter ed., *The Literary Works*, no. 847, p. 105

7. Jean Paul Richter ed., *The Literary Works*, p. 292, p. 296, p. 298

8. Leonardo, *Corpus of the Anatomical Studies*, 114 r (RL19115r)

9. Leonardo as quoted in Martin Kemp, 'The Invention of Nature and the Nature of the Invention' in Paolo Galluzzi ed. *Leonardo Engineer and Architect* (Montreal: The Montreal Museum of Fine Arts, 1987) p. 138

10. Nature, no. 421, p. 792, 2003

11. Leonardo, *Codex Leicester*, sheet 5B/ folio 32r

12. Leonardo in Martin Kemp, *Leonardo da Vinci: the Marvellous works of Nature and Man*, (London : J. M. Dent and sons, 1989), p. 139

13. Leonardo, *Manuscripts*, (Paris, Institut de France, MS L cover); in Jean Paul Richter ed., *The Literary Works of Leonardo da Vinci*, Duke note 12, n. 1414 in Richter

14. Martin Kemp, 'Wrought by no Artist's Hand: The Natural, the Artificial, the Exotic and the Scientific in Some Artifacts from the Renaissance', in Claire Farago, *Reframing the Renaissance Visual Culture in Europe and Latin America 1450–1650*, (New Haven and London), 1995, p. 195

15. John Hayward, *Virtuoso Goldsmiths and the Triumph of Mannerism*, (London: Sotheby's, 1976), p. 209

16. Bernard Palissy, *Architecture et ordonnance de la grotte rustique de Monseigneur le duc de Montmorency*, (La Rochelle: Berton, 1563), (facsimile, Paris, 1919)

17. Louis Dimier, 'Bernard Palissy: Rocailleur, Fontenier et Décorateur de Jardins', *Gazette des Beaux Arts*, LXXVI, n.12, (1943), p. 14

18. B. Fillon and L. Audiat, eds, *Oeuvres de Bernard Palissy*, (Niort, 1888) and *Oeuvres complètes de Bernard Palissy*, with preface by J. Orcel (Paris, 1961), pp. 311–13 and A. La Roque tr., *The Admirable Discourses of Bernard Palissy*, (Urbana, University of Illinois Press, 1957), pp. 192–3

19. Ovid, *Metamorphoses*, 3, 157–62

20. Bernard Palissy, *Recepte véritable*, (La Rochelle: Berton, 1563), K. Cameron ed., (Geneva: Droz, 1988), and *Discours Admirables*, (Paris: Martin le Jeune, 1580)

21. *Oeuvres complètes*, p. 130, trs. pp. 23–4

22. Leonardo, *Il Codice Atlantico della Biblioteca Ambrosiana di Milano*, Augusto Marinoni ed., presentazione di Carlo Pedretti (Firenze, Giunti, 2000), 327a (119va)

23. *Oeuvres complètes*, p. 132, trs. p. 27

24. *Oeuvres complètes* p. 284, trs. p. 167

25. Girolamo Cardano's *De subtilitate* (Basel, 1551) was available in the French translation by R. Le Blanc, *Les livres . . . de la Subtilité*, Paris, 1556, and subsequent editions. Of

Pierre Belon's works, particularly relevant is his compilation, *Les Observations de plus-ieurs singularitez et choses memorables, trouvees en Gréce . . .*, (Paris, 1588). The great work on fishes by Guillame Rondelet, *L' Histoire entière des poissons*, (Lyon, 1558), was known to Palissy. Jacques Besson's *L' art et science de trouver les eaux et fontaines cachées sous terre*, was published in Orléans in 1569. It is also likely that Palissy knew (and generally disliked) Alexandre de la Tourrète, *Bref discours des admirables vertus de l'or potable*, Lyons, 1575; Denis Zacaire and Bernard of Treves, *Opuscule très eccellent de la vraye philosophie naturelle des metaux*, Antwerp, 1567; and Roch le Ballif, *Le Demoste-rior*, Rennes, 1578.

26. A. Paré, *Des monstres et prodiges*, J. Céard ed., (Geneva, 1971), p. 4; J. Pallister tr., *On Monsters and Marvels*, (Chicago: Chicago University Press, 1982)

27. For the list, see trs. pp. 154–5

28. *Oeuvres complètes*, p. 262, trs. p. 147, for wax; and p. 152, trs, p. 43 for the kettle

29. *Oeuvres complètes* p. 192, trs. pp. 82–3

30. *Oeuvres complètes*, p. 161, trs. p. 51

31. For accounts of fossils in these locations, see *Oeuvres complètes*, p. 274ff, trs. pp. 158–62

32. *Oeuvres complètes*, p. 278, trs. pp. 161–2

33. *Oeuvres complètes*, p. 275, trs, p. 158, referring to observations made in the Ardennes

34. Avicenna, *De congelatione et conglutinatione lapidum*, eds and trs. E. Holmyard and D. Mandeville, (Paris: P. Guenthner, 1927). See Besson, *L' Art et science . . .*, I, 3, for the covering of the earth with water.

35. *Oeuvres complètes*, p. 358, trs. p. 233

36. *Oeuvres complètes*, p. 359ff, trs. pp. 234–40

37. Albertus Magnus, *Book of Minerals*, ed. and trs. D. Wyckoff (Oxford, Oxford University Press, 1967), pp. 21–2

38. *Oeuvres complètes*, pp. 315–20, trs. pp. 197–9

39. *Oeuvres complètes*, pp. 151–2, trs. p. 43

40. *Oeuvres complètes*, pp. 299–300 and 304, trs, pp. 182 and 186

41. *Oeuvres complètes*, p. 310, trs. p. 192

42. *Oeuvres, complètes* p. 203; trs, p. 93

43. *Oeuvres complètes*, p. 169, trs. pp. 58–9

44. *Oeuvres complètes*, p. 188, trs. p. 78

45. Quoted in the *Revue de l' Art*, 1987, XIX, p. 59

4

THE ART OF INTERACTION: ROBERT THORNTON AND THE ROMANTIC ERA

P alissy's kingdom was primarily that of the creatures of the waters, those closest to the moist matrix of the generative *semences* (or 'germs'). Robert Thornton's kingdom, over two hundred years later, was that of the flowering plants. They were both specialists, but specialists who believed that they could read the greatest messages in the smallest perfections of nature. Palissy would in no way have demurred from Thornton's claim that 'every flower, however mean in the vulgar eye, is a sermon for the learned'—providing we define 'learned' in terms of those who have learnt how to look with fresh eyes.[1] However, in the two centuries that separated Palissy's death from the beginnings of Thornton's career, the nature of Nature had undergone some radical redefinitions in art and science. Palissy had died on the verge of the transformative changes that can still be called with some justification, the 'Scientific Revolution'. We have already seen signs of one of the great reforms in the consolidation of Copernicus's intuitions by Kepler and Galileo. If we add to the seventeenth-century roll-call such major reformers as Descartes, Newton, and Huygens—to spread the European net from Germany and Italy to France, Britain, and Holland—we can gain some idea of the new bodies of learning that were available by the eighteenth century.

Experiment, Observation, and Mathematics

THE ART OF
INTERACTION:
ROBERT
THORNTON
AND THE
ROMANTIC ERA

To some extent the story of the physical sciences in the seventeenth century may be characterized as the triumph of the appeal to experimental evidence. This is not to say that all the innovatory science was experimental, nor that all experiments were quite what they claimed to be. And the resort to experiment did not in itself guarantee innovation. However, it remains true that the proclamation of testable truths became a distinguishing feature of international dialogue amongst physical scientists. The phenomena were set up to be observed, recorded, and measured, or in a sense they were made to record themselves, in order to proclaim the rule of mathematics in ever more precise and sophisticated ways. Christiaan Huygens's perfection of the pendulum as the best regulator for clocks may stand as an exemplary event. The pendulum had of course been long known, and the rule by which the amplitude of its swing diminished proportionally over time had been investigated by Leonardo, but the mathematics of its amplitude and frequency had escaped observers until Galileo opened new avenues of investigation in 1602 when he announced that the period of oscillation of a pendulum was not dependent on its amplitude or the weight of the bob at the end of the shaft. The debates about the motion of the mathematically subtle behaviour of the pendulum were central to the historically important issue of the rules governing falling bodies. When Huygens proposed a new design solution for a pendulum for clocks in his *Horologium oscillatorium* in 1663, his mechanical invention stood in a wholly symbiotic relationship with his key formula for the period of oscillation, T, as equal to 2 times π multiplied by the square root of the length, l, when l is divided by the gravitational force, g:

$$T = 2\pi \sqrt{l/g}$$

Gravitational force could thus be calculated through the motion of a pendulum, and spring- or weight-driven clocks could be made to keep impressively regular time as they 'wound down'. Theory and practice are thus in concert, as Leonardo required, but the mathamatics that Galileo and Huygens were able to apply to physical phenomena was quite new, relying not least on the algebraic methods from Islam of which Leonardo was ignorant.

Huygens's promotion of the pendulum catalysed new designs for escapements which could exploit its potential for precision. In 1673 for example, Joseph Knibb, based in London, produced two long-case

regulator clocks and a 'split-second' wall clock for the astronomer, James Gregory, who was then working in St Andrews in Scotland. Knibb's innovatory escapement for the wall clock managed to split the second into thirds—though it is doubtful if Gregory's other instrumental observations delivered sufficient precision to use thirds-of-a-second. On the theoretical side, it was observed that variations in the period of oscillation occurred with change of altitude and Robert Hooke was lead to propose, amongst other things, that T^2 varied inversely with the distance of the pendulum from the centre of the earth. The behaviour of the pendulum also highlighted the likelihood that the earth was spheroidal in shape rather than geometrically spherical, and that perfect regularity was a theoretical possibility rather than a realizable actuality. Mechanical contrivance, experiment, and various kinds of theoretical constructs are thus in dialogue. Thornton, as we will see, had a great regard for practical experiment as a vehicle of causal discovery.

The recurrent obsessions were observation and quantification. The experiment was designed to make it all plain to see—*repeatedly*, it was claimed. In retrospect, we have a greater sense that what is actually seen tends to be what the observer wants to be seen, that measurement is a creatively inexact science in human hands determined to get the 'right' results, and that 'experiments' could be conducted in the mind and transposed into physical reality without actual testing. Experiment became a rhetorical mode, a way of winning trust. The kind of trust which Galileo puts into the mouth of 'Simplicio' in *The Two New Sciences* in 1638 is, as we realize, not something we can necessarily take for granted:

> It would have given me great satisfaction to have been present at these experiments. But being certain of your diligence in making them and your fidelity in relating them, I am content to assume them as most certain and true.[2]

Although the role of experiment in science in general and in the 'Scientific Revolution' in particular is subject to such qualifications, the ambition to demonstrate measurable things to plain sight did provide a notable impetus towards the questioning of old truths and did yield notable findings, as Galileo's own work vividly demonstrates.

An aspiration towards plainness was an integral part of a number of the new agendas. Elaborately metaphysical styles of exposition were, in much theory at least, supposed to yield to plain speaking, not infrequently in the vernacular—though Latin still served to transmit the message internationally. The metaphysical base itself tended to

THE ART OF
INTERACTION:
ROBERT
THORNTON
AND THE
ROMANTIC ERA

become less overtly part of the method, at least as paraded in public. The basic idea, particularly prevalent in British science, was that if nature was asked direct and precisely formulated questions through controlled experiment by those equipped with mathematical understanding, it would deliver straight answers in plain language. It is symptomatic that the key interrogator of 'Salviati', the new mathematician of nature, in Galileo's *Dialogue Concerning the Two Chief World Systems* (1632) and *Two New Sciences* should be called 'Simplicio', who resorts to a combination of common sense and Aristotelian wisdom, and that the complex dialogue should be conducted in Italian. 'Simplicio's compound is hardly surprising, since Aristotelian mechanics typically relies on the ingenious drawing of rules from common sense observation.

There was a long ancestry to the idea that a 'simple' interrogator could discern the truth more readily than the sophistic philosopher, encumbered with a great baggage of assumptions. In the fifteenth century, Cusanus's *De docta ignorantia* (*On Learned ignorance*) had centred on just such an interrogator, who could ask the simple and yet stunningly difficult questions—not least to reveal the incomplete nature of human wisdom. Such an interrogator stands to some extent within the tradition of the 'wise fool', who has no absolutely set premises and will not accept the 'accepted' answer if it does not make obvious common sense. He or she may be seen as the ancestor of Hans Christian Anderson's young boy who provides witness to the King's nakedness because he had not been pre-conditioned to say that he sees new clothes. Galileo's 'Simplicio', in spite of performing a key role in trying to see things in the most direct way, does not entirely fit into this mould, since he is more learned in Aristotelian natural philosophy than any 'fool', however 'wise', has a right to be. Moreover, in Galileo's scientifc method, 'simple' acknowledgement of what can be witnessed and believed has to yield in the final analysis to the modern analyst's superior abilities to cast interpretations in terms of high mathematical truths of an 'irrefutable' kind—even if they go against what immediately seems to be the common sense explanation. Even then, as the latter stages of the dialogue progress, key aspects of nature remain enigmatic—presumably requiring better forms of scrutiny and more sophisticated formulations than were available even to Salviati, whether addressing deceptively simple questions or applying impressively elaborate mathematics.

When we look across at the visual arts in the years after 1600, we cannot necessarily assume that they clearly fall under the same cultural umbrella as what in retrospect seem to be the signal developments in the sciences. Even geometry, to which the painters' theories had

contributed so much, was becoming the province of algebraic analysis and moving far beyond the grip of artists. This is not the place to examine liaisons between the visual arts and cognate science in any depth, but it may be helpful to designate some general trends, albeit in a schematic manner.

The most publicly spectacular developments were the complex Baroque splendours of Bernini in Italy and Rubens in Flanders, which, in spite of Rubens's interests in optics and anatomy, hardly align themselves comfortably with the new sciences. Perhaps, if we wish to view them in concert with science, the best we can say is that they serve to remind us that plainness was not a ubiquitous cultural sign in seventeenth-century art, any more than it was in all European science. By contrast, Nicolas Poussin, the French artist working primarily in Rome, aspired to create a more austere style of high philosophical rectitude, which speaks of a kind of 'mathematical' austerity, in appearance if not in actual construction, while Rembrandt in Holland humanely penetrated the less secure aspects of human personality through portraiture in a way which was truly 'vernacular'. Britain, arguably the leader in science, offers no obvious candidate for this schematic roll-call in the figurative arts, serving to remind us that easy cultural equations are to be resisted. The parallel here, if we wish to find such a thing, is rather with modes of architectural design, nor least as embodied in the person of Christopher Wren, prominent member of the Royal Society, accomplished mathematician and founder of an architectural style which blends the legal precision of classical rules with pragmatism of function and structural daring of the highest order. The suspended ceiling of the Sheldonian Theatre in Oxford remains a breathtaking experience over three centuries after its construction.

Perhaps most directly germane to the new sciences, if we do feel a compulsion to seek parallels, is the superb vernacular naturalism that characterized much Dutch art. I am thinking of the landscapes of Ruisdael and Hobbema, the cattle of Cuyp and Potter, the seas of van der Welde, the domestic intimacies of De Hooch and Vermeer, and (in very geometrical modes) the churches of Saenredam, Houckgeest, and de Witte. The plurality of artistic modes appears to respond to local traditions, the demands of patronage, and the market-place in a way that is more diverse and centrifugal than science, which exhibits stronger centripetal tendencies, at least with respect to its internationally sanctioned modes of operation.

It was in the mode of naturalistic description that the Natural and Human Sciences had generally sought to claim progress, The signal reforms had been made in the previous century with the advent of the

THE ART OF
INTERACTION:
ROBERT
THORNTON
AND THE
ROMANTIC ERA

great sixteenth-century 'picture books' of objects 'drawn from life', such as the botanical compendia by Otto Brunfels and Leonardt Fuchs, Vesalius's great anantomical atlas, the *Fabrica*, and Gesner's three-volume encyclopaedia of animals (fig. 33). The naturalistic mode of illustration did not in itself guarantee trustworthy accuracy. Indeed, as will be emphasized in chapter 7, a master of the tricks of the new naturalism could render an imaginary animal as 'real' as a real one—or convey a compelling sense of the luxurious appearance of an ostrich's plumage at some remove from its actual feathers. A well-drawn unicorn would, if anything, have looked more plausible to most Renaissance observers than an equally well-drawn giraffe. Once the naturalistic credentials of an illustration of an imaginary beast were established, the same animal could live for many centuries through serial copying in successive compendia. And Dürer's armour-plated rhinoceros (fig. 34) somehow remained the very image of what a rhinoceros should be—in the face of any number of more soberly realistic descriptions. But the cumulative effects of the illustrated anatomies, flora, and faunas over the course of two-and-a-half centuries were to bring an ever-expanding range of Nature's wonders to the page and into the public domain in an increasingly perfected and trustworthy way. By Thornton's time, floras of the quality of Redouté's, and faunas of the standard of Buffon's compendious *Histoire naturelle*, were using the tools of naturalism for undeniably impressive ends.

Intellectually, the most significant developments to which Thornton could look in natural history involved an increasingly rich sense of

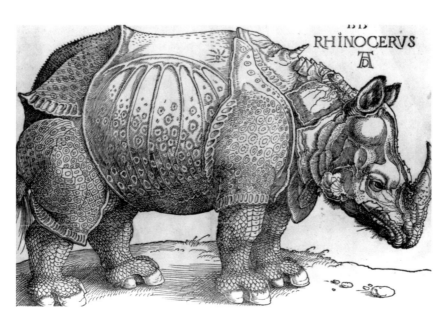

Fig. 34

Albrecht Dürer,
Rhinoceros, 1515

121

the dynamic interaction and interlocking relationships between the individual components in God's creation—not just now but also over the duration of the life of the earth. Indeed, the single unity of Creation which Palissy had taken as given—the 'Great Chain of Being' through which every type of thing now present had always existed—was itself being modified and more fundamentally questioned. It was beginning to seem possible that some of the exhibits in God's eternal *Wunderkammer* had gone on display at different points in its history, and even that some may have been taken off display for good.

Towards a Dynamic View

The figure who framed the eighteenth-century debates was the Comte de Buffon (Georges-Louis Leclerc), whose 36-volume *Histoire naturelle* deservedly achieved worldwide fame. Disposed to respect the huge variety of nature and to emphasize meticulous observation of natural forms and phenomena in all their richness, he was reluctant to embrace highly determined schemes of fixed classification. He sought natural causes behind the processes by which the world had been formed rather than falling back on metaphysical dictates. He was also centrally concerned to relate created nature to the nature of the human being at the hub of creation. In his *Époques de la Nature* he posited a seven-epoch development for the populated earth. During the first epoch, the hot earth was torn from the fiery sun and the moon from the earth, to be followed in the second by the solidifying of the mountains. The third saw a cooling process which resulted in the condensation of the waters and the formation of marine organisms. Next, vast volcanic activity, earthquakes, and erosion reformed the surface of the globe, and at the fifth stage the animals made their appearance. The continents were separated from each other in the sixth, and mankind came to rule during the final epoch. Built into his mature picture of the developing earth was the notion of extinction: for example, the enormous creatures known in the fossil record were unable to survive as the earth cooled. He also believed in the inheritance of acquired characteristics. All the creatures of the earth and the human race had progressively adapted over long periods of time to environmental changes. The first men, during an era of greater heat, were black, but gradually adapted to a range of climates and achieved a mastery over such natural processes as fire. In retrospect, it is difficult to summarize Buffon's complex views and prolific observations without using the word 'evolution'. But it

should be emphasized that he never countenanced the evolution of one species from another. The species, successively created, were the fundamental, God-given units of reproduction, characterized by permanence of hereditary type.

Buffon's magisterial writings ensured that no serious student of nature could avoid addressing issues of dynamic change that apparently contradicted the Biblical account of creation. A complementary sense of the products of nature in dynamic interaction, not least in fierce competition within shared environs, was becoming vividly apparent in the work of a number of artists in the eighteenth century. Animals and plants no longer appeared so secure in the compartments assigned to them in God's order of things. Not the least remarkable of the visions was developed by Maria Sibilla Merian of Frankfurt, an artist and entomologist who undertook an intrepid sea voyage of exploration to Surinam in 1699 accompanied only by her daughter. Maria Sibilla was the daughter of Matthias Merian the Elder, an engraver, illustrator, and publisher, and her stepfather was the still-life painter Jacob Marell. For good measure, she married a painter, Johann Andreas Graff. She would not only have been schooled in the Dutch tradition of descriptive naturalism but would also have been intimately acquainted with the *meaning* inherent in many still-life compositions. Such meaning involved both the symbolism of individual plants and the allegorical message of compositions as a whole, most typically the lesson of the transitory nature of things, conveyed through the traditional symbolism of the *memento mori*.

Both aspects of this background are apparent in Merian's compelling depictions of insects and plants in symbiotic interaction (fig. 35)—both the naturalism of the parts and the sense of narrative in the whole. Her 'ecological' manner of presentation, which she pioneered in *The Wondrous Transformation of Caterpillars and their Remarkable Diet of Flowers* in 1679 and 1683, culminated in her *Metamorphosis of the Insects of Surinam* in 1714. The eggs, larvae, chrysalises, and mature insects are portrayed living out the cycles of their existence in communion with the plant on which their 'worms' feed. While the *memento mori* compositions in her family orbit spoke of the processes of seeding, growth, blossom, and decay, her illustrations meticulously chronicled the cyclical metamorphosis of exotic species. The life of the adult, often manifesting dazzling glories of colour and form, was only a transitional stage in a continuing process of life, change, and death. Even though she does not specifically draw out the religious implications of the metamorphoses in her accompanying text, the brief story of each egg, caterpillar, chrysalis, and radiant butterfly or wondrous moth would

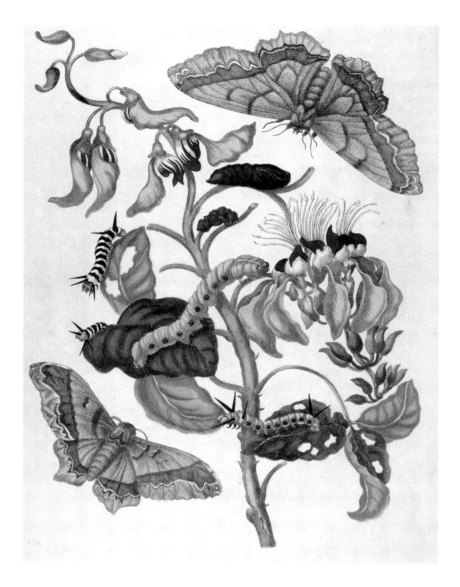

Fig. 35

Maria Sibylla Merian,
*Life Cycle of the Moth
Arsenura armida on a
Pallisade Tree*, from *De
Metamorphosibus
Insectorum
Surinamensium*, 1714

have been readily seen by her readers as pregnant with meaning, both
for human life and the endless cycles of nature writ large. Should we
wonder whether this 'vanitas' motif is relevant to natural history, we
need only record that the great microscopist and fellow entomologist,
Jan Swammerdam, entitled his treatise on the mayfly *A Figure of Man's
Miserable Life* (1675). Merian's own piety is not in doubt. As she had
written in the preface to her *Transformations*:

> I am moved to present God's miracles . . . Thus do not seek to praise and
> honour me for this work, but rather God, glorifying him as the creator of
> even the smallest and most insignificant of these worms.[3]

124

Again, the most meagre and disregarded of parts spoke of the majesty of the whole.

In ornithology, an 'ecological' vision of a comparable kind was developed most spectacularly in the next century by John James Audubon in his monumental *Birds of America*. Perhaps, like Merian, he found it easier to characterize the 'jungle' of nature while working in a wilderness which had neither been wholly tamed in itself nor subject to centuries of traditionally static representation. In any event, his birds, each displayed life size, are all involved in some activity, and rarely of a neutral kind (fig. 36). They seize fish and insects, they threaten weaker

THE ART OF
INTERACTION:
ROBERT
THORNTON
AND THE
ROMANTIC ERA

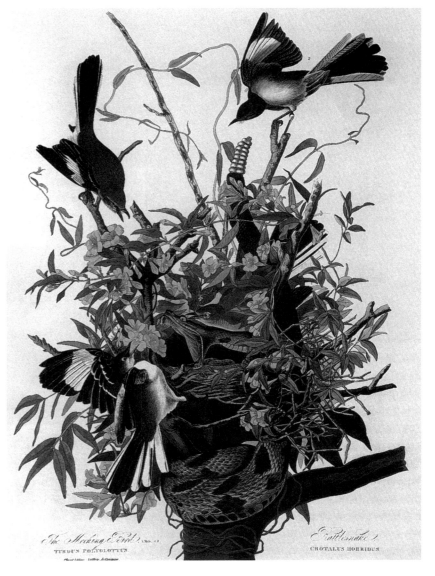

Fig. 36

John James Audubon, *Northern Mockingbirds threatened by Rattlesnake* from *Birds of America*, 1831

species, they posture sexually, they guard their young against aggressors, they fall victim to predators, and they are generally prepared to adopt strategies to look after their own interests in an uncompromising way. It is not a vision of peace and harmony. It rarely betrays any trace of the sweet sentimentality often devoted to 'our feathered friends', although an anthropomorphizing of the bird's lives in terms of human dramas is readily apparent. As a hunter, who shot birds to study them, Audobon was himself an active agent in the struggle for survival that involves the prey and the predator. The means through which he conveyed the dramas involved a kind of somatic physiognomy, in which the posture and motion of the bird, as conveyed by the rhythmic contours of its silhouette and its apparent facial expression, proclaimed the essence of the character which it had been given by God to ensure its due and unique place in the order of things. We will have more to say about the carefully attuned registers of naturalism in Audubon's prints in chapter 7. For the moment we are concerned with the total effect of the plates, separately and cumulatively, in terms of a vision of individual species as entities which cannot be characterized adequately in a static manner. They are no longer discrete units of creation, isolated from natural flux. We are dealing less with a cabinet of many separate drawers and more with the multitudinous ferment of a living society at war and at peace, in motion and at rest, tough and tender, threatening and threatened, vulnerably small and grandly majestic.

Closer to hand in Thornton's Britain, George Stubbs was not only providing masterly portrayals of rural civilization and equine sport, in which man and nature (above all the horse) had long since settled into the traditional order of an agrarian and sporting society, but was also striking out into more exotic territories in which such established comforts were not to be found. His portrayals of man's faithful partner being savaged by lions had a long ancestry, stretching back to classical antiquity through Giovanni Bologna's Renaissance bronzes, but his setting of the violent act against a harshly rocky escarpment indicates a different set of concerns and intuitions than those held by the makers of the isolated sculptural groups. The choice of Creswell Crags, on the Nottinghamshire–Derbyshire border, as the backdrop—not a natural habitat for lions in Stubbs's day—may go beyond his wish to underscore the rawness of the action. Its caves later proved to be rich in fossil remains of lions and leopards, and even in a pre-Darwinian world, could have provided Stubbs with eloquent witness to the ancient violence of the earth's formation and to the savage existence of untamed animals in ages past.

That Stubbs moved in circles in which geological time was of concern

is not in doubt. He had been commissioned by William Hunter, the Scottish doctor, collector, and man of wide curiosity, to portray a young moose which had been imported by the Duke of Richmond in 1770. The portrayal was not simply motivated by curiosity. It was intended to serve as a witness in the debate about the 'Irish Elk', a creature known through fossilized remains but evidently not living in Ireland in the modern era. If the 'Great Chain of Being' was to remain intact, it must still be somewhere on the earth, and the Canadian moose was the obvious candidate. However, a careful scrutiny of the moose beside the fossil remains—Stubbs has included antlers from a mature animal for comparison—revealed that it was not the 'Irish Elk'. The painting in turn served as a point of comparison for Hunter when he took it with him to set beside another moose imported by the Duke three years later. As Hunter said, 'good paintings give much clearer ideas than descriptions'—though Stubbs's moose actually retains more of the 'muscular horse' in its bodily characteristics than the real thing.[4] Having provided irrefutable visual evidence that the moose did not provide the necessary link in the 'Great Chain'—though unable to claim conclusively that the 'Elk' was not lurking undetected in some remote corner of the world—Hunter drafted an essay which proposed the likelihood of the 'Elk's extinction. Whether his potentially radical paper remained unpublished for reasons of scientific doubt or in deference to the accepted views of God's enduring creations is unclear.

Alongside growing intuitions of the fluctuating life of nature current in Thornton's day, new ideas were arising about the chemical and electrical sources which nourished and animated life itself. The researches of Joseph Priestly in England and Antoine-Laurent Lavoisier in France were revealing gaseous elements in the 'element' of air which played literally vital roles in life and the processes of combustion. Thornton repeatedly testifies to his enthusiasm for Lavoisier's ideas and for their experimental base, delighting in those fundamental powers in the physical world whose revelation seemed to be moving human understanding ever closer to the secret of life itself.

Throughout his botanical and medical writings, Thornton was always keen to cite 'irrefutable' experiments, particularly those showing how light, 'oxygen air', and electricity affect the germination of seeds and the growth of plants. As a vivid way to demonstrate the potency of what we now know as oxygen, he provides a brilliant illustration (fig. 37), by an unnamed printmaker, of a demonstration of combustion devised by Jan Ingehouz, in which a piece of paper attached to an iron spring is lit and thrust into a jar of 'vital air'. The metal spring burns with a 'dazzling light, resembling the most brilliant fireworks', precipitating

Fig. 37

Robert Thornton,
*Combustion of a Metal
Spring in 'Vital Air',*
from *Temple of Flora,*
1804

an 'oxyd of iron'.[5] He enthusiastically quotes Ingehouz's assertion that such powerfully combustive qualities show why we may justly consider that 'oxygen air is a pabulum of vegetable, as of animal life'. He also seized upon Humboldt's 1796 experimental demonstration that 'by an increased degree of heat ... *oxygenated water* ... remarkably accelerates the process of germination'.[6] By contrast, he notes that evacuation of air using an '*air pump* stops the growth of a seed'.[7] His representation of the sublimity of vitalistic powers in Ingehouz's experiment speaks the same visual language as Wright of Derby's depictions of nocturnal conflagrations, and his emphasis upon the death-dealing properties of a vacuum deals with the same issues as Wright's theatrical rendering of the effects of an air pump on an unfortunate bird. In one of his typically penumbral scenes, Wright shows members of a family reacting with varied emotions to the bearded 'magus's' demonstration of a white dove collapsing in a glass globe as the air is evacuated.

Just as the science of combustible gases was being redefined around 1800, so the natures of magnetism and electricity were being placed on a new and unified basis. The key moment came in 1800 with Alessandro Volta's invention of the 'pile' or battery, which lead, directly or indirectly, to an understanding of the way in which an electric current can decompose substances by electrolysis, generate heat and light, activate a magnetic needle, and, in the form of lightning, induce magnetic properties into metal needles. The goal was to draw together the phenomena of magnetism and electricity under the reach of a single theory. In our present context, it is significant that Volta's point of inspiration was Luigi Galvani's observation in 1781 that the leg muscle of a frog contracts when an arc of two metals is placed to form a bridge between the muscle and the crural nerve. Although Volta later recognized that the electricity resided in the arc rather than the frog, Galvani's claim to have discovered animal electricity as a vital force gained an enthusiastic following. The chemical potency of electricity as it was being progressively disclosed—and, as a flowing substance, it was thought to belong to chemistry more than physics—seemed the prime candidate to be identified as the mysterious ingredient which infused inanimate compounds with the vital powers of life. It was precisely in

THE ART OF
INTERACTION:
ROBERT
THORNTON
AND THE
ROMANTIC ERA

this spirit that Mary Shelley's Frankenstein constructed his apparatus to galvanize the spark of life into the inert body of his monster. In 1818, the year of the publication of *Frankenstein*, Andrew Ure, a Scottish chemist, sensationally used electricity to induce some signs of life in the corpse of an executed criminal. Thornton, for his part, keenly cites experiments which demonstrate the involvement of electricity in the most vital processes of plant life.

The immediate setting for Thornton's own interest in such vitalistic agencies is clear. It lies with the kind of science of animal excitability practised by Thomas Beddoes in his Pneumatic Institute Bristol and which provided the foundations for Humphry Davy's fervent early work. Davy, attracted by Beddoes's advocacy of the inhalation of gases to treat diseases, experimented in Bristol with 'factitious airs', not least 'laughing gas' (nitrous oxide), which seemed to unlock the highest states of excitable perception. Its beguiling and addictive effects were expressed in Davy's poetic effusions no less than in his scientific essays:

> Not in the ideal dreams of wild desire
> Have I beheld a rapture-wakening form;
>
> Yet are my eyes with sparkling lustre fill'd;
> Yet is my mouth replete with murmuring sound;
> Yet are my limbs with inward transport fill'd,
> And clad with new-born mightiness around.[8]

The spirit of such science was also epitomized by the Lunar Society at Birmingham, in which Wright and Priestly participated and embraced all those investigations which could lay claim to reveal the essential nature of the inner forces of the life of the earth and its inhabitants. One of the newest of these sciences was the burgeoning study of volcanoes. It is natural that Thornton should discuss at length the pioneering observations and theories of Sir William Hamilton in Naples, for whom Pietro Fabris had provided vivid illustrations of the sublime power of these ultimate manifestations of the fiery life of the body of the earth. Thornton concludes, in a way that has much in common with Palissy, that 'there is a continual fermentation going on in the bowels of the earth, liberating fire from its various component parts obeying the laws of attraction and that same law which keeps all the plants, and the whole host of heaven in their respective places'.[9]

At first sight there seems to be a strange contrast between these fiery enthusiasms and the subject that provided the great foundation for his botanical enterprises, the new system of classification established by

Carl Linnaeus. Continuing a long-established search for a system that would be less subjective than variable groupings of perceived resemblances between what seemed to be key structures in various organisms, Linnaeus's posthumously-published *Praelectiones in Ordines Naturales Plantarum* (1792) consolidated his earlier attempts to lay out a network of logical maps through which the taxonomy of plants could be placed on an objective basis. He set out five levels of progressive discrimination: class, order, genus, species, and variety. Relying upon sexual criteria as signalled by the stamens and pistils in flowering plants as the key characteristic, he privileged the genus as the fundamental unit of taxonomic enquiry. His binomial system of nomenclature, denoting genus and species, first gained attention through his *Philosophica botanica* (1751) and set a worldwide standard, familiar to any gardener today who orders a packet of seeds or looks up plants in an encyclopaedia. Linnaeus's aim was logical simplicity and observational accessibility, such that anyone could readily undertake a series of key observations of the sexual organs of plants which they could key into the system. The system itself was to be made accessible in plain and portable handbooks without expensive illustrations.

On the face of it, Linnaeus's system appears to be an archetypal product of Enlightenment rationality, yet behind the logical mapping and tabular ordering lay a complex mesh of earthly passions and spiritual impulses. The system itself, and the collections with which Linnaeus surrounded himself, carry indelible marks of the old microcosmic *Wunderkammer*. 'The earth', as he wrote in 1754 in his preface to his book on the King of Sweden's collections of marvels, 'is . . . nothing but a museum of the all-wise Creator's masterpieces, divided into three chambers'.[10] Yet in other respects he was deeply immersed in the modern romanticism of exotic explorations and the search for a prelapsarian Paradise that could embrace all the varied environments of the globe and the 'natural' wisdom of 'wild nations'. His own particular identification with the idyllic past and primitive present—to the extent of being portrayed in 'Lap' costume, as illustrated by a print in Thornton's *Temple*—was with the Sami people of the Arctic regions of Sweden, whom, despite plentiful signs to the contrary, he regarded as 'noble savages' stranded in a natural state in a direct line of descent from the Garden of Eden. Drawing upon the age-old theology in the book of nature and guided by the enlightenment of systematic scientific understanding in his modern manner, his preached message was that the 'world soul' of God's beneficent Creation could only attain its ultimate fulfilment in a form of universal but not individual and personalized salvation.

Thornton was an unwavering advocate of the scientific rigour of the Linnaean system, in his own 'reformed' version, if not of Linnaean theology. The mathematical, logical character of the taxonomy—expressed in his tables and diagrams—provides a 'noble exercise' in itself, particularly in the training of young minds that are all too easily seduced by pastimes which 'inflame the passions'.[11] By stressing the dispassionately mathematical character of classification, he is consciously confronting the accusation that the sexual basis of Linnaeus's method was an obscene perversion of the innocence of plants and besmirched botany as a study unfit for young ladies.

THE ART OF
INTERACTION:
ROBERT
THORNTON
AND THE
ROMANTIC ERA

Linnaeus had himself spoken of his sexual system in anthropomorphic terms: stamen or *andria* from *aner*, the Greek for husband; and pistil or *gynia* from *gyne*, wife. The marital relationships of plants extended from 'public' to 'clandestine', and involved much tender coupling:

> The flower's leaves ... serve as bridal beds which the creator has so gloriously arranged, adorned with such noble bed curtains, and perfumed with so many soft scents that the bridegroom with his bride might there celebrate their nuptials with so much greater solemnity. When now the bed is so prepared, it is time for the bridegroom to embrace his beloved bride and offer her his gifts.[12]

From the first, there had been a certain unease about such single-minded attention to the 'naughty bits' of plants, but as his ideas seeped into general currency so the reactions became more extreme. The French medical reformer and radical materialist, Julien Offray de la Mettrie, dedicated his 'pornographic' *L'homme plante* to Linnaeus. Author of the notorious *L'homme machine*, published in 1748, La Mettrie argued that all aspects of humans, animals, and plants, including the human mind, might best be understood in terms of natural mechanisms. Although plants were devoid of a central nervous system, which had progressively achieved its supreme evolutionary expression in the brain of man, important aspects of their vital and, above all, their sexual functions were shared with the human organism.

More sober, establishment forces began to express alarm. The *Encyclopaedia Britannica*, published from the Calvinist redoubts of Edinburgh in 1768, railed against the 'disgusting strokes of obscenity' with which Linnaeus had disfigured the picture of nature's innocent beauties.[13] Jean-Jacques Rousseau, an enthusiastic advocate of the new system, nevertheless felt it prudent to warn Madame Delessert in his botanical letters that her young daughter should only be inducted into the secrets of stamens, pistils, and such-like 'by degrees, no more

than is suitable to her age and sex'.[14] Botany and gardening, long the genteel pursuit for young ladies of leisure, were no longer safe for virginal eyes.

It did not take too much in the way of observation to notice that plants were hardly paragons of monogamy and did little to exemplify the marital fidelities advocated by Linnaeus. The potential that Linnaeus had unwittingly released was richly realized in Erasmus Darwin's scientific poem, *The Loves of Plants*, published in 1789 as part II of his *Botanic Garden*. Writing as a radical critic of established religion and committed advocate of many of the values of liberty, equality, and fraternity which fired the French Revolution, Darwin rapturously embraced the vibrant sciences and technologies of the new age, including the explosive study of volcanoes, the combustive experiments on gasses, the shocks of electricity, and the thrusting power of the steam engine. Each section of florid verse is accompanied by a sober and often extensive footnote on its scientific and technological foundations—as if Darwin is not only aspiring to be the new Dante but is also composing the later philosophical commentary on his own poetic text. He was, as he said, aspiring 'to enlist Imagination under the banner of Science'. When he turned his attention to plants, he wrote with relish of the reign of free love and multiple coupling in the plant kingdom. Those plants in which the male stamens decisively outnumbered the female pistils provided a particular stimulus to his 'Imagination':

> Proud GLORIOSA led by *three* chosen swains,
> The blushing captives of her virgin chains.—
> —When time's rude hand a bark of wrinkles spread
> Round her limbs, and silver'd o'er her head,
> *Three* other youths her riper years engage,
> The flatter'd victims of her wily age[15]

Characteristically, this poetic effusion of botanical 'cradle-snatching' is accompanied by a sober annotation:

> *Gloriosa*. 1.119. Superba. Six males one female. The petals of this beautiful flower with three of the stamens, which are first mature, hang down in apparent disorder, and the pistil bends at nearly a right angle to insert its stigma amongst them. In a few days, as these decline, the three others approach.

Thornton's affinities with Darwin appear to be clearly signalled by the image of *Cupid Inspiring the Plants with Love* (fig. 38), one of the opening illustrations in the *Temple*, drawn by Philip Reinagle and accompanied by Charlotte Lennox's verse, which also appears with its two additional

THE ART OF
INTERACTION:
ROBERT
THORNTON
AND THE
ROMANTIC ERA

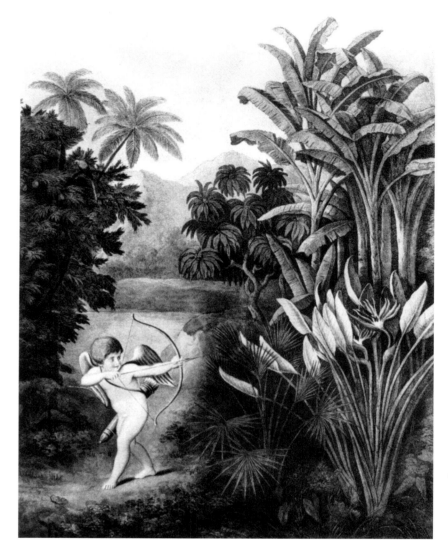

Fig. 38

Robert Thornton,
*Cupid Inspiring the
Plants with Love*, from
Temple of Flora, 1804

opening lines and an adjacent print of the bust of Linnaeus being
crowned by Aesculapius, Flora, Ceres, and Cupid:

> All animated nature owns my sway,
> Earth, sea and air, my potent laws obey.
> And thou, divine LINNAEUS! trac'd my Reign,
> O'er trees and Plants in Flora's beauteous train,
> Proved then obedient to my soft Controul
> And gaily breathe an aromatic soul.

However, the religious, social, and political purposes of Thornton were
diametrically opposed to those of Darwin. Indeed, throughout his life
Thornton maintained his pious belief in the tenets of the established

133

church, the need for sexual propriety, and a total commitment to the British monarchical constitution as a kind of 'act of nature'—not least in the face of what he saw as the 'horrors' of the French Revolution.

The factors at which we have been looking—the roles of observation and experiment, the dynamism and sexuality of nature as articulated in relation to man, and the vitalizing forces being disclosed by the new chemistry—all serve to set the stage for Thornton's life work.

The Temple of Flora

Although Thornton did not follow a career in the Church, as originally intended—studying medicine at Cambridge—all his endeavours were underpinned by deeply-held religious convictions. While at Cambridge, the central focus of his attention was permanently readjusted by the botanical lectures of Thomas Martyn, who was a persuasive advocate of Linnaeus's sexual system. He also attended lectures at Guy's Hospital medical school, where he was later to become lecturer on medical botany. His Cambridge thesis was on the subject of 'oxygen air imbibed by the blood', and already signals the interests in life forces that were to characterize much of his subsequent writings. By the time he set up as a physician in London in 1797, using the pneumatic techniques advocated by Beddoes, he had already begun the publication of his *The Politician's Creed* and *The Philosophy of Medicine, being Medical Extracts*, and was working on his grandiose project for the *New Illustration of the Sexual System of Linnaeus*, of which the *Temple of Flora* was part. The *New Illustration* was first advertised in 1797 and began to appear in parts from 1799, published at one guinea (later twenty-five shillings). The complete text with illustrations was advertised as available in 1799 at the handsome price of twenty guineas. The history of the publication of the *New Illustration* is horribly complicated, with the three main parts being issued at a variety of times and in different formats in increasingly desperate efforts to recoup the huge costs of the production of illustrations, which were intended to outstrip anything then available. As a promotional exercise, he exhibited the originals of his plates in 1804 at 49 New Bond Street, and in 1811 an act of parliament authorized his 'Royal Botanical Lottery', for which he issued twenty thousand tickets at two guineas each. The top prize was the set of original paintings, with other prizes of his printed illustrations and texts. Sadly, in spite of these and other efforts to market great publication, his finances never recovered and his personal fortune was largely dissipated.

Thornton's reputation now rests almost exclusively on the third part of the *New Illustration*, originally entitled 'Picturesque Plates . . .' and retitled in 1804 as 'The Temple of Flora . . .'. The paintings for the twenty-eight plates of plants were commissioned from leading artists such as Philip Reinagle and Peter Henderson, and the specialist botanical illustrator, Sydenham Teak Edwards, together with allegorical images and portraits produced by John Opie, Maria Cosway, and John Russell. Technically, the plates exploited state-of-the-art engraving, using the services of top printmakers, with high-quality hand-colouring. Stylistically, they provide picturesque and even sublime evocations of the characters of plants in vivid landscape settings, in a way that is unequalled in botanical illustration. But the *Temple* has been criticized as being of 'little botanical value' in the standard history of botanical illustration.[16] The best response to this accusation is to ask what we mean by 'botanical value'. The highly romantic portrayal of the *Night-Blowing Cereus*, for instance, has been derided for showing the Jamaican plant against an archetypally English moonlit scene by Abraham Pether, who specialized in such things. The radiant flower stands out vividly against the darkly mysterious, alien landscape. But to regard the innovatory settings as literally 'ecological' is both anachronistic and misses the point of what Thornton was doing. It is also to misjudge the special role of the plates of flowering plants in the 'Temple' in the broader contexts of his publications. The portrayal of a plant in an evocative landscape is just one of the illustrative modes in the *New Illustration* and his other voluminous writings on botanical science. He provided, for example, splendid illustrations of microscopic sections in the tradition of Nehemiah Grew, and we have already seen his neat technical illustration of stamens according to the Linnaean taxonomic system. The various illustrative techniques exploited in his publications were designed to embrace a wide range of approaches and reflect manifold routes towards botanical understanding—from rigorous classification and controlled experiment to the discerning of political connotations and spiritual significances of the most far-reaching kind. Tabular presentation of scientific data and poetic effusions each have their own specified roles to play.

To illustrate the visual range and complex meanings in his texts and illustrations, I will take as a telling example the plate devoted to *Strelitzia*, the 'Queen Plant' (now called the Bird of Paradise Plant) in the *Temple* (fig. 39). It is very different in its presentation from a standard illustration of the kind superbly provided by Redouté, which we have already illustrated. But, in saying this, we should recognize that

THE ART OF
INTERACTION:
ROBERT
THORNTON
AND THE
ROMANTIC ERA

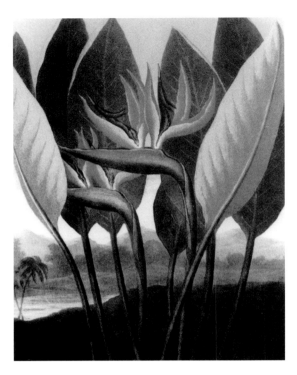

Thornton was able to avail himself of the more standard modes when they were needed, as in the 'Anatomy' and 'Dissection' of Strelitzia in his *Botanical Extracts . . .*, where the parts of the flowers are systematically shown in sober illustrations. Rather than showing the outer and inner structures of the flower, the plate in the *Temple* is primarily concerned to render the essential character of the plant—its 'temperament' as read from its 'physiognomy', 'complexion', and 'customs', to adapt terms from the medical theory of the four humours. Reading a plant's personality might seem to be too subjective and romantic to be of 'botanical value', but for Thornton, as for generations of botanists, our personal understanding of the meaning of a plant within the book of nature underwrote the ultimate value of botanical science. We have already noted his view that 'every flower, however mean in the vulgar eye, is a sermon for the learned'. Indeed, every blossom was a microcosm of meanings, not least the Strelitzia.

The Strelitzia is not, of course, a 'mean' flower, or even a common or garden specimen, but a magnificent, imported blossom of wondrous form. The most notable aspect of its physiognomy for Thornton was that it assumed the guise of a bird: 'Nature here seems to aim at deception', since the inflorescence assumes the 'similitude of the head of some species of crane'.[17] Like Erasmus Darwin, he was particularly pleased to discern any features of plants that exhibit animate qualities, such as the mobile leaves of the *Sensitive Plant*, which seem to twitch with sensuous pleasure at the probing beaks of humming birds. The illustration of Strelitzia plays to the bursting vitality of the flower in contrast to the more sober delineation of its corpse in the 'dissection' and 'anatomy'. It was the revered 'Queen Flower', and was specifically the target of Love's arrow in the print of *Cupid Inspiring the Plants with Love*. Cupid's choice of Strelitzia, named in honour of Queen Charlotte, was deliberate and meaningful. The Queen, to whom the book was dedicated, was described by Thornton as a 'Bright Example of Conjugal Fidelity and Maternal Tenderness'.[18] Thornton's version of love was certainly not the free love of Erasmus Darwin and other libertarian reformers, but rather resided within the divine bond of wedlock

cherished by Linnaeus and lauded by Thornton as the harbinger of peace and harmony throughout the world.

THE ART OF
INTERACTION:
ROBERT
THORNTON
AND THE
ROMANTIC ERA

George III's Queen plays a pivotal role in the most fervent of his pleas for universal love, in a series of texts which accompany the *Group of Roses*, the only plate for which Thornton himself supplied the painting. A sequence of poems on love and spring, and 'Stanzas against War' by Henry James Pye, the poet laureate, are followed by the text of a remarkable letter from Charlotte to the King of Prussia. Written in her teens, when she was 'Princess of Mechlenberg-Strelitz', she issues a notable clarion call for peace, prefaced by a powerful apology for stepping outside her proscribed role as young woman of noble lineage. She is writing to 'congratulate' or 'condole' the Prussian monarch on his recent victory:

> ... I know Sire, that it seems unbecoming of my Sex, in this age of vicious refinement, to feel for one's country, to lament the *horrors* of war, even to wish for the return of *peace*. I know you may think it more properly my province to study the arts of pleasing, or to inspect subjects of a more domestic nature. But however unbecoming it may be in *me*, I cannot resist the desire of interceding for this *unhappy people*.
>
> It was but a few years ago, that this territory [Mechlenberg] wore the most pleasing appearance; the country was cultivated, the peasant looked cheerful. . . .
>
> The whole country (my dear country!) lies one frightful waste, presenting only objects to incite terror, pity and despair. The businesses of the husbundman and shepherd are quite discontinued. The husbundman and shepherd are become soldiers themselves and help to ravage the soil they formerly cultivated . . .
>
> It is impossible to express the confusion which even those who call themselves our friends create.[19]

Her powerful account of the social horrors is followed by a fervent prayer to her relative to use his 'power' in 'repressing the greatest injustice'.

The letter is followed successively by a poetic rendering, apparently by Thornton himself, an 'Address to Venus and Cupid' (denouncing war-like Mars), and a poem 'On the Happy Return of Peace'. The letter is the centrepiece of the sequence, which itself expounds to the key theme in Thornton's writings, namely the need for universal collaboration between nations in the context of free spiritual, intellectual, and commercial exchange between the peoples and regions of the world. This exchange involves both trade between countries that produce

different commodities—again adapting a Linnaean notion—and the importation of plants that can be naturalized in different climates. In the texts on Strelitzia, a poem by Pye gives extravagant praise to the great botanist-explorer, Sir Joseph Banks:

> *Crown of his* [Banks] *labours!* the *imperial flower,*
> Wafted from burning Afric's rugged scene,
> 'Neath Britain's better skies, in happier hour,
> Enjoying the patronage of Britain's QUEEN![20]

Embedded in the illustrations and texts of Strelitzia are interlocked themes of love, feminine virtue, masculine endeavour, world commerce, imperial glory, and the inherently superior condition of Britain, always under the supreme aegis of God's divine purpose.

However, plants do not only testify to the beautiful and the lovely in their sexual natures. In contrast to the regal Strelitzia, the *Dragon Arum* (fig. 40) assumes a sinister and sexually threatening air:

> She comes peeping with her purple crest with mischief fraught; from her green covert projects a horrid spear of darkest jet, which she brandishes aloft: issuing from her nostrils flies a noisome vapour infecting the ambient air: her hundred arms are interspersed with white in the garments of the inquisition; and on her own swollen trunk are observed speckled of a mighty dragon: her sex is strangely intermingled with the opposite! confusion dire! all framed for horror.[21]

Fig. 40

Robert Thornton,
Dragon Arum, from
Temple of Flora, 1804

All this horrid display, Thornton concludes rather lamely, is a warning by divine 'PROVIDENCE' that 'her *fruits* are *poison berries*'.[22]

Just as some plants convey disturbing sexual messages, so some can bear political tidings. Amongst the *Group of Tulips* (fig. 41), the most prominent is that 'named after that unfortunate French monarch, LOUIS XVI, then in the meridian of his glory; it rises above the rest, with princely majesty, the *edges* of whose petals are stained with *black*, which is the emblem of sorrow'.[23] In all its glory, the kingly tulip unwittingly foreshadows what he described elsewhere as 'the spirit of REVOLUTION which stretched its dark and blood-stained poisons over a neighbouring nation . . . which madness menaced our own shores'.[24] What was happening in

France was of huge concern, for reformers and conservatives alike. Thornton blamed the commercial failure of the *New Illustration* on the economic uncertainties precipitated by the French Revolution. In the section on 'Wine' in *A New Family Herbal*, he typically includes a homily in favour of the kind of free trade which he believes will remove friction with the French:

> providence has with consummate wisdom diversified climates, and hence productions, to create a spirit of intercourse, barter or trade; and that when any government, through a narrow, contracted, sneaking jealousy, prohibits by duties the purchase of such a necessary as wine, of a neighbour, that this is a sin against the omnipotent Creator ... Peace and good will should prevail throughout the world, and we shall ever find, that if our neighbours the French be rich, they would be less inclined to do us injury and go to war.[25]

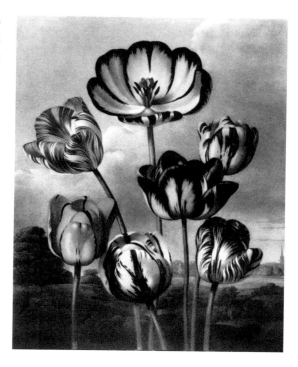

Fig. 41

Robert Thornton, *Group of Tulips*, from *Temple of Flora*, 1804

The aim is to 'make a *garden*, not a *wilderness* of this world', just as the future Queen Charlotte had advocated. The worldwide garden did not just provide for our physical well-being through the 'blessings of commerce', but was more profoundly in keeping with the absolute principles of God's divine providence.

Throughout nature, the percipient observer could discern the universally relevant 'sermons' preached by each blossom. Alongside such obvious and traditional symbols as the cruciform Passion Flower, some aspects of plants exhibit more generic meanings. His *Botanical Extracts* contains a chapter specifically on 'The Seed as an Emblem of the Resurrection', illustrated by reference to a large acorn, from which, by implication, will sprout the mighty English oak towering above it in the plate.[26] Characteristically, this chapter is followed by a systematic and tabulated analysis of the 'Different Forms of Seeds', which even Thornton's critics would recognized as properly 'botanical'. For Thornton, there was a complete continuity between observational rigour, systematic analysis, and religious meaning. The new understanding of nature, Thornton leaves us in no doubt, is the result of those supreme geniuses, like Linnaeus, who are vouchsafed the privilege of revealing the true secrets of God's divine book of nature. Poetic passion, spiritual fervour, natural morality, systematic

observation, persistent experiment, and didactic publication are integral parts of his vision of the mission of science, expressed individually and collectively through men of genius.

Thornton himself has at best a modest claim to stand in the heroic succession of those geniuses of science whom he characterized as making key and enduring discoveries about nature. In this respect, he is comparable to Palissy, and, like the idiosyncratic French potter, he is also well equipped to serve his exemplary status in our present quest. Thornton can be seen in the context of our microcosmic concerns to embody within himself at an intense if individualist level the intellectual and visual motivations that drove what can be called 'Romantic Science'—or perhaps can more safely be described as science imbued with many of the characteristics that we collectively term 'Romanticism'. In Britain we have already noted precocious aspects of this vision in Stubbs's paintings, and glimpsed its character through Darwin, Beddoes, and Davy. In some ways, the limits to which Thornton pushed his vision shares as much with German art and science (much admired by Beddoes) as with his British contemporaries. I am thinking in particular of Goethe, Runge, and Humboldt. And I am thinking of the kinds of sentiment typical of German *Naturphilosophie*, as expressed characteristically by Friedrich Schelling in 1799 in his *Proteus of Nature*. He is speaking of the 'gigantic spirit' trapped within nature:

> The force by which metals sprout,
> Trees in the spring shoot up,
> It seeks all in nooks and crannies
> To twist and turn itself out into the light.
>
> The first flower, the first bud swells,
> To the first ray of the newborn light
> Which breaks through the night like a second Creation,
> And from a thousand eyes of the world
> Illuminates the heavens like day the night.
> it is One force, One interplay and weaving,
> One drive and impulsion to ever higher life.[27]

Schelling's verses would not have been at all out of place in Thornton's anthology of poetic texts on, say, the *Night-Blowing Cereus*.

There is little difficulty in knowing where to look within German art for an expression of comparable rapture at the transcendent spirit of nature, of which we are all potentially an ecstatic part. Runge's *Morning*, a large painting dismembered according to his instructions after his death, and now best appreciated in a smaller version executed

around 1808 (fig. 42), speaks exactly this language, as do his own writings:

THE ART OF
INTERACTION:
ROBERT
THORNTON
AND THE
ROMANTIC ERA

> When the mist courses in the valley and I throw myself down in the grass among the glittering drops of dew, every leaf and every blade of grass teeming with life, the earth living and stirring beneath me, and when everything is tuned to one chord, then my soul cries out aloud with joy and flies into the immeasurable space around me.[28]

The genii of the life-enhancing rays are trumpeted forth by blossoms of amaryllis and virginal lilies in the radiant concert of visual music which heralds the new dawn. The forms of geometrical organization which Runge discerned in such flowers will concern us in the next chapter,

Fig. 42

Runge's *Morning*, c.1808, Hamburg, Kunsthalle

as will the related ideas in Goethe's *Metamorphosis of Plants*, which beautifully exemplifies the mental style of such *Naturphilosophie*. For Goethe and Runge, each leaf, each flower, each tree, each valley, each mountain, the unified earth itself, each star, and the totality of the observable universe speaks of the divine whole through the minutely observed and precisely characterized parts. As Alexander von Humboldt, a great student of parts and whole, wrote to a friend:

> With the simplest statements of scientific facts there must ever mingle a certain eloquence. Nature herself is sublimely eloquent. The stars as they sparkle in the firmament fill us with delight and ecstasy, and yet they all move in orbits marked out with mathematical precision.[29]

In Britain, the poet William Blake, expressed the essential aspiration with a succinct power that was quite beyond Thornton's literary gifts. He provides a fitting note on which to end these chapters of macro- and microcosmic themes.

> To see the World in a grain of sand,
> And heaven in a wild flower,
> Hold infinity in the palm of your hand,
> And eternity in an hour.[30]

NOTES

1. Thornton as quoted in Martin Kemp, 'The "Temple of Flora"', Robert Thornton, 'Plant Sexuality and Romantic Scene' in Giuseppe Olmi, Lucia Tongiorgi Tomasi, and Attilio Zanca, *Natura-Cultura: L'Interpretazione del Mondo Fisico nei Testi e nelle Immagini. Atti del Convegno Internazionale di Studi, Mantova, 5–8 ottobre 1996*, (Firenze: Leo S. Olschki Editore, 2000), p. 19
2. Galileo Galilei, *Two new Sciences*, ed. Stillman Drake, (Madison: Winsconsin University Press, 1974), pp. 169–70
3. Maria Sybilla Merian, *The Wondrous Transformation of Caterpillars and their Remarkable Diet of Flowers*, 1679
4. Hunter in *George Stubbs 1724–1806*, Exhibition Catalogue, (London: Tate Gallery, 1984) p. 118
5. Thornton in Martin Kemp, 'The "Temple of Flora"', *Natura-Cultura*, p. 24
6. Thornton in Martin Kemp, 'The "Temple of Flora"', *Natura-Cultura*, p. 25
7. Thornton in Martin Kemp, 'The "Temple of Flora"', *Natura-Cultura*, p. 25
8. As quoted in Christopher Lawrence, 'The power and the glory: Humphry Davy and Romanticism' in Andrew Cunningham and Nicholas Jardine eds, *Romanticism and the Sciences*, (Cambridge: Cambridge University Press, 1990), p. 219
9. Thornton in Martin Kemp, 'The "Temple of Flora"', *Natura-Cultura*, p. 27
10. Quoted by Lisbet Koerner, 'Linnaeus in his Time and Place', *Cultures of Natural Science* (Cambridge: Cambridge University Press), p. 153; see also her *Linnaeus: Nature and Nation* (Cambridge, Mass: Harvard University Press, 1999)

THE ART OF
INTERACTION:
ROBERT
THORNTON
AND THE
ROMANTIC ERA

11. Thornton in Martin Kemp, 'The "Temple of Flora"', *Natura-Cultura*, p. 24

12. Quoted by Londa Schiebinger, 'Gender and Natural History', *Cultures of Natural History*, p. 167

13. Martin Kemp, 'Implanted in our Natures: Humans, plants and the stories of art', in David Philip Miller and Peter Hanns Reill eds, *Visions of empire: Voyages, Botany and Representations of Nature*, (Cambridge: Cambridge University Press, 1996), pp. 197–229

14. Jean-Jacques Rousseau, *Letters on the Elements of Botany: Addressed to a Lady*, Thomas Martyn trs, (London: B. White and Son, 1785), Letter 1, p. 28

15. Erasmus Darwin, *The Botanic Garden, a poem in two parts*, (London: J. Johnson, 1791), p. 13

16. Blunt and Stearne in Martin Kemp, 'The "Temple of Flora"', *Natura-Cultura*, p. 17

17. Martin Kemp, 'The "Temple of Flora"', *Natura-Cultura*, p. 19

18. Martin Kemp, 'The "Temple of Flora"', *Natura-Cultura*, p. 19

19. Martin Kemp, 'The "Temple of Flora"', *Natura-Cultura*, p. 19

20. Martin Kemp, 'The "Temple of Flora"', *Natura-Cultura*, p. 22

21. Martin Kemp, 'The "Temple of Flora"', *Natura-Cultura*, p. 22

22. Martin Kemp, 'The "Temple of Flora"', *Natura-Cultura*, p. 22

23. Martin Kemp, 'The "Temple of Flora"', *Natura-Cultura*, p. 22

24. Martin Kemp, 'The "Temple of Flora"', *Natura-Cultura*, p. 22

25. Martin Kemp, 'The "Temple of Flora"', *Natura-Cultura*, p. 23

26. Martin Kemp, 'The "Temple of Flora"', *Natura-Cultura*, p. 24

27. Schelling as quoted in S. R. Morgan, 'Schelling and the Origin of his Naturphilosophie' in Andrew Cunningham and Nicholas Jardine, *Romanticism and the Sciences*, pp. 34–5

28. Runge as quoted in Martin Kemp, *The Science of Art: Optical themes in Western Art from Brunelleschi to Seurat*, (New Haven and London: Yale University Press, 1990), p. 296

29. Humboldt as quoted in Malcolm Nicolson, 'Alexander von Humboldt and the geography of vegetation', in Andrew Cunningham and Nicholas Jardine, *Romanticism and the Sciences*, (Cambridge: Cambridge University Press), p. 179

30. William Blake, *Auguries of Innocence* first published in *Poems*, ed. Dante Gabriel Rossetti (1863)

5 | WHOLES AND PARTS

O n the face of it, the kind of metaphysical and spiritual rapture which persisted in the Romantic version of the microcosms and macrocosms could hardly stand in more contrast to the tenor of modern science, and more specifically of the modern biological theories of inheritance devised by Gregor Mendel and evolution formulated by Charles Darwin. However, the problem with such a judgement is that it very much relies on 'the face of it'—that is to say the public face which scientists have progressively set up as our way of recognizing them and their enterprise. The character of this face has also been crucially defined by the way that those at the orthodox centres of the arts have established their own image as beings belonging to a virtually different race of humanity. If we look behind the faces, we will actually see that they are more in the nature of masks than wholly dependable registers of what is happening within. No scientist was more assiduous in defining the character of the face of modern science than Darwin.

The Darwinian Paradigm—from Romanticism to 'Natural Selection'

We have seen the way that the Romantic vision of science centred upon a dynamic nature full of rampant competition and interaction. If we set Darwin's theory of evolution in this context, I believe that it can be characterized as a natural successor to the concepts being explored by Stubbs, the Hunters, Erasmus Darwin, and all those who were more generally seeking the central life forces of an animate nature in

continual flux, in both the short and long terms. In this sense, Darwin may be regarded as a late product of Romantic Science. We can even trace his spiritual ancestry beck to Leonardo and Palissy. This characterization hardly sits easily with the view of Darwin as the inventor of the modern world-view of nature according to the objective and impersonal tenets of evolutionary science.

I am not suggesting that Darwin's theories were not radical or substantially new. Previous moves to weaken the links in the 'Great Chain of Being', or even to posit that it had a temporal dimension, stopped far short of the picture he was to paint of 'Natural Selection'. This is not the place to review the antecedents of Darwinian evolution—something he conspicuously failed to do in *On the Origin of Species*—such as the theories of Jean-Baptiste Lamarck and his own grandfather, or the earlier speculations of La Mettrie, Buffon (upon whom we have earlier touched), and Linnaeus. Rather, I am suggesting that a significant element in the mental climate which Darwin's idea inhabits was the kind of Romantic Science which we have been selectively sampling— that 'Natural Selection' itself represents the emergence of the 'fittest' theory into a very specific environment already inhabited by less developed but cognate ideas.

Darwin himself was more than happy to acknowledge his direct lineage from Erasmus. When, in honour of Charles's seventieth birthday in 1879, Ernst Kraus's published a German biographical review of Erasmus under the title of 'Contribution to the History of the Descent-Theory', the father of evolution responded warmly, facilitating its translation into English and writing an accompanying 'Life of Erasmus Darwin', which contains family reminiscences, a rich anthology of correspondence, and assessments from various quarters.[1] Erasmus became by implication one of the great-grandfathers of evolutionary theory, not primarily through his ability to accumulate empirical evidence but using his high gifts of imaginative insight. As Charles wrote:

> the vividness of his imagination seems to have been one of his pre-eminent characteristics. This lead to his great originality of thought, his prophetic spirit in both science and in the mechanical arts, to his overpowering tendency to theorise and generalise.[2]

However, not wishing to surrender his forebear entirely to the nebulous realm of poetic speculators, he adds,

> Nevertheless, his remarks ... on the value of experiments and the use of hypothesis show that he had the true spirit of the philosopher. That he possessed uncommon powers of observation must be admitted. The

diversity of subjects to which he attended is surprising. But of all his characteristics, the incessant activity or energy of his mind was, perhaps, most remarkable.

Charles picked no quarrel with Kraus's assessments that Erasmus, as the predecessor of Lamarck, 'was the first who proposed and consistently carried out, a well-rounded theory with regard to the development of the living world', and that 'almost every single work of the younger Darwin may be paralleled by at least a chapter in the work of his ancestor'.[3]

Charles Darwin also shared significant concerns with Thornton, not least in the animate species of sensitive and insectivorous plants. He researched his paper on 'The Power of Movement in Plants' with such enthusiasm that his wife, Emma, reported to Lady Lyell, wife of the innovatory geologist, that 'At present he is treating Drosera just like a living creature, and I suppose hopes to end in proving it to be an animal'.[4] In fact he stopped well short of such a proof, but did surmise that 'we perhaps see the prefiguration of the formation of nerves in animals in the transmission of the motor impulse being so much more rapid down the confined space within the tentacles of Drosera than elsewhere'.[5] This represented a kind of convergence, in as much as analogous forms in very different species have arisen to fulfil comparable functions. Perhaps the most striking passage concerns the kind of responsiveness which had so entranced Thornton:

> it is impossible not to be struck with the resemblance between the. . . . movement of plants and many of the actions performed unconsciously by the lower animals . . . We believe that there is no structure in plants more wonderful, as far as its functions are concerned, than the tip of the radicle. If the tip be lightly pressed or burnt or cut, it transmits an influence to the upper adjoining part, causing it to bend away from the affected side. . . . It is hardly an exaggeration to say that the tip of the radicle, . . . having the power of directing the movement of the adjoining parts, acts like the brain of one of the lower animals.[6]

Unsurprisingly, and in keeping with these Thorntonian interests, the importance of sexual reproduction in plants and the role of insects became a prominent concern for Darwin. In his essay on the 'Effects on Cross and Self-Fertilisation in the Vegetable Kingdom', he approvingly quoted Andrew Knight, botanist and specialist in horticultural breeding, to the effect that 'Nature intended that a sexual intercourse should take place between neighbouring plants of the same species'.[7]

However, before we become too captivated by such parallels, it is important to look at the nature of Darwin's most significant writings,

particularly the character of the literary vehicles he used. His *On the Origin of Species by Means of Natural Selection or the Preservation of Favoured Races in the Struggle for Life* stands as both exemplary and pre-eminent. In no sense can it be characterized as a work of rapture in the spirit of Erasmus, Thornton, or even Humboldt. Published in 1859, it is one of the great monuments to the high seriousness and sobriety of nineteenth-century professional science. The tone sets out to be remorselessly objective, even flat, however speculative the argument. The authors of serious science texts began consciously to avoid the rhetoric of humanist philosophy no less than the poetics of romantic science. The tone of the *Origin* is set by the opening words of the brief and unemotional introduction: 'When on board HMS 'Beagle' as a naturalist, I was much struck with certain facts . . .'. Darwin insisted that it was these 'facts' that threw 'some light on the origin of species'.[8] His sensational message is carried in an entirely workmanlike and undemonstrative vehicle, as its modest title page suggests; plain, unadorned, unillustrated, and printed according to what I have called the 'non-style'—that is to say in a style which is deliberately 'functional' and eschews any conventional stylishness. He himself described his text as 'intolerably dry and perplexing'.[9] It is characteristic that the first chapter should deal soberly with the readily available evidence of 'Variation under Domestication' rather than plunging into the potentially polemic heart of his thesis.

The key section, the 'Struggle for Experience', appears as the third chapter, and it is only then that we gain clear signs of the personal and natural drives that lie below the sober surface. Even Darwin's tightly controlled grid of methodical prose lets in subdued moments of poetic light:

> We behold the face of nature bright with gladness, we often see a super-abundance of food; we do not see, or we forget, that the birds which are idly singing around us mostly live on insects or seeds, and are thus constantly destroying life; or we forget that these songsters, or the eggs, or their nestlings, are destroyed by birds and beasts of prey.[10]

The central principle of 'Natural Selection' (capitalized thus) is forcefully characterized as 'a power incessantly ready for action, and is immeasurably superior to man's feeble efforts, as the works of Nature are to those of Art'.[11] This power leads him on occasion into uncharacteristic literary realms. Let me quote just two examples of how compellingly he can paint the picture of the 'great battle of life':[12]

> What a struggle between the several kinds of trees must have gone on during long centuries; each annually scattering its seeds by the thousand;

what war between insect and insect—between insects, snails, and other animals with birds and beasts of prey—all striving to increase, and all feeding on each other or on the trees or their seeds and seedlings, or on the other plants which first clothed the ground and thus checked the growth of trees!

The face of Nature may be compared to a yielding surface, with ten thousand sharp wedges packed close together and driven inwards by incessant blows, sometimes one wedge being struck, and then another with great force.[13]

At the very end of the chapter, as if sensing that his picture is too full of red meat, he offers some comforting words to the reader:

When we reflect on this struggle, we may console ourselves with the full belief, that the war of nature is not incessant, that no fear is felt, that death in generally prompt, and that the vigorous, the healthy and the happy survive and multiply.[14]

At least human beings, as he earlier pointed out, could look to an 'artificial increase in food' and 'prudential restraint from marriage' in order to temper the remorseless law of Natural Selection. The reference to food testifies that he had drawn much inspiration of Malthus's doctrine of population growth in relation to food supply.[15]

And, the last words of the whole book, which could easily be seen as carrying a bleak message, console the reader with a sublime vision of what nature has achieved:

From the war of nature, from famine and death, the most exalted object which we are capable of conceiving, namely, the production of higher animals, directly follows. There is a grandeur in this view of life, with its several powers, having originally breathed into new forms or into one; and that, whilst this planet has gone cycling on according to the fixed law of gravity, from so simple a beginning endless forms most beautiful and most wonderful have been, and are being, evolved.[16]

We find strong hints here of the underlying passion of his vision, which was generally so suppressed in his authoritative later writings, but was earlier much in evidence in his published *Narrative of the Surveying Voyages of His Majesty's Ships Adventure and Beagle* (1839):

Among the scenes which are deeply impressed on my mind, none exceed in sublimity the primeval forest undefaced by the hand of man; whether those of Brazil, where the powers of Life are predominant, or those of Tierra del Fuego, where Death and decay prevail. Both are temples filled with the varied productions of the God of Nature:—no one can stand in these solitudes unmoved, and not feel that there is more in man than the mere breath of his body.[17]

He confesses that his mind is a 'chaos of delight' in the face of nature's abundance.[18] But the savage scene also provokes unsettling intimations of human origins in bestial ancestors:

> Of individual objects, perhaps no one is more certain to create astonish-ment than the first sight in his native haunt of a real barbarian—of man in his lowest and most savage state. One's mind hurries back over the past centuries, and then asks, could our progenitors have been such as these?. . . . part of the interest in beholding a savage, is the same which would lead every one to desire to see the lion in his desert, the tiger tearing his prey in the jungle, the rhinoceros on the wide plain, or the hippopotamus wallowing in the mud of some African river.[19]

And, in our present context, it is interesting to find that his studies on the isolated Galapagos Islands, revealed a perfect microcosm of the system of the world as a whole:

> Galapagos. The natural history of this archipelago is very remarkable: it seems to be a little world within itself; the greater number of its inhabitants, both vegetable and animal, being found nowhere else.[20]

In this 'little world' he was able to sense that evolutionary imperatives had resulted in species that were unique to the islands 'yet their general form strongly partakes of an American character'. These parallels 'in type, between distant islands and continents, while the species are distinct, has scarcely been sufficiently noticed'.[21] They suggested that there must be common mechanisms at work.

In the present book, concerned primarily with 'visual angles', Darwin's most renowned publications hardly provide a rich visual feast and serve to remind us that major contributions to the sciences of the visible world are not bound to use visual vehicles. However, when he did resort to visual demonstration, as in his *The Expression of the Emotions in Man and Animals* in 1872, he inhabited an artistic world that deals with the kind of characterization of animal action and emotion with which we are familiar through Stubbs and his successors. In the final chapter we will see the remarkable photographs, some borrowed and some specially staged, that provided the central demon-strations in his book. For the moment we may note that one of his favoured illustrators was Joseph Wolf, an artist and illustrator who originated from Germany and specialized as a painter in animated animal narratives in which the drama of life in the wild and, not infrequently, its anthropomorphizing dimensions are richly in evi-dence. Wolf's insistence on 'the expression of life. . . . life! life! life!—*that* is the great thing', is entirely consistent with the trend in natural

history illustration and taxidermic tableaux after 1800 to adopt dynamic poses, often in evocative settings and in interaction with adjacent organisms, and it resonates effectively with Darwin's view of the 'Struggle for Existence'. Wolf's illustration of an 'aroused' monkey for Darwin's *The Expression* (fig. 43) exhibits an expressive quality beyond its merely illustrative role, and it nicely exemplifies Darwin's belief in the archetypal sharing of key elements in the facial configurations between human beings and animals as a result of the evolutionary process:

Fig. 43

Joseph Wolf, *Niger Macaque*, from Charles Darwin, *The expression of the Emotions in Man and Animals*, 1872

With mankind some expressions, such as the bristling of the hair under the influence of extreme terror, or the uncovering of the teeth under that of furious rage, can hardly be understood except on the belief that man once existed in a much lower and animal-like condition.[22]

Whatever the 'Romantic' setting for Darwin's view of the evolutionary 'grandeur' of nature, the central intent of his theories was to demonstrate a system which could assume something of the character of a mathematical law or at least an all-embracing principle—a great abstract gravitational force which superseded individual agency, even that of human beings. Had he been more fully aware of the implications of Mendel's statistically-based definition of the inheritance of dominant and recessive characteristics, a mathematical dimension was already available. The very impersonality of Darwin's system, which applies the remorseless logic of 'Natural Selection' to unplanned changes in organisms, is characteristic of an era which in retrospect we can characterize as witnessing the birth of the modern ideal of science. This ideal comprises an unstintingly objective and impersonal revelation of the fundamental, inner mechanisms of nature and the cosmos. It is very much a 'style' of science, in its content no less than in its literary and visual vehicles. The huge gravitational pull in Darwin's thought is towards a dense central mass of general rule, implicitly like the rule of mathematical progression used by Malthus to characterize the growth and constraining of human populations. It is notable that this move towards the primacy of general rule in the natural sciences is accompanied by a downgrading of illustration in general and by veridical picturing in particular. A symptom of this downgrading is that this chapter has been accorded but one illustration.

From Picture to Number: The Case of Mendel

The natural sciences had begun to labour under the stigma that they were not as 'scientific' as physics and chemistry, which could lay claim to experimental bases and mathematical formulas. They had a 'soft' look, which was not good in an age when science was becoming professionalized and institutionalized. For instance, professional archaeologists with geological instincts were taking over the study of early human tools from the antiquarians. The naturalist's collecting of butterflies and drying of flowers hardly seemed to be serious intellectual activities, whereas Malthus's statistical analyses of populations showed how the mathematics could colonize territories previously deemed to be resistant to the quantifiers' skills. The older tradition of discerning geometrical patterns tended to seem less central to natural science in the face of the rise of arithmetic and algebra as tools of analysis.

The genetic researches of Gregor Mendel, Abbot of the Augustinian Abbey in Brno (now in the Czech Republic), provide the most vivid example of the retreat of key areas of the natural sciences from the tradition of pictorial illustration. A paradox of Mendelian genetics is that it is *par excellence* founded on meticulous visual observation, while the results, based upon the counting of peas with distinct characteristics—most famously, wrinkly and smooth—are not primarily expressed in visual terms. Mendel's own key paper of 1865, in which he sets out the data and rules of inheritance, is devoid of illustrative excitement. His experimental results with hand-pollinated peas are laid out in rows of figures and letters. Sets of paired characteristics are designated by capital and lower-case letters—Aa, Bb etc.—in which the capitals signal the 'dominant characters'. The great finding is a ratio: the 3:1 ratio that signals the appearance of paired 'dominant' and 'recessive' traits in successive generations of progeny, according to the four possible pairings AA, Aa, aA, aa, in which only the individual with the aa pair will openly manifest the 'recessive' trait. His paper does not even have the benefit of the neat tabular array of atomic names that gives modest visual appeal to Mendeleev's 1867 publication of his Periodic Table of the Elements, an achievement in chemistry of comparable magnitude and more immediate impact.

The paradox of observational primacy and numerical presentation is shared with several other sciences in the nineteenth century, not least meteorology, which occupied so much of Mendel's attention and provided him with such important methodological foundations.

The nineteenth-century meteorologist typically pursued a long series of wearying observations, which were subjected to basic statistical analysis within a framework of classification for the fluid and elusive phenomena. It is telling that Francis Galton (Darwin's cousin), an obsessional observer, counter, analyst, and classifier should have been drawn to meteorology, inventing the now-familiar weather map, with its isobar lines of equal pressure. Galton, unsurprisingly, was one of the first international investigators to sit up and take notice of Mendel's work.

This is not to say that meteorology as a whole was lacking potent tools for the visual presentation of data. Galton's system of drafting 'weather maps' has provided a neat visual tool for generations of forecasters. More obviously pictorial were the visual systems for the recognition, description, and classification of cloud types, which even exercised a significant impact upon artists, most notably John Constable in his extensive series of painted studies devoted exclusively to skies.

The first two decades of the nineteenth century, when Constable was completing his mature work, saw the birth of scientific meteorology. The new science was devoted to the codification of what Lamarck, the great protagonist of evolution through acquired characteristics, called 'the physiognomy of atmosphere'. Particularly influential were Luke Howard's writings, most notably his *Climate of London* in 1818, which laid the foundations for the systematic classification of cloud types. Of his ten types, five are still currently in use, and the names he accorded them—'stratus, cumulus, cirrus, cirrocumulus, cirrostratus' etc.—have come to comprise what may be described as the poetry of the science of clouds. Shelley's poem, 'The Cloud', wove mobile sentiments around Howard's scientific nomenclature. Within science, Thomas Forster's *Researches About Atmospheric Phenomena* in 1815 complemented Howard's classificatory system with a firmer grasp of meteorological processes. This book was owned and extensively annotated by John Constable in a second-hand copy of the second edition of 1815. His own painted studies are shaped in their acts of looking by the systems introduced by Howard and Forster. As Constable said:

> Painting is a science, and should be pursued as an enquiry into the laws of nature. Why, then, may not landscape be considered a branch of natural philosophy, of which pictures are but the experiments.[23]

Mendel's own fascination with cloud formations is fully evident in his annotated copy of August Kunzek's *Lehrbuch der Metereologie* of 1850. His meticulous meteorological notes bear witness both to his observational concerns and his quest for numerical data. The kind of

meteorology that Mendel practised is just one instance amongst a series of sustained attempts by researchers to place a wide variety of sciences on a 'hard' footing during the course of the nineteenth century. The more mathematical the system the better it was for the new breed of 'scientist'.

The more numerical and statistical the science became, the more it detached itself from acts of traditional 'picturing. Indeed, there are signs of a positive relish for unillustrated books, soberly presented with teeming facts and dry analysis. If illustrations were unavoidable, diagrammatic expositions that eschewed all claims to stylishness were to be preferred. Even those sciences and technologies that necessarily used illustrations extensively, such as anatomy and engineering, avoided the pictorial airs and graces of traditional picture books of the sciences. Henry Gray's famous *Anatomy*, first published in 1858, is remorselessly devoid of stylishness in tone and in its profuse illustrations, as we will see (fig. 82), while engineering books were presented with technical diagrams using the techniques of descriptive geometry pioneered by Gaspard Monge in Revolutionary France.

The readership for the scientists' publications was also changing. The new books were aimed at actual or aspiring professionals, often to be consulted within a professional institution or, in some cases, to be purchased as relatively affordable textbooks. Journals proliferated across Europe, aimed at the growing bands of professionals and organizations, ranging from the great 'Royal' institutions which worked to promote the status of particular professional groups, to the fast-growing bands of regional and local societies of learned enthusiasts who had been bitten by the investigatory bug. In this spectrum of journal publication, Mendel's publication in the proceedings of his local Society for Natural Science in Brno stands at the latter end. Such regional societies and their publications played a major role in the furthering of nineteenth-century science, particularly in the gathering of extensive data based on natural observation.

What Mendel's discoveries eventually achieved for biological studies and, indirectly, for the human sciences was to demonstrate that the most meticulous acts of natural observation could be utilized for the purpose of mathematical analysis in the quest to establish laws that were quantitative and not just qualitative. In his systematic quest, Mendel is more than the founder of modern genetics; he is also a pioneer of the quantification of the natural sciences as a whole. The move from depiction to arithmetical and algebraic techniques may have deprived us of pretty pictures, but it was a key intellectual move in placing significant parts of the sciences of nature on a new basis.

The subsequent identification and clarification of the roles of the chromosomes, genes, and DNA over the course of the next hundred years has plugged the most serious gap in Darwin's theory and demonstrated the mechanisms which Mendel could only infer. Twentieth-century biology progressively disclosed the structures and processes with the nuclei of cells upon which evolution and the laws of inheritance are predicated. As attention progressively shifted from the individual organisms, and even cells to the genetic unit, so it became logical to question the long-held belief in the primacy of species as the basic building blocks of the natural world. Indeed, it could be argued that once the account in Genesis of God's creation of the animals and plants (and their conservation two-by-two by Noah) was no longer to be taken literally, there was no logical reason to retain the privileged position of the species as the discrete units of God's divine invention. This was not a step Darwin could have contemplated, but it has subsequently been taken in his name, above all in Richard Dawkins's theory.

'Selfish Genes' and Levels of Belief

The most extreme modern forms of Darwinism aspire to come closer to characterizing the composition of the central mass of rule than Darwin ever did, and, perhaps, go substantially further than he would ever have wished. The most 'naked' exposition of the mechanism is Dawkins's *The Selfish Gene*, first published in 1976, in which Darwin's cherished 'species' are downgraded to unwitting and ultimately sacrificial slaves to the genetic material of DNA.

As with my brief and partial review of Darwin, my tactic in looking at Dawkins is to proceed by quotation from his classic text rather than later publications, looking at it as a historic text and drawing out implications both on the basis of what is said and the manner in which it is communicated. It is probably best to allow Dawkins himself to define the central notion:

> What is the selfish gene? It is not just one single physical bit of DNA. Just as in the primeval soup, it is all *replicas* of a particular bit of DNA distributed throughout the world ... 'it' is a distributed agency, existing in many individuals at once.[24]

The key criterion for the fundamental unit is that it should be a 'replicator', demonstrating the properties of 'longevity, fecundity and copying-fidelity'.[25] 'Success' is judged in terms of the long-term

endurance and spread of the replicator, or more properly the persistence of the template as replicated across generations of the same or various species independently of the survival of any physical entities, whether the organism or individual bits of DNA. As he points out:

> The life of any one physical DNA molecule is quite short—perhaps a matter of months, certainly not more than one lifetime. But a DNA molecule could theoretically live on in the form of *copies* of itself for a hundred million years.[26]

The level of conceptual abstraction behind Dawkins's 'selfish gene'—signalled by his 'could theoretically live . . .' idea—has not been adequately recognized as the phrase has entered popular consciousness. Indeed, Dawkins's own chosen language of communication has not encouraged such recognition. Some key passages in which he argues for the gene and against the organism as the fundamental unit will serve to give an idea of his very un-Darwinian rhetoric:

> The genes are the immortals, or rather, they are defined as genetic entities that come close to deserving the title. We, the individual survival machines in the world, can expect to live a few more decades. But the genes in the world have an expectation of life that must be measured not in decades but in thousands and millions of years. . . . They march on. That is their business. They are the replicators, and we are their survival machines. When we have served our purpose we are cast aside. But genes are denizens of geological time: genes are forever.[27]

> Vehicles don't replicate themselves; they work to propagate their replicators. Replicators don't behave, don't perceive the world, don't catch prey or run away from predators; they make vehicles that do all those things.[28]

> The genes are master programmers, and they are programming for their lives. They are judged according to the success of their programs in coping with the hazards that life throws at their survival machines, and the judge is the ruthless judge of the court of survival.[29]

The language is rich in apparent purpose and intention—'march on . . . their business . . . purpose . . . ruthless judge'. However, Dawkins expresses the hope that we can safely proceed in such a metaphorical mode while 'always reassuring ourselves that we could translate our sloppy language back into respectable terms if we wanted to'.[30] And, more explicitly:

> I have emphasized that we must not think of genes as conscious, purposeful agents. Blind natural selection, however, makes them behave as if they were purposeful, and it has been convenient, as a shorthand, to refer to genes in the language of purpose.[31]

There is, perhaps, something uneasy in the disjunction between the dominant rhetoric of his book and the abstract and mechanistic content of its underlying theory. On one level, the rhetoric can simply be justified as a way of bringing the points home in a vivid manner to an audience beyond that of professional geneticists. But, on another level, it does come across as a personal way of expressing the modern scientist's relish in the parading of the vast, supra-human powers of natural phenomena, powers beyond the control of any human agency and yet over which the scientist can claim privileged intellectual if not physical mastery. There is at least some paradoxical sense of Dawkins's personal identity with the very impersonality of the overarching power of the abstract rule. In a sense we are dealing with a modern species of the 'scientific sublime'. Such relishing of the big, 'godless', and inhuman rule has become hugely fashionable from the mid-nineteenth century onwards in all those disciplines which have claimed a 'scientific' basis; that is to say, a basis in what is generally believed to be the defining character of modern science. Malthus's rule is an early example. Dogmatic political and economic systems like Marxism and Monetarism are others. They effectively replace God.

A number of observers have commented that Dawkins's 'selfish gene' emerged into the prominent light of day at the time of the rise in Britain and America of Monetarist dogma as the dominant political force, not least in the administrations of Margaret Thatcher and Ronald Reagan. There seemed to be a striking conjunction between the raw action of 'market forces'—favouring the fittest and most self-seeking, while demolishing the weak and dependent—and the remorseless success of truly 'selfish' genes in the global market-place of natural selection. The parallel is not to be taken at the most literal level to mean that Dawkins was directly forging a biologist's form of Monetarism and market economics. Indeed, in a footnote in a later edition,[32] he stresses that his thesis was formulated in Britain during the time of the Labour (more-or-less socialist) government that preceded the Thatcher administration and that his sympathies lay with the political left. Rather we can say that belief in the 'selfish gene' and the rule of 'the market' (as in 'we should let the market decide') are common expressions of the intellectual and psychological will towards non-human, scientific absolutes through which the 'soft sciences' of natural history, politics, and sociology and human society have aspired to adopt the style of the 'hard sciences', most notably physics and mathematics.

Evolutionary theory, in spite of the Malthusian element in Darwin's formulation, does not in itself submit readily to 'hard' formulation, since it deals with incredibly complex, intersecting fields of change,

action, and interaction involving multiple agents which are not necessarily stable entities in themselves. The system is 'chaotic'—both in the lay sense of the term and according to the specific tenets of chaos theory (about which more shortly). The way to endow evolution with 'hard' principles is to reduce the focus to the mechanisms of the units of inheritance, the genes, or, even better, to the molecular engines that comprise the genes. It requires explanations arising at the molecular level, or in terms of the theme of this book, a way of seeing things from a different perspective deep within the organism. As Dawkins says, 'rather than focus on the individual organism, it [the book] takes a gene's-eye view of nature'.[33] The analogy he uses for this change of perspective is that of the famous Necker Cube, the 'wire box' diagram which we can flip perceptually from a cube seen from above and from the right (with upper and right faces obliquely visible) to one seen from below and from the left (with lower and left faces visible). Dawkins's intention is not to 'flip to an equivalent view' but to effect a 'trans-figuration'. In other words a perspective based on the organism or species is to be overthrown by the 'gene's-eye view'. This insistence is based on his conviction that 'In a sexually reproducing species, the individual is too large and too temporary a genetic unit to qualify as a significant unit of natural selection'.[34] The smallest part is now privileged over the whole, not only in terms of explanatory power but also with respect to how nature actually 'works'.

Yet there are hints in a later edition of *The Selfish Gene* that the 'organism-eye view' might not have entirely had its day: In a chapter on 'The long reach of the Gene', which summarizes the argument in his book on *The Extended Phenotype* (1982), he acknowledges that:

> Gene and individual organism are not rivals for the same starring role in the Darwinian drama. They are cast in complementary and in many respects equally important roles, the role of replicator and the role of vehicle.[35]

There is at least some sign here of what I believe to be the equal and intersecting statuses of the levels or zones in the system which we probe with our analytical enquiries, seeking explanatory principles or even laws.

It seems to me to be a philosophical not a biological question as to whether we define the 'significant unit of natural selection' as the gene, DNA, the cell, the individual organism, the species or larger taxonomic entity, the collective sectors of the orbiting environment directly affected by what Dawkins calls the 'long reach' of the phenotypes (the expressions of the genetic constitution in proteins and beyond), the whole of the local environment inhabited by the species, the broader

environmental system of which the local environment is part, the ecosystem of the world as an entity, or larger universal entities which can be described as undergoing cosmic evolution. Even from the limited perspective of the 'gene's-eye view', we can see that the DNA of cellular organisms can only replicate itself in the context of a complex system of enzymes and catalytic reactions within cells. If we adopt a far wider perspective, in stark contrast to Dawkins's insistence on adopting the standpoint of the smallest functional unit that we can identify, James Lovelock proposed in 1982 that the fundamental level of address should become that of the whole earth as a kind of organism—developing what he called the 'Gaia hypothesis', named after the Greek Goddess for the earth. In this sense, the whole earth may be viewed as if it were an organism in the same way that we might consider a coral reef to be 'the organism' for coral, though it is actually the product of an extended colony of individual organisms.[36] Or, just as the body has its cells, so the earth supports its component units of life (animals, plants, etc.), all of which collectively go to make up the total organism, which is characterized as a dynamic, self-regulating biosphere. Even more recently, Lee Smolin has proposed an evolutionary unit of an even larger kind, where the universe—each universe—serves as a replicatory agent via black holes.[37] A scale of scales: DNA, the organism, the earth, the universe. Does the Leonardesque microcosm live again?

I do not believe that it is possible to demonstrate that any one of the alternative levels is 'right', most 'significant', or even preferable. Each level of scrutiny is potentially able to reveal non-arbitrary and operative aspects of the system as a whole. The different levels each lead to a different mode of explanation—each with its own insights and short-comings. Each mode can do a distinct and valuable kind of job in making sense, albeit incomplete sense, of what is happening. If we concentrate on the gene, Dawkins gives us a powerful tool for understanding the role of the gene as a replicatory mechanism, and the explanation has a 'hard' feel to it, but this does not mean that we can safely assume that everything else *serves* the gene. If we look at the level of intersecting populations we seem to be faced by a system that is characterized by chaos, in the technical sense; that is to say a system in dynamic change which may appear likely to be predictable but which proceeds to behave with such complexity that it is impossible to forecast according to absolute laws and knowledge of the starting conditions what will be its precise state at each later stage. Such systems may be chaotic, but they are not random; that is to say their behaviour centres around probabilistic patterns that can be plotted and mapped by computer modelling. In chaotic systems, we are not faced with laws

which deliver sharp-edged predictability according to deterministic principles but with probabilities that can be represented graphically in 'phase space' as shapes, termed 'attractors,' denoting the dynamic parameters within which the 'fuzzy' activity settles.[38]

In the relatively new branch of mathematics that deals with chaos, which builds upon the work of Henri Poincaré in the 1890s, it has been found that systems working according to simple, apparently deterministic rules can produce results that in practice defy precise prediction. This occurs under two circumstances. The first is when the system, such as that which provides our weather, is so complex that the current state cannot be defined with complete mathematical accuracy. We find that accuracy to a *finite* number of decimal places may be insufficient to avoid significant error if a procedure is iterated even a limited number of times.

Let us, as a way of illustrating the problem by analogy, take the number 0.618034 (which, as we will see, is the key number in the so-called 'golden' ratio or section) as a rounding up to six decimal points of 0.6180339 (which is in turn the decimally truncated version of the 'irrational' number). If we undertake the simple deterministic procedure of removing the number in front of the decimal point and multiplying by 10, we successively get 6.18043, 1.8034, 8.034, 0.34, 3.4 and finally 4. But the more accurate number, to seven decimal points, gives a terminal value of 9. Yet eight decimal points would have been more accurate than seven, and so on. However, we have not been given the value of the eighth, let alone the ninth, the tenth . . . In order to avoid such unpredictability with such an *irrational* number, we would need to know the complete sequence of decimals to infinity.

The second circumstance, essentially the same in effect to the first, is when a small perturbation or variation is introduced into the initial state, which is insignificant at first but may become hugely magnified when it is built into an iterative process. Thus, repeating the above procedure, if the initial state is 618034 as a *rational* number, and it is then varied downwards by less than a six-millionth part (i.e. 618033.9), the final number will be 9 rather than 4.

In a related way, what Per Bak and his co-workers have christened 'self-organized criticality' deals with physical set-ups that are in a poised state such that a small event can lead to catastrophic 'avalanches' which do not follow a smooth and predictable path.[39] The archetypal example used by Bak is the sand-pile. If we imagine a steady trickle of sand grains falling on to a flat surface, we know from experience that the resulting cone becomes steadily steeper, until the crucial moment when it becomes subject to avalanches of various dimensions and

durations. Each landslip or series of landslips may be followed by intervals of relatively stable accumulation. However much we may scrutinize the individual grains, the behaviour of the sand-pile cannot be extrapolated from their individual properties. The situation can be modelled on a computer, but even in a grossly simplified form the behaviour of the pile obstinately refuses to be explicable in terms of the dynamics of each of the uniform grains. An apparently simple set-up has resulted in such a level of complexity as to resist ready predictability. To see what happens in a chaotic system or in any phenomenon of self-organized criticality, we have to let the system run and analyse the tendencies it manifests.

There remains, of course, the question as to whether such systems are literally *impossible* to model predictively on the basis of an all-embracing knowledge of the nature of the minutest parts *because* they are definitively resistant to such a mode of explanation, or whether it is merely our present incapacity that prevents us from explaining the complexity on the basis of reduction to the properties of its individual parts. Could we, for example, precisely define the form and behaviour of the moon if we knew everything about its molecular constitution and all the conditions and events which have lead to its present state? Or, to cast the question in terms of the notion of 'parallel' (or alternative or possible) universes, the number of parallel universes is so inconceivably huge as to be effectively useless as a working concept. Let us say I am walking in the park near my house, and I walk round the left hand side of a tree rather than the right. This has triggered one rather than the other possible world. Let us then say that someone in China walks round the left side of a tree in a Chinese park rather than the right. That triggers another one, and in conjunction with my choice, triggers four alternative worlds. If we then extrapolate that to all possible worlds resulting from every possible variable event of every possible kind (e.g. my raising my right arm as I walk past the tree, or the reader getting fed up with this book and abandoning it on a park bench), the possibilities become uncomputable in any practical sense. There are so many contingencies and 'avalanches' (both literal and metaphorical) that we could never arrive at a precise prediction which would coincide exactly—atom by atom—with what is going to exist at *any* point in the future. Although we cannot achieve such a prediction—and it is unlikely that anyone would bother to make the attempt anyway—the theoretical issue is hugely important, since it fundamentally defines what kind of explanation we consider appropriate at each level of potential explainability, and, even more profoundly, what kind of phenomena we believe to lie behind the richness we

see in nature, whether from the perspective of Dawkins or that of Lovelock.

My intuition is that the kind of mathematics that is appropriate for analyses of vastly complex, evolutionary systems is irredeemably different in kind from the kinds of mathematical logicalities that characterize the theoretical models of standard physics and chemistry at the microscopic and sub-microscopic levels. The situation is analogous to the peculiarity in geometry that we can precisely bisect an angle using a straight edge and compass, but cannot trisect it with the same tools. Thus even what looks like the same kind of task does not yield to the same techniques in every instance. I accordingly have a sense that we will never be able seamlessly to link the levels of chaotic and self-organized systems with the 'normal' kinds of mathematical physics and chemistry. Whether, on the other hand, the probabilistic analyses of complexity share something essential with the indeterminacy of quantum mechanics presently seems unclear, certainly to me—but there is clearly a big question and huge potentiality here for future investigators. This question will resurface in the next chapter in a more articulated manner.

What I believe we can say at present is that we are developing different kinds of technique to handle analysis at different levels of the organization of the natural world. Much modern science may be uncomfortable with the 'fuzzier' pictures arising from chaos and self-organized criticality, but they seem to represent something that is real. There is no indication that the fuzzy shapes of such a system at, say, the larger scale of an ecosystem are less *significant* than the neat geometrical patterns woven by DNA at the molecular level. It is true that the huge molecule of DNA as a replicator preceded even the simplest organism in *historical* time (though we should recall that DNA cannot replicate without a complex context). But, once the genetic material is integrated with an organism, they function together in a symmetry of interdependence within the incredibly complex contexts in which they operate. This is just how the system has worked out, as it has run its unforecastable course with bewilderingly complex results over the course of millions of years—like a sand-pile of trillions of grains of different sizes, shapes, and colours. Looking at the gene and the organism, the question of which *serves* which is really a non-question.

There is no single sense of privileged purpose to be lodged at some unique level within nature—on biological grounds. One level does not *serve* another in any sense that is analogous to 'serving' in a human society. Whether there is a greater 'purpose' behind the world, or the universe or human existence, is a matter of belief, a question of

theology, not a decision to be made through biological enquiry. Although we may have abandoned the species as the divinely ordained units of God's creation as described in *Genesis*, there is no reason why it should not assume its proper status as one of the non-arbitrary and effective levels of analysis. Indeed, attention to the species in the persons of its individual representatives will always have a compelling emotional role to play in our relations with the natural world, because it is to the individual organism, manifesting its unique life over the fixed span of its days, that we can relate in terms of our own existence. Modern reaction against the religious and emotional privileging of the species goes too far when it requires that it is viewed merely as a slavish vehicle.

We will be returning to these questions towards the end of the next chapter, having looked at some of the ideas about the factors which literally shape organisms, and we will review more evidence about kinds of order that echo across phenomena at different scales, including fractals and holograms. Something resembling a proper conclusion will be attempted then. For the moment it might be helpful to emphasize one of the constant features of the landscape we have witnessed as we have crossed the terrain from Leonardo to Lovelock. A key feature we have observed is that the investigator's personal level of identification with a particular entity or level within the system provides a powerful lever for the gaining of a purchase on how it operates, not only at that level but in the system as a whole.

Analogy remains a major means of visualization and demonstration, whichever level is chosen. Although I argued that analogy has become simply a neat means to bring an argument home, and that it has lost its underlying power with the abandoning of the metaphysics of the microcosm and macrocosm, we have seen clear signs that such metaphorical concepts as the 'selfish gene' and 'Gaia' do not function for their authors or their readers in a wholly detached, impersonal, and superficial manner. I think it is the nature of any highly-motivated human endeavour that a level of personal and indeed anthropomorphized identification is essential if the necessary passion is to be sustained and communicated.

There are clearly some kinds of temperamental proclivities at work in what individual scientists choose to do. A river ecologist, C. R. Townsend, has speculated about the kinds of people who are drawn to the study of complexity:

> It is probably the case that the science that attracts us is a reflection of our mentality—those who crave order and certainty become physicists or

chemists while those who wonder at variation and complexity become ecologists. River ecologists face one of the stiffest tests of all because of the extreme spatial and temporal complexity of each individual river and the profound variation among rivers.[40]

And we should make no mistake that the passionate motivation and temperamental identification with the field of study is no less a part of the constitution of today's innovatory biologist operating at the highest level than it was when Palissy was battling with the inferno of his volcanic kilns or when Thornton was bankrupting himself to disclose the sermons preached by every flower.

NOTES

1. Errnst Krause, *Erasmus Darwin* with a Preliminary Notice by Charles Darwin, (London: Murray, 1879)
2. Duncan M. Porter and Peter W. Graham, *The Portable Darwin*, (New York: Penguin Books USA, 1993), p. 494
3. Erasmus Darwin in Ernst Krause, *Erasmus Darwin*, pp. 132 and 211, note 1
4. Erasmus Darwin as quoted in Duncan M. Porter and Peter W. Graham, *The Portable Darwin*, p. 398
5. Duncan M. Porter and Peter W. Graham, *The Portable Darwin*, p. 418
6. Duncan M. Porter and Peter W. Graham, *The Portable Darwin*, pp. 515–16
7. Duncan M. Porter and Peter W. Graham, *The Portable Darwin*, p. 429
8. Charles Darwin, *On the Origin of Species, A Facsimile of the First Edition*, (Cambridge, Massachussets and London: Harvard University Press, 1995), p. 1
9. Adrian Desmond and James Moore, *Darwin*, (London: Penguin Books, 1992), p. 474
10. Charles Darwin, *On the Origin of Species*, p. 62
11. Charles Darwin, *On the Origin of Species*, p. 61
12. Charles Darwin, *On the Origin of Species*, p. 76
13. Charles Darwin, *On the Origin of Species*, pp. 74–5 and 67
14. Charles Darwin, *On the Origin of Species*, p. 79
15. Charles Darwin, *On the Origin of Species*, p. 63
16. Charles Darwin, *On the Origin of Species*, p. 490
17. Duncan M. Porter and Peter W. Graham, *The Portable Darwin*, p. 63
18. Adrian Desmond and James Moore, *Darwin*, p. 119
19. Duncan M. Porter and Peter W. Graham, *The Portable Darwin*, p. 63–64
20. Duncan M. Porter and Peter W. Graham, *The Portable Darwin*, p. 40
21. Duncan M. Porter and Peter W. Graham, *The Portable Darwin*, p. 54–5
22. Charles Darwin, *The Expression of emotion in man and animals*, Paul Ekman ed. (London: HarperCollins Publishers, 1998, pp. 12–13
23. Quoted by John Thornes, 'Constable's Paradoxical Rainbow', *Nature*, **403**, 2000, p. 482; see also *Constable's Clouds*, ed. Edward Morris, exhibition catalogue (Edinburgh: National Galleries of Scotland, 2002)
24. Richard Dawkins, *The Selfish Gene* (Oxford: Oxford University Press, 1989), p. 89
25. Richard Dawkins, *The Selfish Gene*, p. 194

26. Richard Dawkins, *The Selfish Gene*, p. 34

27. Richard Dawkins, *The Selfish Gene*, pp. 34–5

28. Richard Dawkins, *The Selfish Gene*, p. 254

29. Richard Dawkins, *The Selfish Gene*, p. 62

30. Richard Dawkins, *The Selfish Gene*, p. 89

31. Richard Dawkins, *The Selfish Gene*, p. 196

32. Richard Dawkins, *The Selfish Gene*, p. 268

33. Richard Dawkins, *The Selfish Gene*, pp. viii–ix

34. Richard Dawkins, *The Selfish Gene*, p. 34

35. Richard Dawkins, *The Extended Phenotype*, (New York: Oxford University Press, 1989), p. 254

36. James Lovelock, *Gaia: A new look at life on earth*, (Oxford: Oxford University Press, 2000, 3rd ed.); *The Ages of Gaia: A biography of our living earth*, (New York: Norton and Co., 1995)

37. Lee Smollin, *The Life of the Cosmos*, (Oxford: Oxford University Press, 1999)

38. For a good introduction, see Ian Stewart, 'Portraits of Chaos', *The New Scientist Guide to Chaos*, ed. Nina Hall, (London: Penguin Books), pp. 44–58

39. Per Bak, *How Nature Works: The Science of Self-Organized Criticality I*, (New York: Copernicus Springer-Verlag, 1996)

40. Colin Townsend, 'Concepts in River Ecology: Pattern and Process in the Catchment Hierarchy', *Archives Hydrobiology*, Sppl.113, Large Rivers, **10**: 3–21

PART III

DISCERNING DESIGNS

6 | NATURAL GEOMETRIES

The separation between qualitative and quantitative science which lies, albeit untidily, behind the division of labour in parts II and III is convenient as a way of thinking about modes of analysis but should not be taken too literally. The characterization of two such different modes is the result of the emphasis in modern science upon 'hard' quantification as the prime model for certain knowledge. In such a light, 'qualitative' is not so much a description as a dismissal. Judged from the historian's perspective, in terms of the way that science has actually been pursued over the ages, the separation has absolute validity—certainly not in the pre-modern era and it needs serious qualification even in those modern sciences where quantification seems to exercise total rule. The modes were not, for much of the historical territory we are covering, necessarily in conflict. The conflict itself is a relatively late invention.

However, the terms do serve useful functions in drawing attention to different styles of science, not least with respect to what scientists claim to have been doing. And they will serve our immediate purposes quite neatly. The difference, in terms of Renaissance natural philosophy, may be described as between one mode of explanation that focused on the poetic metaphors through which God was seen as endowing the book of nature with meaning, and another which sought to measure divine geometry with the precise tools of rational science. In the earliest phases, the commensurable property of rational numbers features less prominently than the incommensurable terms of geometry, such as $\sqrt{2}$ and the 'golden section', which, as we will see, cannot be expressed precisely in numbers. We have already noted the rise of counting, statistics, and algebraic methods in the nineteenth century, and the use

of serial measurements in new human sciences of anthropology and eugenics will be discussed in chapter 9. Here, for the most part, we are concerned with geometry rather than other branches of mathematics because of its consistently prominent role in bringing precision to the visual analysis of nature.

The concept underlying the relationship between the whole and the parts as described in part II is necessarily predicated on principles of design—explicitly or implicitly. This chapter asks about the way that these principles might be defined precisely in terms of mathematical order. We will be inhabiting the territories of the natural world, especially the biological sciences, rather than the zones of physics and modern chemistry, in which such orders are the very foundation of the scientific mapping of the phenomena. The complexity, organic variability, contingency, and even chaos of the natural world has often seemed irredeemably resistant to hard rule and subversive of simple patterns of geometrical or arithmetical regularity. What I will be suggesting is that some striking historical intuitions in earlier science and art can be placed in fruitful juxtaposition with some of the recent ways in which the sciences of complexity are apparently making inroads into some previously intractable problems in the natural sciences. These recent ways will be the subject of the following chapter.

The sorts of metaphor we encountered in part II all carried inherent definitions of what kind of order lay behind natural appearance. There was general acceptance that the order arose from God's creative act, and a series of recurrent metaphors conveyed a good idea of what kind of design was thought to be embodied in nature. God as geometer was a recurrent refrain, particularly for those of Platonizing inclinations. Somehow the idea of God as a modern statistician or algebraicist has seemed less compelling. Closely related to this idealist vision was God as the author of celestial harmonies, a creator who revealed his sublimity through the music of proportion, most notably in the heavens, as Kepler had illustrated. The more hands-on concepts envisaged God as the divine architect or maker of things (the supreme *artifex*), who acted as the builder of the temples of the cosmos and the human body. As the fabricator of the universal and world machines, God was the divine clockmaker, designing the intricate gears of the turning heavens with supreme ingenuity and winding up the whole mechanism to endow it with the motions necessary for life. For the seventeenth-century Jesuit polymath, Athanasius Kircher, God was the builder of the divine organ of Creation, the sonorous chords of which resonated through every aspect of creation. The tenth and culminating book of Kircher's *Misurgia universalis* (Universal Works of the Muses) is entitled:

Decachord of Nature or organ with ten flutes where it is shown that the nature of things looked at in all musical and harmonic proportions and that the nature of the universe is consequently nothing else than the most perfect music.[1]

There was long-standing recognition that, amongst the forms on earth, it was the human body that best exemplified God's harmonic model. Saint Augustine in the fourth to fifth century expresses the idea with characteristic elegance:

> There is in a man's body such a rhythm, poise, symmetry, and beauty that it is hard to decide whether it was the uses or the beauty of the body that the Creator had most in mind. It is clear that every organ whose function we know adds to the body's beauty, and this beauty would be still more obvious if only we knew the precise proportions by which the parts were fashioned and interrelated. I do not mean merely the surface parts which, no doubt, could be accurately measured by anyone with proper skill. I mean the parts hidden below our skin, the intricate complex of veins and nerves, the inmost elements of the human viscera and vital parts, whose rhythmic relationships have not yet been revealed. . . . The beauty of this music no one has yet discovered, because no one has dared look for it. Of course, some parts of the human body appear to have no other purpose than to add to beauty, as the mamillae on a man's chest or the beard on his face. Certainly, if the beard were meant for protection rather than beauty, it would have served a better purpose for the weaker sex, whose face remains uncovered. If, then, we argue from the facts, first, that, as everyone admits, not a single visible organ of the body serving a definite function is lacking in beauty, and, second, that there are some parts which have beauty and no apparent function, it follows, I think, that in the creation of the human body God put form before function.[2]

In this light, God emerges as less of an engineer and more as a fine artist.

At first sight, the proliferation of such metaphors, of which only a selection have been given here, present an impression of conceptual confusion, but in as much as God was regarded as the font of all perfections, he embodied all creative potentialities in the ONE, and was accordingly the model for all the higher human activities of creativity that were available as metaphors for his transcendent power. Such a holistic vision was certainly the goal of Kircher, who sought the universal truths of the all-embracing deity within all the religions of the world.

The common thread running through the main metaphors was of rational, proportional, harmonic design which partook either singly or jointly in number and measure, whether in an abstract or concrete sense and whether in statics or dynamics. The rule of number

manifested itself above all in the Pythagorian harmonies of music in terms of the octave, the fourth, the fifth etc. Whole numbers could be translated into geometrical form, as, for example, when a rectangle is designed with side lengths of 2:3, that is to say corresponding to a musical fifth. But the distinguishing feature of geometrical proportions is that they are not necessarily commensurable. Thus the long side of a rectangle composed from the side length of a square and the diagonal of the same square comprises an irrational number. As demonstrated by Pythagoras's theorem, which states that for a right-angled triangle the square of the hypotenuse is equal to the sum of the square of the two opposite sides, the longer side is equivalent to $\sqrt{2}$, if the shorter side is taken as 1 unit of measure. The term $\sqrt{2}$ cannot be expressed precisely in whole numbers, fractions or decimals. Similarly, if a line is divided such that the ratio of the shorter part to the longer part equals the ratio of the longer part to the whole, the ratio can only be approximated arithmetically as 0.61803398875 ... (to as many decimal points as we might wish). This ratio, the so-called 'divine' or 'golden' section, will feature prominently in a number of the later historical episodes at which we will be looking. It is on such kinds of geometrical rather than arithmetical proportion that we will chiefly be concentrating, since it is their incommensurable mystery that has seemed intuitively to a succession of observers to correspond with nature's ineffable geometry.

The great reservoir of proportional theory in the visual arts was the theory of architecture, and in the Renaissance such theory was essentially identified with the writings of the Roman architect, Vitruvius, whose *Ten Books on Architecture* was the only treatise on the visual arts to survive from classical antiquity. As we saw in chapter 1, it is to Vitruvius that we owe the famous image of the human body with outstretched arms and legs inscribed in a square and circle, immortalized by Leonardo. The eternal geometry of the square and circle, those most perfect of geometrical figures—traced in space by the orbiting tips of the man's fingers and heels of his feet—lies implicitly or explicitly behind all those attempts to create buildings on a perfect, centralized plan, such as Bramante's *Tempietto*. The notions of architectural harmony that the Renaissance distilled from classical antiquity were integrally based on notions of natural design, both anthropomorphic and biological. As an example, let us look at the design of an ionic column in the ancient manner.

Capital Principles from Vitruvius to Leonardo

Vitruvius, necessarily the prime source, tells how the Ionians modelled the columns of their temple to Apollo on the virile proportions of a man, which they determined on the basis that 'the foot was one sixth of the height'. They gave the name 'Doric' to this type of column, after the Dorian people who used it. However:

> when they desired to construct a temple to Diana in a new style of beauty, they translated these footprints into terms characteristic of the slenderness of women, and thus made the column the thickness of . . . only one eighth of its height. . . . In the capitals they placed the volutes, hanging down at the right and left like curly ringlets . . . Thus in the invention of the two different kinds of columns they borrowed manly beauty, naked and unadorned, for one, and for the other the delicacy, adornment, and proportions characteristic of a woman.[3]

The literal illustration of a humanoid ionic column—curly ringlets and all—in one of Francesco di Giorgio's Renaissance manuscripts testifies to the impact of Vitruvius's anthropometry, and to the way in which the visual evidence is fitted to the desired end. Francesco's virtually naked women, corseted by dint of amputation within the outlines of the column, while her head corresponds to the capital and her coiffure forms the ionic volutes. Francesco shows how the metaphor of the femininity of the more slender of the classical orders might be contrived as a mathematical 'fit' by a determined designer, rather than supporting the legend of the strictly 'empirical' discovery of its proportions in nature.

The succession of classical orders as developed over time—basically, the resolute Doric (or Tuscan), the elegant Ionic, the graceful Corinthian, and the ornamental Composite—was, in taxonomic terms, accorded a kind of biological status by Alberti. He saw the basic column unit, composed from base, cylindrical trunk, and capital, as the 'genus', while the various 'races' of column comprised the 'species'.[4] The trunk of the column was almost inevitably seen as tree-like, tapering towards its top according to natural rule, and an array of columnar supports as forest-like. A literal expression of the tree-column is found in the Milanese courtyard of Sant' Ambrogio by Francesco's one-time colleague, Donato Bramante, where a series of columns and half-columns bear the stumps of truncated side branches, arranged in meticulous spiral phyllotaxes (fig. 44). The scheme is reminiscent of the spirally banded column that Francesco placed beside columnar woman.

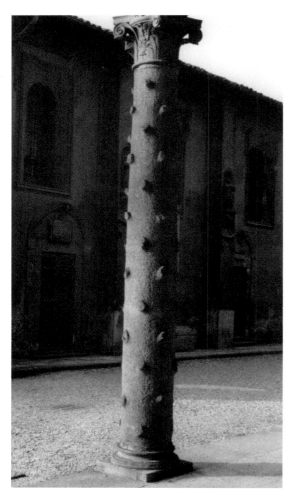

The capitals which canonically adorn the columns of the more elaborate of the classical orders possess, at their best, a sense of living geometry which bespeaks a real dialogue with natural form. This is most obviously true of the acanthus leaves of the ornate Corinthian capital—legendarily said to be invented by the sculptor Callimachus when he saw an acanthus plant thrusting its leaves through the interstices of a basket that had been placed on the tomb of a maid of Corinth—but it is also apparent in the spiralling volutes of the Ionic capital, particularly in the hands of a master designer (fig. 45). Alberti gives one of the geometrical formulas for the design of the volutes, which became a much-debated matter:

> Around the centre of the navel (*umbilicus*) trace a small circle with a radius of one module. At the top of this circle make a mark, and at the bottom another. Then set the fixed end of your compasses on the upper mark, and with the free end construct a line from the point where the abacus meets the scroll, turning down in a complete semi-circle as far as the end of the capital, to exactly below the centre of the small circle. Retract the compasses at

Fig. 44

Donato Bramante,
*Tree-Column from
the Cloister of
S. Ambrogio, c.*1498,
Milan

that point, drawing in the fixed end to the mark at the bottom of the original small circle; then turn the free end to continue the incomplete curve from the point so far reached up to the upper edge of the lip (*labulum*—or more usually echinus), to form a single continuous curve out of two unequal semicircles. Then continue in the same manner, until the spiral, which is the curve so far described, reaches the eye (*oculus*), which is the small circle.[5]

The construction of Alberti's spiral from abutting semi-circles—a modified version of what was called the Archimidean 'method'— hardly aspires to high mathematical sophistication, but the principle of a curve in which the width between the successive revolutions progressively narrows approaching the centre is clear, as is the anthropomorphic tone of names of the parts which comprise the whole.

It is explicitly in this spirit of nature-based design that Dürer produced patterns for geometrically grounded artefacts in his manual, *Instruction on Measurement*, in 1525.[6] Picking up the late Gothic taste for objects and architectural detail that extrapolated decorative shape from natural form, he sought an explicit geometry which might place design on an absolute basis—to counteract the way that young German artists, in his mind, grew up in an untutored and intellectually undisciplined manner, like unpruned trees. Thus, having a proper command of the abstract geometry of various kinds of spiral and helix, and a knowledge of the various practical ways to draw them, the designer has the resources to devise the head of a crosier as a geometrically organic or organically geometrical kind of object. He specifically refers to the shape as a 'leaf line'. In keeping with the practical geometry and vernacular terminology of the masons, he

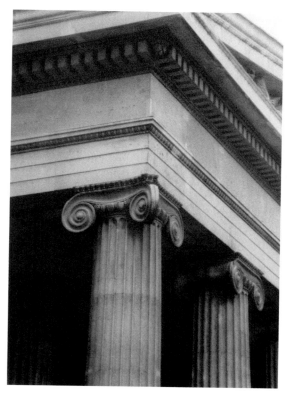

Fig. 45

Charles Smirke, *Ionic Capital in Portico of the British Museum*, c.1845, London

uses such terms as 'snail-line', 'mussel-(or conch-)line' (for conchoids), and 'spider line' (for epicycloids), although he is also acquainted with the 'professional' mathematical names for the conic sections: ellipse, parabola, and hyperbola. It is deeply characteristic of his visual pro-clivities that, having invented a practical technique for the projection of an ellipse for the section of a cone he should call it the 'egg-line'—the 'egginess' of which is enhanced by the misleading flattening at the bottom of the ellipse which results from the practical difficulties in his method.[7]

In Dürer's hands, implementation of such geometry in practical acts of design assumed a kind of transformative flexibility which he sensed was more in keeping with the fecund variety of natural form than a single, invariable template. Leonardo had allowed for a plurality of proportional systems in the human body so as to endow different builds of people—from the stockily strong to the slimly elegant—with their own kinds of bodily music. Dürer both undertook Leonardo's programme on a more systematic basis than his Italian contemporary was able to do himself, and radically extended it into new territory. In his *Four Books on Human Proportion*, published in 1528, Dürer codified the proportional systems of thirteen different types of male and the

same number of female figures.[8] At the beginning of the treatise, he uses a method of measurement based on aliquot fractions of the whole, but in the second book he switches to a precise scale of units called 'measures', each of which is sub-divided three times into 'numbers', 'parts', and 'particles'. A 'particle' is about 1 mm in size. The tabulated columns of data for each view of each full figure run into more than one hundred separate measurements, which he declares to have undertaken on some 200 or 300 'living persons'—a considerable effort of quantification. However, even these twenty-six exemplars failed in Dürer's mind to encompass all the manifold possibilities, and he devised various geometrical methods through which he could seamlessly transform each proportional system so that endless sets of variations could be accomplished non-arbitrarily, without losing all trace of their foundational proportions. The most unexpected method relies upon the projection of the proportional divisions on to a curved intersection, with an effect essentially similar to that produced by a curved mirror in a fairground show. The results of such infinitely graded transformations were geometrically 'continuous' rather than arithmetically 'discontinuous'—to adopt Leonardo's terminology—or 'incommensurable' rather than 'commensurable', in terms of exact measurement.

Dürer's transformational method for head types involves geometrical manipulations of the underlying rectilinear grids, and variations in the pitches of the angles that determine the profiles of the faces (fig. 46). The wide variety of physiognomies resulting from the processes of compression, skewing, etc. not only seemed to speak of individual characters but could also be seen (particularly by observers in later centuries) to evoke 'racial' types on a more collective basis. And we will later see the adoption of Dürer's transformational techniques for heads on a broader basis within the biological theories of growth and form by the Scottish biologist, D'Arcy Thompson.

When we turn, almost inevitably, to Leonardo, there is practically no aspect of his visual scrutiny of the natural world and construction of a 'second nature' in man-made objects that could not potentially be brought under the embrace of geometrical design. In looking at even the most complex aspects of organic morphology, he aspired, in theory at least, to explain every minute feature in terms of the fittingness of form for function in a way that gave his explanation the certainty of a geometrical demonstration. It was in this spirit that he wrote on one of his pages of anatomical investigations—paraphrasing the inscription which Plato is said to have placed above the door of his academy—'let no-one read my principles who is not a mathematician'.[9] There were few occasions on which his geometricizing ambitions were fully

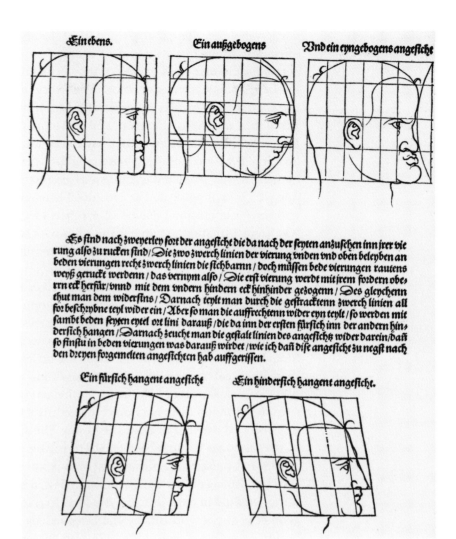

Fig. 46

Dürer, Transformations of the Human Head from Four Books on Human Proportion, 1528

realized—unsurprisingly, because his limited knowledge of the smallest structures, without the advantage of microscopy, and his relatively modest mathematical resources, conspired to constrain what he could accomplish. But he did undertake some nice investigations which show how his vision of organic geometry sought to embrace form and process in addition to the visual harmonics of proportion. The human body, the organic complex to which he devoted most attention, will provide a suitable example to add to the bifurcating system of bronchi in the lungs which we examined near the start of the previous chapter.

When he looked at the valves of the heart, as he did intensively in the dissections of an ox heart that he undertook in the last years of his life, he became fascinated by their dynamic architecture. The pulmonary

aortic valve is the one that yielded most readily to geometrical charac-
terization. It exhibits a three-cusp configuration packed symmetrically
across the circular cross-section of the neck of the aorta. When inflated
by the spiralling vortices of blood in the neck of the aorta, the cusps fill
the aperture and prevent blood expelled from the heart from returning.
Being thin and fleshy, the cusps collapse away from the centre point of
the vessel when the blood is then forced through by the pumping
action of the heart, resulting in a triangular opening through which the
blood can pass. The kind of process of geometrical transformation was
one which he investigated at considerable length in his studies of two-
and three-dimensional geometry. He had specifically planned a book
'On Transformation', studying the rules which govern the volumetric
reshaping of 'one body into another without subtraction or addition of
material'.[10]

The type of transformation that occurred in the cross-sectional con-
figuration of the valve is recognizable in one of his many sheets of
apparently endless variations in equivalencies of area in curved and
rectilinear forms. The kind of geometry apparent in the valve was there-
fore clear to Leonardo, but he could see no muscular mechanism for
its geometrical transformation. He accordingly attributed the successive
filling and collapsing of the cusps to the action of the vortices in the
currents of blood as they poured through the valve and into the pro-
gressively constricted neck of the vessel. The spiralling configurations
of the blood, as it turns back on itself, inflate the cusps momentarily,
until it has pulsed into the aorta. At the next contraction of the heart,
the cusps are again forced open from below, admitting a fresh surge of
turbulent fluid in to the neck of the aorta to recommence the cycle. The
geometry of the vortices, as characterized by Leonardo with all the
beauty of an ionic volute (fig. 47), and the engineering of the valve
provide a perfect illustration of what he called the 'Necessity' of natural
design, that is to say the perfect fitting of form and function in the
context of natural law such that nothing is lacking and nothing is
redundant. In the drawing to the upper right of the sheet, he envisages
the making of a glass model of the neck of the aorta in which his
demonstration could be confirmed. Recent research, involving exactly
the kind of model-building envisaged by Leonardo, coupled with new
imaging techniques, is showing that his envisaging of the flow in the
valve is of extraordinary percipience.[11]

It is this principle that informs the work of the human designer, who
should always, in Leonardo's estimation, aim to work in perfect con-
cord with natural cause and effect, whether striving to invent a 'great
bird' to accomplish man-powered flight—riding the vortices of the air—

Fig. 47

Leonardo da Vinci,
*Vortices of Blood in a
Three-Cusp Valve with
Plan for a Model*,
c.1513, Windsor,
Royal Library, 19079v.

or acting as a water engineer. The same principle is to be observed when
he remakes nature in his paintings, including the devising of ancillary
details. When, for instance, he was contriving a wig for Leda in the now
lost painting of *Leda and the Swan*, he designed the artificial hairpiece
as a complex of intertwined and spiral configurations which work
artificial variations on the natural proclivities of curling hair, which in
turn manifest analogous patterns to water in motion. As he instructs us
in a note beside drawings of turbulent currents of water:

> Observe the motion of the surface of water, which resembles the behaviour
> of hair, which has two motions, of which one depends on the weight of the

strands, the other on the line of its revolving; thus water makes revolving eddies, one part of which depends upon the impetus of the principle current, and the other depends on the incident and reflected motions.[12]

In the case of Leda's wig, his sense of acting decorously towards the principles of natural design could be seen as no more than visual good manners, but when he came to intervene more directly in the workings of nature the obedience became a more weighty matter. For Leonardo, the engineer who does not work in keeping with natural law is courting disaster—as we noted in chapter 2, when we contrasted what happened when the Florentines tried to force the river Arno against its 'will' into a new bed around the rebellious town of Pisa with his own scheme to make a river work with him to shore up a house on its banks.

There was no essential disagreement between Leonardo and Dürer about the primacy of geometrical order in the underlying organization of nature, yet it is worth stressing that the way they articulated their scrutiny of the natural world exhibited fundamental differences. The differences become vividly apparent if we juxtapose their drawings of comparable motifs 'drawn from life', such as Leonardo's *Star of Bethlehem* (fig. 48) and Dürer's study of mixed vegetation in his *Piece of Turf* (fig. 49). Dürer is above all obsessed with a minute account of what the specimen looks like—forcing himself to particularize, organizing his act of seeing so as to deliver what is individual, accidental, and contrary about each part of the whole. Each head of seeding grass is an individual portrait. Each leaf blade stands as an individual in the mixed community of plants rather than as a member of a highly organized collective. The process of individualisation is a hard-won skill that brooks no short cuts. It is applied whether he is depicting a group of plants or portraying a single specimen in isolation.

For Leonardo, the business of seeing and representing is a seamless act of organizational analysis in which the underlying structure is drawn out in such a way that the particular specimen speaks of the general principles behind the form of that particular plant and, indeed, ultimately about the organization of analogous forms and forces

Fig. 48

Leonardo da Vinci,
Star of Bethlehem,
c.1510, Windsor
Royal Library, 12424

in nature. The *Star of Bethlehem* sings a visual hymn in praise of the spiralling beauty of growth and form which we may instinctively feel caresses the foliage into a configuration obedient to the system he believes to be at work rather than particularizing the atypical detail in the manner of Dürer. The gravitational forces of the two artist's visual instincts pull them in contrasting directions. The contrast serves to remind us that comparable intellectual theories do not necessarily result in wholly convergent acts of looking and representing.

Without new visual resources, it is difficult to see how the kind of analyses attempted by Leonardo and Dürer could be taken much beyond the accumulation of comparable examples. There was, as we will see elsewhere in this chapter, a sense that the intuitions and investigative programme were valid but were for the moment simply destined to repeat themselves—assuming the character

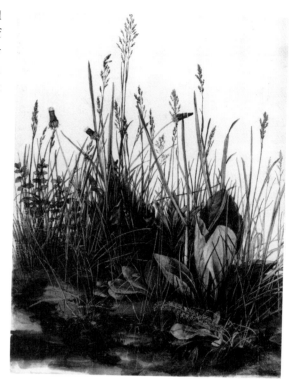

Fig. 49

Albrecht Dürer, *Piece of Turf*, 1503, Vienna, Albertina

of 'so-what science'. Throughout the history of science, we encounter examples of 'so-what science', when the resources reach their limits without apparently delivering more than suggestive description or unresolved analogy. It is not so much that 'so-what science' fails to disclose the cause of the phenomenon—search for the ultimate causal explanation leads inevitably to infinite regress—but that its programme runs out of possibilities that might work towards even a limited causal explanation beyond the characterization of the phenomena themselves. It would be easy to attribute the limits of Leonardo's and Dürer's sciences wholly to their lack of quantification—to their lack of the kinds of mathematical resources at the command of Galileo, Descartes, and Newton. This characterization undoubtedly contains much that is true, but it is not the whole truth. To complete the picture, we need to take into account the levels of scale at which their acts of scrutiny could take place. They were limited to those scales possible within the parameters of the apparatus of the human eye. They could scrutinize things with an intense dedication and with high degrees of knowingness that were and are exceptional, but their technical limits were those that most of us share when we use unaided vision. The telescope, as we saw in the first chapter, brought important new realms into

our visual purview. In terms of the present chapter, the microscope wrought a giant reform into the levels at which patterns could be discerned.

Seeing Small

The reform did not just involve the wonder of seeing 'animalcules' which had previously been invisible, as when the master Dutch microscopist, Anthony von Leewenhoek, somehow managed to see bacteria through his single-lens instrument. The minute structures of wholes and parts at the microscopic level revealed a geometrical architecture that appeared to exceed in precision most of the grosser geometries expressed by larger forms in nature. Some idea of the unexpected wonders of miniature design that were being disclosed can be gained from illustration of the seeds of the Chinese Rose in Giovanni Battista Ferrari's *De Florum cultura* in 1633 (fig. 50), which seems to be the first published plate of microscopic observation in botany. It had been preceded in zoological science by Francesco Stelluti's three-part illustration of a bee, published in an engraved 'broadsheet' by the members of the Accademia dei Lincei, amongst whom was Galileo, in honour of the election of Pope Urban VII in 1625. The family shield of the Pope's family, the Barberini, was adorned with bees as their heraldic emblem. The printed oration explains that Stelluti has 'used a microscope to examine bees and all their parts. I have also figured separately all the members thus discovered to me, no less to my joy than my marvel, since they are unknown to Aristotle and to every other naturalist'. He concludes that, through the revelation of its extraordinary structure, the Pope's 'BEE shows itself even more worthy of wonder'.

Ferrari's seeds were no less wondrous than the Barberini bees, if less heraldically distinguished. Comparing their configuration to a broad bean, he tells us that the 'body' of each grain is 'like pumice or perforated sponge, but minutely'.[13] The geometry of the radiating spines provides a vivid confirmation of the wondrous *disegno* of nature, just as his designs for terrestrial gardens, within which plants could be ordered, serves as representations of 'that Celestial City, that happy hall of eternal stability that is denoted by a square'.[14] Ferrari's book centres upon a sustained dialogue between the artifice of nature and the cultivator's art, including the design of planters as fantasies on classical, geometrical, and organic forms. As he makes clear in his account of a contest between Art and Nature, the inventiveness of human artifice must ultimately yield before God's inventions.

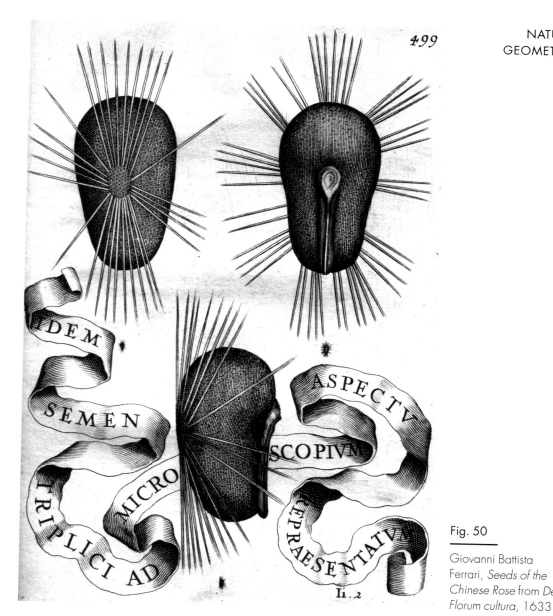

Fig. 50

Giovanni Battista
Ferrari, *Seeds of the
Chinese Rose* from *De
Florum cultura*, 1633

The clearest indications of the visual delights, the perceptual issues
and the philosophical implications of microscopy are knowingly
encapsulated in its first all-round masterpiece, Robert Hooke's *Micro-
graphia*, published in London in 1665. Working in the context of the
newly founded Royal Society, Hooke was commissioned to complete
the project of microscopical observation and representation com-
menced for King Charles II by Sir Christopher Wren, mathematician
and architect. He was dedicated above all to 'plainness and soundness

181

of *Observation*.[15] But, as he well knows, seeing and representing are complex businesses, above all with the 'adding of *artificial Organs* to the *natural*',[16] as is the case with both microscopes and telescopes. The crucial problem is the 'disproportion of the Object to the Organ'[17]—whether the object is too big for the eye or too small, too close or too far away. In this connection, it is significant that he should include, towards the end of his book, a brief section of lunar observations in which he characteristically draws a visual and physical analogy between the surface of the moon and a 'boiling pot of Alabaster'.[18] The key, as Galileo had realized in his studies of the moon, was to be able to translate the seen patterns of lights and darks into a coherent, three-dimensional image with reference to known forms. Thus looking down his microscope, Hooke describes how:

> I have endeavoured (as far as I am able) first to discover the true appearance, and next to provide a true representation of it . . . I never began to make a draught before by many examinations in several lights, and in several positions to these lights, I had discover'd the true form. For is it is exceeding difficult in some Objects to distinguish between a *prominency* and a *depression*, between a *shadow* and a *black stain*, or a *reflection* and a *whiteness in the colour*.[19]

As an example of the perceptual problems, he cites the eye of a fly, which was the subject of one of his most stunning plates (fig. 51):

> The Eye of a Fly in one kind of light appears almost like a lattice, drill'd through with abundance of small holes . . . In the Sunshine they look like a surface cover'd with golden Nails; in another posture, like a surface cover'd with pyramids; in another with Cones; and in other postures of quite other shapes.[20]

Fig. 51

Robert Hooke, *Eye of a House Fly*, from *Micrographia*, 1665

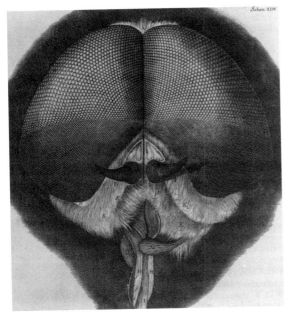

Providing the puzzle of true appearance can be mastered, and accurate draughtsmanship can communicate observations with unrivalled directness: 'more can be expressed in a small Picture of the thing, than can be done by a Description of the same thing in as many words as fill a sheet'.[21] However, illustration is a functional thing, and he cautions that 'Pictures of things which only serve for Ornament or Pleasure, in the Explication of things as can better be describ'd by words is rather noxious than useful'.[22]

The texts he uses to describe the revealed appearances of things of the minute world in his microscope rely repeatedly on the use of analogies with the familiar world of objects visible to the naked eye. This use of resemblance is integral to the act of coherent seeing in a new world of previously unknown forms, and it also serves to underline that the new technology was disclosing ever more minute signs of the microcosmic affinities between things. As he wrote:

> Little Objects *are to be compar'd to the greater and more beautiful* Works of Nature, *A Flea, a Mite, a Gnat, to a Horse, an Elephant, or a Lyon.*[23]

The larger of his folding plates deliberately negate any sense of scale in such a way that minute animalcules can be seen to possess a grandeur of design equivalent to that of large organisms. Thus a moss, as a 'most perfect Vegetable . . . properly be reckon'd with the tall cedar of *Lebanon.*'[24] The flea, as a miracle of micro-engineering, is:

> adorn'd with a curiously polish'd suit of *sable* Armour, neatly pointed, and beset with multitudes of sharp pins, shap'd almost like Porcupine's Quills, or bright conical Steel-bodkins.[25]

Moulds were a particular source of fascination, since Hooke believed that they arose from putrefied vegetable matter without the processes of reproduction and generation which give rise to each normal organism. Each mould assumed the guise of:

> A very pretty body shap'd by concreted mechanical principles, without the least show or probability of any other seminal *formatrix.*[26]

In the case of mosses, he uses one of his characteristic analogies to explain how they arise from the decayed components of 'higher' forms. He envisages that a clock falls to pieces and is reassembled by someone who has no sense of what a clock is and what it does. Its design remains mechanical in character, even disassociated from its original mechanism.

Throughout the miniature world, he discovered miracles of mechanical construction according to the strictest principles of geometrical design. The compound eye of a fly, which permits it to see across a wide field of vision without being able to rotate its eye or significantly turn its head, is a spectacular case in point. To emphasize the kinds of principles of contrivance at work, he opens his sequence of numbered 'Observations' with works of human artifice, surprising us with the roughness of the point of a needle, before progressing to other 'Bodies of a *simple nature*', such as the crystalline structures visible in frozen urine. He next looks at components of plants, such as cork, wood, and

moulds, and then at parts of animals (including the eye of the fly). His exposition of the minute world culminates in his pictures of the whole bodies of small insects. Again and again, the mechanical geometry of natural design is made manifest.

It was this thrilling and unexpected world of minute geometry that gave Nehemiah Grew's *The Anatomy of Plants* in 1682 its compelling and beautiful character. The publications by Grew, who made his living as a physician, owed their origins to the same circle of Royal Society pioneers that included Hooke and Wren, and it was the latter who produced the official authorization of Grew's collected work on *The Anatomy of Plants*. The text and remarkable illustrations (fig. 52)—some displaying microscopic sections on grand folding plates to register the full details in all their glory—sing hymns in praise of God's miraculously precise regulation of minute order in variousness. To reveal the 'Various and Elegant' features on the smallest scale, Grew emphasizes the microscope's role as an agent of 'undeceitful and accurate Observation'.[27] In the letter of dedication he tells us that 'one who walks with the meanest *Stick*, holds a piece of *Nature's Handicraft* which far surpasses the most elaborate *Woof* or *Needle Work* in the World'.[28] This analogy, of a type characteristic of Grew no less than Hooke, is later developed when he is discussing the fibres in stems:

> *Fibres* are transversely continued, thereby making a *Warp* and *Woof*; So are they (as in divers woven *Manufactures*) of very different *Bulk*; those of the Former being much bigger, and therefore much stronger, than those of the latter. By which means, as *Cloth* or *Silk* will often Tear one way, and not another, so here, while the *Warp* of those *Fibres* which are spirally continued, are usually *unroaved* without breaking; thin smaller ones, by which they are *stretched* or *woven* together, easily tear in sunder all the way.[29]

Although it is the microscopical order that attracts Grew's primary attention, he also provided geometrical illustrations to show how 'the leaves of most *Plants*, have a regular *Figure*, and this Regularity, both in length and Circuit [is] always definable'.[30] It comes as no surprise to find that he was attracted to the study of the geometry of 'icicles' in snow, a topic which we will encounter shortly in a treatise by Kepler.

The revelations of the microscope lead to the inevitable conclusion that the rule of mathematical principles is no less inherent in minute appearance than in musical harmonics. Hooke, like Wren, was a keen student of acoustics, speculating that the harmonies of periodic vibrations caused by notes—as made visible in the ripples that arise when a violin bow is drawn across the rim of a tumbler of water—could be regarded as analogous to the causes and effects of colours.

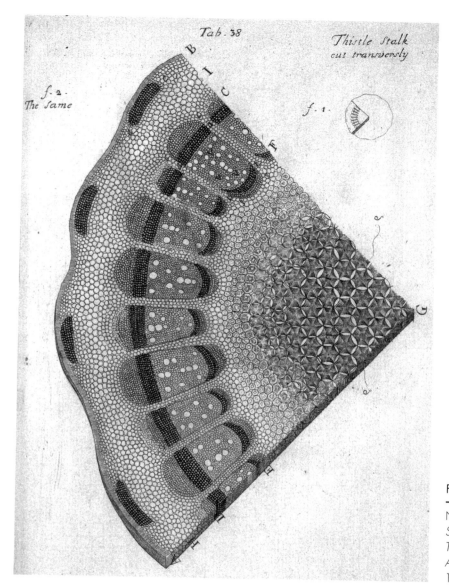

Fig. 52

Nehemiah Grew,
*Section of the Stem of
Thistle,* from *The
Anatomy of Plants,*
1682

Hooke's citing of hexagonal patterns in frozen urine knowingly
plays towards what was already a *locus classicus* of nature's geometry;
that is to say frozen water in the form of snow crystals. Johannes
Kepler, that most insistently geometrical of cosmologists, had already
composed a small unillustrated treatise specifically in honour of *The
Six-Cornered Snowflake* (1611). Offered as a 'New Year's Gift' to his
'Imperial Majesty', John Matthew Wacker, it is a sprightly and specula-
tive expression of delight, wonder, and some perplexity in the face of
such marvellous regularity. His account of what triggered his thoughts
gives a nice idea of its tone:

Specks of snow fell here and there on my coat, all with six corners and
feathered radii. 'Pon my word, here was something smaller than any drop,
yet with a pattern; here was the ideal New Year's gift for the devotee of
Nothing'.[31]

The jest that his patron is a 'devotee of Nothing' probably makes a
philosophical play on the supreme abstraction of pure geometry, in
which its fundamental unit, the point, is literally 'nothing' since it is
without physical dimension.

The question Kepler wishes to answer is: what agent can we identify
as the cause of the six-corned configuration? Before doing so, he notes
the most spectacular of nature's other six-sided constructions, the cells
in bees' honeycombs:

The architecture is such that any cell shares not only six walls with the six
cells in the same row, but also three plane surfaces on the base with three
other cells from the contrary row.[32]

The geometrical packing, which he also compares to the seeds in a
pomegranate, is attributed to a physical process similar to that observed
when pellets are systematically compressed in a round vessel. But
the regularity of the physical actions must themselves be caused by
something, and Kepler concludes that God 'prescribed to it [the bee]
those laws of its architecture' which resulted in geometrical forms.[33]

The polyhedral architecture of the snowflake yields nothing in
perfection to animate creations. He notes that the dodecahedron
and icosahedron 'cannot be found without the divine proportion'
(the 'Golden Section') and that the ratio of the divine proportion is
equivalent to that of successive arithmetical terms in the Fibonacci
series, as we will see later. Such mathematics is also manifest in the
world of plants:

It is in the likeness of this self-developing series that the faculty of propaga-
tion is, in my opinion, found; and so in a flower the authentic flag of this
faculty is flown, the pentagon.[34]

And, having reviewed inconclusively, a range of physical explanations
for the forms of the snowflake, he concludes that:

the cause of the six-sided shape of the snowflake is none other than that of
the ordered shapes of plants and numerical constants.[35]

This cause is the 'formative virtue'—the *facultas formatrix*—which God
has insinuated into matter in terms of 'world-building figures'.[36] But,
in the final analysis, Kepler senses that something is missing in his
understanding of that matter in its own right, and he concludes by
announcing that 'I have knocked at the door of chemistry . . .'[37]

Constructive Geometries

In the three centuries following Kepler's enquiry, a series of investiga-
tors—most often mathematicians and astronomers with a taste for the
natural rather than natural historians—returned to the classic instances
of nature's constructive geometry—the snowflake, the webs of spiders,
the honeycombs of bees, the shells of marine creatures, and the
arrangements of parts in plants. A characteristic visual expression is
found in Mario Bettino's illustration of a spider's geometrical creation
above a formal avenue of trees in his *Apiaries of Mathematical Philosophy*
in 1645, which explores nature's garden of mathematical wonders,
including, inevitably, honeycombs. Continuing the astronomers'
bent, Gian Domenico Cassini, the Italian who came to dominate
French astronomy after his move to Paris in 1669, illustrated the pretty
geometry of the snowflake, while the far from easy mathematics of
the honeycomb were studied by his nephew, Giacomo Filippo Maraldi
in the garden of Cassini's observatory in Paris. The snowflake attracted
the attention such distinguished investigators as Descartes, Thomas
Bartholin, and Hooke (whose influential illustrations owed much to
Bartholin). The geometry of the bees' cells had proved to be an
enduring bone of contention from the ancient times of Pappus of
Alexandria. It appeared at one stage that the bees knew more than the
best mathematicians, including Christopher Wren, and the angle of the
faces at the base of their cells still warranted a substantial historical
review by D'Arcy Thompson in 1917.

Like Bettino, the English physician and mystic, Thomas Brown(e)
cast his net wide in a search for the high 'Geometry of Nature'. His
eccentric little treatise, *The Garden of Cyrus*, published in his *Works*
in 1686, is picturesquely subtitled, 'the Quincuncial, Lozenge, or Net-
work Plantations of the Ancients, Artificially, Naturally and Mystically
Considered'. Ostensibly concerned with the 'elegant ordination of
vegetables' in gardens, he touches on a huge range of mathematical
patterns in nature, ranging from snakes' skins to artichoke leaves, and
from catkins to battle formations. He hailed the 'sexagonal Cells' of
bees as 'edificial Palaces',[38] but his greatest delight was reserved for
quicuncial of five-part harmonies which are characteristically found in
plants. Like Runge was later to do, he discerned that many types of leaf
could be inscribed within a pentagon, because 'Nature delighteth' in
five.[39] Looking at 'Leaves successively rounding the Stalk', he observed
that 'in many round-stalked plants, the Leaves are set in Quintuple
ordination, the first Leaf answering the fifth in lateral disposition'.[40]

Faced with a plethora of natural fives, Brown is in no doubt about the ubiquity of the rule of number and measure in the design of nature, and he leaves us in no doubt that it reveals itself to those acquainted with scripture and the deepest secrets of ancient wisdom.

Alongside such general discussions, particularly fertile traditions of specialist study were built around the configurations of shells and of leaves in plants, and it is on these I intend to concentrate briefly, through a few selected examples from the seventeenth to nineteenth centuries.

Two instances of visual devotion to shells, one from Jesuit Italy and the other from Protestant England, will serve to lay down the basic motifs. Filippo Buonanni's *Recreation for the Eye and for the Mind in the Observation of Snails*, published in Rome in 1681 makes particular play on the dialogue between the order of nature, citing the by now familiar litany of phrases—the 'providence of God', 'divine artifice', 'marvels of nature', 'clockwork', the 'theatre of the world', etc.—and the God-given pleasure which the mind receives from the viewing of that order.[41] The human eye, Buonanni stresses, is definitively distinct from that of the 'brutes' precisely because it is designed as the miraculous instrument which participates in the revelation of God's natural geometrical propensities, not only in shells but also in other such instances as the structure of crystals, snowflakes, and geometrical packing, as in honeycombs. He cites, for example, 'grains of sand which under the microscope look like large balls of culverine'.[42] Buonanni's mathematics are hardly sophisticated, but he does argue consistently that the basic geometrical templates, the sphere, the cone, the spiral, etc. arise as a matter of utter necessity as 'formative virtue' exercises its irresistible logic in the shaping of matter.[43] The geometry of the 'turbinated' form, which attracts particular attention, is expounded in terms of an Archimidean or equable spiral of equal revolutions formed by successive semi-circles in the manner of Vitruvius's ionic volute. With considerable insight, the particular form of the base of the shell is understood in terms of the mechanics of the motion of the snail's foot.

A brilliant visual catalogue of the manifold variations which arise around the few basic shell types was provided by the English physician and fellow of the Royal Society, Martin Lister. His *Historia . . . conchyliorum*, published in four books between 1685 and 1692 and superbly illustrated by his wife Ann and daughter Susan, takes the form of a 'paper museum' organized taxonomically, with each carefully delineated specimen 'shelved' or 'boxed' systematically on the appropriate page. Line illustrations below the shells in the illustrated page show the 'fractal' junctions visible on the surface of the growing

shells. The printed figures exploit curved and swelling lines engraved into the surface of copperplates to endow the images with a compelling sense of real existence within and even overlapping their engraved frames, and with a beautiful air of graphic elegance which emulates the linear grace of the shells themselves (fig. 53). The Listers' microscopical studies of the internal anatomies of the molluscs revealed the same repertoire of forms at tiny levels of organization. The cumulative effect of the succession of plates is to provide almost musical variations on morphological themes. A sense of geometrical organization is inescapable, but Lister has the instincts of a specialist natural historian and physiologist rather than that of a cosmic mathematician. His impulse is to describe and classify, according to similarity and difference—minutely and patiently characterized—rather than to formulate mathematical laws for shell-archetypes. Lister is serving God no less than Buonanni, but he does so primarily by inculcating a reverence for the infinite variety of the Aristotelian natural world rather than a mystical insight into the Platonic geometry of the divine brain.

A key step in the mathematicizing of plant morphology was undertaken in the early eighteenth century by Guido Grandi, editor of Euclid and of the first Florentine edition of Galileo's works, who was an innovatory mathematician of curves. In his *Flores geometrici ex rhodenearum et coeliarum curvarum descrptione resultantes* (*Geometrical flowers resultant from an account of rhodean and clelian curves*) in 1728, he explored how, for example, a construction of curves (subsequently known as 'Grandi's curves') could be observed in flower forms with five and six petals. His illustrations combine complex geometrical constructions with allusions to organic form.[44] The 'rhodean' curve of his title was derived from the Greek for rose, in spirit with the naturalising geometrical terminology we observed with Dürer. Grandi's sense of mathematics in the structures of material things is also expressed in his essay on an architectural-geometrical problem posed by Vincenzo Viviani, Galileo's leading pupil. The problem required the design of a cupola with four windows in such a way that the remaining area of the cupola is quadrable (i.e.

Fig. 53

Martin Lister, *Shell of Cochleis Fluviatilibus,* from *Historiae Conchyliorum,* 1685–92

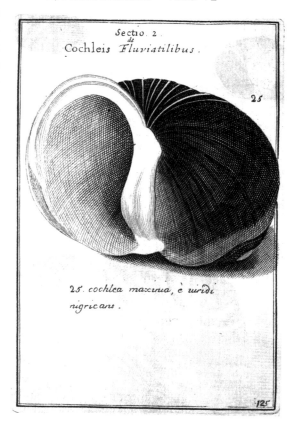

Sectio 2
de
Cochleis *Fluviatilibus.*

25

25. cochlea maxima, è viridi nigricans.

125

'squared' to determine its area), and involved understanding the loga-rithmic curve, which was attracting much attention from leading geometers. It was the logarithmic curve and spiral that were to provide the most productive tools for the mathetmaticizing of morphogenesis in the natural sciences, as we will see later.

The Poetry of Form

In the wider world of letters and arts, the inherently geometrical organization of form and growth in plants that was being progressively disclosed by geometrical analysis attracted two supreme students in late eighteenth- and early nineteenth-century Germany—although to characterize either Johann Wolfgang von Goethe or Philipp Otto Runge as belonging exclusively to the 'world of art and letters' is far too simple. Alongside Goethe's renowned literary output, he published works which specifically addressed scientific questions, most notably his *Versuch die Metamorphose der Pflanzen zu erklären* (*An Attempt to Explain the Metamorphosis of Plants*) in 1790, and *Farbenlehre* (*Theory of Colours*) in 1810. Runge, for his part, also published an important treatise on the science of colours, inventing a particularly beautiful colour solid.[45]

Goethe's scientific endeavours were generally received with unease, coming as they did from an 'outsider', and given his reluctance to confine himself to modes of analysis sanctioned within the world of professional science. Goethe regarded analysis as best directed by the deepest faculties of personal insight possessed by the individual human observer:

> What is all this intercourse with nature if by the analytic method we will merely occupy ourselves with the individual material parts, and do not feel the breath of the spirit, which prescribes every part its direction, and orders, or sanctions, every deviation by means of an inherent law![46]

The consequence is not to proscribe the study of parts in favour of wholes but to discern subjectively, in a minutely reverent attention to the parts, the greater spirit with which they are infused.

The goal of Goethe's studies of natural history was the perception of unities or commonalties of type behind the endless diversities of appearance, such that the archetypal (or *Ur-*) form could be inferred behind each individual part. The *Ur-form* is defined as an 'instance in a thousand, bearing all within itself'. Such an archetype was the true sign of:

Him [God], whose creative wealth permitted him to create after many
thousand plants, a plant in which all the rest are contained, and to produce,
after many thousands species of animals, a being that contains them all—
namely man.[47]

In the case of plants, the archetype of its lateral and terminal parts is
the *Urblatt* (the 'leaf archetype' or 'primal leaf'). This theory has been
widely caricatured and misinterpreted, and it is not easy to summarize
it without making it seem risibly simplistic—as when the idea that
'everything in a plant is leaf' is made to stand for the whole theory.
Indeed Goethe's own initial and much-quoted formulation, on his
Italian travels, lends itself to schematization:

Hypothesis: all is leaf.

This simplicity makes possible the greatest diversity.[48]

In trying to avoid over-simplification and make sense of a set of
demanding notions, it is easier to begin by defining what he is *not*
saying. He is not saying that all plant parts *evolved* (in the modern sense)
from primordial leaves or that they *developed* (in terms of modern
morphogenesis) from embryonic leaves during the germination and
growth of each plant according to a set programme. It is 'primal' but not
in a rigidly chronological sense. Nor is he promoting his *Urblatt* as the
ideal Platonic leaf, of which all the parts of individual specimens are but
imperfect reflections. And he is not according any actual leaf privilege
over the petal, the sepal, the stamen, or the cotyledon. Each real leaf is as
much a variation on the *Urblatt* as is a stamen. The 'leaf archetype' has
no existence as such. Rather it is a supreme exemplar of the kind of
organizing and generative template (or metaphysical 'form') which the
discerning student can recognize as expressing the principles of unity
on which God has constructed the manifold varieties of nature. What
determines the actual form of each leaf-type is the action of directional
and cyclical factors as shaping quotients in real nature which meta-
morphose the intelligent principle of the archetype. There are three
types of metamorphosis: regular, according to the vivacious ascent
of the plant; irregular, according to contrary motions of decline; and
accidental, according to infestation, disease, and damage.

The directional factor decrees a hierarchy in which the upper parts are
exactly that—'higher' in a spiritual as well as a physical sense, closer, as
it were, to heaven. His little book is arranged in this spiritual sequence,
commencing with the lowly and gross cotyledons of the germinating
seed. The vehicle of refinement in the plant is the sap, which becomes
purified by a kind of filtration as it ascends through successive layers

of leaf-type forms. As the dross is drained off, so the leaf-type forms are able to adopt their most refined manifestations in the petals and parts of the inflorescence:

> We see the leaves finally reach their fullest expression and elaboration, and soon thereafter we become aware of a new aspect, apprising us that the era we have been studying has drawn to a close, and that the second is opening—the era of the flower.[49]

The cyclical coordinate works around this directional core, according to successive waves of contraction and expansion. Above the base and contracted cotyledons of the seed arise the expanded green leaves, which in turn gather to produce sepals, before their expansive flowering in the radiant petals. The pistil and stamens represent the next compression, and the final expansion occurs with the abundance of the growing fruit. He recognizes that the successive sequences of parts around the core characteristically arise as 'products of spiral vessels',[50] the germs of which are visible microscopically. The forms that result are expressions of 'elementary forces' ('vegetable' and 'reproductive') in the context of the elasticity and tensions of the living matter of the plant.

The way in which each diverse member arises from systematic transformations of the *Urblatt* shares much in common with Dürer's transformational procedures (fig. 46), and with Pieter Camper's more nearly contemporary analysis of varied head types and facial features in terms of Düreresque schemas, which we will encounter in the final chapter. Diversity, revealed through a meticulous programme of dissection and description across multitudinous species, is to be respected no less than generality, since it is only through the most minutely comprehensive apprehension of the parts that the underlying whole can be intuited. The *Urblatt* is not some crude underlying schema or neat Platonic Idea, but a living principle of the highest spiritual subtlety. It is his concern to promote the notion of the archetype as an intelligent principle rather than an actual form that helps to explain why Goethe provided no illustration of it. His work is, as he says, 'preliminary' both in the sense of 'hypothetical' and in the 'preparatory' sense for the scrutiny of living plants. At this stage of his endeavour, the diversity to which he wishes to alert the reader was no more to be reduced to a limited selection of concrete visual examples than the metaphysical archetype was to be rendered concretely specific by depicting it.

The qualitative thrust of Goethe's botanical theories is so dominant that he belongs as much with the theorists of the previous chapter as with the pattern-seekers in our current sequence, but the potential

of his vertical and cyclical coordinates for mathematical modelling is readily apparent. The closest visual realization of the spiritual forces at work in Goethe's world of plants is provided by his one-time friend and correspondent, Runge. And it is Runge who gives geometrical form to the templates in a way that Goethe was reluctant to do. His *Morning* which we set beside Thornton's effusions in the previous chapter (fig. 54) positively bursts with expansive urges and vertical strivings. The whole visual impetus of the picture is towards the heavenly

Fig. 54

Philip Otto Runge,
*Geometrical Study
for 'Night'*, 1809,
Hamburg, Kunsthalle

radiance. The penumbral lower zone of the genii trapped in the cages of the roots is relieved only by the compromised light of the eclipsed sun, while the ethereally pale flowers bear their bright charges to the radial burst of divine radiance above the inner frame. An underlying geometry articulates the harmonies of form and colour into a rich visual music. A constructional drawing for a related composition of *Day* (fig. 42) demonstrates the type of elaborate geometrical armature that lies beneath the surface of such pictures, while his studies of individual elements of plants show the kind of geometry he saw as inherent in the details of natural form. His study of a *Cornflower* analyses the inflorescence in terms of concentric sequences. The stamens are set in four expanding rings of four, while the petals radiate in clock of twelve units. Such a quest for organizational geometry is part of a broader programme to establish the universal harmonics that run through all the underlying principles of Nature, including the rationale of colour. This programme is all of a piece with Runge's interest in the kind of seventeenth-century mysticism that we encountered when we illustrated the harmonic ideas of Athanasius Kircher.

Runge's kind of visual dialogue between the absolute regularities of geometry and the contingencies of nature is nowhere more urgently central in nineteenth-century art than in the protean theories of John Ruskin. Such was the elasticity of Ruskin's embrace that he could simultaneously advocate complete submission to natural law and revel in high imaginative 'fancy'. Between the poles of mathematical exactitude—regular and stable—and organic vitality—irregular and mobile—lay fields of infinitely fertile potential for natural form. When instructing the tyro to draw regular forms freehand, he juxtaposes the shield of St George with a bird's feather. The feather is represented in natural glory with a gently curved central 'spine', while the shield is rigorous in its mathematical symmetry. Ultimately, he leaves us in no doubt that the variousness of the beauty of nature, orbiting around inherent geometry, is superior to the raw geometry itself:

> The curve which terminates the hen's feather pleases me, and ought to please *you*, better than the point of the shield, partly because it expresses such relationships between the length of the filaments and the plume as may fit the feather to act best upon the air, for flight; or in unison with other such softly inlaid armour for covering.[51]

The moral for the designer is to avoid the unnatural regularity of geometry as manifested in the strictest kind of classical architecture and to cultivate the organic sense of living form which he sees as

characteristic of the best of Gothic design. Thus the tyranny—with all the social implications carried by that term—of an 'Attic' style of ash leaf 'on the Greek principles' stands in unpleasant contrast to the liberating vitality of the growing formation, in which the stalks 'spring *precisely as a Gothic vaulted roof springs*' (fig. 55).[52] Looking at his beloved Gothic, he finds no shortage of examples of the mediaeval masons incorporating such beautiful 'innocence' of natural form. When lecturing in Edinburgh in 1853, he pointed to the decoration surrounding the west window of Dunblane Cathedral:

Fig. 55

John Ruskin, *Attic and Natural Ash Leaves* from *Lectures on Architecture and Painting*, 1891

> For he was no common man who designed the Cathedral of Dunblane . . . And just in proportion to his power of mind, that man was content to work under Nature's teaching; and instead of putting merely a formal dogtooth, as everybody else did at the time, he went down to the woody bank of the sweet river beneath the rocks on which he was building, and he took up a few of the fallen leaves that lay by it, and he set then in his arch, side by side, for ever.[53]

There are clear signs that Ruskin perceived such natural patterns not just in terms of static beauties, but in more dynamic and temporal terms. The artist is exhorted to see natural contours as signals of life:

> In a wave or cloud . . . leading lines show the run of the tide and of the wind, and the sort of change which the water or vapour is at any moment enduring in its form, as it meets the shore, or counter-wave, or melting sunshine. Now remember, nothing distinguishes great men from inferior men more than their always, in life or in art, *knowing the way things are going*. Your dunce thinks they are standing still, and draws them all fixed; your wise man sees the change or changing in them, and draws them so,—the animal in its motion, the tree in its growth, the cloud in its course, the mountain in its wearing away. Try always, whenever you look at a form, to see the lines in it which have power over its past fate and will have power over its futurity . . . Those, then are their fateful lines.[54]

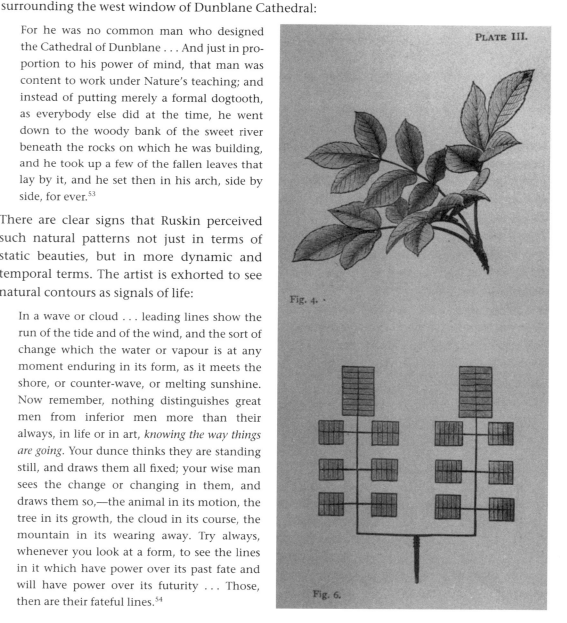

PLATE III.

Fig. 4.

Fig. 6.

Like the intuitions of Goethe, Ruskin's insights were more qualitative than quantitative. The next move within science, of which neither man might have approved, was to place the dynamics they discerned in natural growth and form on to a more precisely mathematical base.

Logarithmic Analyses and Fibonacci Forms

The elegant mathematics applied to natural forms in the seventeenth and eighteenth centuries was to be placed on to a far more intimate basis by the Revd Henry Moseley in the nineteenth—in the era which, as we have seen, was characterized by a drive to mathematics as many sciences as proved possible. Writing in the 1830s and 1840s, Moseley explored the geometrical configurations of univalve shells. His paper 'On the Geometrical Form of Turbinated and Discoid Shells' was hailed as 'one of the classics of natural History' by D'Arcy Thompson, who quoted with apparent approval Moseley's homily that 'God hath bestowed upon this humble architect [the mollusc] the practical skill of a learned geometrician'.[55] Moseley undertook a dense and sophisticated mathematical analysis of various shell types, replete with complex formulae, on the basis of an unshakeable conviction that 'providence has subjected the instinct which shapes out each to a rigid *uniformity* of operation'.[56] Underlying the types of shells are simple 'generating figures', somewhat in the manner that we will later see at work in fractal geometry, with its iterative procedures and properties of 'self-similarity' at different scales. Indeed, one of his hypotheses states that 'the form of the Mollusk' is 'supposed to remain geometrically similar to itself' as it changes its dimensions.[57] The generating figure for the *cornus virgo* is a triangle; *trochus* shells a trapezoid; and *trurbo* a curve, 'to whose perimeter the axis of revolution is a tangent', such that 'the spiral of the operculum is thus a logarithmic spiral'.[58] The logarithmic or equiangular spiral, the properties of which were first properly analysed by Descartes in 1638, exhibits whorls which continually increase in breadth according to a fixed ratio. The ideal form of a 'logarithmic' shell may be envisaged as a coiled cone.

In those shells generated by revolution around a fixed axis, mathematical analysis reveals the 'value of the constant angle . . . connected by a necessary relation with the economy of the material of each, and with its stability, and the conditions of its buoyancy'.[59] Above all, Moseley stresses the divine artistry by which material is shaped according an inexorable will to form:

There is traced in it [the turbinated configuration] the application of
properties of a geometric curve to a mechanical purpose of HIM who metes
the dimensions of space and stretches out the form of matter according to
this perfect geometry—properties which, like so many others in nature, may
also have their application to art'.[60]

The main vehicle for Moseley's 'application to art' was not his own
highly technical paper but the sections inspired by the Reverend
mathematician in Thompson's 1917 book, which is to establish our
terms of reference in the following chapter.

As with shells, a fully developed programme to explore the nature
of spiral systems in plant phyllotaxis was only undertaken during the
nineteenth century. The climactic work was undertaken by Arthur
Church, and laid out in a series of publications around 1900. Although
his project for a set of beautifully-illustrated volumes on *Types of Floral
Mechanism* remained unfinished, the plates he did publish succeeded
in setting the standard. Church elucidated a series of mathematical
patterns, for instance the 2+3 phyllotaxis of leaves and the 8+13
arrangement of the stamens in *Helleborus foetidus*. He was pleased to
note that the theoretical angle of divergence was 137.5° for successive
elements when the phyllotaxis conformed to an equiangular spiral, an
angle which exhibited a 'conformity' with the 'normal Fibonacci series'.

The Fibonacci series, named after Leonardo Fibonacci of Pisa, the
thirteenth-century mathematician, consists of the successive addition
of pairs of numbers such that the higher number of the previous
addition is added to the product of that addition, beginning with 1+1
and proceeding indefinitely: thus 1+1=2, 1+2=3, 2+3=5, 3+5=8, 5+8=13,
and so on. This series, generated by such innocent means, proved
to possess numerous properties of high mathematical interest. For
instance, in our present context, the ratio of successive numbers in the
series progressively converges on that of the 'golden section'; that is to
say 1:1.618 . . . Or, to express the term in a different way, the successive
intervals converge on the limit of $(\sqrt{5}-1)/2$. If we apply the ratio to the
division of a circle, we find that it results (to the nearest approximation)
in an inverse angle of 137° 30′ 27.95″. Church's 'conformity' uses the
rougher approximation of 137.5°. In a phyllotaxis in which the leaves
are set successively around a stem at a divergence angle of 137.5°, no
leaf would be precisely above any other—an arrangement that might
appear to confer distinct advantages in giving even lower leaves access
to light. Church himself considered that such patterns represented a
'definite aim on the part of the organism', although 'the reason for such
a mechanism of symmetry is still far to seek'.[61] It is the quest for this
'reason' that is to occupy the next chapter.

1. Athanasius Kircher, *Misurgia universalis*, (Rome: Francesco Corbeletto 1650), X

2. St. Augustine, *De Civitatae Dei*, XXII, 24, 4

3. Vitruvius, *Ten Books on Architecture*, IV 1, tr. M. Hickey Morgan (New York: Dover, 1960)

4. Leon Battista Alberti, *On the Art of Building in Ten Books*, I 10, tr. Joseph Rykwert, Neil Leach, and Robert Tavernor (Baridge, Mass: MIT Press, 1988)

5. Alberti, *On the Art of Building in Ten Books*, VII 8

6. Albrecht Dürer, *Instruction on Measurement* as *The Painter's Manual*, ed. Walter Strauss, (New York: Strauss, 1997)

7. See Martin Kemp, *The Science of Art*, (London and New Haven: Yale University Press, 1990), p. 56

8. Albrecht Dürer, *Vier Bücher von menschlicher Proportion*, (Nuremberg: Jeronymus Formschneider, 1528)

9. Leonardo da Vinci, Windsor 19118r; Martin Kemp, *Leonardo da Vinci: The Marvellous Works of Nature and Man* (Oxford, 2006), p. 293

10. Leonardo, London, Victoria and Albert Museum, MS Forster I 3r; Kemp, *Leonardo*, p. 250

11. Mory Gharib, Martin Kemp, David Kremmers and Manoochehr M. Koochesfahani, 'Leonardo's vision of flow visualization', *Experiments in Fluids*, XXXIII, 2002, pp. 219–23

12. Leonardo, Windsor 12579r

13. Giovanni Battista Ferrari, *Flora over Cultura di Fiore*, (Rome: Facciotti, 1638), p. 494

14. Ferrari, *Flora over Cultura di Fiore*, p. 23

15. Robert Hooke, *Micrographia*, (London: Martyn and Allestry, 1665), preface

16. Hooke, *Micrographia*, preface

17. Hooke, *Micrographia*, preface

18. Hooke, *Micrographia*, p. 242

19. Hooke, *Micrographia*, preface

20. Hooke, *Micrographia*, p. 175

21. Robert Hooke, *Posthumous Works*, 1704, p. 64 (facsimile ed., London: Frank Cass, 1971)

22. Hooke, *Micrographia*, p. 175

23. Hooke, *Micrographia*, preface

24. Hooke, *Micrographia*, p. 134

25. Hooke, *Micrographia*, p. 210

26. Hooke, *Micrographia*, p.130

27. Nehemiah Grew, *The Anatomy of Plants*, (London, 1682), p. 72

28. Grew, *The Anatomy of Plants*, preface

29. Grew, *The Anatomy of Plants*, pp. 117–18

30. Grew, *The Anatomy of Plants*, p. 150

31. Johannes Kepler, *A New Year's Gift, or On the Six-Cornered Snowflake*, (Frankfurt, G. Tampach, 1611), facsimile Oxford, 1611, pp. 6–7

32. Kepler, *Six-Cornered Snowflake*, pp. 9–11

33. Kepler, *Six-Cornered Snowflake*, pp. 18–19

34. Kepler, *Six-Cornered Snowflake*, pp. 20–1

35. Kepler, *Six-Cornered Snowflake*, pp. 32–3

36. Kepler, *Six-Cornered Snowflake*, pp. 34–5

37. Kepler, *Six-Cornered Snowflake*, pp. 44–5

38. Thomas Brown(e), *The Garden of Cyrus, or the Quincuncial Lozenge, or Net-Work Plantations of the Ancients, Artificially, Naturally and Mystically Considered*, (London: Charles Browne, 1686), p. 38

39. Browne, *The Garden of Cyrus*, p. 37

40. Browne, *The Garden of Cyrus*, p. 34

41. Filippo Buonanni, *Ricreatione dell-occhio e della mente nella osservatione delle Chiociole*, (Rome; Varese, 1681), eg. pp. 300–1

42. Buonami, *Ricreatione dell-occhio e della mente nella osservatione delle Chiociole*, p. 300

43. Buonami, *Ricreatione dell-occhio e della mente nella osservatione delle Chiociole*, p. 305

44. Guido Grandi, *Flores Geometrici ex Rhodonearum, et Cloeliarum curvarum descriptione resultants*, (Florence: Regiae Celsitudinis, 1729)

45. See Kemp, *The Science of Art*, 1990, pp. 295–7, and plate VIII

46. Johann Wolfgang v. Goethe, *Versuch die Metamorphose der Pflanzen zu erklären*, (Gotha, 1790), translated in Adolph Portmann, *The Living Form and the Seeing Eye*, (Problems in Contemporary Philosophy, vol. 20, Lampeter: Edwin Mellen, *c*.1990)

47. Goethe, *Versuch die Metamorphose der Pflanzen zu erklären*

48. Goethe, *Versuch die Metamorphose der Pflanzen zu erklären*

49. Goethe, *Versuch die Metamorphose der Pflanzen zu erklären*, p. 16 §28 trs. p. 215

50. Goethe, *Versuch die Metamorphose der Pflanzen zu erklären*, p. 37 §60 trs. p. 224

51. John Ruskin, *The Laws of Fésole*, (Orpington: George Allen, 1879)

52. John Ruskin, *Lectures on Architecture and Painting*, (Orpington: George Allen, 1891) p. 20

53. Ruskin, *Lectures*, pp. 29–30

54. Ruskin, *Elements of Drawing*, (London, 1857, New York: Dover, 1995), para 104

55. Rev. Henry Moseley, 'On the Geometrical Form of Turbinated and Discoid Shells', *Philosophical Transactions of the Royal Society*, 1838, part II, pp. 351–70

56. Moseley, 'On the Geometrical Form of Turbinated and Discoid Shells', p. 359

57. Moseley, 'On the Geometrical Form of Turbinated and Discoid Shells', p. 360

58. Moseley, 'On the Geometrical Form of Turbinated and Discoid Shells', p. 351

59. Moseley, 'On the Geometrical Form of Turbinated and Discoid Shells', p. 361

60. Moseley, 'On the Geometrical Form of Turbinated and Discoid Shells', pp. 354–5

61. Arthur Church, *Types of Floral Mechanism*, (Oxford: Clarendon Press, 1908)

7 | GROWTH AND FORM

W hat we have witnessed in nineteenth-century art and natural science in the latter parts of the previous chapter is the concept of what might be called 'living design', in terms of growth, action, and articulation of certain principles along novel courses, rather than the assigning of a fixed pattern according to God's taste for geometry. The climax of the exploration of the geometry of nature in terms of the dynamics of growth and physical process is to be found in the work of D'Arcy Wentworth Thompson, the redoubtable Scottish biologist and man of letters. A passage from the introduction to his classic book, *On Growth and Form*, first published in 1917, immediately suggests an intuitive affinity with Ruskin's sense of the life of forms, now transmuted into a specific doctrine of morphogenesis:

> The waves of the sea, the little ripples on the shore, the sweeping curve of the sandy bay between the headlands, the outline of the hills, the shape of the clouds, all these are so many riddles of form, so many problems of morphology, and all of them the physicist can more or less easily read and adequately solve: solving them by reference to antecedent phenomena, in the material system of mechanical forces to which they belong, and to which we interpret them as being due. They have also, doubtless, their *immanent* teleological significance; but it is on another plane of thought from the physicists that we contemplate their intrinsic harmony and perfection, and 'see that they are good'.[1]

In the second edition of *On Growth and Form*, he makes explicit reference to the Greek notion of 'holism' which 'is exhibited not only by a lyre in tune, but by all the handiwork of craftsmen, and by all that is "put together" by art or nature'.[2]

D'Arcy Thompson, who spent his long professional career in Dundee and St Andrews on the East coast of Scotland, enjoys nothing like the same exposure as John Ruskin, which is hardly surprising given the often technical nature of the theories he was propounding. However, his *magnum opus*, in the successive editions on which he continued to work until his death in 1948, has rightly been hailed as a great work of scientific *literature*, and stands as a masterpiece of English prose in any field. He was a figure of extensive learning—a master of Greek and Latin—gifted with deep insights into natural form and endowed with a high level of mathematical understanding. He will serve as the worthy hero of the opening part of this chapter.

Ruskin's influence on art and architecture needs no stressing. I think it is fair to argue that Thompson's influence, if less immediately apparent, was no less profound, extending as it did—and still does—across such fields as art, architecture, engineering, and even the social sciences, as well as across those disciplines concerned with the mathematics and physics of organic design. When we find individuals as diverse as the influential anthropologist Claude Lévi-Strauss,[3] the action painter Jackson Pollock, and the painter of minimalist canvases, Barnett Newman, consulting Thompson's book, we can be sure that we are dealing with an exceptional phenomenon. And within his own specialist field, the mathematics of morphology, his work is, after an interval of comparative neglect, proving to be a rich source of inspiration, not least for those scientists who are using computer modelling to explore some of the problems which proved intractable with Thompson's 'hand-driven' mathematics. A full-scale investigation of the protean reach of Thompson's ideas, as both understood and misconstrued, remains to be undertaken, and in the present context I can do little more than suggest how he stands in a grand tradition and give some glimpses of the kinds of inspiration he continues to provide.

Thompson's Eye

The first edition of Thompson's masterpiece has a unity of structure which the later editions, for all their added 'evidence', tend to lack. Before sampling his ideas, it will be worth exploring how the original form of the book expresses the function which Thompson conceived for it.

He begins, somewhat disarmingly by declaring that:

> This book of mine has little need of a preface, for indeed it is 'all preface' from beginning to end. I have written it as an easy introduction to the study

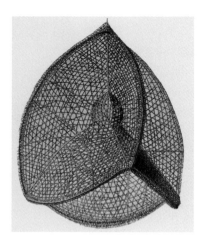

Fig. 56

D'Arcy Wentworth
Thompson,
*Comparison of a
Nasellarian Skeleton
and Suspended
bubbles*, from *On
Growth and Form*,
1942

of organic Form, by methods which are common-places of physical science, which are by no means novel in the application to natural history, but which nevertheless naturalists are little accustomed to employ.[4]

His subsequent 'preface' of the book extends massively over an astonishing range of morphological themes, including the fundamental laws governing the dimensions of organisms and their growth, the dynamics and statics of cell design and of tissues (including the phenomena of geometrical packing and membranes under tension, symmetries, and cell division), the engineering and geodesics of skeletons in simple organisms (fig. 56), spiral formations in shells, horns, etc. and in plant phyllotaxis, the properties of hollow forms, the structural properties of bone and natural engineering, and the systematic comparison and geometrical transformation of related forms. His now famous exposition of spiral forms, which is often taken as what his book is essentially about, does not enter the fray until page 492, and in total occupies only 159 of its 779 pages of text and figures.

Although he was throughout writing a book of biology which is focused single-mindedly on mathematical explanations, he was continually alert to the consequences of his observations for the production of human artefacts. Thus, when he looked to the 'instantaneous' photographs of splashes in 'Mr. Worthington's most beautiful experiments', he not only noted that they 'present curious resemblances and analogies to phenomena of organic form', but also to the work of the human hand:

> To one who has watched the potter at his wheel, it is plain that the potter's thumb, like the glass blower's blast of air, depends for its efficacy upon the physical properties of the medium on which it operates, which for the time being is essentially a fluid. The cup and the saucer, like the tube and

the bulb display (in their simple and primitive forms) beautiful surfaces of equilibrium as manifested under certain limiting conditions. They are neither more nor less than glorified 'splashes', formed slowly, under conditions of restraint which enhance or reveal their mathematical symmetry.[5]

It is not just that the biologist can provide lessons for the artist. He acknowledged, for example, that 'the art of the glass-blower is full of lessons for the naturalist as also for the physicist ... In like manner the potter's art illustrates ... a figure of equilibrium which is an *open* surface, or solid, of revolution'.[6]

The principle through which he explores the genesis of form in relation to function is that of teleology; that is to say the definition of form considered as if there is a definite 'aim' in view on the part of nature as an 'engineer'. This is not an anti-Darwinian stance as such, and he acknowledges the power of the theory of Natural Selection, which is a 'teleology without *telos*'. However, he argues that the old method can be rescued to good effect:

The teleological principle is but one way, not the whole or only way, by which we may seek to learn how things came to be made, and to take their place in the harmonious complexity of the world. . . . Like warp and woof, mechanism and teleology are interwoven together, and we must not cleave to the one and despise the other.[7]

His emphasis is upon the physical forces and their inexorable laws rather than on genetic imperatives: 'chromosomes or the germ-plasm can never *act* as matter alone, but only as seats of energy or centres of force'. He was, to use an anachronistic term, a student of the bio-engineering of nature.

In order to give a more detailed insight into how his thought proceeded, I will highlight two exemplary themes that are of particular relevance to our present concerns: his famed interest in spiral formations, and his use of Dürer's method of proportional transformation.

He concentrates on the spiral that had so fascinated Moseley and Church; that is to say the logarithmic spiral, in which the radius of the curve is continuously extended. The basic geometry of the spiral is demonstrated and its progressively widening whorls contrasted with the regular whorls of the Archimidean spiral in chapter 11, and subsequent chapters deal with 'The Spiral Shells of the Foraminifera', 'The Shapes of Horns, and of Teeth or Tusks, with a Note on Torsion', and 'On Leaf-Arrangement, or Phyllotaxis'. The first note in chapter 11 acknowledges that 'a great number of spiral forms, both organic and

artificial, are described and beautifully illustrated in Sir T. A. Cook's *Curves of Life*, 1914, and *Spirals in Nature and Art*, 1903',[8] and at the beginning of the chapter on phyllotaxis he records Cook's opinion that 'Leonardo da Vinci would seem . . . to have been the first to record his thoughts upon this subject'.[9]

Theodore Andrea Cook is little known today, but he was a prominent and influential 'character' who deserves wider recognition. Educated in classics at Oxford, he exhibited considerable prowess at sports, gaining a rowing blue in 1889 and captaining the British fencing team at the Olympics of Paris in 1903 and Athens in 1906. His account of his voyage to the Athens Olympics incorporates rhapsodic descriptions of visits to major sites of ancient and later architecture in Greece and *en route*, some of which were illustrated by his own accomplished photographs.[10] He was a remarkably prolific author of books on art, architecture, and a wide range of sports, and was an appropriate editor-in-chief for *The Field* from 1910. A staunch patriot, he used his editorials in *The Field* to give vent to powerful anti-Prussian feelings during the First World War, republishing his diatribes in a series of books that were well received by Germany's adversaries.

The logarithmic spiral characteristic of shells and phyllotaxis was central to Cook's thesis about the design of nature and art. Designated as the Φ spiral, or the 'spiral of Pheidias', in honour of the Greek sculptor, it is seen as having a ubiquitous significance, not least for its associations with such mathematical favourites as the Fibonacci series and the 'golden section'.[11] Cook cast his net widely for examples of spiral formations in nature and art, not only searching for the supreme spiral of Pheidias but also for related spirals, helixes, vortices, and screw configurations. In addition to the inevitable botanical and zoological examples, such as the seeds in a sunflower or helical horns of ungulates, he looked to astronomy, engineering, architecture, and a range of worldwide plastic arts from prehistoric to modern times.

He rightly drew attention to the pioneering study of spirals in Dürer's *Underweysung der Messung*. Leonardo provided equally appropriate grist for Cook's mill. The newly available range of Leonardo's previously unpublished manuscripts revealed an altogether unsuspected variety of researches into natural phenomena, and Cook studied them avidly. He recorded in *The Curves of Life* that 'before me as I write are some 500 careful photographs of the originals existing in England', probably taken from the Forster, Arundel, and Leicester Codices as well as the Windsor Leoni volumes.[12] Cook enthusiastically illustrated a range of vortex formations from the manuscripts, including the most spectacular studies of hydrodynamic turbulence and the *Deluge Drawings*,

juxtaposing them with analogous configurations in hair, wigs, plants (fig. 48), and man-made objects.

Cook's pièce de resistance is a comparison of the sinistral spiral staircase at the Royal Palace of Blois to a rare, sinistral form of the spiralling shell of *voluta vespertilio*, a comparison which is used to support the attribution of the staircase to Leonardo himself—an attribution that is no longer sustainable. Cook reasoned that:

> the Blois staircase was definitely suggested by a certain shell; this involves that the architect was an Italian; we find further that he must have closely studied shells and leaves in order to try and discover the secret of their growth and beauty; that he was left-handed; that he must have been appointed architect to the King of France; and that he must have lived at or near Blois between 1516 and 1519.[13]

For Cook, the true artist or architect assumed a special role in the revelation of the central truths of natural design, since the insightful artist's perceptual system was 'of a more sensitive fibre' than that of ordinary mortals.[14] This notion bears some resemblance to Continental ideas in the nineteenth century, particularly those of the Goncourts and Bergson in France, but Cook, as an English sportsman, resolutely 'sound' in mind and body, would have harboured no sympathy for the febrile neuroses and pathological vibrations to which the Continentals were drawn. For his part, Cook argued on the basis of his observations that artists endowed with the requisite attributes would intuitively arrange their compositions according to the privileged rhythms. Thus he used the Φ ratio to analyse not only a Botticelli Venus but also the more unexpected examples of Frans Hals's famous *Laughing Cavalier* and Turner's popular *Fighting Temeraire*.

Although Thompson paid due respect to Cook's wide ranging anthologies of spirals, he subsequently referred unfavourably to the 'mystical conceptions' at the heart of Cook's theories.[15] Thompson extended this criticism to three other theorists of spiral forms: John Goodsir, the Edinburgh Professor of Anatomy; Lorenz Oken, the German exponent of *naturphilosophie*; and the French biologist, Alfred Lartigues. What Thompson rejected in their theories was not their emphasis upon the spiral as an important feature in morphogenesis but their characterization of the logarithmic spiral as if it were the privileged manifestation of life itself. Thompson deflatingly pointed out that their beloved shells, horns, and such-like are non-living by-products rather than living tissues in their own right.

Thompson's own exploration of the 'curious' properties of the spiral and its relations to the Fibonacci series and the 'golden mean', confirms

that he was as alert as Cook to its beauties, both in itself and in its natural manifestations. In his epilogue he explicitly says that 'the harmony of the world is made manifest in Form and Number, and the heart and soul and all the poetry of Natural Philosophy are embodied in the concept of mathematical beauty'.[16] He also acknowledged the 'many beautiful constructions based on the molluscan shell'[17] in Samuel Colman's book, *Nature's Harmonic Unity* (edited by C. Arthur Coan), which had appeared in New York in 1912 and to which Cook had hurriedly devoted an appendix in *The Curves of Life*.[18] In the 1942 edition of *On Growth and Form*,[19] Thompson inserted a reference to John Wallis's account in 1659 of 'Sir Christopher Wren contemplating the architecture of a snail-shell, and finding in it the logarithmic spiral'. Wren was as we have seen not only a major architect but was also an accomplished mathematician who had contributed to the mathematical analysis of the 'cycloids' on which Wallis was working.

For all their shared enthusiasms, the tones of Cook's and Thompson's enterprises were quite different. Although Cook insisted that his mathematical system reduced much of the supposed arbitrariness of aesthetic judgements, he still had ultimate recourse to some indeterminate factor at the heart of life and aesthetics, a recourse also favoured by Church. By contrast, Thompson did not accept that there were theoretical limits to the ever more rigorous extension of the physical and temporal analysis of morphogenesis at increasing levels of mathematical precision, minuteness, and sophistication. Underlying Thompson's mode of analysis was his belief that 'Natural Selection' and the principles of heredity were not in themselves adequate explanations for the forms assumed by organisms, particularly for the recurrence of key configurations across various types of organisms over long spans of space and time. His chapter on 'The Logarithmic Spiral' ends with a characteristic attack on the failure of 'Natural Selection' to explain why, 'irrespective of climate or local conditions, we see them [forms which are identical, mathematically speaking] mixed up, one with another, in the depths and on the shores of every sea'.[20] Comparably, at the end of the chapter on phyllotaxis, he argues that Church's hypothesis of a plant 'aiming' at an 'ideal angle' is not 'rendered more acceptable when Sir T. Cook qualifies it by telling us that 'all a plant can do is to vary, to make blind shots at constructions, or to "mutate" as it is now termed'.[21] Without rejecting evolution as such, Thompson argued that an adequate explanation of organic forms cannot be reduced to a series of chance mutations, a tiny few of which will be favoured on functional grounds, but rather that there are

fundamental shaping factors in the order of natural things, pertaining to mathematics, physics, and chemistry.

Characteristically, Thompson's mathematical rigour lead him to question the way in which exponents of the spiral theory of life confused the mechanical primacy of the generating or 'genetic' spiral in a form like the sunflower disc with the accidental spirals which follow as a consequence of the symmetry of the system. Accordingly he declares that it is 'a mathematical coincidence devoid of biological significance'[22] when we are able to draw the 'golden mean' (corresponding to 0.61803 as the final term of the convergent series ½, ⅔ ⅗, etc.) out of such phyllotaxes as that of a fir cone. Making characteristic demands on his reader's knowledge, he asserts that 'it is but a particular case of Lagrange's theorem that the roots of every numerical equation of the second degree can be expressed by a periodic continuing fraction'.[23] To regard such secondary configurations as manifesting the 'energies of life', as Church claimed, is therefore unacceptable. This does not mean that Thompson rejected the visual appeal of the 'endless variety of other gnomic figures' generated as accidents of the genetic spiral. Indeed, his praise of Colman and Coan acknowledged that beautiful constructions may be *based* on the shell.[24]

However, as we saw in the case of the glass blower, art was not always on the receiving end of nature's 'lessons'. The most remarkable instance of what the world of art can teach the biologist occurs in the last and climactic chapter of *On Growth and Form*, which draws on Dürer's method of proportional transformations to master the problem of 'related forms'. Thompson praised Dürer's books on geometry and proportion for 'the manner in which the human figure, features and facial expression are all transformed and modified by slight variations in the relative magnitude of the parts is admirably and copiously illustrated'.[25] He combines Dürer's system of the transformed grid with Descartes's 'Method of Coordinates' to create a full 'Theory of Transformations'. Descartes's method had itself been based, in Thompson's view, on 'a generalisation from the proportional diagrams of the artists and the architect'.[26]

Four basic types of transformation are involved: (1) uniform extension along one axis; (2) non-uniform extension along one axis according to a regular logarithmic increase or decrease; (3) deformation by simple shear, in which the co-ordinates are arranged obliquely; (4) curved transformation in which one set of co-ordinates radiate from a focus, and the other set is comprised of arcs cutting the radial co-ordinates orthogonally. Permutations of two, three, or four of the basic transformations provide a plastic system of unlimited potential.

207

Thompson applied this method to 'related forms', relying very much upon the Aristotelian conception of 'genus', within which 'species' are formed by differences of relative magnitude and proportion.[27] The power of the method is that it could now enable the mathematical analysis of morphologies, which had previously been possible only with respect to small organisms and selected parts of larger organisms, to be applied to the whole and component parts of even the most complex animals. The method could also cope with configurations of such subtlety of geometrical form as resist the available mathematical formulae for compound curves.

As an example, we can look at Thompson's use of Dürer's oblique coordinates in connection with his analysis of the transformed shape of a tapir's lateral toes (fig. 57). The first move is a simple shear, of the Dürer kind, which is then augmented by a progressive narrowing along the horizontal coordinate. The technical definition is given by Thompson as:

> the difference between the outline of the middle toe of the tapir and the next lateral toe may be almost completely expressed by saying that if the one be represented by rectangular equidistant co-ordinates, the other will be represented by oblique co-ordinates, whose axes make an angle of 50°, and in which the abscissal interspaces decrease in a certain logarithmic ratio.[28]

The further addition of the curved deformations enables differences in conformation between forms which are very different on first inspection to be brought 'under the conception of a simple and homo-geneous transformation, such as would result from the application of some not very complicated stress'.[29] One example is the relation-ship between the skulls of extinct forms of rhinoceros. The basic rect-angular grid that provides the proportional schema for the originating form is subject to various curlinear distortions without surrendering the organizational network that dictates the relative positions and underlying shapes of the forms, Thompson was at pains to stress that his method of transformations was not designed to demonstrate

evolutionary chains of descent, but was concerned with variations in morphology arising from various material causes in time and space. His analysis of the human skull should not therefore be used to demonstrate that 'one straight line of descent, or of consecutive transformation, exists' between pre-human and anthropoid types in the past and 'the lower and higher races of modern man'.[30]

Thompson was aware that the mathematics available in his era fell well short of being able to handle the awesome complexity of all the observable themes and variations in the design of nature:

> The organic forms which we can define, more or less precisely, in mathematical terms, and afterwards proceed to explain and to account for in terms of force, are of many kinds, as we have seen; but nevertheless they are few in number compared with Nature's all but infinite variety. The reason for this is not far to seek. The living organism represents, or occupies, a field of force which is never simple, and which as a rule is of immense complexity. And just as in the very simplest of actual cases we meet with a departure from such symmetry as could only exist under conditions of *ideal* simplicity, so do we pass quickly to cases where the interference of numerous, though still perhaps very simple, causes leads to a resultant which lies beyond our powers of analysis.[31]

Although he argued that it is reasonable to ask the physicist or mathematician to 'give us perfectly satisfying expressions for the form of a wave, or even of a heap of sand', he acknowledged that it was not realistic to 'ask him to define the form of any particular wave of the sea, nor the actual form of any mountain-peak or hill'. Having begun with his admission that the book is 'all preface', he ends with no conclusion but with a plea for biological mathematicians and mathematical biologists to cultivate 'a field which few have entered and no man has explored'.[32]

In the light of developments in chaos theory, self-organizing systems, fractals, and related techniques in the mathematics of iteration and variation, particularly as facilitated by the enormous power of modern computers, we now have a clearer realization of the kind of mathematics which might satisfy Thompson's ambitions. His studies lead him to express a remarkably prescient and beautifully expressed insight into the generation of complexity from simple causes:

> If we blow into a bowl of soapsuds and raise a great mass of many-hued and variously shaped bubbles, if we explode a rocket and watch the regular and beautiful configuration of its falling streamers, if we consider the wonders of a limestone cavern which a filtering stream has filled with stalactites, we can perceive in all these cases we have begun with a system of very slight

complexity, whose structure in no way foreshadowed the result, and whose comparatively simple intrinsic forces only play their part by complex interaction with the equally simple forces of the surrounding medium.[33]

Complexity theory has provided a means of modelling exactly these kinds of phenomena. And only recently, with the theory of self-organized criticality, has Thompson's 'heap of sand' yielded to mathematical techniques which can deal with the unpredictable but non-random landslides that determine the form of a particular sand pile.

Thompson's enterprise not only stands in an honourable tradition from Leonardo and Dürer to present techniques of modelling, it also stood within a remarkable landscape of national (and often national-istic) movements in the fine and applied arts. The national species of the quest for form involves such contrasting luminaries as the German biologist-illustrator, Ernst Haeckel, who was much admired by Thompson, the great French Art Nouveau designer of organic fantasies, Emile Gallé, the Catallan architect, Antoni Gaudí, and art theorists such as Alois Riegl. In 1893 Riegl published his *Stilfragen* (Questions of Style), the first of the treatises in which he advocated his theory of *Kunstwollen*, or 'will to form', as a remorseless evolutionary principle which ultimately assumes precedence over whatever expressions of artistic individuality might be possible at any one time.[34] In its developed manifestations, Riegl's theory decreed that specific artistic forms evolved morphologically in the ecological contexts of the societies in which they needed to flourish. The *fin-de-siècle* 'will-to-form', either as an autonomous drive or as a socially adaptive strategy, was less obviously radical than relativity and quantum mechanics, but it has retained a potent and enduring presence as an abstract power in twentieth-century art and science.

Thompsonisms

Thompson's own enduring legacy is still unfolding and will continue to do so. In our present endeavour I will limit myself to looking at three areas in the visual arts in which his goals have been emulated—with greater or lesser degrees of awareness. The larger goal that exists in a shadowy manner behind my fragmentary account of Thompson's influence is that it may be possible to witness a common core of per-ceptions as expressed in widely varied historical contexts within the arts and sciences. The promise is that we may be able to discern the common thread that joins, say, the spirals of Leonardo da Vinci and

Albrecht Dürer with those of Naum Gabo or, more distantly, the coiled Aztec serpent with the decoration of a Minoan vase. We may understand why they all share an affinity with biologists' ways of analysing and demonstrating spiral configurations in morphogenesis, while at the same time acknowledging the historically specific vehicles in which the insights are conveyed. We are dealing with what I have called 'structural intuitions'—structural in the shared senses that observers of very different types have intuited certain basic structures in natural forms and processes, and that our perceptions themselves exhibit an innate gravitational pull towards such structures. If this dual sense should sound alarmingly circular, we may remind ourselves that the potentialities of our perceptual system have evolved to deal in a functionally efficacious way with the common forms and forces of nature—whether these forms and forces are sensed imaginatively or subjected to intense scientific modelling.

My approach exhibits some affinities with Conrad Hal Waddington's *Behind Appearance* published in 1969. Waddington, Professor of Animal Genetics in Edinburgh, was married to the architect Margaret Justin Blanco White, and enjoyed contact with a number of leading artists from the 1930s onwards, including John and Mary Myfanwy Piper, Henry Moore, Ben Nicholson, Barbara Hepworth, Ivon Hitchens, Alexander Calder, László Moholy-Nagy, and Walter Gropius.[35] He illustrates a series of important works by modernist artists, with a strong emphasis on abstraction from nature, together with images from twentieth-century science that appear to betray similar organizational principles. His suggestive mingling of art and science begins to do the kind of visual job with which I am concerned, but lacks a developed explanatory framework—whether historical or theoretical. The three areas I will be considering in my own attempt to illuminate 'structural intuitions' can be labelled, somewhat crudely, as 'structure', 'the splash', and 'the geometry of growth'.

Thompson's principles of natural engineering embraced such huge examples as the stress diagram of a dinosaur's backbone, analysed by analogy to the Forth Rail Bridge in Scotland, and such microscopic subjects as the structural geometry of the skeletons of microscopic organisms like the Radiolara (fig. 56). Looking at the skeleton of *Callimitra agnesae* Thompson determined that the configuration arose as the result of balanced tensions within a tetrahedral system in a manner that was analogous to those that the Belgian physicist, Joseph Plateau, had demonstrated in his classic experiments with clusters of bubbles, from which he deduced a set of universal laws for the form of bubbles within foam.[36] The illustration of what happens when a

tetrahedral wire cage is dipped into soap-solution in fig. 56 appeared in the later editions of *On Growth and Form*. As Plateau had demonstrated, a spherical tetrahedron is suspended at the centre in a tense equilibrium with the six films that adhere to the outer skeleton.

If we look for a Waddington-style parallel to the Nassellarian skeleton, an obvious place to turn is the constructive sculpture of the Russian émigré sculptor, Naum Gabo, which often relied upon exactly the same kind of tensions within skeletal cages. Typically, he sets up a curving, geomtrical 'exo-skeleton' criss-crossed by taught strings that collectively act like interpenetrating membranes. When we read Gabo's declaration in *The Realist Manifesto* in 1920, the parallel becomes more than purely visual: 'With a plumb line in the hand, with eyes as precise as a ruler, with a spirit as taut as a compass, we build them [sculptures] in the same way as the universe builds its own creations, as the engineer his bridges, as the mathematician his formulae of the orbits.'[37] While there is no evidence to suggest that Gabo knew Thompson at this date, he was introduced by Herbert Read to Thompson's text during his seven years living in Cornwall at Carbis Bay near St Ives, where the vigorous colony of British artists included Hepworth, Nicholson, and Wilhemina Barns-Graham (fig. 58), the Scottish-born artist who had been educated in St Andrews, where she had personally encountered the formidable figure of the eminent professor.[38] Barns-Graham often works telling variations around geometrical motifs, such as the 'golden section', which are drawn from the shared organic and inorganic patterns of growth, life, and motion in nature. Not only are there formal aspects of Gabo's work that seem to respond to *On Growth and Form*, but his new interest in the notion of 'truth to materials'—in carving no less than in construction—is consistent with Thompson's emphasis upon morphogenesis as expressive of the physical qualities of the materials from which the organism is constructed. As Gabo wrote in 1937, 'carved or cast, moulded or constructed a sculpture does not cease to be a sculpture as long as the aesthetical qualities remain in accord with the substantial properties of the material.'[39] Not surprisingly, his stone carvings often breathe a sense of Thompson-like forms in the process of genesis, including the ubiquitous spiral configurations that provided successive generations of morphologists with such vital evidence of geometrical design.

Fig. 58

Wilhemina Barns-Graham, *Expanding Forms, Touch Point Series (Movement over Sand)*, 1980

Fig. 59

Brian Goodwin,
Acetabularia, from
*How the Leopard
Changed its Spots*,
1994

One of Thompson's most suggestive references to inorganic patterns that 'present curious resemblances and analogies to phenomena of organic form' was, as we have seen, to the configurations revealed by 'Mr. Worthington's beautiful experiments on splashes' and by experiments with water jets and drops of viscous substances in water, which parallel the form of such marine organisms as medusoids and hydroid polyps.[40] As Waddington pointed out there is a problem in how to interpret the analogy, because 'the forces which mould the body of a sea anemone cannot be the same as those which bring out the structure of a splash', and we have to assume that 'we are dealing with systems which involve the same mathematical relations' but with quite different kinds of force and materials.[41]

It seems to me that Thompson had indeed alighted on a fundamental visual insight, however we may handle the difficulty that Waddington identified, and that this insight has great potential appeal for the understanding of morphogenesis in the work of those artists who have been particularly concerned with 'truth to materials' in terms of dynamic process rather than engineering statics. We might, perhaps most obviously in the light of Thompson's own suggestion, look to the work of such a potter as Bernard Leach, a prominent member of the St Ives circle. But I should also like to propose that we might also cast our net wider, taking in, more unexpectedly, Jackson Pollock's drip paintings, which represent an extreme form of process in terms of what viscous fluids do under the action of certain kinds of force

and constraint. As it happens, I have not chosen Pollock altogether innocently, since Pollock is known to have admired Thompson's book and may have been acquainted with it before he was given a copy of the 1948 reprint.[42] I am not suggesting that Thompson was a significant 'influence' on the means that the painter employed, although it might be possible to detect some signs of organization according to splash-like principles in some of Pollock's work in and after 1948. My point is less concerned with such historical niceties than with the nature of the dialogue between the behaviour of materials in nature and the conscious remodelling of the underlying processes in different ways in science and art—a dialogue with an ancient and enduring history.

The strongest case for a Thompsonian art in the twentieth century is probably that which concerns the spiral formations on which we focused earlier. The presence of the 'golden section' and the Fibonacci series, which we have seen to lie at the heart of spiral formations, is not infrequently adduced, Cook-like, in the analysis of works of art, particularly amongst theorists with a taste for geometrical mysticism. Generally speaking, such analyses are not grounded on any firm sense of what actually went into the design of the works in question. There are, however, artists whose work has consciously created analogues for the structures of growth in nature and for whom the spirals of phyllotaxis have become a major expression of the forces of nature. Major examples who spring to mind are Andy Goldsworthy and Peter Randall-Page, who relate centrally to the British nature tradition that so permeated the earlier St Ives school.[43] Goldsworthy's work, in particular, ranges across many of the processes which Thompson discerned to exercise morphogentic potential. Goldsworthy is unrivalled in range and skill as a 'nature artist'. He works as a collaborator with natural phenomena during the passing seasons, feeling deep into the essence of soil, stone, water, ice, flowers, leaves, stems, sticks, and trunks. He is a natural engineer in the manner of the bower bird, spider, swallow, bee, beaver, or shellfish—or, in human terms, the Eskimo, dry-stone waller, or oriental master of Zen gardens. Tensile strength is conjured from fragile delicacy, and stable unity is compounded from separate elements without artificial adhesives.

Goldsworthy creates genera of forms—spheres, rings, spirals, holes, arches, spires, snakes, fissures, and splashes—which cut across (sometimes literally) the conventional taxonomies of genus and species. Through sight, touch, and motion he searches out morphological commonalities which arise from the material and processes of nature. For example:

Some works have the qualities of snaking but are not snakes. . . The snake has evolved through a need to move close to the ground, sometimes below and sometimes above, an expression of the space it occupies. This is a potent recurring form in nature which I have explored through working in bracken, snow, sand, leaves, grass, trees, earth. It is the ridge of a mountain, the root of a tree, a river finding its way down a valley.[44]

Across diversity, Goldsworthy sees commonalties, like Thompson, and in complexities he intuits shared shaping. The analogies he senses spring within nature from diverse and sometimes unrelated causes. Some perceived commonalities possess an essentially artistic rationale rather than offering anything that a biologist, geographer, or physicist would presently encompass in a programme of research. But in their totality, his genuses of morphological types play towards powerful and operative forces of organization in nature across a wide range of scales.

In science, the story is rather different. The mainstream of developmental biology has subsequently put almost all its eggs in the genetic basket, seeking explanations for morphologies exclusively in the dictates of the gene, and subjecting Thompsonian themes either to benign neglect or to downright dismissal. However, amidst this general sense that Thompson practised a science in which the 'so what' factor assumed terminal proportions, there has been a small but unbroken (and apparently growing) succession of mathematically-minded biologists who have sustained his basic insights.

The most publicly prominent was, before his recent death, the Harvard biologist, geologist, palaeontologist, theorist of evolution, and man of letters, Stephen Jay Gould. Throughout his career as a palaeontologist and public commentator, Gould informed his work with a keen understanding of the historical setting for current endeavours, and amongst his historical antecedents none has played a more enduring role than D'Arcy Thompson. The introduction Gould has provided for the paperback edition of J. T. Bonner's abridgement of Growth and Form is just the latest in a series of homages. Without wholly endorsing Thompson's more extreme polemics against the implications of rigid Darwinian theories for morphogenesis, Gould shares Thompson's sense that recurrent patterns of form in nature require something other than an explanation cast solely in terms of genetics, mutation, advantage, and natural selection.

A classic exposition of Thompsonian thinking is to be found in Gould's essay, 'How the Zebra Gets its Stripes'. A few excerpts will convey the style:

Biologists follow a number of intellectual styles. Some delight in diversity for its own sake and spend a lifetime describing intricate variations on common themes. Others strive to discover an underlying unity behind the differences that sort these few common themes into more than a million species. Among searchers for unity, the Scottish biologist and classical scholar, D'Arcy Wentworth Thompson (1860–1948) occupies a special place. . . .

D'Arcy Thompson struggled to reduce diverse expressions to common generating patterns. He believed that basic designs had a kind of Platonic immutability as ideal designs, and that the shapes of organisms could only include a set of constrained variations upon the basic patterns. . . . But he worked before computing machines could express such transformations in numerical terms, and his theory achieved little impact because it never progressed much beyond the production of pretty pictures. . . .

As a subtle thinker, D'Arcy Thompson understood that emphases on diversity and unity do not represent different theories of biology, but different aesthetic styles that profoundly influence the practice of science. No student of diversity denies that common generating patterns exist, and no searcher for unity fails to appreciate the uniqueness of particular expressions. But allegiance to one or the other style dictates, often subtly, how biologist views the organisms they chose to study.[45]

I am less confident than Gould that all or even most developmental and evolutionary biologists—if they are to be included amongst his 'students of diversity'—acknowledge that apparently common patterns have any potential value as subjects of investigation in their own right. And his allusion to Thompson's 'Platonism' is overly telegraphic—perhaps necessarily in the context of his relatively brief essay. But the essay itself has a subtlety, precision, and elegance which is worthy of his predecessor's adherence to a science of beautiful insights.

The essay centres upon a study of striping in different species of Zebra by J. B. L. Bard, an embryologist from Edinburgh whose work stands within the Scottish tradition which extends from Thompson through Waddington. Bard proposes 'a unity underlying the different zebra striping patterns' in the three basic types—Grey's Zebra, the Mountain Zebra, and Burchell's Zebra. He argues that the differences in the patterns, most conspicuous in the relative stretching of the stripes transversally across the hindquarters, arise in response to the laying down of the pattern at different stages in the embryonic growth of the three types, such that the pattern is subject to varying forces of growth in different regions of embryo at the various stages. The general proposal that such configurations could arise as the result of the pattern-making action of activators and inhibitors during the early weeks of

embryo formation was advocated by James Murray, a mathematician working in Oxford, while the hypothesis that a pattern of markings as realized is not genetically dictated has been confirmed by the divergence between a cloned kitten and its biological mother. Gould, as ever alert to the power of analogy, asks us to envisage the basic pattern as a sheet painted with regular stripes and hung over a taut wire. If this pattern is laid down when the embryo is relatively advanced, it will be subject to relatively little subsequent stretching, while an earlier advent of the pattern will subject it to considerable deformation as the embryo undergoes differential growth. Looking at the three species, we may therefore suggest that Grey's Zebra acquired its stripes relatively late, while the Mountain Zebra was striped somewhat earlier (before the large increase in size of its posterior), and that Burchell's Zebra acquired its pattern earlier yet again (when its back was still to undergo its greatest expansion). To pick up Gould's model of the hanging sheet, it is as if a curvaceous composition by Bridget Riley has been created by the systematic deformation of the flat surface on which regular stripes have been laid down.

If the basic module of the Zebra stripes remains constant, it follows that 'the larger the embryo when the stripes first form, the greater the number of stripes'.[46] If it supposed that the three types acquire their stripes at five, four, and three weeks respectively, when their respective lengths are about 32 mm, 14–19 mm, and about 11 mm, it can be calculated that a basic stripe width of 0.4 mm would give the observed results in the mature animal. It should be noted that this argument is not dependent on whether we consider the three species to be closely related to a single common, striped ancestor or whether they evolved stripes independently (as Gould suggests).

Gould is ready to acknowledge that Bard is proposing an explanatory model rather than recording observations made on developing embryos. What I want to stress in our present context is not whether Bard has hit on what might prove to be the best solution to the problem but that his *mode* of explanation retains a power which acts as an essential complement to other explanatory methods. The reason why Zebras have stripes at all is much disputed—the camouflage argument hardly seems to work in the animals' present habitat—and the Bard model does nothing to indicate what advantage such a stripy 'horse' has over an un-striped one, but it does address an important visual characteristic of the striping as it is laid down in the three species.

Gould has referred to the way that 'computing machines' have released Thompson's insights from what had seemed to be their

historical prison. One of the most avid computer modellers in a Thompsonian mode is the Canadian developmental biologist, Brian Goodwin, who was a student of Waddington in Edinburgh and made his career in Britain. With Goodwin, we encounter a scientist who stands outside what is currently perceived to be the mainstream in his subject, and, as with so many practitioners who are positioned on the margins, the adverse reaction of the orthodox centre has forced him progressively further away from that approved core. Goodwin's classic piece of modelling brings us back to the kinds of problem faced by Thompson in explaining such radial forms as spirals and whorls.

The large (up to 5 cm long) single-celled alga, *Acetabularia*, popularly known as 'Mermaid's Cap', passes through an intermediate stage in its life cycle, before the formation of a mature cap, in which its growing 'stem' develops sequences of filaments in whorls. The alga apparently invests a good deal of effort in producing successive whorls, but each set of filaments is in turn shed without having 'done' anything useful— as far as we can tell. The standard explanation for such apparently redundant features is to consider them as vestigial, that is to say vestiges of something that once had a function. However, un-economic redundancy of such an order, in Goodwin's view, seems to work actively against the 'survival of the fittest', and it would have been to the organism's advantage no longer to make the whorls at all. Arguing from a negative stance is always dubious—we may believe that the whorls have no function simply because we have not discovered it—but Goodwin adopts the more positive strategy of seeking an alternative model. The model relies upon physico-chemical forces in the manner of Thompson—or more precisely on the Thompsonian hypothesis proposed by Alan Turing in his 1952 paper, 'The Chemical Basis of Morphogenesis'.[47] Turing, an extraordinary mathematician, pioneer of computers, theorist of artificial intelligence, and war-time code breaker *extraordinaire*, showed that processes of diffusion in mixtures of chemicals, one of which is an 'activator' and the other an 'inhibitor', do not result in even distribution but in instabilities which give rise to complex patterns of concentration. He proposed that such patterns of uneven and unstable concentration provided an explanatory model for pattern formation in morphogenesis, such as the growth and arrangement of tentacles in a hydra. The Turing model is known as the 'reaction-diffusion' system (RD).

Goodwin's RD model for Acetabularia relies upon a series of factors: the concentration of free calcium; the viscosity and elastic modulus of the cytoplasm as an excitable medium; and the cell wall dynamics. Basically, a concentration of calcium acts as a short-range activator

for the cytoplasm, while the mechanical strain acts as a long-range inhibitor. When we come to look at fractals, the rough equivalents will be the generator and the constraints under which it operates. The model, requiring no less than 26 mathematical parameters to simulate the simple set of biological factors, plots the response of the developing tip of *acetabularia* in relation to small, local changes in calcium concentration. As the stem develops, its calcium gradient, which is at its maximum at the very tip, becomes unstable and is transformed into an annulus. The cell wall is now softened in this ring-shaped configuration, bending more readily, and the tip is duly flattened. Around the annulus, as Goodwin's model ran its course, a series of peaks of calcium occurred unexpectedly, and at the weakened spots around the rim a series of protrusions originated in the manner of the observed whorls. The model, in spite of its computational complexity, is relatively crude morphologically and visually, compared to the complexity and beauty of the living organism. And, like the theory of the Zebra's stripes, it is an artificial model which at best acts as an analogue for the real process. But in this case, independent measurements of calcium concentration around the annulus suggest that the fit between the model and the developing organism is notably promising.

However, experimental evidence in other areas of morphogenesis, such as limb formation and feather germination, suggests that the RD model does not work adequately. Rather, shapes and patterns are seen as arising from internal genetic imperatives that determine cell movement (CM) through the action of mechanical and chemical cues. The differing biological fundamentals of the RD and CM models readily lead to stark polarizations amongst professional biologists—polarizations that look unnecessarily wide from my perspective as an outside observer. Given the wide variety of types of pattern formation, some arising simultaneously while others are generated sequentially, and the intricate intersection of genetic imperatives, mechanical properties, and chemical forces, it would seem likely that the mathematical models of RD and the experimental thrust of CM have complementary and varied roles to play if a rounded understanding is to be achieved. In any event, in terms of the present polarization, Goodwin stands firmly towards the Thompson–Turing pole.

It is unsurprising to find that the section on the Mermaid's Cap in Goodwin's book, *How the Leopard Changed its Spots*, is followed by a chapter on 'The Evolution of Generic Forms' in which phyllotaxis plays a central role. He is able to throw a nice new element into the Thompsonian equations through the research of two French scientists, S. Duoady and Y. Couder. Their model involves dripping magnetized

drops of a fluid onto a disk covered with oil and subject to a magnetic field that repels the drops centrifugually. At faster rates of dripping, each new drop lands sufficiently close to others to be affected by both the magnetic field and by its neighbours. They found that spiral patterns emerged, and that the most stable of these patterns corresponded to a divergence angle of 135.5°, that is to say the 'Fibonacci spiral' so beloved of Cook. Again, they are constructing a *model*, in this case using forces that are unlikely to operate in anything like that magnetic manner in an actual meristem, but they are able to show that a relatively simple set of dynamic forces can produce exactly the kinds of spiral that are observed in more than 80 per cent of the quarter million species of higher plant. It is on the basis of both computerized and mechanical models that Goodwin has felt able to characterize the biological process of phyllotaxis as reliant upon 'a morphogenetic field in the meristem, defined primarily by the mechanical strains in the surface layer of the epidermal cells acting as an elastic shell that resists the pressure exerted by the growing tissue underneath.'[48]

To confirm that mechanical forces and constraints exercise a necessary shaping imperative on the pattern of development in a bud primordium is not the same as saying that the combined action of the forces and constraints comprise a sufficient cause of the configuration. Indeed, it has proved possible to identify some of the specific genetic components that play a crucial role in dictating the morphology of flowers. The example I am citing concerns a mutant form of toadflax (*linaria vulgaris*).[49] The inflorescence of normal toadflax, organized around a 5-part base of the kind that delighted Thomas Browne centuries ago, exhibits bilateral symmetry. There are two long dorsal petals, two lateral petals with wide lobes and a ventral petal with smaller lobe. The mutant retains the 5-part base but now exhibits radial symmetry, with all the petals resembling the smaller ventral type. Researches at the John Innes Centre in Norwich have shown that the advent of the radial form arises as the result of an identifiable genetic (or more strictly, epigenetic) defect. What this does not address, of course, is why the five-part base is common to both the standard and mutant forms—and why it is so common as a mode of organization in the botanical world.

What the different kinds of evidence suggest is that there is a complex interplay between natural mechanical properties and genetic prescription such that each plant can develop with the maximum economy and efficiency in the context of physico-chemical laws, at the same time as achieving the astonishing range of variations that nature works on a simple set of templates. In the process of explanation within biology,

the construction of models (physical or computerized) tends to play towards the general principles which exhibit a propensity towards basic patterns, while genetic enquiries tend to disclose the individual mechanisms for specificity and divergence. As a non-biologist, it looks to me as if both forms of explanation are necessary if we are to arrive at a rounded understanding, while one alone is never sufficient.

New Complexities and Old Simplicities: Mainly Fractals

The immense powers released for iterative processes by modern computers are providing new and more subtle ways through which we can propose the kinds of mathematical model that may lie behind the relationships between the reductionist parts and the complex wholes— in themselves and even within their complex settings. There are three aspects of the new mathematics of complexity that seem to me to stand in a particularly suggestive relationship to the predominantly geo-metrical themes that have concerned us during this and the previous chapter. These are the self-similar systems known as fractals, the patterns that may be discerned in chaos, and the state of poised equilibrium termed self-organized criticality, examined briefly in the previous chapter. I do not intend to infer that these themes cover all that may be relevant to organic forms in the sciences of complexity, nor am I claiming to provide an adequate introduction to them from a technical standpoint. Rather, in keeping with my aspiration to illustrate how the matters of current interest appear from my perspective as a historian of visual things, I am selecting some examples which seem to me to stand in clear lines of visual descent from the kinds of notion of natural design we introduced through Leonardo and Dürer. Along the way, we will look passingly at the models of wholes and parts proposed by the physicist, David Bohm, in his theory of 'implicate order'.

In looking at fractals, the first of these topics, it will be helpful to begin with a brief technical explanation, if only to give some idea of the small number of component parts that can give rise to complexity. Fractals were so christened by Benoit Mandelbrot in 1975, on the base of the Latin word *fractus* (= 'broken into smaller parts', from *frangere*).[50] Fractal geometry has given new life and fresh relevance to some earlier mathematical 'oddities', the so-called Julia sets, named after the French mathematician, Gaston Julia, who with Pierre Fatou first published them in 1918. The basis lies in polynomial equations such as $w = z^2 + 1$

(where z is a variable assigned a particular value). In the process of iteration, w successively becomes the new value for z, according to $z \to z^2 + 1$. If 1 is replaced by any constant, c, and z and c are complex numbers (i.e. composed of two variables, x and y, one of which is the 'imaginary number', $\sqrt{-1}y$), and z is taken as a moving particle, the plot of the position of z as iterated on a computer screen follows an extraordinary visual path and delineates wholly unexpected figures. In such a process of modelling, the equation provides the rule for the assigning of a tone and/or added colour to each pixel at each successive iteration. The actual tones and hues used in each programme are matters of the designer's choice. So odd and abnormal were the visual results that they were stigmatized as 'pathological' and 'monstrous' beside the resolved beauty of classical methods. Encoded graphically in colour on the VDU of a computer, existing and newly invented sets— including one named after Mandelbrot himself—have given birth to extravagant convolutions of 'Rococo' form, at once geometrical and organic, assuming the air of exuberantly decorative growths which typically pursue wildly curvaceous courses across and (by illusion) into the pictorial space of the screen. On 'zooming' into ever smaller details of the nodules, helices and tendrils, analogous configurations successively unfold in inexhaustible profusion. In our present context of wholes and parts, it is this property of self-similarity across scales, without apparent limit, that provides the most relevant and striking feature of the new visual creations. Indeed, Mandelbrot's description of the essential property of a fractal—'a shape made up of parts similar to the whole in some way'—evokes for us particular historical resonances.

Perhaps the clearest way to grasp the kind of limitless similarity which is involved is to look at an early example involving a simple geometrical iteration, the 'snowflake' schema devised in 1904 by Niels Fabian Helge von Koch. The 'von Koch snowflake' or 'island' involves the modification of a straight line (the initiator) by an open 'protrusion' (the generator) in the shape of an equilateral triangle. If the procedure is carried out repeatedly (i.e. iterated) in the closed form of an equilateral triangle, the second stage is a five-pointed, equilateral star, and after a smallish number of iterations a remarkably 'fuzzy' crystal is generated. Looking into the details, we can see that on ever smaller scales the parts constantly recreate the configurations visible on larger scales at earlier stages in the process. A paradox of the 'snowflake' is that its bordering line is of potentially infinite length and of no perpetually definable direction at any particular point while at the same time enclosing a finite area.

If we move on to the case of a meandering, open form, using a simple L-system generator which involves just two scaled copies, the process of iteration produces a progressively denser pattern which assumes an apparent 'organic' complexity seemingly unforeshadowed by the rectilinear simplicity of its generative components (fig. 60). Looking into the detail inside the figure we can see that the line does not produce an endlessly complex, closed border in the von Koch manner but rather that it progressively fills the space within the limiting parameters of the overall shape. Such is the curvaceous look of the resulting figure (after no more than eight or nine iterations on the scale of the present illustration), that it has become known as the 'Dragon', or more precisely the 'Herter Heighway Dragon'.

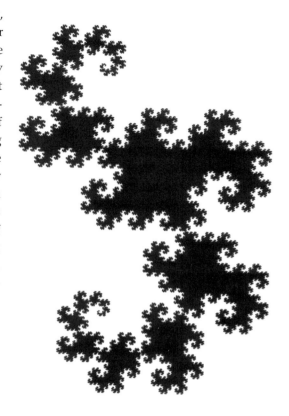

Fig. 60

The 'Herter Heighway Dragon'

The design of structures that appear to be analogous to complex natural forms can also be achieved through surprisingly simple techniques for the generation of branching systems. The most obvious is through a programme that branches repeatedly in a self-similar manner. Using a rudimentary L-system and some simple rules to determine branching angles, scaling values and symmetries, as few as nine levels can produce an image of considerable beauty and complexity (fig. 61), the 'Barnsley Fern' (after M. F. Barnsley, an influential pioneer of fractal imaging). It is relatively easy to add such further 'naturalistic' dimensions as the progressive grading of stem size at each level in the system. The underlying processes are entirely in keeping with what Leonardo envisaged as the way to understand the rationales behind different forms of bifurcation and asymmetrical branching.

A more unexpected but still fundamentally simple way to produce branching systems is by a process known as DLA (Diffusion Limited Aggregation), which was ingeniously modelled in 1983 by T. A. Witten and Leonard Sander. The basic principle is that a succession of particles are released into a given space within which there is a fixed particle. The mobile particles diffuse randomly—as in the Brownian motion in liquids and gases—until they encounter either the fixed particle or one or more of their companions already adhering to it. On a simple level,

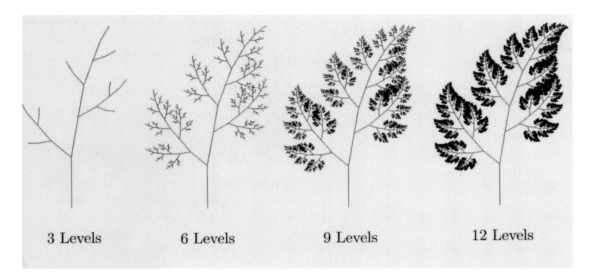

3 Levels 6 Levels 9 Levels 12 Levels

Fig. 61

The 'Barnsley Fern'

the process can be envisaged as occurring on an extended draughts (or chequers) board: a single piece is placed on a square near the centre of the board, and other pieces move randomly around the grid; when one arrives at a square next to the static draught, it becomes fixed and in turn acts as a 'fixer' of any draught that arrives on an adjacent square, and so on. On a large enough board, the process of aggregation results in irregular branching structures which can, with small adjustments, effectively model such aggregates as copper sulphate crystals, aggregate columns formed under the influence of a 'gravitational force', or patches of viscous oil pumped into water.

The four examples, the 'snowflake', 'dragon', 'fern', and DLA, all exhibit fractal properties and are comparable to natural structures, but it is important to make a series of discriminations in terms of the processes involved. The first point of discrimination is that one type of fractal system exhibits *deterministic* self-similarity, in that a regular, repeated process results in features that resemble each other on all possible scales. This is clearly true of the 'snowflake', and also applies to the 'dragon' and the 'fern'. The second basic type arises from *non-deterministic* programmes, such as that which emulates Brownian motion, and results in fractals in which the precise form of the features may vary at each level but whose statistical properties remain invariant regardless of scale.

The second discrimination is between fractal models that act as analogues to actual processes in nature and those that 'forge' or 'fake' natural appearance through more-or-less anomalous procedures of representation. The deterministic system of successive branching that gave rise to the 'fern' clearly stands in a direct relationship (albeit in a

highly schematic manner) to actual processes of branching in a living plant. Similarly, the non-deterministic procedure of DLA acts in a manner analogous to the formation of some kinds of natural aggregates. On the other hand, the successive fragmentation that results in the 'snowflake' or space-filling convolutions on the 'dragon' are formed in a predominately opposite direction to their visually analogous forms in nature. The centrifugal process of growth in the 'fern' involves what might be called 'constructive ramification', while the ever smaller crinkling that occurs with the 'Koch curve' involves what I will term 'deconstructive fracture'.

Deconstructive operations can result in images of remarkable naturalism, such as the famous fractal mountainscapes of the type used in science fiction films but the actual processes through which real mountains assume their craggy shapes—involving long and intricate procedures of deposition, uplift, fracture, collapse, fire and ice, erosion, etc.—cannot be adequately characterized in terms of the successive fractalizing of a basic mountain shape in the physical processes of nature. In such cases the relationship between the processes of representation and the physical processes of nature is at best partial or oblique. Perhaps the best we can say is that the tendency of a given geological formation to fracture in a certain way endows them with a propensity towards fractal morphologies. It is also possible to arrive at a computer model of channel and river formation when rain falls evenly on a random landscape (i.e. rough, like sandpaper). In such a model, the topography of the mountainscape self-organizes so that successively wider tributaries pour into a main river, resulting in an elaborate landscape of peaks, ridges, and valleys. However, even this type of modelled process is indicative of a self-organizing tendency in just one of the many different kinds of processes at work in mountain formation.

What I am suggesting is that there is a general differentiation to be made between models which exhibit analogies to nature through broadly shared processes, and similarities that arise from representational techniques for morphological types which do not stand in a straightforward relationship to the generative processes of the physical world. Thompson had no clear way of making this differentiation, and the standard, received view of fractal images too often neglects to do so.

Much the same point can be made with respect to the forms generated by self-organized criticality. In the case of a physical process which results from the piling of granular materials—as in the beautiful 'Alpine' landscapes created by Jonathan Callan when he shakes cement

225

Fig. 62

Jonathan Callan,
Dustscape, 1 detail,
1999

powder over a template punctuated with round holes at irregular intervals (fig. 62)—the model and the natural phenomenon are closely analogous, but we know that mountains are not formed in such a manner.[51] The resemblance of Callan's topography to the Alps arises from such general laws as decree the stability and instability of conical formations composed of non-continuous materials. Both real mountains and sand piles are subject to unpredictable land-slides when the slope becomes to steep, but this is not to say that mountains come about in the same way as sand piles. A mathematical model which provides an analogous morphology cannot *necessarily* be taken as providing a causal explanation for a physical phenomenon. In the light of this caution, we can say that certain kinds of 'artist' have always been in the business of sensing such affinities as those that exist between sand piles and mountains, without needing to be accountable to the question 'why?' in the manner of the scientist (at least in terms of the modern definition of a scientist).

After I had published an article on 'Callan's Canyons' in the journal *Nature*, Adrian Webster of the Royal Observatory in Edinburgh published an essay indicating that the cellular structure of the piles viewed from above correspond to 'Voronoi's cells', named after the Ukrainian mathematician whose ideas have proved to have wide applicability to the sciences of the physical and natural world. As Webster wrote:

> The key to the underlying geometry comes from noting that any grain of powder that flows through the board does so through the hole nearest to its starting position in the layer.
>
> It is then possible to draw on the board the catchment region of each hole, because it consists of all the points in the plane of the board that are closer to that particular hole than to any other, which is the definition of a geometrical entity termed the Voronoi cell.
>
> When the holes are so small that they may be regarded as Euclidean points, the Voronoi cells take the simple form of complex polygons, in which the boundary between any cells and its neighbours consists of several straight-line segments enclosing the parent hole.[52]

Noting that the Voronoi tessellation has wide applicability, Webster highlights its value as a model for the foam-like distribution of the galaxies as masses of three-dimensional, polygonal cells. The galaxies 'inhabit thin sheets at the boundaries between huge voids'—in other words, along the cell walls—taking us back to the foam structures that were first codified by Plateau. At one level, Jonathan Callan was no less astonished than this author at the super-cosmic resonances of his technique, but, considered in terms of 'structural intuitions', the parallel between the patterns which emerged during his process and the configurations which characterize the relative position of the galaxies should not come as too much of a surprise.

What all this means is that the relationships between visual models and the processes behind formations in nature is extraordinarily varied—ranging from shared processes, in which the visual model is constructed in a manner closely analogous to the actual phenomenon, through models in which there are underlying mathematical and physical affinities but no directly shared processes, to visual analogies which appear to have no causal connection and which may be largely or wholly coincidental.

Alongside this qualification, another key differentiation which needs to be applied to systems of fractal modelling in relation to physical phenomena is between what may be called 'real curves' and one that may by illusion or convention be taken as curves. In talking of the kinds of computer-generated 'organic' configurations at which we have been looking, mathematicians use the term 'curves'—the 'Koch' curve, the 'Dragon curve', and so on—but we know that there is not a single curved element (in the lay sense of the term) in them. How, therefore, is the concept of the curve to be understood? This is more than a mathematical question, since it is central to any attempt to justify fractal patterns as informative models of nature in terms of both form and process. There are two distinct senses in which curves may be seen as present in configurations compounded from straight lines, but these senses have become misleadingly elided in the kinds of illustration now familiar through the burgeoning popular literature on fractals.

The first sense, which I have not seen adequately acknowledged, is perceptual. However sharp an individual's sight may be, his or her ability to see detail inevitably breaks down at small scales. It may be a question of absolute scale—that we cannot, even under the most favourable circumstances, ever hope to see things that small—or it may be brought on by viewing things from a longish distance, in poor light, through a murky medium etc. We know that entirely convincing,

apparently solid illusions of complex organic forms can be supplied by images composed of identical units disposed in regular grids—dots in some forms of screen printing and television screens, and rectilinear patches or 'pixels' in computer images. The inherent desire of the human perceptual system to bring naturalistic coherence into images made of such improbably artificial components has long been exploited by master printmakers, such as Claude Mellan in the seventeenth century who composed an image of Christ from a single, spiralling line of varied density and width.[53] Looking at it from a modest distance, we see Christ rather than the spiral. In a similar way, we can take a coarsely pixellated image of a human head and torso (fig. 63) and manage to read it coherently by adopting some 'blurring' strategy, such as half closing our eyes or by moving to a critical viewing distance from the image. We somehow end up seeing more than is actually there. In the illustrated image of Alan Turing it is remarkable how we are able to turn the collections of angular facets into rounded eyes, nose, and chin, and to produce a convincing neck-tie. And, more than that, we can often recognize the individual who is portrayed. In a related way, the American painter, Chuck Close, composes giant portraits from rows of abstract elements that only congeal into illusions of faces when viewed from a certain distance. The determining perceptual factor appears to be that the angle subtended in the eye by each element should fall above or below a critical value of around 0.3°.[54]

Fig. 63

Pixellated Image of Alan Turing

Illustrations of fractals that either go down to a scale below the level of our finest discrimination, or in which the procedures of printing are unable to cope with the detail without the congealing of mathematically discrete parts, act illusionistically in comparable ways, producing the perceptual effect of organic curves. It may seem easy to write off this perceptually illusionistic sense of curves as no more than a visual curiosity, but we have seen that the scales at which we can operate visual discrimination with the unaided eye and with powerful instruments have radically affected what we think we are seeing when we observe the structures of nature. And whether we are seeing angles or curves at a particular scale is not a trivial matter in the physical world.

The second sense brings us to fundamental questions of organization at every scale, mathematically and physically. In classical, Euclidean geometry, a straight line is irredeemably a straight line, and a curve is a curve. But in non-Euclidean geometry, in which parallel lines (in the popular formulation) are seen as meeting at infinity, the straight line is a curved line of infinite radius. Space-time according to Einsteinian relativity is itself curved. Or, if we zoom continuously into the line that composes a circle, it will become effectively indistinguishable from a straight line. In a comparable way, the 'Koch curve' is a geometrical abstraction which is not tied to the common-sense distinctions between straight and curved within the finite spaces with which we surround ourselves—mentally and physically. Its description as a curve refers to the essential properties of the figure regardless of whether its course is plotted through iterations of discontinuous or continuous components. Mathematically speaking, there is no problem with a curve composed from sets of lines subtending 60° angles to each other. Something of this was prefigured in the ancient method of determining the area of a curvilinear figure by 'exhaustion'; that is to say approximating a curve, such as the circumference of a circle, by as many straight lines as possible. Thus a circle could be approximated by a polygon of as many sides as we might chose. But can the conceptual processes which merge curved and straight actually be transferred to the properties of the physical world at every level of organization?

As we move down the scales, from the smallest normally visible, through the microscopic and sub-microscopic levels, to the smallest sub-atomic discrimination that can be accomplished, we see the straight becoming curved, the smooth becoming rough, the regular becoming irregular, and, in turn, the curved becoming straight and the rough becoming smooth, and the irregular becoming regular, in an endless cycle of regression In the age of quantum mechanics, uncertainty principles and motions that are both particle-like and wave-like, we can probably say no more than that the fundamental organizing principles share equally of the natures of the curve and of the straight line, without being precisely either. Whether this duality is the result of the limitations of our modes of seeing, detecting, and representing or whether it really is in the nature of things is unclear to me. On balance, I would put my money on the former, and say that we are stuck with this limitation, even in the era of bubble chambers, scanning tunnelling electron microscopes, Hubble space telescopes, and computers—and that we have to live with it.

Within the field of the smallest discernible physical phenomena, the idea that possesses the most obvious relevance at this stage of our

enquiry is the very beguiling, fractal-like theory of self-similarity in atomic physics developed by David Bohm, the American scientist. Bohm's special relevance at this point in our argument is that he developed powerful strategies for understanding the question of limits of human comprehension. Like Goodwin, Bohm seems to stand on the edge of the contemporary mainstream in his chosen science, but viewed in a longer historical perspective, they can both be seen to be located amongst a succession of creative thinkers who have striven to relate parts to wholes. It is not my intention, here or elsewhere, to set myself up as a judge of the rightness or wrongness of their ideas in technical terms, but to say that they are representatives of a very fertile field of investigation which has yielded plentiful harvests in the past and which seems to me to promise continued fruitfulness in the future. Indeed, in human terms, their style of investigation represents one of the enduring and necessary ways that we have been able to make sense of the physical world over the centuries. They belong, integrally, to the historical story of wholes and parts with which we are presently concerned.

David Bohm's notion of the 'implicate order', which he expounded in his book *Wholeness and the Implicate Order* in 1980 has an undeniably metaphysical dimension of ineffability—in that it proposes a supreme level of organization that can never be *directly* accessible to any methods we might conceivably invent to investigate the properties of the physical world.[55] However, it was not devised by some kind of anti-scientific crank. Bohm was an atomic physicist of world stature, who wrote in 1951 what was then the best overall introduction to quantum physics and was a significant player in the vigorous post-war debates on how quantum mechanics might be understood and characterized. Born in America in 1917, Bohm studied with Robert Oppenheimer and was appointed to a post in Princeton, but was dismissed when he fell foul of the notorious House Committee on Un-American Activities, and spent the later part of his career at Birkbeck College in London. He became increasingly dissatisfied with the intractable qualities of quantum mechanics as an account of 'real' events—classically expressed by Feynmam's statement that 'nobody understands [i.e. can visualize] quantum mechanics'. Instead, he explored the idea that contemporary physics, for all its enormous power and efficacy, needed to look outside the parameters of its accepted technical and theoretical concerns to posit the unifying principles of order that underlie the mysteries of the quantum universe. He felt—and I use the word 'felt' advisedly—there was something inherently unsatisfactory with a set of physical explanations that could accept something as simultaneously wave-like

and particle-like, without any physical explanation as to how any-thing could contain such self-contradictions. He could rest happy with a science that worked potently in relation to its own kind of mathematics and related instrumentation but could not offer explanations beyond the answer, 'it's just that way; it works OK, and it's no good being distracted by other questions that we can't answer'. Bohm's style of answering was to look for alternative explanatory modes, not only within the classical parameters of the older, classical physics but also at ideas that stood outside the standard proscriptions of western science, most notably the thought of the Indian philosopher, Jeddi Krishnamurti, with whom he entered into a sustained dialogue.

From our present point of view, his most telling styles of 'answer' rely upon the time-honoured method of analogy. Two analogies served him particularly well, that of the hologram and of the 'unfolded dots'. A hologram uses the properties of a laser beam, which holds together and does not disperse, to record the wave field of light scattered by a visible object in the form of an interference pattern on a plate. The 'normal' optical array of the object can be reconstituted by a laser to such effect that we see a fully three-dimensional illusion which even responds within set parameters to the moving of the observer's viewpoint, thus imitating the phenomenon of parallax. Not the least remarkable properties of the holographic 'photograph'—and the one which most intrigued Bohm—is that any part of the plate can be used to reconstitute the whole image, down to quite small fragments. This property is similar to Leonardo's theory of the inherent presence of images (what he called 'species') at every point in the air around an object: 'every opaque body fills the surrounding air with infinite images, by which infinite pyramids diffused in the air present this body all in all and all in every part'.[56] Such images only become visible when the right conditions are present; that is to say, in the case of Leonardo's 'species', when the eye is placed at a specific position which is situated at an appropriate distance from the object, or, in the case of a hologram, when a laser reconstitutes the image for an appropriately positioned observer. The holographic property of each small part embodying the whole image is clearly very different from a standard photograph. A corner torn from a standard photographic negative will only contain that part of the image that resides in that corner—say, a foot—and certainly cannot be used to print the whole image. We may say there-fore, that the swirling pattern of a holographic plate contains in all its parts the optical order with which our sight operates but that this order is inherent within another level of organization such that we cannot

directly see a coherent image of the original object when looking in the normal way at the plate.

Bohm's second analogy involves a physical experiment. A viscous fluid is placed in the space between two concentric glass cylinders such that the outer can turn in relation to the inner. A dark droplet is introduced into the fluid and is visible as a suspended dot. When one of the cylinders is slowly rotated, without turbulence, the dot becomes progressively attenuated and eventually disappears from our view. The droplet no longer has any discernible existence. However, if we carefully turn the apparatus in the opposite direction, 'unwinding' it, the original dot is completely reconstituted once the same number of rotations have taken place in reverse. If the experiment is repeated with two or more droplets, they become attenuated and interpenetrate, but are again reformed when the apparatus is reversed. If a second droplet is added when the first has been dispersed by n rotations, and it is itself dispersed by a further n rotations, the second one will be reconstituted by $1n$ reverse motions, while the first will require $2n$ motions, by which time the second will have been re-dispersed in the reverse direction. Not only does this analogy demonstrate the possibility that an original order can be 'unfolded' (Bohm's term) to such an extent that it becomes un-seeable, but that its re-folding has a temporal dimension such that the unfolded order can simultaneously embody two folded orders which re-appear separately over time and can never be seen together in their folded states. This more dynamic vision of different levels of order obviously has more potential purchase on the dynamical systems of physics. It provides an image of what Bohm has called 'holomovement', combining the notion of optical self-similarity of the hologram with the temporal processes of unfolding and folding in the rotating fluid. The 'holomovement' may be said to bear witness to the 'implicate order' in a system, when that order is not detectable by any means of direct observation.

It is important to realize that the hologram and unfolded dots are *analogies*, not literal descriptions of the physical properties of the implicate order behind quantum mechanics. Indeed, we can explain how a hologram works, and a sufficiently minute examination of the fluid containing the dispersed droplets could certainly detect the physical properties and state of the dispersed substance which will eventually recompose the droplets. What he is saying is that we are, as observers of quantum mechanics, in an observational position equivalent to that of someone who stares unavailingly at a holographic plate or at a fluid containing unfolded dots. We simply have no access to the direct 'seeing' of the order in the visible array, given the fixed parameters

of the means of observation available to us. In terms of quantum mechanics, this means that the order we can actually discern is 3-dimensional—equivalent to the folded order of the dot—while the 'implicate order' of quantum mechanics only manifests itself in multi- or $3n$ dimensional space, which is not manifest in itself and is undetectable to the same extent that the dispersed dot is invisible. Like the 'flatlanders' who cannot see a solid sphere, but only its series of circular profiles at it passes through two-dimensional space, we can only see the folded order at the level in which our system of detection is trapped. To accept that there is an implicate order is in the final analysis an act of faith or intuition. Such acts of faith have always been part of the age-old impulse to arrive at models of observed phenomena, and I believe that they always will be. At least we can now confirm, through new aspects of the mathematics of complexity, above all chaos theory, Bohm's necessary contention is that there may be crucial levels of order that are wholly inaccessible to what had previously been accepted as the proper means available to us.

New Complexities and Old Simplicities: A Note on Simple Chaos

When we turn to the properties of chaotic systems, we will find an intimate relationship between fractals and chaos, above all in the kinds of non-deterministic systems involved in DLA. Not the least of the shared features is that they signal the revival of *visual* mathematics, which had become progressively impotent in other than very restricted zones, such as projective and descriptive geometry, more or less since the Renaissance and certainly since the triumph of algebraic notation in the hands of Descartes and his successors. The rise of the new visual mathematics has resulted in something of a cultural schism in the world of professional mathematicians. Freeman Dyson, theoretical physicist and Nobel laureate, appears to rank quantum mechanics so highly precisely because it is basically non-visual, in that the symmetries of quantum systems are described in the abstract conventions of algebra rather than the visual structures of geometry. By contrast, the vocabulary used by mathematicians of chaos has much in common with the concretely physical terms used by Dürer. They speak of 'sinks', 'saddles', 'tangles', 'cascades', 'flows', 'sheathing', 'bifurcations', 'mappings', 'orbits', 'trajectories', 'attractors' . . ., all richly suggestive of the inherent physicality of the mathematics of

chaos. Yet the principles behind 'pictures' involved in the modelling and representation of chaos are not precisely those which we use to depict the space we normally see. To explain this, I will adopt an example used by the physicist, Michael Berry.

Let us take a snooker (or billiard) ball rolling on a table—which is already a simplification, since its main trajectory is confined to two dimensions.[57] Its position in space is defined though two coordinates or variables. Its speed is defined through two more variables, time and distance. Its spin is described in relation to its axis of rotation (two variables) and speed of rotation (two further variables). At any one moment, therefore, we need eight variables to describe its precise state. Over a period of time, the moving ball changes its state, and the plotting of the transition involves the quantification of the changes in all eight variables. Mapping these eight coordinates involves an eight-dimensional 'phase space' which cannot be seen other than through conventions of graphical plotting which deal with two or three coordinates at a time.

We now imagine that the ball rebounds repeatedly from the cushions of the table (without pockets) with no loss of energy. On a rectangular table, the trajectory settles into a regular pattern, but if the shape of the table is composed from even a simple, symmetrical combination of straight and curved elements the motion becomes chaotic, with no regular pattern. However, what has been discovered about such chaotic motions is that they are not random, and that mapping sets of coordinates in phase spaces reveals remarkable configurations in two and three dimensions which graphically represent the statistical parameters within which the behaviour of the system operates. The shapes, in the form of closed loops called 'attractors', act as kinds of gravitational fields of positions that a particle or unit tends to occupy according to the probabilities at work in the system. Mapped in phase space, the behaviour of a snooker ball on the table with curved cushions is drawn into the inescapable field of the kind of attractor that we will see at work in the case of a coupled pendulum.

To illustrate the remarkable visual qualities of the attractors as represented on a computer screen, I will adduce briefly at one of the classic problems of the dynamics of chaos, the coupled pendulum. From a pendulum which can swing in one plane hangs a second pendulum that swings at right angles to it. The pivot of the upper pendulum is driven up and down at a regular frequency. There are five coordinates at work: the velocity of the top pendulum; its angle; the velocity of the drive; the velocity of the lower pendulum; and its angle. As the frequency of the drive changes, complex, chaotic assemblies of periodic

234

motions are generated. Selecting three of the five coordinates and plotting the trajectories in the phase space, two attractors emerge, which (within the conventions of the mapping, and assigned different colours to differentiate them) progressively merge at lower frequencies. The resulting configuration consists of two flat, oval 'doughnuts' lying at shallow angles to each other and crossing at their shorter axes. It is possible to vary the colour within the torus bands of the attractors to map a selected fourth dimension so that a further aspect of the behaviour of the system can be graphically represented.

It is worth thinking, as we near the end of this chapter, about the implications for biological complexity and reductionism of the way in which chaotic motion arises with the coupling of such a classic exemplar of classical mechanics as the pendulum. A single pendulum can be shown to work within the framework of classical laws and behaves with such predictable regularity that it has served for centuries as the regulator of time. The mastery of its laws by Galileo and Huygens was one of the key successes of seventeenth-century mathematical dynamics. The coupled pendulum has become a *locus classicus* of chaos theory. The mathematics of the single pendulum will not predict what happens when two are coupled. And it is unlikely that a system of coupled pendulums would serve as an appropriate vehicle to investigate the law that Huygens formulated. It may be in the future that it will be possible to conjoin the predictionist mathematics of one with the unpredictability of the other—though I suspect not. For the moment, we can acknowledge the power of the two modes of analysis, and, in a historical context, recognize them as corresponding to enduring traits in the way in which we have articulated our structural intuitions about the physical world.

Looking at the way in which the dynamics of the coupled pendulum is articulated by conceptual maps in phase space, the paradox is that the attractors are represented as 'real' objects in regular 3-D space—as luscious artefacts which have been endowed with aesthetic characteristics. What we are seeing in such visual models are shapes of dynamic activity which are not literal portraits of the paths described by objects in physical space as normally conceived. In a sense, we are seeing wholes which are not so much whole bodies as holistic patterns of dynamic behaviour which arise in complex systems composed of defined components.

We seem to be a long distance from our starting points with Leonardo and Dürer. The levels of conceptual abstraction, mathematical power and graphic convention in attractors occupy planes of complexity that they could not have even begun to conceive. Yet, when Leonardo

searched for patterns of order in the turbulence of water, or when Dürer used geometry to construct his 'leaf line', they were intuitively inhabiting the same visual territory that has always attracted those who have striven to disclose the beauties of nature's inherently mathematical design. They were not 'anticipating' the modern sciences of complexity, rather, by supreme acts of observation, perception, cognition, intellect, imagination, and memory they became aware that the phenomena of nature combined structurally predictable regularity of a mathematical tenor with organic variability in which the individual form or phenomenon intransigently resisted being reduced to absolute regularity. They had no access to the mathematics that would have allowed them mastery in either mode of analysis—just as we are short of the final theory that unites them—but, no less than proponents of classical science of the modern era or the post-modern theorists of chaos and fractals, Leonardo and Dürer were in the fundamental business of exploiting structural intuitions of wholes and parts—and they did so in specifically visual terms. Leonardo's water drawings, Dürer's 'leaf lines', Mandelbrot sets, and the attractors of chaology are part of the same story of the human proclivity to visualize geometrical order in the apparent chaos of complex systems in nature.

NOTES

1. D'Arcy W. Thompson, *On Growth and Form*, J. T. Bonner ed., (Cambridge: Cambridge University Press, 1961 reprinted 1992), p. 7
2. 2nd ed. of *On Growth and Form*, Cambridge, 1942, p. 10. Quotes are from this ed. unless otherwise noted.
3. Claude Levi Strauss, *Structural Anthropology*, C. Jacobson and B. G. Schoepf, trs. (Harmondsworth: Penguin Books, 1968), p. 328 and n. 18
4. Thompson, *On Growth and Form*, 1917, preface
5. Thompson, as quoted in Martin Kemp, 'Spirals of Life: D'Arcy Thompson and Theodore Cook, with Leonardo and Dürer in Retrospect', *Physis*, **XXXII**, 1995, p. 48
6. Thompson, *On Growth and Form*, p. 238
7. Thompson, *On Growth and Form*, 1917, p. 4
8. Thompson, *On Growth and Form*, p. 493
9. Thompson, *On Growth and Form*, p. 635
10. Theodore Andrea Cook, *The Cruise of the Branwen: Being a short history of the Olympic Games, Together with an account of the adventures of the British Fencing Team in Athens in 1906*, (privately printed, 1908)
11. Theodore Andrea Cook, *Spirals in Nature and Art: A Study of Spiral Formations Based on the Manuscripts of Leonardo da Vinci*, (London: Constable, 1903), pp. 420, xii–iii, and 427
12. Theodore Andrea Cook, *Spirals in Nature and Art: A Study of Spiral Formations Based on the Manuscripts of Leonardo da Vinci*, p. 258

13. Theodore Andrea Cook, *Spirals in Nature and Art: A Study of Spiral Formations Based on the Manuscripts of Leonardo da Vinci*, p. 359

14. Theodore Andrea Cook, *Spirals in Nature and Art: A Study of Spiral Formations Based on the Manuscripts of Leonardo da Vinci*, p. 424

15. Thompson, *On Growth and Form*, p. 751

16. Thompson, *On Growth and Form*, p. 779

17. Thompson, *On Growth and Form*, p. 514

18. Theodore Andrea Cook, *The Curves of Life: Being an Account of Spiral Formations and their Application to Growth in Nature, to Science and to Art, with Special Reference to the Manuscripts of Leonardo da Vinci*, (London: Constable, 1914), pp. 433–41

19. Thompson, *On Growth and Form*, p. 785

20. Thompson, *On Growth and Form*, p. 586

21. Thompson, *On Growth and Form*, pp. 650–1, quoting *Curves*, p. 85. Cook's sentence continues, 'and the most suitable of these constructions will in the long run be isolated by natural selection'.

22. Thompson, as quoted in Martin Kemp, 'Spirals of Life: D'Arcy Thompson and Theodore Cook, with Leonardo and Dürer in Retrospect', *Physis*, **XXXII**, 1995, p. 47

23. Thompson, *On Growth and Form*, p. 649

24. Thompson, *On Growth and Form*, pp. 513–14

25. Thompson, *On Growth and Form*, pp. 740–1

26. Thompson, *On Growth and Form*, p. 723

27. Thompson, *On Growth and Form*, p. 725

28. Thompson, *On Growth and Form*, p. 741

29. Thompson, *On Growth and Form*, p. 761

30. Thompson, *On Growth and Form*, pp. 757 and 772

31. Thompson, *On Growth and Form*, pp. 32 and 722

32. Thompson, *On Growth and Form*, p. 778

33. Thompson, *On Growth and Form*, 1917, p. 59

34. Alois Riegl, *Stilfragen*, (Berlin, 1893), trs. E. Kahn, as *Problems of Style*, (Princeton: Princeton University Press, 1992)

35. Conrad Hall Waddington, *Behind Appearance: A Study of the Relations between Painting and the Natural Sciences in this Century*, (Edinburgh: Edinburgh University Press, 1969)

36. Thompson, *On Growth and Form*, pp. 476–7

37. Naum Gabo as quoted in Martin Kemp, 'Doing what comes Naturally. Morphogenesis and the Limits of the Genetic Code', in Art Journal, Spring 1996, **XLII**, n. 1, p. 29

38. Martin Kemp, 'Introduction: Faithful lines, drawings by W. Barns-Graham' in *W. Barns-Graham, Drawings: Exhibition Catalogue*, (Crawford Arts Centre, St Andrew's, 1992), pp. 2–4

39. Naum Gabo as quoted in Kemp, 'Doing what comes Naturally', p. 30

40. Thompson as quoted in Martin Kemp, 'Doing what comes Naturally', p. 30

41. Waddington as quoted in Martin Kemp, 'Doing what comes Naturally', p. 30

42. Martin Kemp, 'Doing what comes Naturally', p. 30

43. Martin Kemp, 'Doing what comes Naturally', p. 30

44. Goldsworthy as quoted in Martin Kemp, *Visualizations*, (Oxford: Oxford University Press, 2000), p. 161

45. Stephen J. Gould, 'How the Zebra gets its Stripes', in *Hen's Teeth and Horse's Toes*, (New York: W. W. Norton, 1983), p. 367

46. Stephen J. Gould, 'How the Zebra gets its Stripes', p. 371

47. Alan Turing, 'The Chemical Basis of Morphogenesis', *Philosophical Transactions of the Royal Society*, B, **237**, 1952, pp. 37–72

48. Brian Goodwin, 'How the Leopard changed its Spots', (London: Weidenfeld and Nicolson, 1994)

49. P. Cubas, C. Vincent, and E. Coen, 'An epigenetic mutation responsible for natural variation in floral symmetry', *Nature*, **401**, 9 Sept. 1999, pp. 157–60

50. Benoit Mandelbrot, *The Fractal Geometry of Nature*, (Oxford: Freeman, 1982)

51. Martin Kemp, *Visualizations*, pp. 148–9 and Marina Wallace 'Art and Science', *'Project 8', exhibition catalogue*, (Total Museum of Contemporary Art, Seoul, 1998)

52. Ian Stewart in Martin Kemp, *Visualizations*, p. 149

53. Martin Kemp, 'Coming into Line: Graphic Demonstrations of Skill in Renaissance and Baroque Engravings', *Sight and Insight: Essays on Art and Culture in Honour of E. H. Gombrich at 85*, ed. J. Onians, 1994, pp. 221–44

54. Denis Pelli, 'Close Enounters—An Artist shows that Size Affects Shape', *Science*, **CCLXXXIV**, 1999, pp. 844–6

55. Davis Bohm, *Wholeness and the Implicate Order*, (London: Routledge, 1995); David Bohm and David Peat, *Science, Order, Creativity*, (London: Routledge, 2000, 2nd ed); Jeddi Krishnamurti and David Bohm, *The Ending of Time*, (San Francisco: Harper, 1985)

56. Leonardo, Paris, Institut de France, MS Ash II 6v; in Martin Kemp, *Leonardo da Vinci: The Marvellous Works of nature and Man*, (London: J. M. Dent and Sons, 1989) p. 130

57. Michael Berry in *The New Scientist Guide to Chaos*, ed. Nina Hall, Penguin, London, 1992, p. 185

PART IV

OUT OF OUR HANDS

8 | THE CAMERA

When spectacular colour images from the Hubble Space Telescope were reproduced in the magazine *National Geographic* in April 1997, the cover proudly announced the advent of 'Hubble's Eye on the Universe' (fig. 64). The article inside the magazine invites us to share the wonders visible through 'Hubble's unmatched eye'.[1] The orbiting telescope was named after Edwin Hubble, the astronomer who in the 1920s formulated the proportional relationship of the distances between clusters of galaxies and their speeds, and proposed a constant—the 'Hubble constant'—for the rate at which they are moving away from each other. It was launched as a 'window on the universe' with great fanfare in April 1990. The infamous fault in the mirror, which was disastrously blurring Hubble's vision, was corrected by the spectacular repairs effected by the crew of the space shuttle 'Endeavour' some three years later, and the performance began more than to match expectations. We have already noted in chapter 2 how the images have invaded the world of 'Art' and excited our proclivities for armchair exploration. 'Hubble is simply the greatest tour guide ever', William Newcott tells us in the magazine article. We are, to mix metaphors, being given ever more vivid access to the ultimate performance in the theatre of the universe: 'Hubble has confirmed the existence of black holes, revealed a rogue's gallery of bizarre

Fig. 64

Etched Hourglass Nebula as Seen by the Hubble Space Telescope, from *National Geographic*, April 1997

galaxies, ushered us into a ring-side seat for a comet collision with Jupiter, and chronicled the catastrophic explosions of dying stars'. Looking at the Etched Hourglass Nebula, as illustrated on the cover, 'it seemed that the eye of God was staring back'. Our propensity for cosmic metaphor dies hard.

Yet the 'eye' of Hubble is very much not a human eye. And the translation of its 'perceptions', some 370 miles into space, into brilliant cosmic landscapes which are accessible to our visual system requires a level of contrivance even greater than that of a traditional landscape painter. The fact that Hubble 'can look back some 11 billion years' separates its images radically from the normal snapshot, which operates over such relatively short distances that the image may be considered effectively instantaneous. As a mechanical eye, the Hubble telescope stands in a long succession of human endeavours to create the ultimate form of sight—one that is all powerful and rigorously objective, untouched, as it were by human hand and more importantly uncontaminated by the fallibilities of our limited visual apparatus.

This chapter and the two that follow are designed to provide an incomplete chronicle of and commentary on some of the characteristic endeavours to take the job of seeing and representing out of our hands. These endeavours not only stand in an intimate relationship to the perspectival questions we examined in the earlier part of this book, but also have profound implications for the issues of scale that lay at the heart of the chapters on wholes and parts.

The naturalistic tradition from the Renaissance onwards had depended upon the belief that those responsible for visual representation possessed techniques that certified objectivity. The enduring thrust of early art theory and the subsequent teaching methods of the academies was to produce rule-based methods that could be formulated, acquired, and publicly accredited. Leonardo planned that his treatise on painting would remind 'the painter of the rules and methods by which the painter may imitate with his art all ... the works by which nature adorns the world'.[2] Perspective is the most immediately apparent of the rules, but the behaviour of light and shade in space, the elusive behaviour of colour, the construction and action of the human body, and the register of the 'motions of the mind' through gesture and expression were all subject to codification. Yet for all this effort to produce objective naturalism, the human variability of the results remained constantly conspicuous, both because of the vagaries of individual style (which were increasingly recognized and described during the Renaissance) and with respect to widely varying notions of what the 'imitation of nature' actually comprised. Was 'nature' to be

identified with the raw appearance of things or with some notion of the ideal or essential qualities embedded deeply within the material world? How was the role of poetic imagination in artistic creation—the faculty of *fantasia* lauded by Leonardo no less than by Dante—to be allied to precise imitation? The answers to these questions varied both over time, as cultural ideas of 'man' and 'nature' changed, and within the same culture according to contrasting philosophies of art and nature.

Within the empirical tradition in science, which insisted that the starting point of all serious investigation must be precise observation, the systematic recording of appearance through a command of optically-based techniques of naturalism would on the surface—in the most literal sense—appear to be less troubled by notions of ideal imitation and poetic imagination than the practice of art. The basis of the pictorial revolution of such Renaissance pioneers as Fuchs in botany and Vesalius in anatomy was indeed founded upon an assumption shared by author and reader that things were, as they say, being 'taken from life' and were accordingly reliable as pictures of reality. Fuchs and Vesalius both indulge in visual strategies to reinforce this conviction. The former illustrates the stages through which the makers of the illustrations transmitted the image in a direct line from specimen to page by showing the artist and engraver at work. The latter exploits such devices as the depiction of tools for dissection and eye-witness descriptions in the text of such practical procedures as the way in which dissected bodies are supported by ropes. Such 'rhetorics of reality', as I have called them, reached their peak with such devices as the bent pins and a fly in the illustrations made by Gerhard de Lairesse ('the Dutch Poussin') for the Dutch anatomist Gottfried Bidloo in 1685. It is typical that when he lifts the brain from the base of the cranium, he should show a hand performing the act (fig. 65). However, as we will see later, the problem of raw versus ideal imitation, was not to go away as quietly in science as the proponents of veridical naturalism might have supposed or wished.

An even more radical problem resided in the often unspoken contract between those responsible for the scientific representations and those who took them on trust. Any representation that has been designed so that it bears internal signs of having been 'taken from life' or that is set in a textual vehicle in which such claims are embedded, asks to be taken on trust, and we are generally only too willing to acquiesce. The techniques of naturalistic representation commanded by a master draftsman, such as Leonardo, can readily serve as a double-edged sword. In Leonardo's hands, a dragon can be portrayed with such vivacious conviction of life that it can stand as an eyewitness account, no less than his wonderfully perceptive drawings of cats. An attractive

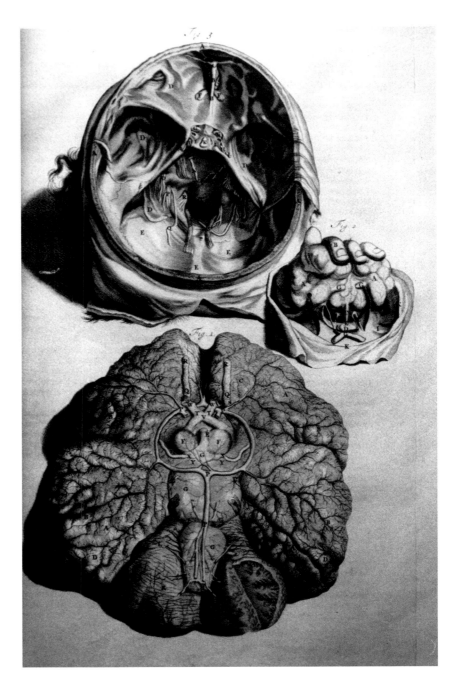

Fig. 65

Gerhard de Lairesse,
*Direction of the
Cranium* in Gottfied
Bidloo, *Anatomia
humani corporis*,
1685

depiction of a unicorn was more likely to seem trustworthy in the
Renaissance—given the generally plausible appearance of the horse-like
animal and its long literary history—than a scrupulous portrayal of
such an improbable piece of natural engineering as a giraffe. And in the
field of botany, a master engraver like Abraham Bosse can endow the

Mandrake within humanoid roots in such a naturalistic vein that we may be convinced that its legendary reputation is fully certified by direct observation. The existence of Bosse's plate as a sober engraving in Nicolas Robert's authoritative *Plantes* means that the conditions for the 'rhetoric of reality' are adequately fulfilled.[3]

The range of illustrations in the first volume of Conrad Gesner's great animal encyclopaedia in 1551 shows the dilemma of trust very clearly. In presenting his *'vero icones'*, Gesner declares that he has striven to ensure that 'all are taken from life'.[4] If not always drawn under his direct supervision, the representations are taken from what he regarded as trustworthy sources or from drawings and accounts supplied by friends and correspondents throughout the world. Faced with the need to portray the rhinoceros, he unsurprisingly looks to Dürer's compelling warrior in full plate armour, which served as the very image of rhinocericity for centuries—to such good effect that it came to represent the essence of the beast better than the animal itself could ever do. Gesner, with typical openness, acknowledges his source in the 1515 woodcut by his predecessor, and takes pains to try to distinguish published accounts of the rhino from the unicorn, his *Monoceros*, the plate of which he presents with clear reservations about its accuracy. However, for all his scrupulous scholarship, the all-inclusive ambitions he set for his volumes mean that he inevitably has to give concrete visual reality to mythical animals if it seems that the weight of historical witness testifies to their existence.

The more that sober techniques of apparently objective representation are involved, the sharper the doubled-edged sword becomes. This is encapsulated in the oft-repeated phrase, 'the camera does not lie'. Even in the age of digital manipulation, this popular reaction to photographically-generated images dies hard. There is a kind of gravitational force that makes us want to believe that the photograph is letting us see the real thing. Whether we are looking at a photograph to prove that the football (soccer ball) did really cross the line in the 1966 Football World Cup final between England and Germany, at a paparazzo's telephoto shot of a celebrity indulging in indiscretions, or at the face of a notorious rapist to discern signs of what makes him like he is, we seem to want to retain a degree of trust which runs counter to what we know as photographic trickery, even in the pre-digital era. The famous fake fairies of Cottingley by two ingenious girls, Elsie Wright and Frances Griffiths, comprise only one incident amongst many in which the camera has been used to lie with its own special level of conviction. The fifteen-year old Elsie and her cousin, Frances, aged nine, used a box camera in 1917 to document their claims to have been

playing with fairies. No less a master of detective techniques than Conan Doyle, begetter of Sherlock Holmes, enthusiastically published the photographs in 1920, occasioning much public clamour. Controversy about the authenticity of the photographs rumbled on, and only in the 1980s was it finally revealed conclusively that Elsie and Frances had photographed cut-out fairies supported by hat pins.

The photographic image has a peculiar authority beyond anything produced by even the best draftsman. When we see an obviously drawn image of a unicorn in an advertisement for a circus, we are more reluctant to surrender our disbelief than when we are presented with a 'real photograph' of the same animal sharing the front page of the *New York Post* with a 'framed' rapist, and resting with a charming baby on an inner page (fig. 66).[5] The story inside the newspaper explains that the 'unicorn', named Lancelot, was created by the transplantation of the horn buds of a baby goat by two self-proclaimed naturalists, Morning Glory and Otter G'Zelle, whose names are as questionable as their exploitative posing on the inner pages of the newspaper. Here the trickery is not photographic—though the images in themselves provide no guarantee that it is not. The unfortunate Lancelot has been apparently 'framed' by surgery which is documented by a 'genuine

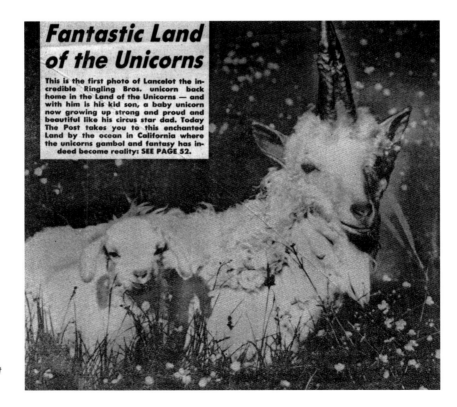

Fig. 66

The 'Real' Unicorn,
from the *New York Post*
12 April 1985

photograph'. This is precisely the phrase need by some of the prosti-tutes advertising their wares on calling cards in London telephone boxes. Aware that potential customers have little reason to trust the printed images of the improbably pneumatic beauties as corresponding to the reality they will encounter, some of the advertisers use such phases as 'genuine photograph' or 'genuine picture' to persuade the viewer that what you see is what you will get. In the case of a trans-sexual, the veracity of the image's feminine allure is particularly crucial.

The issue of trust involved in such images and in the devices used to induce trust in the viewer will be an enduring theme in this chapter. It also relates back to some of the questions we examined when looking at the early reactions to images formed in telescopes and microscopes. The debates become more rather than less urgent when we look at today's panoply of image-making technologies. Our central concern in this chapter will be with the use of devices which are both thought of as 'mere' machines and regarded as purveyors of reality.

Machines and Cameras

If the business of depicting nature consisted of the accurate recording of arrays of geometrical light rays on a plane surface, as maintained by perspective theory, it seems obvious that such a record ought to be achievable by optical or mechanical means. If someone could produce a means by which visible appearances could be counterfeited without the normal human agencies of seeing and representing, the debates on the nature of imitation would clearly be affected quite radically. This is not the same as saying that such a means would define what was meant by art, since anyone who espoused a doctrine which emphasized ideal imitation or imaginative fantasy would clearly resist 'mindless' naturalism.

Photography, announced to the public in 1839, is generally taken as the first technique through which nature could be adequately counterfeited by mechanical reproduction, but the ambition has a long history—a history which is matched by much other mechanical and optical ingenuity. The story of the devices that comprise the pre-history of photographic images is not as fully acknowledged in writings on photography as it should be—particularly with respect to some of the big conceptual and societal claims often made for photographic images—but it has occasionally been told elsewhere, both by others and myself. Generally, there has been a noted reluctance amongst art historians to undertake sustained investigation of the extent to which

optical devices were used by artists from the Renaissance onwards. The British painter, David Hockney, who has himself been using a camera lucida to lay down some bare essentials at the start of making a portrait, argues that lens-based devices and concave mirrors were far more extensively used than anyone has previously supposed.[6] His challenge has met with a predictable degree of hostility from many historians, who resent the idea that their favourites were somehow 'cheating' or not demonstrating true creativity.

For our present purposes, it will suffice to discuss a supreme example of each of the two main species of device—the mechanical 'perspectographs' and the optical 'cameras'—and to focus briefly on the role of machine-based imitation in the half century before the advent of photography. Both kinds of device aspire to trace the optical array on the 'window' through which perspective posits that we see the world in front of us. Perspectographs do this by moving some kind of marker across the plane of the 'window' in such a way that it denotes the contours of things as viewed monocularly from a single, fixed viewpoint. Cameras use lens- or prism-based optical devices to project light originating from objects on to a flat surface which serves potentially as the 'window'. The one type plays towards perspectival geometry, while the other posits a kind of painting with light.

The exemplary perspectograph I have chosen was devised by the Florentine painter and architect, Ludovico Cigoli, who has already featured as Galileo's confidant and graphic defender. In his unpublished but nevertheless influential treatise on perspective, which he was composing in the years after 1600, Cigoli took up the popular sixteenth-century themes of devices for the imitation of nature.[7] A series of variants on existing designs, including those which had been published by Dürer, and machines of his own invention testify to Cigoli's geometrical and technical ingenuity. His culminating invention is an automated machine in which the motion of a sighting bead in any direction across the picture plane is coordinated with the motion of the drawing instrument in the draftsman's hand (fig. 67). The draftsman looks through an aperture at the top of a jointed rod. In his right hand he holds the drawing instrument, which is attached to a line that runs through a groove at the end of a horizontal bar (decorated with the artist's initials, LC) under a transverse rod, and up a vertical member, over the top of which it passes down to a hanging counterweight. As the operator's hand moves towards and away from the machine, a sighting bead on the upright chord will run correspondingly upwards and downwards. This motion of the draftsman's hand will therefore automatically register the apparent vertical height of any

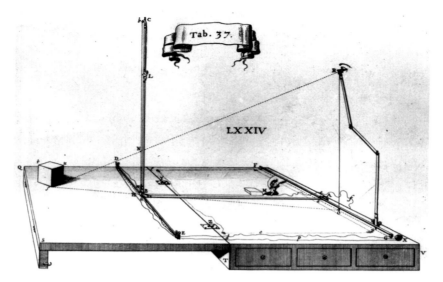

Fig. 67

Ludovico Cigoli,
Perspectograph from
Prospettiva Pratica,
c.1508, Florence,
Uffizi

object. The operator's other hand moves a chord which passes around a pulley and is attached to the upright rod in such a way that the rod can be moved leftwards and rightwards along the transverse bar—courtesy of the sleeve which joins the upright and transverse elements. This motion will register the apparent position of any seen point along horizontal coordinates. Combining the vertical and horizontal co-ordinates means that any point across the 'window'—defined by the motion of the upright rod across the full extent of its traverse—can be registered by the drawing instrument's motion across a horizontal drawing surface. A certain amount of patient practice would be required to become fluent in its two-handed operation, but a version built by Filippo Camerota confirms the perspectograph's ingenious utility.[8]

Cigoli's device was certainly known—one example was in a French noble collection—and it was still being produced, albeit in mechanic-ally refined versions, in the mid-nineteenth century. In its original context it would have thrived in the kinds of cabinets of wonders that included deluxe astronomical and surveying devices, as witness to the intellectual and technical ingenuity of the age which prided itself on the telescope and the microscope. Although Cigoli's treatise outlines his perspectograph's practical utility for artists engaged in various tasks of picture-making and interior decoration, it is unlikely that it was ever used (or was expected to be used) by painters on a widespread or regular basis. It is a piece of perspectival robotics that certifies the objectivity to which perspectival rendition can aspire.

The lens-based camera which provides my second supreme repre-sentative is William Storer's 'Royal Accurate Delineator'. Patented by

the East Anglian instrument maker in 1778, Storer's 'Delineator' stood in line of succession from the earliest camera obscuras in the sixteenth century that had added a lens to the ancient device of a 'dark chamber' and pin-hole aperture. Storer's 'camera' was equipped with an 'eye' of two rectangular lenses, and a telescopic focusing device. The image passed through the double lens to a ground glass screen, below which was placed an additional plano-convex lens. Improvements in the quality of lenses played a large role in justifying Storer's claims that the 'Delineator' could be used 'without the assistance of sun in the day-time, and also by candle-light, for the drawing of the human face, inside rooms of buildings, also perspectives, landscapes, foliage and fibres of trees and flowers'. Produced in an initial edition of fifty, Storer's instrument was hardly designed to be a popular, inexpensive tool. It found an enthusiastic constituency amongst those gentleman and lady 'amateurs', who were connoisseurs of charming scenery in nature and in art. Horace Walpole, builder of the extraordinary 'Gothik' Strawberry Hill, enthusiastically wrote in 1777 that the 'Delineator':

> charms me more than Harlequin did at ten years old, and will bring all paradise before your eyes . . . It will be the delight of your solitude . . . [and] serves for taking portraits with a force and exactness incredible. Sir Joshua Reynolds and [Benjamin] West are gone mad with it, and it will be their own faults if they do not excel Rubens in light and shade, and all the Flemish masters in truth. It improves the beauty of trees,—I don't know what it does not do—everything for me, for I can have the inside of every room here drawn minutely in the size of this page . . . It will perform more wonders than electricity, and yet it is so simple as to be contained in a trunk, so that you may carry on your lap in your chaise . . . In short it is terrible to be three score when it is just invented'.[9]

The main customers for such devices were aristocratic 'amateurs', particularly woman, for whom genteel accomplishment in representing the picturesque beauties of nature was a desirable social attribute.

However, it would be wrong to deduce from this example that cameras were no more than 'executive toys' for the leisured rich. The contentious question about the extent of the use of lens- and mirror-based devices by professional artists in earlier centuries lies outside our present scope, but for the moment we can confidently note that a series of landscape artists in the eighteenth century, including Paul Sandby's brother, Thomas, and probably Paul himself, had recourse to such instruments to aid their depictions of British topography. Rather than being regarded as shameful 'cheating', the mastery of optical imitation was a source of pride, not least for topographical artists like the Sandbys, who were officially employed as map-makers and providers of

'portraits' of locations for civil and military purposes. It should also be said that the best instrument in the world cannot transform a poor artist into a good one.

Readiness to resort to devices was predicated on one essential proviso—that the direct recording of natural appearance was regarded as a desirable goal in art. Within the European academic tradition, history painting of fictional subjects according to classical ideals stood at the top of the genres, while the lower genre of viewpainting tended to be valued the more it aspired to ideal rather than natural imitation. Only in portraiture, which also stood below the lofty ideals of great narrative painting, and genre painting of 'real life' subjects in a 'vulgar manner', were more direct forms of naturalism the accepted rule. Accordingly it was in societies which valued genres which involved the less synthetic forms of naturalism, such as seventeenth-century Holland and Britain around 1800, that the camera image could most readily serve as a more or less direct model for art on a widespread basis.

In science, above all in natural history and anatomy, as we have seen, there was a tradition of support for the proviso that the direct representation of natural appearance was desirable, and, indeed, essential. Given the strength of the British empirical tradition, as embodied in the scientific ideals and practices of major players in the Royal Society, it is unsurprising to find that Christopher Wren published his version of a perspectograph in the *Philosophical Transactions of the Royal Society* in 1669, and that Robert Hooke described two versions of his improved camera, which used a gently concave screen to achieve even focus across the image.[10] The limitation on the practical use of cameras for precise scientific recording came from the inability of the early devices to deliver the kind of detailed sharpness that someone like Lister, for example, required of his wife's and daughter's portraits of shells. For artists, such as Vermeer, the generalizing qualities of the camera image could, by contrast, comprise part of their attraction. By the eighteenth-century, there had been sufficient improvement in the performance of cameras that it did become conceivable to use them for the making of detailed pictures of complete scenes. Before that, their greatest potential utility for most artists would have lain in making separate studies for the component parts of paintings.

The pioneer of their use in science was the English surgeon, William Cheselden, who, as the inventor of a new way of treating ('couching') cataracts, was deeply engaged in questions of vision. His defining case study concerned a teenage boy whom he endowed with sight. Cheselden found that the young man needed to *learn* how to see: 'when he first saw, he was so far from making any judgements about distances,

that he thought whatever objects touch'd his eye (as he express'd it), as what he felt, did his skin ... he knew not the shape of anything, nor any one thing from another, however different in shape and magnitude'.[11] Only gradually did Cheselden's patient learn how to give formal structure to the myriad impressions of coloured light in the eye. Located within a vigorous contemporary debate about seeing and knowing—which centred upon polar disagreements between those empiricists who believed that everything needed to be learnt from experience and those nativists who maintained that inherent mental structures were responsible for our acquisition of visual knowledge— Cheselden's observations were clearly relevant to questions of scientific seeing and representing. An additional layer of engagement with the visual came with his involvement as anatomical instructor in the artists' St Martin's Lane Academy, the predecessor of the Royal Academy in London, between 1720 and 1724. Here he would see draftsman of varying experience and competence grappling with the problems of drawing what they thought they saw—a problem that became particularly troublesome when they were faced with unfamiliar aspects of human anatomy and did not even know what they were seeing.

Cheselden's first illustrated book, *The Anatomy of the Humane Body*, published in 1713 when he was 25, hardly provided a rich visual feast, and he asked a member of the Academy, Gerard Vandergucht, to provide new plates for the later editions of what became a highly successful text-book. However, even employing an artist of accomplishment did not solve all the problems. As Cheselden he explained in his *Osteographia or the Anatomy of the Bones* in 1733, even 'measuring every part as exactly as he [Vandergucht] could'[12] did not entirely remove the difficulties that arose when the artist tried to comprehend the configurations of parts that were unfamiliar to him and that he had no established way of drawing. This dilemma is closely related to that of the boy with the couched cataract, in that the draftsman has learnt to see and draw what he already knows but cannot bring his acquired knowledge to bear on visual impressions of unknown forms.

The way Cheselden proposed to bypass the problem of seeing, knowing, and representational habits was to resort to a splendid camera obscura:

> I contrived (what I had long before meditated) a convenient camera obscura to draw in, with which we corrected some of the few designs already made, and finished the rest with more accuracy and less labour. . . .
>
> About six inches within that end where the draftsman sits, is fixed the table glass, upon the rough side of which he draws with a black-lead pencil, which

he afterwards traces off on paper; towards the other end, in a sliding frame, is put the object glass [convex lens], which being moved backwards or forwards, makes the picture bigger or less, and the inside of the case is made black to prevent reflections of light.[13]

The most spectacular fruit of this method was the *Osteographia*, in which he consciously set himself the task of making a great visual product, fit to stand in the tradition inaugurated by Vesalius's *Fabrica*. He boasted that every bone 'is delineated as large as the life', and he himself contrived the poses for the full skeletons with an overt sense of what was striking and stylish. Such was his conviction that he was creating something worthy of such a divine machine that each volume was issued with two sets of the 56 plates, 'one set unlettered to shew them in their full beauty and one set lettered for explanations'.[14]

Even so, Cheselden was aware that the veridical naturalism of his illustrations was mediated by both medium and manner. The method by which burin lines are used to express 'the smoothness of the ends of the bones', while the rougher textures were etched, 'was also my contriving'.[15] Moreover, his two artists also displayed a difference in manner which was indelibly apparent in the plates. Vandergucht, whom he calls a 'great artist', exhibited an 'open free stile' in the 53 of the 56 large plates for which he was responsible.[16] Shinvoet, who etched the small plates and three of the larger, possessed a 'wonderfully neat and expressive' technique, but the result was 'nevertheless much inferior in stile to that of Mr. Vandergucht'.[17]

Cheselden's goal, notwithstanding such inevitable mediations, was directed primarily to the achieving of 'warts and all' naturalism with respect to the specimen in front of the artist, rather than a synthetic portrait of the archetypal forms. The alternative modes of anatomical illustration were neatly summarized by William Hunter, author of the great, life-size obstetrical atlas, *The Gravid Uterus* (1774) and first Professor of Anatomy at the Royal Academy (fig. 68). Should the anatomist, in Hunter's words, concentrate on 'a simple portrait in which the object is represented exactly as it is seen', or strive to achieve 'the representation of the object under such circumstances as were not actually seen', but conceived in the imagination in such a way that the illustrator can 'exhibit in one view, what could only be seen in several objects'?[18] Hunter, himself, sided unequivocally with those who aspired to represent something 'exactly as it is seen', not least because it exhibits the 'elegance and harmony of natural objects'—even to the extent of showing the reflection of a 12-paned window in the moist membrane over the foetus in one plate.[19]

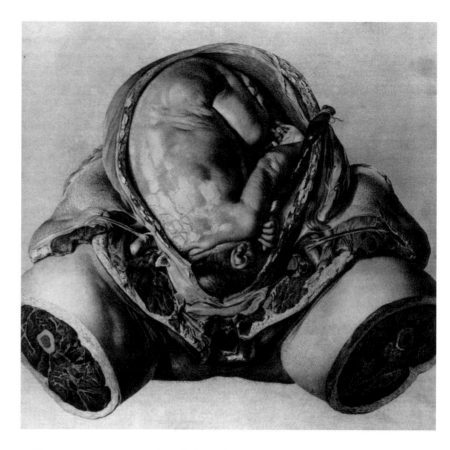

Fig. 68

William Hunter, *Foetus in the Womb*, from *The Anatomy of the Human Gravid Uterus*, 1774

The supreme example of the alternative, synthetic technique was provided by Bernhard Siegfried Albinus's hugely stylish and successful *Tables of the Skeleton and Muscles*, first published in Leiden in 1747 (fig. 69). It may come as something of a surprise that Albinus also devised an optical method for the achieving of accuracy. After taking immense pains to prepare, preserve, and dispose each skeleton with its cartilages and ligaments—achieving the elegant poses through elaborate arrangements of chords, pulleys, and wedges—he went to great pains to 'have an exact figure made of it'.[20] He recognized that if the likeness 'was taken off merely viewing the original', the results would be no better than the erroneous representations that traditionally resulted from anatomists sitting artists down in front of specimens.[21] He found that the draftsman performed increasingly less well 'the further he proceeded amongst the internal', with results that 'were quite different from those which I had planned in my own mind'.[22] Albinus's solution was to employ a developed version of the squared 'veil' which had been described as early as 1435 by Alberti and illustrated by Dürer amongst others.

254

Albinus placed one grid of strings 1.2 metres from the skeleton, and a second, which was 10% smaller, a further 1.2 metres beyond this. Stationed at a point 12 metres away, the two grids would coincide for the artist. From this (very) distant point, the basic disposition of the pose was laid in, while the details were taken from closer to. By aligning the relevant points of 'decussation' on the two grids, the closer views could be accurately located on the coordinates of the overall map. This hugely demanding procedure 'occasioned an incredible deal of trouble to the engraver' and required that Vandelaar acted 'as if he was a tool in my hands'.[23]

The aim for Albinus was not, however, the rawly direct portrayal of the individual specimen in all its particularity. Not only did he choose a subject that was 'elegant and at the same time not too delicate', but he also strove to remove those things that 'were less perfect' in the skeleton—just as portrait painters 'render the likeness more beautiful' by concealing the obvious imperfections of the sitter.[24] It was on this ideal, synthesized armature that he then built the musclemen, adding successive muscles on the basis of his knowledge of 'their positions, connexion, figure, thickness and substance'.[25] The result is a god-like remaking of the ideal man as a prefect creation in the 'second world of nature'—in Leonardo's sense. The figures, posed like elegant grandees in Rome on the Grand Tour, are pictured against backgrounds redolent of ancient grandeur and nature's magnificence, over which man heroically if mortally rules. The fourth stage of the muscles from the front poses Albinus's anatomical aristocrat against a grand rhinoceros rendered in soft chiaroscuro. The 'portrait' of the animal was taken from a rhinoceros that was toured as an exceedingly rare curiosity, year after year 'round the tables of Gentlemen and Ladies like a lap-dog'.[26] Owned by a Dutch sea captain, the unfortunate animal was displayed in Leiden in 1742, where Albinus was Professor. Vandelaar was dispatched to take a likeness of the wondrous beast. No sitter can ever have been portrayed by artists in so many European centres. Amongst the more notable authors of likenesses were Jean-Baptiste Oudry in Paris in 1749 and Pietro Longhi in Venice in 1751. It

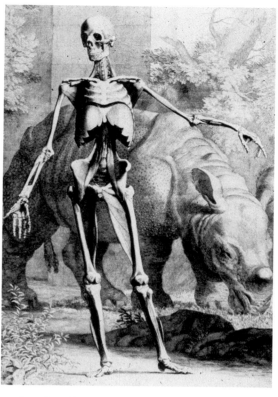

Fig. 69

Bernhard Siegfried Albinus, *Muscle Man with Rhinoceros*, from *Tables of the Skeleton and Muscles*, 1747

was the 'Dutch Rhinoceros' that finally began to elbow aside Dürer's armour-plated image, which had dominated pictorial and scientific imagery for two-and-a-half centuries. In Albinus's plate, the animal not only serves to reduce the glare of the white paper—as Albinus maintained—but also as a monstrously spectacular foil for the muscle-man's visual and social polish.

The rise of optical means of reproduction—with the implication that anyone suitably equipped with the right visual technology could accomplish what had previously required professional artistry—has been seen as prefiguring the 'democratic' art of photography, particularly when it is coupled with the rise of reproductive techniques in early nineteenth-century printmaking which could serve something resembling a mass market. When we add that a demand for convenient and affordable visual records was fuelled by the increasing availability of 'tourist' travel (above all with the advent of railway excursions), the equation of the mechanical image with mass consumption begins to seem irresistible. But the three episodes we have studied from the eighteenth century, Storer's 'Delineator', Cheselden's camera, and Albinus's grids, should give us pause for reflection. They are all firmly anchored in exclusivity. Sir Horace Walpole may be taken as a typical patron of Storer's invention, and the anatomies by Cheselden and Albinus were large, deluxe picture-books which belonged in aristocratic libraries rather than the hands of country doctors. Cheselden sold his great book to subscribers for the goodly sum of 4 guineas, with a guarantee that the plates would be destroyed after the printing of 300 for the English edition. Generally in the later eighteenth century, the scientific style of minutely detailed description was irredeemably tied to the patronage of the wealthy, not least in view of the very high investment costs in the generation and production of the images in state-of-the-art printing techniques on large copper plates. In retrospect, we can see that camera images had the *potential* to serve the growing market for naturalistic 'pictures' of places and people, but it was only a *potential*, and most of the immediate needs were met by new techniques in woodcuts, the invention of lithography, and the perfection of steel engraving, all of which could produce very large editions of prints.

Probably the first significant move of the machine-generated image towards a wider market was made by the 'Physionotrace' invented in 1786 by Gilles-Louis Chrétien, a musician, portraitist, and engraver. The essentials of the instrument, the name of which makes obvious reference to physiognomics as the diagnostic science of human character, were recorded in the year of its invention by Edme Quenedey,

miniaturist and collaborator of Chrétien, who specialized in drawing the images before they were engraved (fig. 70). The 'Physionotrace' stood in a long line of descent from devices which operated with sights and series of levers like those devised for the pantograph in 1603 by Christoph Scheiner (Galileo's leading disputant in the sun-spot controversy). As the sight, set within the tapering rod which is attached to a long vertical bar, moves around the contours of the sitter's features, it traverses the 'window' in the upper third of the framework. It is linked to two double sets of parallel levers, articulated in such a way

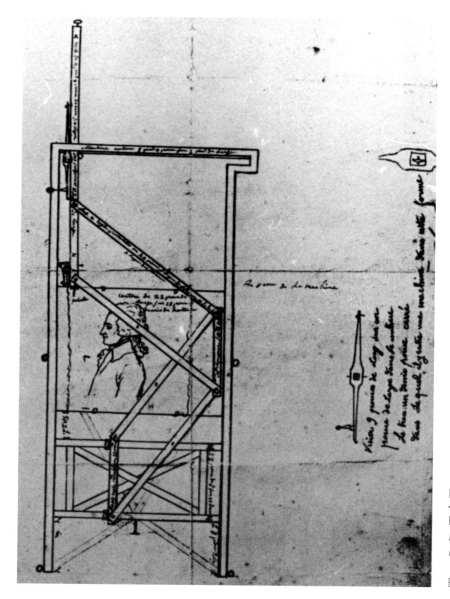

Fig. 70

Edme Quenedey, *Drawing of a Physiognotrace*, 1786, Paris, Bibliotèque Nationale

that a 'point' located over the drawing surface automatically traces the profile and main internal features of the sitter's head and shoulders. Not only was the method quick and, in the hands of a practised operator, reasonably foolproof, it also lent itself to the production of sets of similar drawn and printed images on different scales. Again the locus of the invention is decidedly aristocratic—Chrétien was a musician in the King's orchestra at Versailles—but its obvious associations with silhouettes and miniatures, the two more affordable kinds of portrait in the 1780s, immediately aligned it with a less exclusive market than that for painted portraiture.

Chrétien's device and its products thrived in the eras of the Revolution, Consulate, Empire, and Restoration in France, and it was taken up by a number of practitioners. Quenedey became its leading and successful exponent, aiming to capture a likeness in no more than six minutes. There is no doubt of its appeal for sitters living in or visiting Paris, like the future American President, Thomas Jefferson, aficionado of ingenious devices and himself the inventor of a machine for copying correspondence. A series of fashionable profiles in various engraved formats could be supplied to each sitter at reasonable cost. When Charles Févret de Saint-Memin set up his physionotrace practice in various locations in North America, announcements were made in appropriate newspapers, such as the one published in *Aurora* in 1799:

> Physiognotrace
>
> Likenesses Engraved
>
> The Subscriber begs leave to inform the public that he takes and engraves portraits on an improved plan of the celebrated physiognotrace of Paris, in a style never introduced before in this country. A great number of portraits of distinguished persons, who honoured the artist with their patronage at New York, may be seen at S. Chaudron's, No 12 South Third Street, or at the Subscriber's, No 32 South Third Street. He delivers the original portrait, with the plate engraved and twelve copies of the same.[27]

Standard prices were $25 for the drawing of a man, with an extra $10 for a woman. The engraved copies cost as little as $1.50 each. The results mapped the individuality of profiles in a highly effective manner.

What we are seeing here is the extension of portraiture, one of the earlier prerogatives of rich and 'distinguished persons', into more bourgeois circles. The air of 'scienticity' attached to the new technology struck obvious chords with a generation which was benefiting from the new wealth and the opportunities for leisure which went hand-in-hand with the revolution in manufacturing industries and the increasing provision of public utilities.

Given the 'scientific' exactitude of the 'Physionotrace' it is not surprising to find it used as a physiognomic recording device in the service of the investigation of racial types in the earliest phases of ethnography. When we look at some of the scientific uses of photography, we will say more about this development. For the moment it is worth noting that Saint-Memin took a series of documentary 'likenesses' of Native Americans at the request of Jefferson between 1804 and 1807.[28]

For all its wider accessibility, the physiognotrace and a number of rival devices remained largely within the orbit of the professional image-maker, as had earlier lens-based devices. Other devices were aimed at the increasing bands of 'amateurs'—beyond the relatively exclusive circles served by Storer's expensive camera. Again to choose one representative example, I will look briefly at the 'camera lucida'— not least because it leads directly into the invention of photography in its British guise.

The traditional camera obscura suffered from two main drawbacks. The first—that it only provided a clear image if the receiving surface was located in a dark space—had been mitigated by Storer, but the second—its cumbersome nature—remained a hindrance to the plein-air adventurer. The solution was provided by William Hyde Wollaston, chemist, physicist, and physiologist. Just as Talbot was later to do when he invented photography, Wollaston worked on his camera to overcome the frustration he felt at his own modest efforts in 1800 to 'take the outline' of attractive scenery. By 1806 he had perfected his 'Camera Lucida' and took out a patent. At its heart was a prism with two faces at an angle of 135°, which permitted a view to be seen by double internal reflection. Using 'split-pupil' viewing—that is to say using part of the pupil to pick up the reflected view while the other looks down to the drawing surface—the scene can be 'seen' on the paper and directly traced by the user's pencil. To assist the viewer in 'splitting' his or her pupil, an eyeshade with a small aperture could be hinged over the near edge of the prism, and the discomfort of the dual focus for the eye required by the distant view and near paper could be mitigated by a convex lens as required by individual users. Not only did Wollaston's camera lucida offer ready portability, but it could also be used in bright conditions without shading devices, literally as a camera 'lucida' rather than 'obscura'. It also provided a wider field of view than any camera obscura. It rapidly moved into manufacture, both at home and abroad, and was produced in various 'improved' versions. They were available at prices in the £1 to £3 pound range.

For all its convenience, the camera lucida did not (even potentially) turn everyone into an accomplished topographical artist or portraitist. The problems were legion. Not the least of them was the measure of optical control and patient persistence required to master the 'split-pupil' technique and differential focus. Many optimistic users must have given up, and it took determination beyond the average to reach the point at which it could be used regularly with total ease. Even if the view could be seen clearly on the drawing surface, the artist still needed the relevant repertoire of graphic tricks and manual dexterity to render the scene effectively and attractively—as Talbot later found to his chagrin. And there were the perceptual problems, familiar to any amateur photographer of distant views and described nicely by Sir David Brewster, Scottish physicist, inventor of the kaleidoscope, and pioneer of photography. Brewster recorded an encounter with the sculptor, Sir Frances Chantrey, who was a keen user of optical devices, not least as an aid to likeness in portrait sculptures. In some of his land-scape drawings using the camera lucida, Chantrey was surprised by:

> the flatness or rather lowness, of the hills, which to his own eye appeared much higher . . . In order to put this opinion to the test of experiment, I [Brewster] had drawings made by a skilful artist of the three Eldon hills . . . and was surprised to obtain, by comparing them with their true perspective outlines, a striking confirmation of the observation made by Sir Francis Chantrey.[29]

What Chantrey and Brewster had discovered was that what something 'looks like' to us is not the same as its optically accurate transcription in an instrument.

In any event, the camera lucida, its derivatives and rivals became relatively popular accessories for artistically-inclined 'amateurs' on their picturesque travels. Not the least accomplished of the 'amateurs' (as an artist, at least) was the great astronomer Sir John Hershel. Not only did he have what is called a 'good hand', but he was also a master of using his eyes with optical devices. He turned to a refined camera lucida made by the astronomer and botanist, Giovanni Battista Amici of Modena, to take a series of splendid views at home and overseas, including the approved vistas of ancient and Renaissance splendours on a tour of Italy in 1824, one of which shows Brunelleschi's dome in the bowl of Florence. Unusually, but in keeping with his deeply-ingrained habits as a systematic observer, he generally marked his drawings with a dot surrounded by a circle to denote the azimuth (equivalent to the point on the surface perpendicularly below the eyehole) and sometimes measurements along the coordinates, X, Y, and

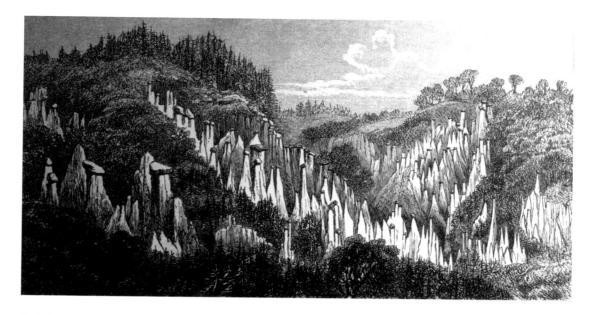

Z (left to right, from bottom to top, and from paper to eye). Although his drawings of views were made recreationally, one did have an unexpectedly scientific consequence. One of the sketches he made of the *Earth-Pillars of Ritten* when he was in the Tyrol in 1821 was used by Sir Charles Lyell in his seminal *Principles of Geology* in 1865 (fig. 71), because he 'could get no good photograph' and the precarious pillars had meanwhile been damaged by an earthquake.

Although, as we will shortly see, the camera lucida in Talbot's disgruntled hands became inadvertently responsible for its own obsolescence in the taking of visual souvenirs, it has survived as a specialist device for the transcription of images viewed in a microscope. In such a context, the hand-drawn line still performs a vitally descriptive job—in terms of the act of seeing by the original observer and the process of visual pointing for the viewer of the published plate.

Fig. 71

Sir John Herschel, *Earth-Pillars of Ritten* (Tyrol, 1821) in Sir Charles Lyell in his seminal *Principles of Geology*, 1865

Photography: Earth and Moon

The picturesque story of William Henry Fox Talbot's frustration with the feeble landscapes he drew with his 'Wollaston's Camera Lucida' on his Italian honeymoon in 1833, and his subsequent striving to capture the transitory image in permanent form, has often been told, and it is not my intention to repeat the narrative here. However, certain aspects are very germane to our present involvement with the implications of the machine-made image, and warrant drawing out.

It was on a visit to the much-admired Villa Melzi on the River Adda in north-west Italy that Henry took one of his 'sketches with Wollaston's Camera Lucida', with such lack of success that 'the faithless pencil had only left traces on the paper melancholy to behold'.[30] He rightly concluded that proficient use of the camera 'required a previous knowledge of drawing'.[31] The failure was all the sharper because his wife, Constance, and his half-sister, Caroline, produced a series of accomplished drawings and watercolours. Henry, like the women, had been exposed to the teaching of drawing masters—those artists who supplemented their income by teaching the 'genteel' art of topographical sketching to ladies and gentlemen of leisure—but had signally failed to profit from his lessons. A sketch made by Constance virtually at Henry's elbow while they were on the terrace of the Villa shows a very decent command of graphic formulas to achieve descriptive effects and of the kind of compositional devices that the drawing masters recommended to bring out the best in a view. It was the failure of his own pencil that provided the vital impetus to his persistent efforts to find a way that the 'pencil of nature' could do the job for him.

Crucially, as a gentleman scientist of professional stature, he had sufficient knowledge of the action of light on silver salts to know in which areas of optical chemistry to seek a solution. As we know, the forming of the image on sensitized paper in one of his little 'mousetrap' camera obscuras was not the most difficult part. Fixing the image was where the real difficulty lay. By 1835 he had achieved what he later labelled as the first negative, showing a window at Lacock Abbey, his family seat in Wiltshire, to such effect that 'when first made, the squares of glass about 200 in number could be counted with a lens'. He had achieved what he initially called the 'Photogenic' or 'Sciagraphic' process, i.e. 'generated by light' or 'delineated by shadows'. His alternative designations, one crediting light and the other shade, mirror the traditional pairing of *chiaro* and *scuro* in *chiaroscuro*—the artist's term for the lights and darks that provided fictive relief, and that had provided the basis for Galileo's reading of the mountainous moon.

Talbot's counting of the panes with a lens immediately draws attention to what was the key factor which gave photography its unique status from the moment of its invention; that is to say, the conviction that it provided a 'faithful record' because a human agency is not directly involved in the process by which the light passes through the 'eye' of the camera and is then imprinted in due order on the 'retina' of the sensitized surface. The excitement of such a non-human method, which could transcend such individual foibles of seeing and

representing as the artist's personal style, is nicely conveyed in the letter that his one-time tutor, George Butler, wrote to him on 25 March 1841:

> What I should like to see, wld. be a set of Photogenic Calotype drawings of Forest Trees, the Oak, Elm, Beech, &c. taken, of course, on a *perfectly calm* day when there should not be one breath of wind to disturb and smear-over the outlines of the foliage. This would be the greatest stride towards effective drawing & painting that has been made for a Century. One Artist has one touch for foliage, another has another; and we may from such characteristic touch devine the intended tree & perhaps name the Artist. But your photogenic drawing would be a portrait; it would exhibit the *touch* of the great Artist, Nature. And, by copying *that touch*, in a short time our modern artists wld. acquire a facility & accuracy & decision in the characterising of trees & delineating their respective foliage, as has never been described in all bygone Ages. What a beautiful Set of *Studies* of Trees, Shrubs &c. might be prepared in a very short time! and what an extensive sale must it obtain! Laporte, Burgess, &c wld. be nothing to it, either in popularity or effect.[32]

Laporte and Burgess were two of the drawing masters who had produced the kind of instructional manuals from which Constance and Caroline had profited.

In endeavouring to capture the 'touch' of nature herself, Talbot may at one level be seen as making a virtue of a necessity, since he lacked any touch of his own. Thus, with real pleasure, he proclaimed that now 'there is assuredly a royal road to *Drawing* . . . Already sundry *amateurs* have laid down the pencil and armed themselves with chemical solutions and with *camerae obscurae*'.[33] Many of his early photographs of scenery and architecture show that he was strongly affected by the conventional tastes for picturesque views and frequently used compositional devices akin to those of the drawing masters. However, he does not appear to have been as readily equipped for the artistic knack of 'seeing Nature' in terms of the established criteria of pictorial excellence as his wife and other members of his immediate family circle. But at another level, his photographic naturalism may be seen as more positively purposeful, and deliberately opposed to key elements in conventional pictorialism. He made a positive virtue of what he saw as the scientific veracity of such an empirical process of recording an image. The factor which John Herschel singled out with most pleasure in one of Talbot's studies of nature was the fact that 'it is very unlike any drawing'—and we have seen that Herschel was a highly skilled draftsman with an unquestionably cultivated eye.

Perhaps the most revealing story was told by Thomas Malone in 1860, during the course of an interesting debate at the Photographic

Society on the issue of 'natural perspective' as recorded by the camera in relation to the 'conventional perspective' used by artists. At the centre of the debate was the notorious problem of the apparent convergence of verticals when looking upwards at a tall object from a close viewpoint:

> Mr. Collen, an artist, was experimenting with Mr. Talbot, and it was proposed to take a ladder & a loft door, which was very much above the level of the ground. Mr. Talbot of course pointed the camera up, and produced a very awkward effect, from the peculiar manner with which the lens was placed with reference to the object. Mr Collen said, 'You are not going to take it so, surely!' Mr Talbot relied, 'We cannot take it any other way, and then Mr. Collen said, 'As an artist, I would not take it at all.'[34]

The photograph at issue, *The Ladder*, published in the third part of Talbot's *The Pencil of Nature* in 1844 (fig. 72), does indeed disobey many of the rules of picturesque view-taking, and gives credence to the spirit of the anecdote, even if Malone's report may be doubted as a verbatim account. Although a reviewer in *The Athanaeum* was so impressed by the chairoscuro of Talbot's published calotype that he was 'led at once to reflect on the truth to nature observed by Rembrandt in the disposition of his lights and shadows', we can see why Collen was unsettled.[35] Judged by an eye trained in the 'rules' of art, the main masses of the image are overly centralized; the base line of the architecture is too starkly parallel to the picture plane; the abrupt termination of forms at the top of the picture is graceless; there are troubling signs of the upward convergence of verticals, the effect that particularly worried Collen; the scale and definition of the figure in the loft are out of kilter;

Fig. 72

Talbot, *The Ladder*, from *The Pencil of Nature*, 1844

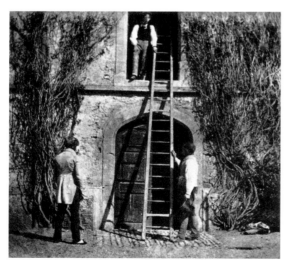

and the distribution and poses of three participants are hardly in keeping with the highest standards of artistic composition. Talbot's reputed answer, 'we cannot do it any other way', shows that his ultimate priorities for photogenic drawing were different from those that guided the draftsman's or draftswoman's eye and hand. He tackled each subject in its own 'way', and if the necessities meant that the rules of conventional art needed to be set aside, so be it. A picturesque subject would elicit a picturesque response, but the pre-ordained requirements of pictorial composition should not be allowed to dominate either the choice of subject or the

new mode of depiction. This attitude explains the lack of internal stylistic uniformity in his own work—a lack of contrived consistency which may be seen as providing a new kind of aesthetic in its own right and giving his work its special strength in responding to different kinds of photographic task.

This does not mean of course that Talbot's photographic *oeuvre* as a whole fails to exhibit a special visual character of its own. Indeed, he fully recognized that each photographer tended to exhibit a personal style. As he wrote to Mlle Petit:

> You say that to encourage true genius each artist should put his name to his own images: that is all very well, but even without the signature one would soon learn to tell them apart, for I find that each Calotypist has a style peculiar to him alone. Even here it is already apparent; soon they will be as Different as Raphael and Rubens.[36]

However, the *manner* in which the medium mediates between the individual artist and the seen object has been transformed by the photographic procedure, since one of the key mediating factors in conventional drawing or painting, the inevitably manual 'touch' of the draftsman, could now be gainsaid by the 'pencil of nature' herself. As Michael Faraday readily acknowledged in 1839, the drawing masters seemed redundant now that 'Dame Nature' has become a 'drawing mistress'.[37]

Given Talbot's interests in the public furthering of science—he was to become a founder-member of the British Association for the Advancement of Science—it is not surprising that he immediately recognized its high promise in scientific recording. When Talbot was stung into revealing his results by the announcement in Paris of Daguerre's spectacular plates, one of the types of item to which Faraday drew attention in the hastily arranged exhibition at the Royal Institution on 25 January 1839 were 'some images formed by the Solar Microscope, viz. a slice of wood very highly magnified, exhibiting pores of two kinds, one set much smaller than the other, and more numerous', plus 'another Microscopic sketch, exhibiting the reticulations on the wing of an insect'. Talbot's *Slice of Horse Chestnut*, dated 28 May 1840, gives some idea of what Faraday's learned audience was invited to inspect, and those with a knowledge of botanical tradition would have recognized that Talbot's image stood in conscious succession to Grew, just as his image of an insect wing was descended from Hooke's famous engraved plates in the *Micrographia*. Also amongst the examples of photogenic drawing chosen to show 'the wide range of its applicability' were 'pictures of flowers and leaves' formed by the direct exposing of

specimens placed on sensitized paper, a process of direct transcription of plant morphology which appealed powerfully to Talbot's botanical interests. It was this procedure that Anna Atkins employed to make 'Cyanotype Impressions' of plants—a technique invented by Herschel which uses iron rather than silver salts—most spectacularly for her volumes on *British Algae*, beginning in 1843.[38] Her radiant plates, exploiting the vivid blue tint of the cyanotype, comprise the first instance of any photographic process being utilized for systematic scientific recording on an extensive scale (fig. 73).

Although Talbot's French rival, Louis Jacques Mandé Daguerre, arrived at his parallel invention by a very different personal route—via a career as a visual entrepreneur famed for dioramas—he was alert from the first to the scientific credentials and potentials of the daguerreotype. In preparation for the disclosure of his invention, he went to great pains to ally himself with the ambitious secretary of the Académie des Sciences in Paris, François Arago, who could deliver a prestigious context for the announcement, protect Daguerre's claims for priority, and promote the photographer's hopes for financial reward from the French state. Daguerre shared Talbot's awareness of photography as a medium of scientific record. One of his early plates showed shelves of fossils parading their geometricizing patterns for the unblinking eye of the camera—as a visual essay in the tradition of a book like Lister's.

Fig. 73

Anna Atkins, *Dictyota dichotoma*, cyanotype from *British Algae*, 1843

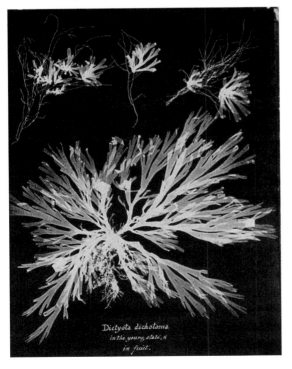

One of the first tyros to be instructed directly by Daguerre was Andreas Ritter von Ettinghausen, a Viennese professor of mathematics and physics, who achieved stunning results with a solar microscope (fig. 74), again with one of the classic subjects of the microscopist's art. From the earliest, therefore, photography was not simply confined to its role as a recording 'eye' but was exploited to give concrete form to images at scales too small to be inaccessible to our unaided vision.

One of the paradoxes involved in the differences between the two rival processes—Talbot using paper negatives to print his calotypes and Daguerre fixing his images directly on silvered plates—is that Talbot could deliver the multiple reproductions that were necessary for scientific publishing, while it was Daguerre's unique plates that

Fig. 74

Andreas Ritter von Ettinghausen, *Section of Stem of Clematis Taken with a Solar Microscope*, Daguerreotype, 1840, New York, Mack Coll.

delivered the high level of detail needed to emulate traditional engravings. Ultimately the future for scientific photography lay with the reproducibility of the negative-positive process as it was progressively refined by Talbot and other practitioners. Talbot's technique meant that the 'faithful record' could go hand-in-hand with potentially unlimited copies, all more-or-less identical. The promise was that anyone, anywhere, and at any time would be enabled to see the unvarnished truth of the specimens subject to the camera's dispassionate scrutiny.

Looking back on the early years of photography from our perspective, it is easier for us than it was for the pioneers and their audience to see that crucial choices of a subjective kind at virtually every stage in the process determine the appearance of the photographic image. The first and absolutely crucial choices involve the selection of a subject to be represented from a particular viewpoint, and, not infrequently its staging with respect to the preparation, arrangement, and lighting of the subjects. Talbot's own multiple views of a classical bust of Patroclus under different angles of illumination showed at an early stage how the same object could be visually transformed. As he wrote in *The Pencil of Nature*, the interplay of the two variables of viewpoint and illumination produced 'an almost unlimited variety' of 'effect' in the images of the bust.[39]

The earliest bands of professional portrait photographers could have been under no illusion about the crucial effects of visual staging. The

setting up of the apparatus and photosensitive surface are also decisive. With the earliest photographs, created using rudimentary cameras, time-consuming protocols, and unreliable processes, any clear and fixed image was welcome. As the equipment and chemistry became more refined so it became possible and indeed necessary to control such technical parameters as focus and depth of field in relation to aperture and exposure. As new photographic emulsions and supports were developed in increasing profusion (such as wet collodion to make glass negatives with superb detail and tonal range) so the look of a negative made from the same subject could vary enormously. Subsequently, the printing of the negative in the dark room could yield very different results, depending upon the equipment, the duration of printing, the preparation and nature of the surface on which the image is printed, and any cropping and mounting. And, even when the image has been solidified as a fixed artefact, it is, like any other visual representation, dependent upon the conditions of its viewing—its setting, labelling, and mental context, and the viewer's expectations and interpretative proclivities.

This is not to suggest that all the early advocates of photography were wrong when they hailed it as a new form of representation. It undoubtedly does posit a different set of relationships between the maker, the tools, the technique, the temporal act of recording, the final form of representation, and the audience, than for any hand drawn or painted image. At is simplest, the heart of the process is dependent on the array of light originating from surfaces in front of the camera, on a set of precise optical conditions in the device, and on specific chemical reactions in direct response to the light. The key factors which mediate between the properties of the subject and the final representation are primarily located in different places in the process from those acts of representation that involve the artist's 'hand'. And many of the parameters of those mediating factors, such as aperture, exposure, and scale, can be precisely described and quantified in ways that can then be duplicated, varied, and codified. In this sense, the pupil, lens, and retina of the photographic camera are available for scrutiny and control in ways that our human perceptual system continually confounds. We will also see how, in the case of 'freezing' very rapid motion and seeing inside opaque bodies by means of X-rays, the technological eye began to see things that lay beyond the scope of our normal vision. In such cases, technical parameters dictate how the unseeable is presented in a form accessible to our eyes. However, we should always remember that it is the human visual system that initiates any kind of photographic activity, that the end product is rigged to work within the parameters of

268

our sight, and that the images are irredeemably subject to our ways and habits of seeing in all their variability.

Surveying the widespread international attempts to harness the new art of photography in a wide range of sciences in the first three or four decades after its debut lies far beyond the scope of our present enterprise. Thus, in keeping with my approach so far, I will look at what seem to me to be episodes which are both exemplary and bear directly upon the issues of seeing and knowing that have been concerning us from the first. I intend initially to revisit a familiar problem, the seeing and picturing of the heavenly bodies, especially the moon, before looking in the next chapter at some uses of photographic images in the human sciences. The medical and anthropological uses on which I will be concentrating involve the overtly descriptive science of anatomy, and the attempts to use photography as a communicative and classificatory tool in the new discipline of eugenics and in the burgeoning efforts to bring some order into the diagnosis of insanity.

As an astronomer of note François Arago was naturally keen to investigate the applicability of the daguerreotype to his professional calling. Daguerre's own early photograph of the moon, no longer traceable, probably revealed the potential of the medium rather than offering any immediate utility, as did his daguerreotype of the solar spectrum taken at Arago's request to provide 'proof that scientific work could be conducted using this process'.[40] The role of the photographic record as a new kind of certifiable and communicable witness of experimental results understandably engaged the attention of the great scientist and photographic pioneer, Sir William Herschel, who had been responsible for the establishing of 'photography' as the standard name for the new 'art'.[41]

The first surviving image of the moon of real quality was exhibited by John Whipple and George Bond at the Great International Exhibition in 1851, to be followed by rival moonscapes by other photographers, including Lewis Rutherfurd, whose detailed masterpiece of tonal modelling in 1865 did much to silence those critics who claimed that photographic images of the moon were falling far short of what could be mapped with a telescope in the traditional manner. Just as the telescope itself had done, the camera as an adjunct to astronomical observation occasioned much debate on what was been recorded and seen. The most sustained exploration of these questions occurs in Nasmyth's and Carpenter's photographically illustrated book in 1874, *The Moon, Considered as a Planet, a World, and a Satellite*. James Carpenter was a professional astronomer at the Royal Observatory in

Greenwich, while James Nasmyth was an engineer who came from large family of Scottish artists. Nasmyth's father, Alexander, was regarded as the 'father of Scottish landscape painting' and, as James himself recorded, was much concerned with what he called 'graphic eloquence'—that is to say how marks on a surface can be construed as an impression of reality.

Nasmyth and Carpenter used a notable range of diagrammatic and representational modelling—including prints of Nasmyth's own wonderfully crisp drawings, a photograph of the moon by Warren de la Rue and Joseph Beck, a 'picture map' with some shading, a 'skeleton map' of lines alone, imaginative impressions of an 'Ideal lunar landscape' and eclipse of the sun as viewed from the moon, plaster models of the lunar surface which were photographed under immaculately controlled lighting (fig. 75), and a photograph of a laboratory simulation of a live volcano. The authors' justified claims for high visual literacy were based on 'upwards of thirty years of assiduous observation' during which 'every favourable opportunity has been seized to educate the eye'.[42] As part of this education, they resorted to exactly the same kind of visual analogies that had performed such a vital service for Galileo and the telescopists and Hooke and the microscopists in the early years of their disciplines. To attune our interpretation of the patterns of chiaroscuro visible in the telescope, Nasmyth and Carpenter illustrate striking photographic 'heliotypes' of an aged hand and a shrivelled apple under lateral illumination (fig. 76). Elsewhere they reproduce a beautiful photograph of a glass sphere cracked by internal pressure. By visual means they are accomplishing what earlier authors had striven to do with verbal parallels of a less immediate kind. Their visual analogies involve both appearance and process, in the case of the wrinkles between the mechanics of the folding that occurs when the inner core has a surface area smaller than its covering skin, either through the contraction of the former or stretching of the latter. This emphasis upon the dynamic and enduring processes underlying appearance is, as we have seen, characteristic of mid-nineteenth century visions of nature. Their sense of the universe and its parts in 'perpetual mutation', evolving from primeval matter, is nicely expressed on the first page of their text. Since:

Fig. 75

James Nasmyth and James Carpenter, *Photograph of the Moon by Warren de la Rue*, from *The Moon Considered as a Planet, a World and a Satellite*, 1874

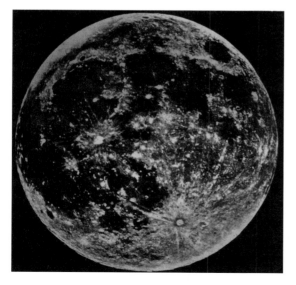

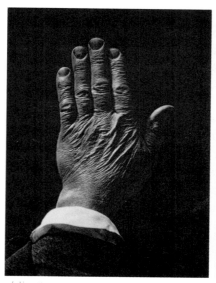

J. Nasmyth Heliotype

Fig. 76

James Nasmyth and
James Carpenter,
*Aged Hand and
Shrivelled Apple,*
from *The Moon
Considered as a
Planet, a World and
a Satellite,* 1874

the same laws work in the great as well as the smallest processes of nature, we are compelled to believe in an antecedent state of existence of the matter that composes the host of the heavenly bodies.[43]

Nasmyth's and Carpenter's photographs of the plaster models under changing angles of illumination constitute forms of visual 'proof', in that the acts of observation and analysis are completed by an act of 'conclusive' re-making in an almost Leonardesque manner. It was the ability of photographs to chart changing appearance under different lighting and with the passage of time that encouraged a number of astronomers, lead by Herschel, to advocate the recording of eclipses of the sun and the passage of sun spots, both celestial events that provided much vital evidence about solar light and the nature of the sun. The early results probably had more value as curiosities than as subjects for analysis, but by the time that Warren de la Rue made 31 prints of an eclipse visible in Spain in 1860, some much-disputed solar phenomena were being clarified by their inscription on the photographic plate. For example, the phenomenon of 'Baily's beads', a necklace of light patches caused by the last glimmers of light filtering through the rugged fringe of the moon, was duly confirmed. De la Rue, London bookseller and paper manufacturer, also collaborated with Benjamin Loewy at Kew to take thousands of three-foot large photographs of sunspots with a specially constructed 'photoheliograph'. He also took up the long-standing challenge of seeing and knowing by using the stereoscope, invented by Sir Charles Wheatstone in 1838 and perfected by Sir David Brewster in the late 1840s. Two views of

the moon, taken simultaneously through apertures separated by a distance equivalent to that between our eyes, when viewed through the binocular viewing apparatus, presents a stereoscopic illusion of its sphere in three dimensions. Old visual needs for articulate picturing in astronomy were being met in new ways.

NOTES

1. *National Geographic*, April, 1997
2. Leonardo in Martin Kemp and Margaret Walker eds and trs, *Leonardo on Painting*, (New Haven and London: Yale University Press, 1989), p. 16
3. Nicolas Robert, *Roberti Icones Plantarum (Receuil des Plantes)*, (Paris, 1701)
4. Conrad Gesner, *Historiae animalium*, (Christopher Froschauer: Zurich, 1551–1587)
5. New York Post, 12 April 1985
6. Martin Kemp, *Visualizations, The Nature Book of Art and Science*, (Oxford: Oxford University Press, 2000), pp. 64–5
7. Ludovico Cigoli, *Prospettiva Pratica*, Martin Kemp 'Ludovico Cigoli on the Origins and Ragione of Painting' in *Mitteilungen des Kunsthistorischen Institutes in Florenz*, vol. 35, no. 1,1991, pp. 133–52
8. Filippo Camerota, *Il Segno di Masaccio*, exhibition catalogue, (Florence: Uffizi, 2002), p. 205
9. Horace Walpole as quoted in John H. Hammond, *Camera Obscura: A Chronicle* (Bristol: Adam Hilger Ltd, 1981), p. 79
10. Martin Kemp, *The Science of Art: Optical themes in Western Art from Brunelleschi to Seurat*, (New Haven and London: Yale University Press, 1990), p. 190
11. William Cheselden, *Osteographia or the Anatomy of the Bones*, (London: W. Bowyer, 1733), preface
12. William Cheselden, *Osteographia*, ch. VIII
13. William Cheselden, *Osteographia*, ch. VIII
14. William Cheselden, *Osteographia*, preface
15. William Cheselden, *Osteographia*, preface
16. William Cheselden, *Osteographia*, preface
17. William Cheselden, *Osteographia*, preface
18. William Hunter, *The Anatomy of the Human Gravid Uterus*, (Birmingham: John Baskerville 1774), preface
19. William Hunter, *The Anatomy of the Human Gravid Uterus*, preface
20. Bernhard Siegfried Albinus, *Tabulae sceleti et musculorum corporis humani*, (Leiden: Johann and Herman Verbeek, 1747) and *Tables of the skeleton and muscles of the human body*, (London : H. Woodfall for John and Paul Knapton 1749)
21. Bernhard Siegfried Albinus, *Tabulae sceleti et musculorum corporis humani*
22. Bernhard Siegfried Albinus, *Tabulae sceleti et musculorum corporis humani*
23. Bernhard Siegfried Albinus, *Tabulae sceleti et musculorum corporis humani*
24. Bernhard Siegfried Albinus, *Tabulae sceleti et musculorum corporis humani*
25. Bernhard Siegfried Albinus, *Tabulae sceleti et musculorum corporis humani*
26. T. H. Clarke, *The Rhinoceros: From Dürer to Stubbs 1515–1799*, (London: Sotheby's Publications, 1986), pp. 47–8

27. In Peter Friess, *Kunst und Machine, 500 Jahre Maschinenlinien in Bild und Skulptur*, (München: Deutscher Kunstverslag, 1993), p. 138

28. Friess, *Kunst und Maschine*, p. 139

29. Sir David Brewster, *The Stereoscope*, (London: John Murray, 1856), p. 172

30. William Henry Fox Talbot as quoted in Larry Schaaf, *Out of the Shadows: Herschel, Talbot and the Invention of Photography*, (New Haven and London: Yale University Press, 1992), p. 35

31. Larry Schaaf, *H. Fox Talbot's The Pencil of Nature, Anniversary Facsimile*, (New York: Hans P. Kraus Jr. Inc, 1989), 1844, notes to plate XVII

32. George Butler as quoted in Martin Kemp 'Talbot and the Picturesque View. Henry, Caroline and Constance', *History of Photography*, winter 1997, **21**, n.4, pp. 276–7

33. Larry Schaaf, *H. Fox Talbot's The Pencil of Nature, Anniversary Facsimile*, (New York: Hans P. Kraus Jr. Inc, 1989), 1844, part I, historical introduction

34. Martin Kemp, 'Talbot and the Picturesque View. Henry, Caroline and Constance', *History of Photography*, winter 1997, **21**, n.4, p. 279

35. Martin Kemp, 'Talbot and the Picturesque View. Henry, Caroline and Constance', *History of Photography*, winter 1997, **21**, n.4, p. 280

36. Martin Kemp, 'Talbot and the Picturesque View. Henry, Caroline and Constance', *History of Photography*, winter 1997, **21**, n.4, p. 281

37. Michael Faraday, 'Obituary', *Proceedings of the American Academy of Arts and Sciences*, **8**, 4 June 1872, p. 470

38. Anna Atkins, *British Algae, Cyanotype Impressions*, (Halstead Place, Sevenoaks: Privately Published, 1843–53)

39. Larry Schaaf, *H. Fox Talbot's The Pencil of Nature, Anniversary Facsimile*, (New York: Hans P. Kraus Jr. Inc, 1989), 1844, notes to plate XVII

40. Arago in Anne Thomas, 'Capturing the Light: Photographing the Universe', Ann Thomas ed., *Beauty of Another Order: Photography in Science*, (New Haven and London: Yale University Press in association with National Gallery of Canada, Ottawa), p. 196

41. Kelley Wilder and Martin Kemp, 'Proof Positive in Herschel's Concept of Photography', *History of Photography*, 2002, **VVXI**, pp. 358–66

42. James Nasmyth and James Carpenter, *The Moon, Considered as a Planet, a World, and a Satellite*, (London: Marey, 1874), preface

43. James Nasmyth and James Carpenter, *The Moon, Considered as a Planet, a World, and a Satellite*, (London: Marey, 1874), p. 1

9 | 'THE FAITHFUL RECORD'

In many ways the nearby body of human beings provided more intractable problems for early photography than the distant body of the moon. Some of the issues are shared with all documentary photography, but some are particular to medical images, and it will be helpful to review some of the more prominent of them before looking at the two areas on which I have chosen to focus, the anatomy of the body, and the characterization of facial types.

Medical photography has always involved a continual struggle to extract visual legibility from the confusing and largely unfamiliar interior landscape of the body, particularly in view of the limitations of its static, 'one-eyed' perspective and, in the earlier phases, the shortcomings of the monochromatic image. Photographic images in medical texts needed (and often still need) explanatory line-diagrams or were reinforced by retouching to help viewer look selectively at the desired information. In addition, we need to remember that photographic images were necessarily transposed into engravings, woodcuts, or lithographs in the earlier phases of photographically-generated illustrations in books, because there was no means of reproducing them directly on the printed page. The need for selective visual pointing became particularly urgent with the rising demands to record, correlate, and classify specific pathological signs of defined maladies, in the context of the new requirements of diagnostic medicine in the nineteenth century.

In medical photography, the issue of staging is particularly crucial. The specimen needs to be prepared for photography, the forms dissected and clarified, left in the body or removed, supported in desired positions, perhaps sectioned, possibly stained and labelled, kept

moist or dry, and lit to bring out desired features. Only then can the photographer take all the technical choices about the camera, film, exposure, depth of field, contrast, printing, etc. With the exception of special illustrations of pathology, in which a report on a particular case will place an emphasis upon what is specific in this individual instance, there has been a general tendency to nudge the photographic image destined for instructional texts in the direction of the normative or non-specific, through a careful rigging of the various medical, visual, and technical choices.

Not the least significant of these choices is the contextual and accessory material visible in the photograph. If the photographer is, say, required to represent a goitre on a patient's neck, more than the goitre is likely to be revealed. How far does the photographer, or who-ever prints the image, include details of the patient's face and body, clothed or unclothed? Are medically 'redundant' aspects of those parts of the scene that enters the eye of the lens to be excised or masked? Or can they be included with impunity, assuming that they have no effect on our understanding of the intended content of the image? Is the issue of their elimination simply one of preserving the patient's right to anonymity in the age of photographic portraiture? The irrele-vance of accessories and contexts (such as Albinus's landscape back-grounds) was commonplace in earlier histories of medical illustration, but it has been increasingly realized—as was apparent to those who chose the staging in the first place—that the visual supports performed important if often unrecognized roles, particularly with respect to what may be called the intellectual and social rhetoric of the imagery.

The very inclusiveness of the photographic image means that it can rarely avoid the seepage of 'border information' unless the image is trimmed or otherwise doctored. For example, in the case of the portrayal of a whole body suffering gross damage or deformity, the posing of the figure, its costume, and its setting require conscious and unconscious choices, and any choice carries with it some kind of meaning. Even when portraying parts of the body within a more limited pictorial frame, it was difficult to avoid signs which gave some clue about the attitude of the originators of the image, and perhaps about the status of the patient in a variety of social and racial terms. If the clues could be eliminated, the elimination in itself may comprise a statement about the Olympian objectivity of the doctor and the position of the patient as an anonymous 'case'. Repeatedly in the earlier phases of medical photography, we find the apparently gratuitous posing of the 'sitter' and staging of the photograph in keeping with a series of accepted stylistic modes in both medical illustration and more

broadly in terms of conventions of artistic portrayal, photographic or otherwise. This tendency to fit photographic images within existing genres of portrayal was, as we will see, particularly marked when depicting the insane.

Bodies

By the time of the advent of photography, the traditional 'stylishness' of anatomical picture books was becoming discredited in the face of a rising fashion for simple, unadorned, visually reticent, and stylistically sober portrayals, aimed not least at the growing numbers who were learning and practising medicine within the professional colleges, societies, and institutions which were increasingly dominating nineteenth-century medicine in the urban societies of Europe and North America.

This 'non-style', as I am calling called it, found its perfect expression in 1858 in the first edition of Gray's *Anatomy*, which assumes the nature of a rhetorical style in its own right, designed to preach the objective values of a professional class dedicated to a high scientific understanding of the mechanisms of the human body (fig. 77). Henry Gray's *Anatomy: Descriptive and Surgical*, with 363 'drawings by H. V. [Vandyke] Carter, late Demonstrator of Anatomy at St George's Hospital' first appeared in a fat but unpretentious quarto volume, bound in matter-of-fact brown cloth. As Gray emphasized, the aim was restrictedly practical, avoiding any taint of philosophic anatomy in favour of introducing such verbal and visual descriptions as would be useful for the aspiring surgeon. The text, like Darwin's *Origin*, aspires to 'scientific' sobriety through anonymous flatness of tone, while the woodcut diagrams use business-like lines of no more than three or four thicknesses to achieve a steady register of unseductive description. The avoidance of any appealing views of the whole body—even the depiction of a complete skeleton—and Gray's functional setting of the illustrations within the pages of printed text consistently negate any tendency to think that we are dealing with the

Fig. 77

Henry Gray,
*Musculature of
Abdomen, Lateral
View,* from *Anatomy,
Descriptive and
Surgical,* 1858

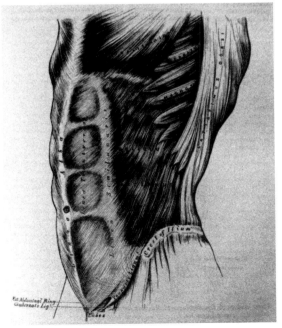

'arty' production of a picture book. The most laconic of prefaces is fol-
lowed by the table of contents and list of illustrations, before the text
opens with an eleven-line definition of the classificatory branches of
Anatomy. Then the reader is plunged *in media res* with a detailed
account of osteology. After an unrelenting progress through the various
systems, his text ends abruptly with an account of the recto-vesical
fascia. The only conclusion is provided by a prodigious thirty-page
index. The whole book presents a heroically disciplined exercise in
intellectual restraint, and unequivocally exudes the air of institutional-
ized science instruction in the mid-nineteenth century. As a con-
sequence, it has a special voice and visual style all of its own.

Photography, in the minds of its early evangelists, was ideally placed
to participate in this 'non-style', given its apparent elimination of the
artist's hand. But, for the reasons we have outlined, it took a great deal
of work to make it do so. The problems are readily apparent in Nicolaus
Rüdinger's pioneering attempts during the 1860s and 1870s to exploit
'non-subjective' techniques of representation in the illustration of
anatomy books. Impressed by the potential of photography to provide

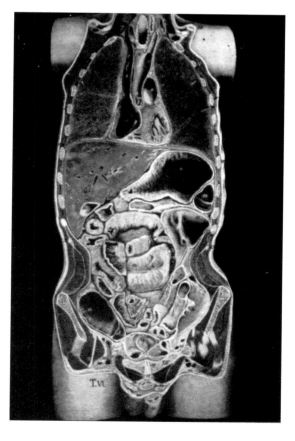

Fig. 78

Nicolaus Rüdinger,
collotyped by
M. Gemoser, *Vertical
section of the Thorax
and Abdomen*,
from *Topographisch-
chirugische anatomie
des Menschen*, 4 vols,
1873–9

a true record of a dissection, the Munich
anatomist availed himself of newly available
methods of photographic reproduction to
illustrate frozen sections and other aspects
of his anatomical demonstrations (fig. 78).[1]
Sectional anatomy had been attempted as
early as the Renaissance, but it was only in
the early nineteenth century that a method
was developed for sectioning frozen bodies
in such a way that the organs remained in
their true locations. Particularly interesting
from our present standpoint was Wilhelm
Braune's technique of depicting the sections
directly on a transparent paper placed over a
thin layer of ice on the surface of the section
(fig. 79). As he explained, 'when the drawings
concern such an elaborate mechanism as the
human body, every line must be true to
nature and copied with the greatest care'.[2]
Published in 1867 and 1872, followed by a
number of subsequent editions and trans-
lations, Braune's sections combined a high
level of visual sophistication with an air of
high scientific objectivity which gave them

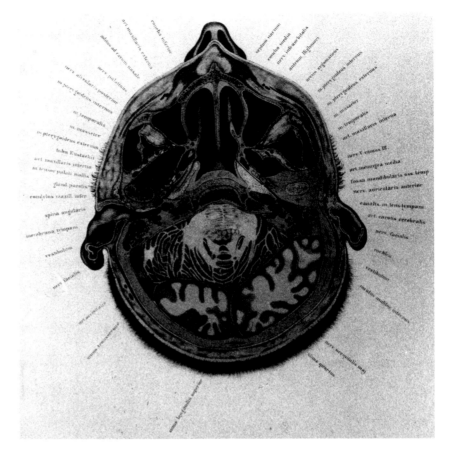

Fig. 79

Wilhelm Braune,
drawn by C.
Schmiedel, *Horizontal
Cross-Section of
the Head*, from
*Topographisch-
anatomischer Atlas.
Nach Durchschnitten
an gefrorenen
Cadavern*, 1872

an obvious appeal—even if the reconstruction of the sections into a complete picture of the organs required a considerable act of visualization. The assembly of such sections into plastic wholes is now accomplished by computerized stereography, which uses statistical methods to reconstruct three-dimensional data.

Rüdinger's photographic publications faced an uphill task in rivalling Braune's levels of definition. Rüdinger's *Atlas of Peripheral Nervous Systems* (*Atlas des peripherischen Nervensystems*) in 1861 was illustrated with photographs by Joseph Albert, but they were so heavily reworked as to become virtually hand-made prints.[3] Albert's photographs were later used in Rüdinger's *The Anatomy of the Human Spinal Nerves for Students and Doctors* (*Die Anatomie der menschlichen Rückenmarks-Nerven für Studierende und Aertze*) and *The Anatomy of Human Cerebral Nerves* (*Die Anatomie der menschlichen Gehirn-Nerven*) but only as a basis for plates in steel engraving by Meermann and Bruch.[4] In 1873, the first and second parts in his more comprehensive anatomical series, *Topographisch-chirurgische Anatomie des Menschen* (*Topographical and*

278

Surgical Human Anatomy) proudly advertised 'thirty six figures in collotype [*Lichtdruck*] by Max Gemoser'.[5] The collotype process involved direct printing from a gelatine-coated plate after exposure to light under a photographic negative. It had been developed by Joseph Albert, and was first exploited in the printing of larger editions from lithographic stones by Max Gemoser in Munich in the year of Rüdinger's publication. The process found it hard to deliver the degree of definition achieved with hand-drawn lithographs in earlier atlases, and Gemoser's collotypes show extensive signs of retouching. Even with such extensive manipulation and the added enhancement of colour, the clarity of detail still fails to rival representations by specialist artists. However, for Rüdinger as for other users of early photography in science, the virtue was that he could claim to be showing the real thing.

Indeed, the use of photography became a sign of modernity—of being abreast of the latest in high-tech image-making—just as we now see computer graphics used as a way of demonstrating that the author and publisher are masters of the latest techniques. Increasingly, there was a discernible 'Craze for Photography in Medical Illustration', to use the title of an editorial in the *New York Medical Journal* for 1894.[6] Indeed, it was claimed that some authors' motives for the liberal use of photographic illustrations went beyond what was strictly necessary for the medical content of the text. During the course of the 1894 debate, the intelligibility of photographs was compared unfavourably with drawn illustrations. An article in the 1886 edition of the *British Medical Journal* had already compared photographs of morbid specimens to 'Ovid's Chaos'.[7] Critics of photography also pointed out that the anonymity of patients was often compromised, not least without their consent, and that images of naked figures could all too easily pander to voyeurism.[8] The portrayal of naked women evoked obvious taboos, and the display of the genitals of either sex possessed an obvious potential to scandalize more sensitive or censorious spectators. As early as 1865, a photograph of a man with two sets of genitalia in the *Lancet* was condemned as a 'mere mask for obscenity'.[9] The public issue of photographs of congenital 'freaks' and pathological 'monstrosities', particularly those intended for the popular stereoscopic viewing devices, suggests that fears of an unhealthy market for such images were well founded.

Used responsibly, the stereoscope proved to be the most effective of the early attempts to overcome the shortcomings of medical photography. A nice example is provided by *The Edinburgh Stereoscopic Atlas of Anatomy*, devised by David Waterston and published by T. C. and E. C. Jack in 1905. The *Atlas* comprised a series of cards (fig. 80) on the lower part of which were pasted stereoscopic photographs, to be

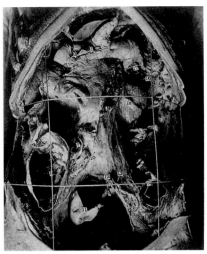

Fig. 80

David Waterston,
*Dissection of the
Abdomen*, from *The
Edinburgh
Stereoscopic Atlas of
Anatomy*, 1905

viewed through the kind of lenticular stereoscope which Brewster had earlier perfected at St Andrews (where Waterston was to become Bute Professor). The upper section of the card contained the descriptive text, which was keyed into the labels which had been stuck over the actual specimen. The boxes of cards were issued with a specially designed metal stereoscope, with spring-loaded, folding parts.[10] The additional level of illusion in the three-dimensional images is visually fascinating in itself, but more importantly it provides something of the ability to separate out superficial and deeper structures which is generally lost in photographs of dissections. The image of the partially excavated thorax, for example, becomes a glimpse into a great monochrome cavern. The greatest drawbacks of the stereoscopic images were their necessarily small scale, even when enhanced by the viewing lenses, and the relative inconvenience of needing access to a special viewer.

In spite of this relatively effective foray into the use of photography as a way of providing an alternative to the artist's hand, when Waterston came to provide the illustrations for his *Anatomy from the Living Model* in 1931 he used photography only to a limited degree for the surface features of the body.[11] When it came to the main sequences of dissected views of the head and neck, and thorax and abdomen he devised his own method of 'orthogonal' or non-perspectival projection to achieve the desired level of accuracy (fig. 81). He stabilized the body within a plaster of Paris frame, and placed a sheet of glass horizontally over the dissection. The main outlines and details were then traced on the glass using a 'diopotrograph'—an instrument 'made specially for me by Negretti and Zambia, Regent Street, London'.[12] The device was designed to ensure that the traced lines were laid down perpendicularly

above the contours of the forms. The drawings were then re-traced on to paper, before being 'shaded and coloured' by Waterston's draughtsman, J. T. Murray. Although the final plates were on a reduced scale, by 11:40, they retained the consistency of relative size which meant that they could be precisely overlaid to show the relationship between superficial and deeper features.

Very much this same style of illustration, with clear outline and unassertively descriptive detail, is still apparent in one of the most widely-used books of current instruction, J. C. Boileau Grant's *Atlas of Anatomy*, first published in 1943 (fig. 82).[13] As he had insisted in his earlier publication, *Grant's Method of Anatomy* (1937), an 'illustration to be of value must be simple, accurate and convey a definite idea'.[14] The simple line illustrations in his *Method* were designed to facilitate an understanding of the 'underlying principles' behind the assembly of the human body, in such a way that the student may proceed to learn through 'logic, analysis and deduction—as opposed to dry memory work'. The more detailed illustrations in the *Atlas* were produced in collaboration with Elizabeth Blackstock by a method not unlike that of Waterston, though the projection was not 'orthogonal' in this case:

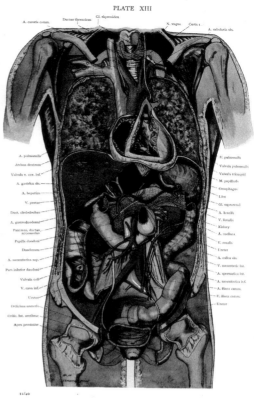

Fig. 81

David Waterston, *Section of the Thorax and Abdomen* from *Anatomy from the Living Model*, 1931

> each specimen was posed and photographed; from the negative film, an enlarged positive film was made . . .; with the aid of a viewing box the outlines of the structures of the enlarged film were traced on tracing paper; and these outlines were scrutinised against the original specimen . . . The outline tracing was then presented to the artist who transferred it to suitable paper, and having the original dissection beside her, proceeded to work up a plastic drawing in which the important features were brought out.[15]

Not surprisingly, the resulting illustrations rely heavily on the outlining of contours to bring out the 'important features'. The impression of a relatively style-less style in Grant's demonstrations is enhanced by the consciously simple and graceless labelling on the organs themselves, which has a certain kind of unpretentious charm. Grant's business-like air may be seen as a logical development of one of the

281

Fig. 82

Elizabeth Blackstock,
*Dissection of the
Shoulder and Armpit,*
from J. C. Boileau
Grant, *Atlas of
Anatomy,* 1943

main characteristics of Gray's plates, though Blackstock's judicious modelling and colouring gives his atlas more overt visual appeal than Gray seems to have sought.

A number of modern photographic atlases have finally brought photography to bear with wide-ranging success on the illustration of anatomy. However, none of the modern books which exploit photography, of which McMinn and Hutching's *Colour Atlas* is a leading example, can really be considered as offering straightforward photographic representations of a normal dissection.[16] The specimens have been 'suitably prepared' in a very careful and elaborate manner, before being photographed in high-quality colour against neutral backgrounds and under skilfully arranged illumination. To achieve such levels of naturalism—to 'bring out the features', as the expression has it—much sustained contrivance is required. The strikingly vivid photographs belong more with the William Hunter than with the visually reticent Gray.

Faces

When we turn to our other areas of related focus in photography and the human sciences—eugenics and insanity—hugely complex issues

arise, since individual human beings are directly represented in contexts fraught with fear and prejudice. I will look first at the recording of racial and other 'types', and then at the codifying of insanity and criminality. The role of the camera became increasingly that of a measuring device, a perspectival charting machine which emulated the ambitions of the Renaissance 'mappers' we first encountered in chapter 1.

Granted the central role of portraiture in early photography, it was hardly unexpected that it should be taken up avidly in those branches of the human sciences concerned with facial features and the external appearance of the head. The science of physiognomy—reading the 'signs' of the face to detect fundamental traits and temperaments—was of great antiquity, having been credited for a long time to Aristotle. After falling into relative obscurity, it had been given a huge international boost by the theories of Johann Caspar Lavater, whose extensively illustrated writings, following their debut in Germany in 1775–8, appeared across Europe in various editions and popular abridgements, persisting well into the nineteenth century. Lavater's baggy compendia of observations and theories only occasionally aspired to more precise geometrical analyses.[17] We have already encountered one device for physiognomic recording in the form of Chrétien's 'Physiognotrace' (fig. 70). A further boost to the systematic study of the configuration of the head in the early nineteenth century was provided by the 'Phrenology' of Gall and Spurzheim, which in its popular guise claimed to diagnose mental proclivities from the 'bumps' of the cranium.[18] It is nice to find that Spurzheim was drawn by Cornelius Varley in the 'Graphic Telescope', the sophisticated device that Varley had invented as an improvement on the camera lucida, and that Gall was the subject of one of the sets of reference casts assembled as visual data bases for phrenological study (fig. 83). Presumably an informed scrutiny of Spurzheim's own head would be expected to reveal marks of his superior intellect. The growing interest in the scientific definition of normal and deviant physiognomies and head types through physiognomy and phrenology became progressively entangled with the new notions of inheritance and evolution, particularly the sensational ideas of Darwin, and with the increasingly methodical study of racial types during the major era of world colonization by European powers.

The photographic camera rapidly became a favoured tool for the intrepid explorer who wished to record the appearance, customs, and dwelling places of native inhabitants of newly discovered territories. Sets of photographs, taken and compiled according to methodical

Fig. 83

F. J. Gall, plaster based on death mask, 1825, Edinburgh University, Edinburgh Phrenological Society Collection

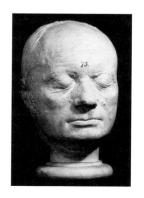

283

programmes, were increasingly seen as providing a rich source of data for the 'natural history of man'. Particularly striking examples are the photographs of 'natives' of the British Empire taken by Lawrence and Selkirk for Thomas Huxley (fig. 84). By the 1860s, the general taking of photographs of ethnic types, often on the basis of their picturesque novelty as 'savages' within the expanding imperial domains, was increasingly redirected into more systematic endeavours, such as that initiated by Huxley through the British Colonial Office. In Paris the Société d'Ethnographie began a major project to document human types across the globe, not least because it was felt that the discrete nature of ethnic groups was increasingly threatened by cross-breeding. One of the grandest individual projects was undertaken by the Hamburg photographer, Carl Dammann, who published an *Album* of more than 600 photographs in 1873–4, which was issued in English as the *Ethnological Gallery of the Races of Men* in 1875.[19] The demand was increasingly for data based on systematic recording, measurement, and classification. Faces and heads were the prime focuses of the measurers' attentions, as they followed the trend towards quantification.

The most systematic of the anthropological measurers of crania was Paul Broca, Professor of Clinical Surgery at the Faculty of Medicine in Paris, who was the first to provide clear clinical evidence of the localization of brain functions. He was a founder of the Anthropological Society in 1859 and of the *Revue d'anthropologie* in 1872.[20] As an anthropologist, he worked on the premises that various human races could be ranked on a scale of human ability, and that those races exhibiting what we might call 'lesser degrees of humanness' stood closer to evolutionary descent from ape-like ancestors. Accordingly, he classified and minutely measured key features of the body and most particularly of the head, to determine what criteria would best serve to place the races on the scale. Such was the subtlety of measured differences between key dimensions, particularly that of the capacity of the cranium, that photography could not be used as a source of data. Only tables of figures could do that job, However, certain key characteristics, such as the facial angle result-

Fig. 84

Lawrence and Selkirk, *Khosian Men and Groups of Khosian Prisoner*, 1870–1, Oxford University, Pitt Rivers Museum

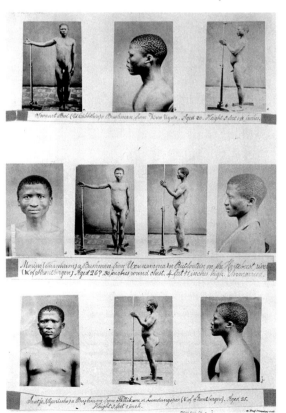

ing from prominent jaws, thick lips, flat nose, and receding forehead, could be recorded photographically to provide a graphic comparison between 'advanced' whites and other races whose appearances and behaviours 'recapitulated' more primitive stages in the evolutionary process.

A particularly effective illustration of how photography could serve the needs of phrenology and physiognomy as applied to racial types is provided in 1873 by Lieutenant Colonel William Marshall's study of a group of inhabitants of south India, *A Phrenologist amongst the Todas*, illustrated with 'autotypes' of photographs by Bourne and Shephard of Simla, and Nicholas and Curths of Madras(fig. 85).[21] Marshall declared that he was undertaking a 'phrenological enquiry into the nature the barbarous races'.[22] Not least he was concerned to provide some insights into the 'mysterious process by which, as appears inevitable, savage tribes melt away when forced into contact with a superior civilisation'.[23] He regarded small, relatively enclosed communities as particularly revealing, since endogamy produces a greater uniformity of type than was apparent with communities of more mixed composition. Since isolated races 'present scarcely more differences in appearance and character than any one dog does from any other in the same kennels of hounds', no more than ten representative photographs of each sex were considered adequate to provide a record of the characteristic head type.[24] His 'examples of "real life" ' were each photographed in profile and front face, in keeping with the systematic form of representation promulgated by Pieter Camper in the eighteenth century, who had himself been inspired by Dürer.[25] For good measure, Marshall placed squared paper backdrops behind his sitters' heads, so that crucial dimensions could be determined. On the basis of the photographic and physical surveying of the heads, allowing for difficulties caused by the natives' hair-styles, such traits as the 'Concentrative' and 'Amativeness' were readily discernible. Marshall was confident that he could identify, for example, that the women of the Todas manifest 'love of children and adhesive feelings', yet are demonstrably inferior in 'perceptive faculties'.[26]

It is easy now to be dismissive of such potentially dangerous pseudo-sciences, and to exclude them from even the fringes of proper medicine, but the promise of quantifiable criteria for the definition of race and character possessed an obvious appeal in an age which was obsessed with the promotion of all branches of study of humanity into domains of measured certainty. It is no coincidence that this was the age in which Giovanni Morelli, trained as a doctor, promised to identify the styles of great artists of past eras on the basis of a systematic study of

Fig. 85

William Marshall, *Toda Man in Profile and from the Front*, from *A Phrenologist amongst the Todas*, 1873

the physiognomy of the tell-tale features, such as ears, eyes, and noses, which painters and sculptors characteristically accorded to their figures. And it was in this spirit that John Down in 1866 originally gave the name 'Mongolian idiocy' to the congenital syndrome that he was the first to characterize. He did so on the grounds that the strange physical characteristics and mental 'degeneration' of those afflicted made them resemble members of the 'great Mongolian family'.[27] In an age more alert to the racist implication of such naming, the term 'Down's Syndrome' is now generally preferred.

The most impressively systematic of all the projects to use photography in the service of a new sciences of humankind was undertaken by Francis Galton, a cousin of Darwin, in the 1870s and 1880s. We have already briefly met Galton as the inventor of the 'weather map'. In his *Inquiries into the Human Faculty* in 1883, which effectively established the term 'eugenics', he aimed to define an all-encompassing science of human heritable attributes, ranging from intellectual and moral to physical, with respect to individuals, families, groups, classes, and racial types.[28] The purpose of such understanding would be to 'co-operate with the workings of nature by seeing that humanity shall be represented by the fittest races'.[29] Faced with the reality of 'natural selection' as the Darwinian dynamic of evolutionary change, Galton believed that eugenic understanding could potentially ensure that 'what nature does blindly, slowly and ruthlessly, man may do providently, quickly and kindly'. Armed with the right data, man could:

> learn how far history may have shown the practicability of supplanting the human stock by better strains, and to consider whether it might not be our duty to do so by such efforts as may be reasonable; thus exerting ourselves to further the ends of evolution more rapidly and with less distress than if events were left to their own course.[30]

Since Galton was convinced that the mental attributes could be measured through a study of physical signs in the body, and that the face provided a singularly eloquent witness to heritable qualities, ways were required through which visual typologies could be established with a view to defining chains of descent and nexuses of affinities in individuals and various groupings. Having observed a portrait painter in action, he estimated that a detailed likeness was the result of recording as many as '24,000 separate traits', and realized that series of hand-made images could never be produced on the necessary scale.[31] Convinced that photography provided a special 'assurance of truth' and that it was 'subject to no errors beyond those incidental to all

photographic production', Galton looked towards photography to accomplish the massive task of documentation which would be required by his programme of research.[32] In 1877 he obtained photographs from the Home Office of inmates at Pentonville and Millbank jails, analysing them within three categories: killers, thieves, and sex offenders. In 1884 he launched his *Record of Family Affinities*, as a kind of questionnaire for doctors, and in the same year he established his project for *Life History Album*, promoted by the British Medical Association, which solicited the help of parents in compiling written and photographic records of their children's progress. As he worked through his accumulating bodies of visual material, he found that by 'continually sorting the photographs in tentative ways, certain natural classes began to appear'.[33]

As a way of defining the 'central physiognomical type of any race or group', he devised his technique of 'composite portraiture' as the analytical arm of 'pictorial statistics' (fig. 86).[34] He claimed that his composites had finally achieved that exalted synthesis of 'typical forms' for which artists had been erratically striving over the ages. By re-photographing portraits of members of his groups on a single photographic plate (sometimes combining as many as 200 examples), he aimed to extract the essential features of the common type underlying the individual variations in physiognomy. In addition to the defining of criminal physiognomies, he sought composite 'family likeness', and the common features of other groups, such as Jews, lunatics, and patients prone to particular illnesses.

Galton's theories and programmes were hugely influential. Even today, the Medical Graphics and imaging group and Galton Laboratory at University College, London, are undertaking an extensive programme of the computer scanning of faces in the context of modern genetics 'to provide some answers to the old question of what makes each of us look the way we do'. As the website seeking volunteers tells us, the images of faces are to be digitized into around 30,000 coordinates in 10 seconds, and the results are to be mapped both as conventional pictures and as Mercator projections to permit detailed comparisons of family and other groups. Unsurprisingly, given the history of such programmes, one of the funding

Fig. 86

Francis Galton, *Composite Photograph of Criminals (4, 9 and 15 and All at the Centre)*, London, University College Library, Galton Collection

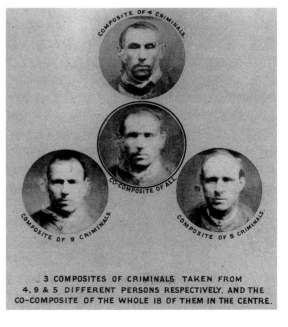

3 COMPOSITES OF CRIMINALS TAKEN FROM 4, 9 & 5 DIFFERENT PERSONS RESPECTIVELY. AND THE CO-COMPOSITE OF THE WHOLE 18 OF THEM IN THE CENTRE.

agencies is the Forensic Science service of the British Home Office. We will shortly be seeing that a comparable scheme of measurement for forensic purposes had been set up in nineteenth-century France.

The more general line of descent of Galton's programme of eugenic manipulation into hideous manifestations in the first half of the last century is all too obvious. In retrospect, his science, with its aim of reducing the 'residuum' of undesirable types of humanity, carries the whiff of genocide. The definition of 'degenerate variants' in a book like Morel's *Traité des degenerescences physiques, intellectuelles, et morales de l'espèce humaine* (1857), or Lieutenant–Colonel Douglas's essay on 'The Degenerates and the Modes of their Elimination', published in the *Physician and Surgeon* in 1900 with half-tone illustrations, could lead all too clearly to measures far from the benign kind envisaged by Galton himself.[35] It is difficult to look at Galton's programme without the benefit of appalled hindsight, but if we take into account the tremors caused by Darwin's theories and their implications for the slow and brutal processes of the 'survival of the fittest' in future generations of humans, Galton's aspiration to use the new sciences and technologies in order to avoid the pain of bringing 'beings into existence whose race is predoomed to destruction by the laws of nature' becomes more understandable and appears to be less sinister than misguided.[36]

Alongside such studies of fixed features, a branch of physiognomics had been developed to provide criteria for the interpretation and portrayal of transitory expressions in terms of emotional states. A particularly influential impetus had come from the visual arts, in the form of Charles le Brun's widely translated *Conférence . . . sur l'expression générale et particulière* in 1667, which annexed Cartesian notions of the way the bodily machine expressed the passions of the soul in the quest to define the specific facial configurations which could be taken as manifestations of such emotions as love, anger, and fear.[37] Advocates of 'pathognomics' could claim a testable basis for their ideas, not least in terms of the study of facial musculature, in a way that eluded those who advocated the divination of character from the fixed features. From Dr James Parsons in 1747 to Dr Charles Bell in 1806 and 1844 (fig. 87), emphasis shifted towards a detailed study of the complex muscular interplays

Fig. 87

Charles Bell, *Musculature of the Lips, Lateral View,* from *The Anatomy and Philosophy of Expression as Connected with the Fine Arts,* 1806

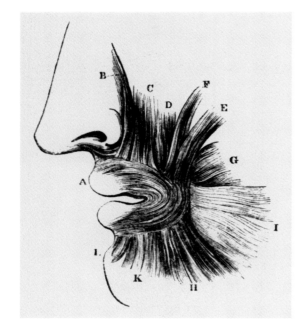

which resulted in such eloquent expressions.[38] Again, photography seemed particularly well-placed to act as a tool of record and analysis. However, no one who has photographed faces in action can fail to discover how slippery are the readings of fleeting expressions. What was needed was some form of experimental control.

Such a means of control was devised by Guillaume-Benjamin Duchenne de Boulogne in his 1862 treatise on the *Mécanisme de la physionomie humaine*, which can lay claim to be the most remarkable of all the photographically illustrated books in medical science before 1900.[39] Arguing, unremarkably, that photography is as 'truthful as a mirror' as a form of 'orthography of the physiognomy in motion', and given the traditional view that facial features are the 'mirror' of the soul, he began in 1856 to photograph inmates at the Salpêtrière in Paris, the hospital which housed mentally disturbed patients and in which he was employed.[40] He devised an experimental method for the activation of individual muscles in the face, convinced that each muscle separately manifested a 'movement of the soul'.[41] The 'grand zygomatique', for example, he identified as the 'muscle of joy', and at one point he lists no less than 53 emotions that are to be codified in terms of muscular action.[42] His technique involved the application of electrodes to male and female volunteers in order to precipitate the expressions which arose from the contraction of a particular muscle or muscle group.

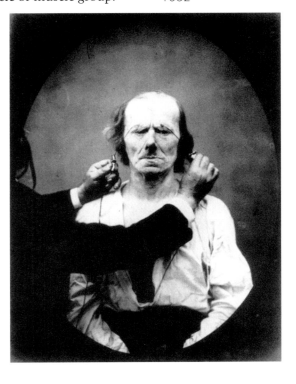

Fig. 88

Guillaume-Benjamin Duchenne de Boulogne, *Man's Face Activated by Electrodes*, from *Mécanisme de la physionomie humaine*, 1862

An elderly man proved to be the ideal subject, on account of his lined face, lack of fat, emphatically 'coarse' look, and limited cutaneous sensitivity (fig. 88). The resulting photographs, taken with the assistance of Adrien Tournechon (brother of the famous Parisian photographer, Nadar), are as visually striking as the often exaggerated portrayals in the drawn manuals of expression. They were consciously set by Duchenne in the context of the great tradition of Leonardo and Michelangelo as artist-anatomists, compared to the paintings of such masters of expression as Caravaggio, Rembrandt, and Rivera, and praised as exemplars for those practising the 'plastic arts'.[43] The 'Partie Esthetique' towards the end of his book included photographs of women expressing a variety of appropriate emotions in little erotic dramas, and analyses of famous

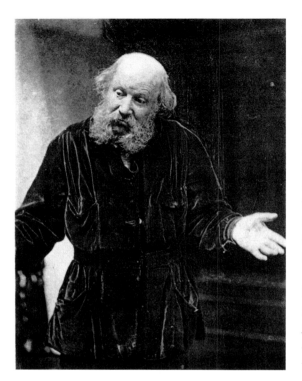

Fig. 89

Oscar Rejlander,
*Helplessness and
Indignation,* in Charles
Darwin, *The
Expression of Emotion
in Man and Animals,*
1872

sculptures from antiquity. Photography, for Duchenne, demonstrated how the face could be read as a complex seat of narrative expression, even to the extent of documenting simultaneously competing instincts and convictions, such as 'terrestrial love' and 'celestial love'.[44] His instrumental analysis of the expression of emotions achieves compelling visual results, yet the definition of the subject's emotional state remains that of the observer, because the 'sitter' was not actually experiencing that particular emotion at the time of the making of the image.

Duchenne's methods and even some of his illustrations were influentially adopted by Darwin in his *The Expression of Emotion in Man and Animals* (1872), which was highly critical of the unscientific arbitrariness of traditional handbooks.[45] He quotes a section on 'Fright' from Le Brun to illustrate the 'surprising nonsense that has been written on the subject', and argues that very few works of art shed any worthwhile light on the question.[46] Like so many of his contemporaries, he saw photography as a tool for arriving at the truth, since it extended the limitations of the subjective eye: 'I have found photographs made by the most instantaneous process the best means for observation, as allowing more deliberation'.[47] He supplemented the photographs which he had obtained Duchenne's permission for using, with other examples, above all those taken both independently and at his behest by Oscar Rejlander, some of which exhibit the photographer's special penchant for theatricality. In some cases, actors demonstrate the series of rhetorical signs that they used to convey emotions on the stage. There were, however, areas in which the photographic technology of his time could not successfully venture, and illustrators such as Joseph Wolf were accordingly pressed into service, as we have seen (fig. 43).

Where Darwin characteristically extends Duchenne's work is by setting human expressions in the broader context of the natural world and its evolution, not in terms of traditional parallels between human facial types and animal physiognomies but through an understanding of the origins of the expressive mechanisms:

No doubt as long as man and all other animals are viewed as independent creations, an effectual stop is put to our natural desire to investigate as far as possible the causes of expression. . . . With mankind some expressions, such as the bristling of the hair under the influence of extreme terror, or the uncovering of the teeth under that of furious rage, can hardly be understood except on the belief that man once existed in a much lower and animal-like condition.[48]

Indeed, the expression of emotion in the human sense was not the reason why the muscles were evolved:

every true or inherited movement of expression seems to have had some natural and independent origin. But, when once acquired, such movements may be voluntarily and consciously employed as a means of communication.[49]

The result is that some actions of the muscles result from the direct and spontaneous reaction of the nervous system, while others are the result of acquired habits and their consciously expressed antitheses.[50]

As ever concerned with the global scope of the study of man, Darwin circulated questionnaires to correspondents around the world, and his book analyses the results of the 36 that were returned. He concluded that 'the same state of mind is expressed throughout the world with remarkable uniformity', in spite of all the obvious cultural differences in the languages of gesture.[51] Darwin's methods were aimed at placing the subject on a broader and firmer scientific basis than even Duchenne had achieved.

Given its role as a physiognomic transcriber, it is not surprising that photographic 'portraiture' was increasingly adopted by those who wished to describe the external signs of insanity in relation to the classification of mental states. The first developed programme which used photography as a major tool in the sciences of the insane was established in 1852 within the women's section of the Surrey County Asylum in Twickenham by Hugh Welch Diamond, who coined the phrase 'a perfect and faithful record' which I extracted for the heading of this section the chapter.[52] As a founder-member of the Royal Photographic Society, Diamond was exceptionally placed both to recognize the potential of photography in defining the visual signs of the 'types of insanity', and to control the technical parameters of the new medium in delivering the desired results (fig. 90). In an address to the Royal Society in 1865, he made an eloquent plea for the status of photography as a kind of universal language, much as Leonardo had claimed for painting in the Renaissance.[53] The photographer, he informed his distinguished audience of scientists, has:

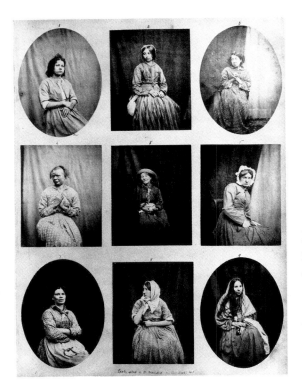

Fig. 90

Hugh Welch
Diamond,
*Photographs of Insane
Women,* 1856,
London, Royal Society
of Medicine

in many cases, no need for any language but his own, preferring rather to listen with the picture before him, to the silent but telling language of nature—it is unnecessary for him to use the vague terms which denote a difference in the degree of mental suffering, as for instance, distress, sorrow, deep sorrow, grief and melancholy, anguish and despair; the picture speaks for itself with the most marked impression and indicates the exact point which had been reached in the scale of unhappiness.[54]

Photography, for Diamond, presented a means of avoiding those 'peculiar views, definitions and classifications' that had arisen when no adequate bank of visual images was available. The images provided by the photographer 'arrest the attention of the thoughtful observer more powerfully than any laboured description'. In addition to its analytical and communicative potential, Diamond also investigated the possibility that photography might even play a role in treatment. He claimed that patients who were shown photographs of themselves *in extremis* were better able to develop an objectively therapeutic view of their condition.[55] Looking at Diamond's actual portraits we can see how their staging works entirely within the framework of portrait photography of his time, including the costumes and backdrops. It was the accepted nature of the conventions that permitted the attentive viewer to determine where postures and expressions departed from the decorous norm.

The ambitions subsequently set for psychiatric photography by Dr Jean-Martin Charcot at the Salpêtrière Hospital for the insane in Paris were no less extensive than those of Diamond. Charcot placed photography in the service of his unrivalled attempt to create what may be called 'visual psychology', in which imagery and environments played a central role in diagnosis, recording, clinical suggestion, treatment, and the design of the patients' surroundings. It was at the Salpêtrière in 1822–3 that Théodore Géricault had produced his superb painted portraits of insane 'types' for Dr Etienne-Jean Georget. From 1862, Charcot collaborated with his assistant, Paul Richer, who had previously trained as an artist, on a richly illustrated series of annual

publications devoted to the *New Iconography of the Salpêtrière*, which promoted a 'method of analysis that completes written observations with images'.[56] Richer also illustrated Charcot's *Démoniaques dans l'Art* (1887), which used artists' representations of possession and insanity to underscore the historical pedigree of his visual ambitions.[57] Not surprisingly for someone who trained under Duchenne, Charcot had already identified photography as a major resource.

Désiré-Magloire Bourneville and Paul Regnard, who arrived at the hospital as an intern in 1875, worked with Charcot on the *Iconographie photographique de la Salpêtrière*, which appeared in Paris as a series of volumes between 1876 and 1880, each of which is visually prefaced by a comforting image of the hospital, particularly the view which portrays it as a gracious establishment at the end of an avenue of trees.[58] Each photograph (fig. 91) or series of photographs is used to document a case study, which includes a detailed diary of the patient's behaviour. The selection and presentation of the images sets the photographs consciously within the grand tradition of historic art, above all by reference to the rhetorical and theatrical resources developed by history painters over the centuries. This is particularly true of the depiction of women, who express emotions in ways familiar through generations of paintings and sculptures of sensually ecstatic martyrs. However, for Charcot, the real value of the new objective tool lay in its ability to provide non-subjective data for the reading of emotional states in an analogous way to the works of the great masters, who had taught us the language of bodily signs as best they could in the pre-photographic age.

By 1878 Charcot was sufficiently confident of what was being achieved to found an official, in-house photographic unit at the Salpêtrière. Four years later, Albert Londe, who was to become a historian and major theorist of medical photography, and who was to make a significant contribution to photography in pathological anatomy, arrived to work under Charcot's direction, not only taking photographs of the now expected kind but also devising new technologies for the recording of symptoms which had remained elusive for both the draftsman and the standard photographic

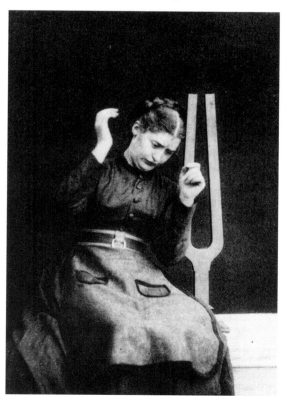

Fig. 91

Desiré-Magloire Bourneville and Paul Regard, from Jean-Martin Charcot, *Lethargy: Patient Agitated with a Diapason*, from *Iconographie Photographique de la Salpêtrière: 1876–80*

camera.[59] Londe was responsible for at least three inventions: a double camera, by which one of the lenses could be used to focus on mobile patients while the other linked system could be activated without delay to capture the instant of any significant motion; a portable reflex camera carried on a neck strap, devised in collaboration with Charles Dessodieux, which could be used informally and without the need to intimidate patients with the normal rituals in the staging of a portrait; and an elaborate apparatus with twelve lenses and an electric shutter set for five speeds, which could expose twelve sequentially 'frozen' images on one plate.[60] Londe also recognized that somewhat longer individual exposures, which resulted in the blurring of moving limbs, could also convey the nature of repetitive motions of patients in an effective manner.

In addition to his practical work, Londe produced a major reference work dedicated to Charcot in 1893, his *La Photographie médicale*, which provided a historical overview of the photograph in medical practice, as an introduction to his definitions of the means and ends available to the specialist photographer.[61] In his preface, he justly noted that the practitioners of his own day were 'only at the infancy of this new science'. When photographing the exterior of the body, which was his particular concern at the Salpêtriére, he set out a systematic agenda in five parts: the depiction of the whole patient in systematic views from front, sides and behind, against a neutral grey background: the portrayal of the head alone, defining three vertical planes as reference levels for depth of field (those of the eyes, nose, and ears) and warning that photography of heads from close range produces unwanted distortions of relative scale through extreme effects of perspective; studies of hands, placed over a diagonally disposed board; pictures of the feet and lower limbs; and detailed images of the skin. Sets of photographs demonstrated successive states of the patient's condition under the influence of different stimuli.

The use of photography of faces in medical and pseudo-medical contexts to define and classify characteristic forms of 'normal' and 'deviant' physiognomies found a natural outlet in the context of the growing study of 'criminal types', both for the obvious purposes of the recording of individuals in police records and as an analytical tool in the more general investigation of criminality. Galton's investigation of the facial types of criminals in the London jails in 1878 set the tone for the analytical studies. The second major point of reference for the definition of kinds of criminality in relation to physical characteristics was provided by the Italian psychologist and physician, Cesare Lombroso, whose *The Criminal Man* (*L'uomo diliquente*), first published

in Turin in 1876, went through many editions and translations in Europe, and America.[62] Lombroso set himself the task to determine those physical signs or 'stigmata' that marked out the innately criminal person from the normal one. Studying the skull of Vihella, a notorious villain, and noticing what he deemed to be a special abnormality, he came to a sudden and wondrous realization that the head of a born criminal revealed 'an atavistic being who reproduces in his person the ferocious instincts of primitive humanity and the inferior animals'.[63] All those features of the head which could assume 'primitive' forms, resembling those of apes and animals, were read as denoting savage traits. A set of plates, each of which included as many as 56 individual photographs of criminals from Italy and elsewhere, were subjected to a tabular analysis according to seventeen key physiognomic signs, with the intention that typical criminal traits would become vividly apparent.

Although the well-founded conservatism of the judiciary meant that such evidence gained limited credence in courts of law, large programmes of judicial measurement were set in train by police forces, both for reasons of precise identification and as data for systems through which the criminal type may be detected. The systematic recording of criminal types became a minor industry, with photography playing a central role. In France, Bertillon's *Judicial Photography* (*La photographique judicaire*) in 1890 and *Signaletic Instructions including the theory and practice of anthropometrical identification* in Chicago, 1896, described and codified the procedures which were increasingly adopted throughout the world by those countries which had advanced systems of policing and record-keeping.[64] Unsurprisingly, Bertillon was an enthusiastic taker of fingerprints, the use of which in individual identification had first been established by the assiduous Francis Galton. One of the most influential promoters of photographic procedures in the nineteenth century was Havelock Ellis in *The Criminal* (1890), in which the influence of Gall and Lombroso is openly acknowledged.[65] Amongst the photographic evidence illustrated by Ellis were composites and four-part images made with mirrors, as Galton had also advocated. The results were supplied to Ellis by Dr Hamilton Wey at Elmira, the New York State Reformatory. Such photographic surveys not only served the need to identify criminals but were also widely seen as providing incontrovertible Lombrosan evidence about how to recognize deviant departures from the healthy norm.

At one level, craniometry and criminal anthropology remained specialist territories, disputed over by partisans of various theories and by argumentative number-crunchers. Yet the ideas irresistibly entered

common currency, often in schematic form, much like the story of our descent from apes. Photography played a significant role in this popular transmission.

Sir Arthur Conan Doyle, who was trained as a doctor in Edinburgh, regularly allows Sherlock Holmes to exercise his physiognomist's eye for criminal and non-criminal traits. This example is from *A Scandal in Bohemia*:

> A man entered who could hardly have been less than six feet six inches in height, with the chest and limbs of Hercules . . . From the lower part of his face he appeared to be a man of strong character, with a thick hanging lip, and a long, straight chin, suggestive of resolution pushed to the length of obstinacy.[66]

When Robert Louis Stephenson, another resident of Edinburgh, wished in 1885–6 to describe external manifestations of how the chemical cocktail has released the 'ape' normally suppressed within the worthy breast of Dr Jekyll, he concentrates on the elusive and subtle nature of the signs of emotional deformity. The first person to give an eye-witness account of Mr Hyde confesses that:

> He is not easy to describe. There is something wrong with his appearance; something displeasing, something downright detestable. I never saw a man so disliked, and yet I scarce know why. He must be deformed somewhere; he gives a strong feeling of deformity, although I couldn't specify the point.[67]

Dr Jekyll's own account gives a clue as to the kind of signs of animalistic atavism that could be read by a trained witness, in his case the doctor himself:

> Now the hand of Henry Jekyll . . . was professional in size and shape: it was large, white, firm and comely. But the hand which I now saw, clearly enough, in the yellow light of a mid-London morning, lying half shut on the bed clothes, was lean, corded, knuckly, of a dusky pallor and thickly shaded with a swart growth of hair. It was the hand of Edward Hyde.[68]

Techniques of physiognomic, phrenological, eugenic, and criminological discernment are above all classificatory—separating type from type, black from white, good from bad, advanced from degenerate. Classification was one of the obsessions of nineteenth-century science. Photography was well placed to become the central tool for the multiple recording that was necessary to sustain such endeavours, in the human sciences no less than in natural history and geology. The making of series of photographic images of the same kinds of things could be accomplished more prodigally than was possible when specialist draftsmen had to be employed. The resulting collections of

images allowed their systematic arranging in sets according to a variety of classificatory categories. Banks of photographs could be built up for reference and analysis, perhaps even (as Galton had found) suggesting new classifications of objects which might stand in a special relationship to each other. Galton's method of eugenic analysis comprises just one of many campaigns that used serial photographs as a major tool in taxonomic programmes.

Like all systems of categorization, the new methods facilitated by photography could be used for good or for ill. Furthermore, like the old, hand-made techniques of naturalistic representation, the level of trust inspired by the very naturalism of the images has to be seen as a double-edged sword. The conviction of truthfulness implicit in the system of photographic representation, which is greater even than that inculcated by techniques of traditional naturalism, can all too readily be exploited to tell convincing lies. As with any image that purports to tell the truth, the viewer has a responsibility to ask hard questions.

NOTES

1. Nicolaus Rüdinger, *Atlas des peripehrischen Nervensystems des menschlichen Körpers*, (Munich: Cotta, 1861); Nicolaus Rüdinger, *Die Anatomie der menschlichen Gehirn-Nerven für Studierende und Aertze*, (Munich: Literarisch-Artistische Anstalt, 1868); Nicolaus Rüdinger, *Die Anatomie der menschlichen Rüchenmarks-Nerven*, (Stuttgart: Cotta, 1870), and Nicolaus Rüdinger, *Topographisch-chirurgische Anatomie des Menschen*, 4 vols, (Stuttgart: Cotta, 1873–9)
2. Wilhelm Braune as quoted in Albert Eycleshymer and Daniel Schoemaker, *A Cross-Section Anatomy*, (New York and London: Appleton-Century-Crofts, 1923), p. xi
3. Nicolaus Rüdinger, *Atlas des peripherischen Nervensysytems des menschlichen Körpers*, (Munich: Cotta, 1861)
4. Nicolaus Rüdinger, *Die Anatomie der menschlichen Rückenmarks-Nerven*, a and b
5. Nicolaus Rüdinger, *Topographisch-chirurgische Anatomie des Menschen*, 1873
6. 'The Craze for Photography in Medical Illustration', editorial, *New York Medical Journal*, LIX, 1894, pp. 721–2; and William Keiller, 'The Craze for Photography in Medical Illustration', letter on pp. 788–9
7. *British Medical Journal*, I, 1886, p. 163
8. Medicus, 'Indecency in Photography', letter, *The New York Medical Journal*, LIX, 1894, pp. 724–5
9. 'A Remarkable Case of Double Monstrosity in an Adult', *The Lancet*, II, 1865, p. 185; with the response in *The British Medical Journal*, II, p. 165
10. The example in the Wellcome Institute is inscribed: TC & EC JACK EDINBURGH. PROV.Y. PROTECTED
11. David Waterston, *Anatomy in the Living Model: A Handbook for the study of the Surface, Movements, and Mechanics of the Human Body and for the Surface Projection of the Viscera etc.*, (London: Hodder and Stoughton 1931)

12. David Waterston, *Anatomy in the Living Model*, p. 248

13. John Charles Boileau Grant, *Grant's Atlas of Anatomy*, A. Agar ed., (Baltimore: Williams and Wilkins, 1991, 1st ed 1943)

14. John Charles Boileau Grant, *Grant's Method of Anatomy*, J. Basmajian ed., (Baltimore: Williams and Wilkins, 1989, 1st ed 1937), preface

15. John Charles Boileau Grant as quoted by K. Roberts and J. Tomlinson, *The Fabric of the Body: European Traditions of Anatomical Illustration*, (Oxford: Clarendon Press, 1992), pp. 599–600

16. Robert McMinn and R. Hutchings, with J. Pegington and P. Abrahams, *Colour Atlas of Human Anatomy*, (London: Wolfe Publications, 1993, 1st ed 1977)

17. Johann Caspar Lavater, *Essays on Physiognomy*, Henry Hunter tr., (London: John Murray, 1789–98)

18. Franz Joseph Gall and Johann Caspar Spurzheim, *Anatomie et Physiologie du Système Nerveux en Général et du Cerveau en particulier*, (Paris: F. Schoell, 1810–19)

19. Carl Dammann, *Anthropologish-Ethnologisches Album in Photographien*, Berlin, Wiegart, Hempel and Parey, 1873–4, and *Ethnological Gallery of the Races of Man*, London, 1875

20. Paul Broca, *Mémoires d'anthropologie*, (Paris:Reinwald, 1871); *Instructions craniologiques et craniometriques de la Societé d'Anthropologie de Paris*, (Paris: Masson, 1875)

21. William Marshall, *A Phrenologist Amongst the Todas, or the Study of a Primitive Tribe in South India: History, Character, Customs, Religion, Infanticide, Polyandry, Language*, (London: Longman Green, 1873)

22. William Marshall, *A Phrenologist Amongst the Todas, or the Study of a Primitive Tribe in South India: History, Character, Customs, Religion, Infanticide, Polyandry, Language*, p. vi

23. William Marshall, *A Phrenologist Amongst the Todas, or the Study of a Primitive Tribe in South India: History, Character, Customs, Religion, Infanticide, Polyandry, Language*, p. vi

24. William Marshall, *A Phrenologist Amongst the Todas, or the Study of a Primitive Tribe in South India: History, Character, Customs, Religion, Infanticide, Polyandry, Language*, p. vi

25. William Marshall, *A Phrenologist Amongst the Todas, or the Study of a Primitive Tribe in South India: History, Character, Customs, Religion, Infanticide, Polyandry, Language*, p. 32

26. William Marshall, *A Phrenologist Amongst the Todas, or the Study of a Primitive Tribe in South India: History, Character, Customs, Religion, Infanticide, Polyandry, Language*, p. vi

27. Stephen Jay Gould, *The Mismeasure of Man*, (Hardmonsworth: Penguin Books 1981), pp. 134–5

28. Francis Galton, *Inquiries into the Human Faculty*, (London: Macmillan 1883)

29. Francis Galton, 'Eugenics: its Definition, Scope and Aims', *Sociological Papers*, I, 1905, p. 50

30. Francis Galton, *Inquiries into the Human Faculty*, Introduction

31. Francis Galton, *Inquiries into the Human Faculty*, p. 5

32. Francis Galton, 'Composite Portraits', *Journal of the Anthropological Institute*, VIII, 1878, pp. 132–48, reprinted in *Nature*, XVIII, 1878, pp. 97–100

33. Francis Galton, 'Address to the Department of Anthropology, Section H', *British Association Report*, 1877, pp. 94–100, reprinted in *Nature*, XVI, 1877, pp. 344–7

34. Francis Galton, 'Photographic Chronicles from Childhood to Age', *Fortnightly Review*, CLXXXI, 1882, pp. 26–31

35. Bénédict Morel, *Traité des dégénérescences physiques, intellectuelles et morales de l'espèce humaine*, (Paris, 1857); Lieutenant-Colonel Douglas's essay on 'The Degenerates and the Modes of their Elimination', *Physician and Surgeon*, I, 1900, pp. 48–89.

36. Francis Galton, 'Hereditary Improvement', *Frazers Magazine*, **VII**, 1873, pp. 116–30

37. In English as Charles le Brun, *The Conference of Monsieur Le Brun Chief Painter to the French King, Chancellor and Director of the Academy of Painting and Sculpture; Upon Expression, General and Particular. Translated from the French and adorned with 43 copper plates*, (London: John Smith, 1701)

38. James Parsons, *Human physiognomy explain'd*, (London: C. Davis, 1747); Charles Bell, *Essays on the Anatomy of Expression in Painting*, (London: Longman, 1806), later eds. titled *Essays on the Anatomy and Philosophy of Expression*

39. Guillame-Benjamin Duchenne de Boulogne, *Mécanisme de la physionomie humaine ou analyse electro-physiologique de l'expression des passions*, 2 vols., Paris, Ballière, 1876; trs. R. Andrew Cuthbertson, *The Mechanism of Human Facial Expression*, Cambridge, Cambridge University Press, 1990

40. Guillaume Duchenne, *Mécanisme de la physionomie humaine ou analyse electro-physilogique de l'expression des passions*, p. xii

41. Guillaume Duchenne, *Mécanisme de la physionomie humaine ou analyse electro-physilogique de l'expression des passions*, p. 15

42. Guillaume Duchenne, *Mécanisme de la physionomie humaine ou analyse electro-physilogique de l'expression des passions*, pp. 42–3 and 49

43. Guillaume Duchenne, *Mécanisme de la physionomie humaine ou analyse electro-physilogique de l'expression des passions*, pp. ix, 55–6 and 132

44. Guillaume Duchenne, *Mécanisme de la physionomie humaine ou analyse electro-physilogique de l'expression des passions*, plate no. 77

45. Charles Darwin, *The Expression of the Emotions in Man and Animals*, (London: Murray, 1872)

46. Charles Darwin, *The Expression of the Emotions in Man and Animals*, p. 5

47. Charles Darwin, *The Expression of the Emotions in Man and Animals*, p. 155

48. Charles Darwin, *The Expression of the Emotions in Man and Animals*, pp. 12–13

49. Charles Darwin, *The Expression of the Emotions in Man and Animals*, p. 376

50. Charles Darwin, *The Expression of the Emotions in Man and Animals*, pp. 29–30

51. Charles Darwin, *The Expression of the Emotions in Man and Animals*, p. 17

52. Sander Gilman ed., *The Face of Madness: Hugh W. Diamond and the Origin of Psychiatric Photography*, (New York: Bruner and Mazel, 1976)

53. Hugh W. Diamond, 'On the Application of Photography', in Gilman ed., *The Face of Madness*, pp. 19–20

54. Hugh W. Diamond, 'On the Application of Photography', in S. L. Gilman ed., *The Face of Madness*, pp. 19–20

55. Hugh W. Diamond, 'On the Application of Photography', in S. L. Gilman ed., *The Face of Madness*, pp. 19–20

56. Jean Martin Charcot, *Nouvelle iconographie de la Salpêtrière*, (Paris: Lecrosnier and Babé, 1888), vol 1, p. ii

57. Jean Martin Charcot and Paul Richer, *Les Démoniaques dans l'Art*, (Paris, Delahaye and Lecrosnier, 1887); and *Les difformes et les malades dans l'art*, Paris: Lecrosnier and Babé, 1889, (both reprinted by Macula, Paris, 1984)

58. Désiré-Magloire Bourneville and Paul Regnard, *Iconographie photographique de la Salpêtrière*, 3 vols., Paris, Delahaye, 1876–80

59. For Londe's pathological anatomy, see Paul Bloque and Albert Londe, *Atlas d'anatomie pathologique de la moelle épinière*, (Paris: G. Masson, c.1891)

60. Albert Londe, 'La Photographie en médicine', *La Nature*, 1883, pp. 215–18

61. Albert Londe, *La Photographie médicale: Application aux sciences médicales et physiologiques*, (Paris: Gautier-Villars, 1893). See also the review by Ludwig Jankau, *Die Photographie in der praktischen Medizin*, (Munich: Seitz and Schauer, 1894)

62. Cesare Lombroso, *L'uomo deliquente in rapporto all'anthropologie, alla giurisprudenza ed alle discipline carceraire*, (Turin, Bocco, 1876). Translations include: *L'Homme criminel*, (Paris: Félix Alcan, 1887); *Criminal Man*, (London and New York: Putnam, 1911)

63. Cesare Lombroso, *Criminal Man*, pp. xiv–xv

64. Alphonse Bertillon, *La photographique judicaire*, (Paris: Villars, 1890); *Identification anthropométrique: Instructions signalétiques*, (Melun: Imprimière Administratives, 1890–3)

65. Havelock Ellis, *The Criminal*, (London: Scott, 1980)

66. Arthur Conan Doyle, 'A Scandal in Bohemia', *The Adventures of Sherlock Holmes*, (London: George Newnes, 1892), pp. 7–8

67. Robert Louis Stephenson, *The Strange Case of Dr Jekyll and Mr Hyde and Other Tales of Horror*, (1886, London: Penguin Books, 2002), p. 10

68. Robert Louis Stephenson, *The Strange Case of Dr Jekyll and Mr Hyde and Other Tales of Horror*, p. 61

10

INVISIBLE WORLDS

The photography of static bodies is essentially in the business of giving enduring form to what can be seen with the eye, whether unaided or amplified by optical devices. As such, it provides a natural extension to the story of veridical representation that began with Brunelleschi. Far more radical, in conceptual terms, has been the use of instrumental techniques of representation to capture items or phenomena which are simply not available to scrutiny in the optical array that is presented before our eyes. These techniques are of two kinds. The first uses photography itself to perform acts of seeing that we cannot accomplish, while the second uses emissions at wavelengths that lie outside the parameters of our visual apparatus. They have both disclosed invisible worlds of great wonder across wide ranges of macro-cosmic and micrcosmic scales.

Frozen Moments

The mechanical eye of the camera not only augmented those of the telescope and microscope in its role as recorder but also possessed an important potential to act in its own right as a direct agent for the extension of human vision. The first major adjunct to the act of seeing that was wholly specific to photography was the 'freezing' of very rapid motions by 'instantaneous' photographs, which became possible as the sensitivity of photographic emulsions increased spectacularly during the first half-century of photography's existence. Talbot and Herschel had envisaged the use of stroboscopic effects to freeze action, but the real pioneers of 'chronophotography' as a practical proposition were

Eadweard Muybridge in America and Julies-Ettienne Marey in France. They used series of rapidly sequential exposures to reveal the unseen, intermediate, and often unsuspected positions of the limbs of human beings and animals in rapid motion. In so doing, they were claiming that photography could provide a truer way of seeing than was possible with our limited human apparatus.

The originator of 'time lapse' photography, Eadweard Muybridge, an Englishman originally christened Edward Muggeridge, became a leading landscape photographer in California in the 1860s. In 1872, Leland Stanford, ex-Governor of California, railroad magnate and devoted race-horse owner, enlisted Muybridge's services to remove the long-standing bone of contention over whether there was any stage in the locomotion of a horse in which all its feet were free of contact with the ground. Their quest was interrupted briefly when Muybridge was convicted of the 'justifiable homicide' of his wife's lover in 1874. Resuming their work with renewed energy, the photographer and his patron devised a track with cameras activated by parallel trip wires perpendicular to a wall marked with numbered lines. As the horses careered along the track they encountered galvanized cotton threads which triggered a series of twelve camera shutters in rapid succession. Initially constrained by the relative slowness of the wet collodion plates, the earliest series of images were limited to silhouettes (fig. 92). The photographs not only began to answer their immediate question, showing that the 'flying gallop' of equestrian art did not appear to correspond to how a horse actually runs, but they also revealed

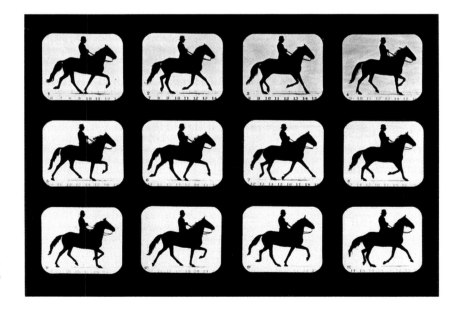

Fig. 92

*Eadweard Muybridge,
Silhouettes of Horses in
Motion,* 1877–8

hitherto unsuspected dispositions of wheeling limbs. The programme
was progressively refined and broadened. By 1879 Muybridge was using twenty-four cameras and had extended his study to other animals and to energetic human volunteers from the local San Francisco Athletic Club. Some of his serial images were printed as strips for a Zoetrope or 'Wheel of Life', a stroboscopic device perfected by W. G. Horner of Bristol that originally used hand-drawn sequences to create a primitive form of cinematic motion. When Muybridge devised a method for projecting his flickering sequences of images through a kind of magic lantern, the modern cinema seems, in retrospect, to all effects and purposes to have been invented, though Muybridge himself never saw its potential for extended narratives.

After one of his popular demonstrations of his 'Zoopraxiscope' projector in Philadelphia in 1883, he met Thomas Eakins, the realist painter who was a committed photographer and had already written to Muybridge in 1878. Eakins's enthusiasm helped persuade the University of Pennsylvania to set up a studio-laboratory for the photographer in the grounds of the campus hospital. Initially with Eakins's direct assistance, Muybridge worked intensively to perfect his methods, aiming in a systematic manner to produce sets of thirty-six images of each example of human and animal motion, twelve from one lateral viewpoint, and twenty-four from two angled or frontal and rear viewpoints. The sustained endeavour resulted in Muybridge's weighty, multi-volume magnum opus, *Animal Locomotion: An Electro-Photographic Investigation of Consecutive Phases of Animal Movements*, commenced in 1887 and completed in 1897.[1] As a visual entrepreneur, more in the style of Daguerre than Talbot, Muybridge had an eye not only for the 'scientific revelations' of his invention but also for the public appeal of his images as mini-narratives. In one titillating drama in miniature a naked women snatches a toga from a female companion whose nudity is revealed to the camera, accompanied by a provoking show of reluctance.

What surprised all observers, from the earliest silhouettes of horses to the latest pictures of complex motions in space, was how strange the intermediate poses were for the more dynamic actions. In showing that the horse always retained some contact with the ground, Muybridge had decisively falsified the 'flying gallop' beloved of equestrian painters—the stretched-out pose with legs simultaneously extended to front and rear. For artists schooled in the accepted conventions for the depiction of animal and human motion, the revelations were profoundly unsettling. The case of Ernest Meissonier will serve us well.

Meissonier, renowned for his genre paintings and his striking series of Napoleonic paintings, was acclaimed as the supreme horse artist of his time, in the succession of Théodore Géricualt and Carle Vernet. Anatomy and motion were the twin focuses of his attention. To capture the elusive positions of horses' legs, he invented a device of a 'sofa' on wheels which ran along railway tracks. Sitting on the sofa, he endeavoured to plot—leg by leg, and position by position—the horse's gait as it walked, trotted, cantered, and galloped beside him. His success with the walk was striking, but the more rapid actions proved elusive even to Meissonier's dedicated scrutiny. In these circumstances, he persisted with the 'flying gallop'. On seeing Muybridge's photographs, he lamented that 'after thirty years of absorbing and concentrated study, I find I have been wrong. Never again shall I touch a brush!'[2] This threat was not to be realized, however, and he returned to painting. But how was he to the deal with Muybridge's revelations? Should he remain true to his eye (indeed, to anybody's eye) and portray what he seemed to be seeing? Or should he depict what he now knew but could not see? His solution, in as far as he arrived at one in the very last years of his life, was to incorporate the new ideas judiciously and selectively. The revised watercolour version of his *1807—Friedland* exhibited in 1889 modifies the legs of the foremost charger just enough to acknowledge Muybridge's discoveries, but he could not bring himself to abandon on a wholesale basis the flying gallop, given its continued visual efficacy as a pictorial way of evoking the horse moving at top speed.

In the context of the patronage he was receiving from Philadelphia University, Muybridge was expected to deliver 'scientific' results. One initiative, in collaboration with Francis Dercum, who was an Instructor in Nervous Diseases, sought to create living inscriptions of the irregular gaits of those afflicted by various kinds of anatomical and motor disorders (fig. 93). Together they documented such conditions as infantile paralysis, spastic walking, and lateral curvature of the spine, as well as artificially induced convulsions in a healthy subject. Selected images were published in twenty plates at the end of *Animal Locomotion*. Dercum recognized Muybridge's revelations as providing potentially important evidence in understanding the neurology of patients with various kinds of motor deficiencies and irregularities.

The medical context is even more central to the chronophotography of Etienne-Jules Marey, French doctor and experimental physiologist. Marey had a long-standing interest in forms of instrumentation which could directly transcribe the exterior and interior actions of the bodily machine. Mechanical transcription allowed nature to write 'the language of life itself', as Marey called it. One of his devices, for

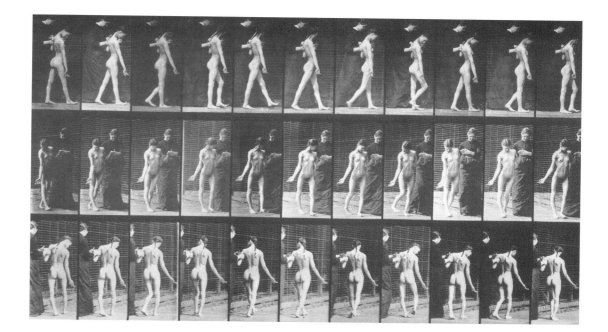

example, activated a stylus to inscribe the beating of the pulse on the surface of a smoke-blackened cylinder. And, in keeping with the tradition that runs from Leonardo to Nasmyth and Carpenter, he certified his results by remaking such creations of nature as the heart and flying birds. It was from this perspective that he viewed the potential of the Muybridge photographs published in the journal of popular science, *La Nature*, in 1878. Following his attendance at one of Muybridge's Zoopraxiscope shows in Paris in 1881, he set to work on his own device, a *fussil photographique*, a 'photographic gun' which snapped 'shots' of moving bodies at the remarkable speed of ¹⁄₇₂₀ of a second. Aiming to illustrate the parameters of position, time, and space more rigorously than Muybridge, Marey worked with his collaborators, Georges Demeny (who was set on giving gymnastics a scientific foundation) and Otto Lund (his brilliant technician) to achieve a method which was at once descriptive and analytical. His aspirations were realized when he clad Demeny in a costume of black velvet on which the lines of the limbs and key pivots were marked in white. The resulting images of levers and fulcrums (fig. 94) transmute the photographs into 'instant diagrams' which vividly speak of the body as a mechanical system acting in concert to produce the 'continuous quantity' of motion in space which Leonardo had intuited.

Even without taking into account its role in the invention of cinema, chronophotography as pioneered by Muybridge and Marey exercised a long reach into areas in which the representation of the unseeable was

Fig. 93

Muybridge. *Study of an Irregular Gait of a Spastic Walking*, from *Animal Locomotion*, 1887

Fig. 94

Marey, *Man Dressed in Black with White Strips Walking*, 1886

becoming a matter of urgent concern. Wave theory, so vital to modern physics, became a particularly fertile field for a method of instantaneous photography that used sparks of a duration as little as one ten-millionth of a second to capture the rapid motions of projectiles and elusive flow of fluids. The great physicist and philosopher, Ernst Mach, visually snared the hyperbolic bow waves, lateral waves, and trail of turbulence from a bullet travelling well over the speed of sound. The English physicist, Arthur Worthington, working at the Royal Naval College in Devonport, used a spark of less than three-millionths of a second to make systematic records of what he called the 'exquisite forms' of splashes produced by different drops in a variety of liquids. Such revelations as the corona of doplets thrown up around a spherical drop as it penetrates the surface of the liquid disclose a sequential pattern of events that 'taxes the highest mathematical powers to elucidate' but which are nonetheless 'orderly and inevitable'. Like D'Arcy Thompson, who illustrated Worthington's photographs in the first edition of *On Growth and Form*, the physicist had arrived at a point where he could intuit that a very remarkable form of order was present but lacked the mathematical resources to model phenomena that we now recognize as subjects for mathematicians of chaos.

The aesthetics of such images—blending new scientific wonders with patterns of order and disorder long exploited by artists—found enthusiastic audiences in popular no less than in scientific arenas. Harold Edgerton, the American inventor, set up a large scientific-cum-commercial enterprise at 'Strobe Alley' at MIT in Cambridge, Massachusetts, to such effect that he forged a career as the literally flashy entrepreneur of multicolour images that were *Quicker 'n a Wink*, to cite the title of his highly successful film. It was his image of the milk

drop coronet which became the public icon of instantaneous photography rather than Worthington's quietly pioneering photographs. When the British milk marketing company, Milk Marque, used a highly schematized version of the creamy crown to emblazon their lorries (fig. 95), they were assuming that it would be generally recognized—even though it is something that none of us has seen other than in the artefact of a photographic image captured at the non-human speed of three thousandths of a second.

Fig. 95

Milk Marque Tanker, 1998

The use of the instantaneous image to forge an 'art of science' is nowhere more potently expressed that in the work of the American photographer, Berenice Abbott. In the 1930s Abbott was associated with a group of 'objectivist' photographers who looked to Alfred North Whitehead's *Science in the Modern World* (1925) and *Process and Reality* (1929) in their attempt to define a remorseless form of supra-personal realism which revealed the 'Absolute' as manifested in the appearance of things. The tone of the endeavour is conveyed by her remarks in 1929 on Eugène Atget, the devoted photographer of a depeopled Paris: 'as an artist he saw abstractly, and I believe he succeeded in making us see what he saw'.[3] She claimed that photography comprises:

> a new way of seeing. Indeed, the vision of the twentieth century may be said to have been created by photography. Our familiar awareness of the visual world has been evolved for us not alone by the eye but by the camera, used for a myriad of purposes.[4]

Best known for her portraits and cityscapes, her most innovatory work involved the reform of the techniques, communicative values, and aesthetics of the photography of scientific phenomena. She served as photographic editor of *Science Illustrated* and collaborated on two high-school science books, *Physics* and *Physics: Laboratory Guide*.[5] Using a projection system she christened 'Supersight', she at first concentrated on the kinds of familiar subjects that directly revealed their structure to the lens, such as insects' wings and soap bubbles. During the 1940s and 1950s she invented devices that could capture invisible motions, not least the behaviour of waves and paths of fast-moving bodies.

Abbott was drawn to some of the classic problems of Galilean dynamics, such as the path of a projectile fired upwards from a moving platform, the response of a pendulum to gravitation, and the phenomena of wave motion that were of such moment in contemporary physics

(fig. 96). Her exploitation of high-speed flash and dark backgrounds allowed the phenomena to 'draw' their own diagrams, Marey-like, in a way that surpassed in vividness and beauty any conventional diagrammatic representation. Her aim was neither to act as a mere documenter of phenomena nor to exploit scientific photography for its decorative potential. Rather, she sought to use those properties of photography as a visual medium that distinguished it from painting and hand-made graphics to speak eloquently of the transformation of energy in terms of invariable structures embedded in phenomena. Her focus on energy was profoundly consistent with the leading issues for mid-twentieth-century physics, while the search for the patterns behind appearance corresponds to the age-old quest that has occupied much of our attention.

New Traces

Perhaps even more dramatic than instantaneous photography, in the public imagination no less than in the technical worlds of science, were the results achieved by photographic techniques which involved emissions of a frequency or type invisible to the unaided eye. The first

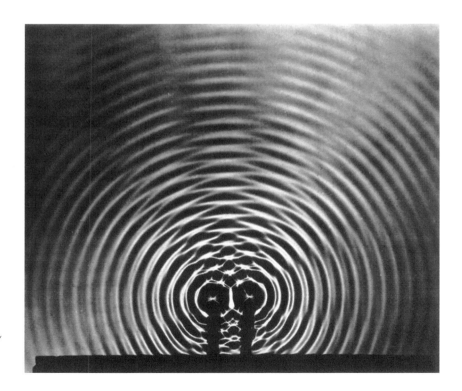

Fig. 96

Berenice Abbott, *Study of the Interference of Two Waves*, c.1954

and unsurpassed sensation was the discovery of X-rays by Wilhelm Röntgen in 1895, which seemed magically to transcend the normal definitions of sight with respect to opaque bodies. The fact that the whole process, from the generation of the emission to its reception and recording, was in the 'hands' of non-human agencies lent the X-ray a special status as a scientific record. Yet is also left the image open to the accusation that it was an artefact of the system used rather than a record of visible reality. When Henry Baraduc published photographs which claimed to record the invisible 'aura' of energy surrounding people in particular states in his *The Human Soul, its Movements, Lights and the Iconography of Invisible Fluidity* (*L'Ame humaine, ses mouvements, ses lumiéres et l'Iconographie de l'invisible fluidique*) in 1897, there was no obvious reason for the viewer to distrust the results any more than those produced by X-rays, although we now know that Baraduc's images have as much claim to truthful representations as Wright's and Griffiths's photographs of fairies.[6]

When Röntgen discovered X-rays, he was not looking for them. Rather he was pursuing his investigations into cathode rays (streams of electrons), when he noticed that his Crookes tube (a partially evacuated glass vessel with electrodes at either end) was emitting something that penetrated black paper and travelled further from the tube than forecast. These peculiar emissions were found not only to pass through many solid items placed in their path, including the hands of himself and his wife, but also to activate phosphorescent materials and produce images on photographic plates. What he had discovered were electromagnetic waves of very short length, about one thousandth of the wavelength of the light that we can see. Alongside the serious science—Röntgen was the recipient of the first Nobel Prize for physics in 1901—the 'see-through rays' attracted much popular attention, both humorous and alarmist. If we could now see through opaque surfaces, what was there to prevent the making of devices which allowed voyeuristic men to inspect the naked bodies of fully-clothed women? A poem in the journal *Photography* in 1896 precisely captured the air of public circus that inevitably came to surround the invention, in spite of Röntgen's own public reticence:

> The Roentgen Rays, the Roentgen Rays,
> What is this craze:
> The town's ablaze
> With the new phase Of X-ray's ways.
> I'm full of daze, Shock and amaze,
> For now-a-days
> I hear they'll gaze

Thro' cloak and gown—and even stays,
These naughty, naughty Roentgen Rays.[7]

The *Pall Mall Gazette* was disgusted by their 'revolting indecency' and one enterprising London entrepreneur advertised 'X-ray proof underclothing'.[8]

Like instantaneous photography, X-radiography simultaneously developed as an important tool of scientific investigation and as a public performance, exploited across Europe and America by 'scientific' showmen, heedless of what we now know about the risks of prolonged exposure. And it similarly became a source for the aesthetic of nature's hidden order. Just one year after Röntgen's announcement, Joseph Maria Eder, Viennese photographic chemist, and author of still authoritative texts on the technical history of photography, and Eduard Valenta, also a photochemist, collaborated on a portfolio of fifteen beautifully modulated photogravures of inner orders to accompany their largely technical text.

Röntgen's rays were only one of a series of emissions that transformed the visual texture of physics around 1900. Henri Becquerel, inspired by Röntgen's procedures, conducted a series of investigations of radioactivity through the photographic action of the radiant energy emitted by uranium, which in turn stimulated Marie and Pierre Curie in their crucial work on new radioactive elements for which they received the Nobel Prize in 1903. As the atom was progressively split into component parts, so techniques were devised that would allow the ever smaller, more elusive, and short-lived particles to inscribe their feverish trajectories for varieties of 'photographic' recording.

In the earliest years of the century the question was not how we could see what particles and atoms look like, but whether they were real or simply useful theoretical constructs. The crucial proof came not so much from measurements and calculations, valuable though these were, but from when they could be 'seen' to exist, or rather, when visual traces of their presence became undeniable. The work of Perrin, Svedberg, and Rutherford drew much of its conviction from the visual records of what was happening in their experiments. By 1911 the cloud chamber, invented by Charles Wilson as a way of modelling observations he made of clouds on Ben Nevis in Scotland, was being used to plot the paths of single charged particles as recorded by tracks of water droplets. Like its later cousin, the bubble chamber (which contains a superheated liquid) the images present visually compelling representations of charged particles as they perform their geometric dances under the influence of a magnetic field. In a bubble chamber,

tens of thousands of photographs may be analysed, using more than one camera to achieve a three dimensional picture of the tracks. Fundamental discoveries in particle physics, including the detection and often exotic naming of new particles, have depended heavily on the propensity of the particles to produce their own characteristic signatures in the lines they draw in cloud and bubble chambers during minute increments of time. As in the cases of instantaneous photographs and X-radiographs, images of the nuclear signatures have achieved their own popular iconography, particularly in computer-enhanced versions in glorious Technicolor that adorn the pages of popular science books and the press.

However, the signatures themselves only describe in a very selective manner some of the traces of what happens when particles collide, exchange quanta, and so on. Diagrammatic representations of a different kind are required to show what is believed to be happening in terms of 'deep structures.' The most effective of these representations have been Feynman diagrams—named after their inventor, Richard Feynman—in which graphic conventions such as arrows and zigzags serve to encode in visual form the assumed pattern of physical events. The motive for their invention lies in the gravitational pull of physical modelling and graphic picturing in Feynman's approach to physics.

He was continually bothered by the way that physical behaviour could be expressed in algebraic conventions without concrete visualization: 'Strange! I don't understand how it is that we can write mathematical expressions and calculate what the thing is going to do without being able to picture it'.[9] As Freeman Dyson recalled, 'he was a natural physicist, and he thought in terms of concrete objects. The mathematics was an encumbrance, something you had to stick on afterwards, more or less . . . as a necessary evil'.[10]

The now ubiquitous 'Feynman Diagrams' achieve the graphic encoding of phenomena whose very nature means that they cannot be subject to direct picturing. In the 1949 paper which inaugurated his method, he provided the classic demonstration of the 'fundamental interaction' in which electrons exchange a proton. The electrons are figured as solid lines, while the process of exchange of a 'virtual quantum' is represented by a wavy line, which graphically signals that the photon can be emitted from one electron and absorbed by the other, or, if it travels backwards in time, in reverse. Either way, the result is the deflection of both electrons, denoted but not literally represented by their angular deviation. Feynman diagrams look superficially like the simple graphics that physicists have used for centuries. But they are devices of exceptional power—intuitively and analytically. Within

their space-time coordinates, Feynman was able to side-step the long-winded algebraic formulas which treated electrons and positrons separately. All the equations came together in one picture in a way that preceded and even directed calculation.

The diagrams rapidly and economically explained and predicted in ways that were at once intuitive and analytical. Feynman himself described the intuitive element in characteristically graphic way:

> 'It's like asking a centipede which leg comes after which—it happens quickly, and I'm not exactly sure what flashes and things go on in the head. I do know it's a crazy mixture of partially solved equations and some kind of visual picture of what the equation is saying is happening, but not as well separated as the words I'm using.'[11]

The diagrams mirror his conviction that 'there is . . . a rhythm and a pattern between the phenomena of nature which is not apparent to the eye, but only to the eye of analysis'.

Feynman diagrams are ways of rendering events in visualizable forms without in any sense laying claim that the events would 'look' much like the diagrams if we could actually see them. Indeed, to talk about 'seeing' them is meaningless since they inhabit dimensions of time and space which are incompatible with our tools for seeing and visualizing in three spatial dimensions. Given the widespread use of Feynman diagrams as ways of thinking visually about atomic physics, this incompatibility is far from comforting for the non-specialist who yearns for some kind of realistic 'picture' and may act as a serious conceptual inhibition for the professional physicist in breaking out of current frameworks of assumption. It is possible that such a potent grammar of permissible diagrams and matching equations not only provides a marvellous tool but also performs a constraining function in what minds lesser than Feynman's permit themselves to envisage.

Molecular Modelling

At higher levels of atomic and molecular organization than those recorded in accelerators, electrons can themselves be used to supply data for the modelling of three-dimensional structures—most notably of the most complex organic molecules which lie at the heart of lifeforms. The technique which achieved most in providing visual evidence of the nature of atomic and molecular configurations in solids uses Röntgen's X-rays for a purpose he could not have foreseen. In chapter 1 we have already noticed Max von Laue's laying of the

foundations for X-ray diffraction techniques. What he discovered not only confirmed that X-rays were *waves* but also showed how interference patterns provided decodable information about the internal structure of the crystals. The translation of an X-ray diffraction image into a three-dimensional model of the atoms in the unit cell is a hugely demanding process. Initially the results, such as those of W. L. (Lawrence) Bragg, developing the work of his father in Leeds, concentrated on the confirmation of the assumed models for inorganic crystalline substances such as diamond, but increasingly X-ray crystallography was establishing remarkable if hard-won gains in the understanding of organic molecules. One of the most spectacular acts of modelling in the new discipline of molecular biology was initiated in 1937 by Max Perutz's work on the structure of haemoglobin.

It was in Perutz's Cambridge circle that Francis Crick and James Watson were to embark on their famous collaboration. As Perutz graphically recalled, 'the first protein structures revealed wonderful new faces of nature'.[12] That he found it necessary to reveal these 'faces' visually rather than mathematically became rapidly apparent:

> I began giving a course in X-ray crystallography of biologically important molecules for students of biochemistry and other biomedical subjects. In my first lecture I introduced lattice theory, trigonometric functions, and Fourier series very lucidly, I thought, but half the students failed to turn up for my second lecture. . . . The following year I replaced my forbidding lecture with a non-mathematical, largely pictorial introduction called 'Diffraction Without Tears'.[13]

The potency of the visual model over the mathematical formulation goes far beyond the need to sweeten the technical pill for biologists and medics. The three-dimensional model has proved a vital tool in how a new substance can be 'engineered' (Perutz's term) to lock onto the molecular structure of a hostile protein in order to neutralize its adverse effects on the body.

As we saw in chapter 2, the X-ray diffraction photograph which played perhaps the most dramatic role of all in modern biological science was that of deoxyribose nucleic acid (DNA) by Ray Gosling and Rosalind Franklin. With such complex organic molecules, the intricate patterns of scattered rays in the flat image requires an extremely high level of spatial visualization before it can be comprehended in terms of its three-dimensional origins, and we should not be surprised when divergent models are proposed. This is just what happened when model builders in Britain and America worked on possible structures for DNA, before Watson and Crick famously

formulated what is now taken as the definitive double helix. But general agreement on a definitive model to 'fit' the X-ray pattern does not solve all the fundamental problems in the act of modelling. The range of models extends from the kind of spidery lattice that Watson and Crick revealed to the world in 1953 to the concrete, futuristic architecture of Perutz's 1962 Haemoglobin model. In terms of two-dimensional picturing, the height of visual sophistication in the age before computer graphics was reached in 1961 in John Kendrew's masterly article on the structure of whale myoglobin, in which he illustrated Irving Geis's remarkable illustrations of the spatial structure of the molecule (fig. 97).[14]

What is striking to a historian of the visual is how the models have 'styles' which are very much of their period—datable visually in much the same way that a historian of twentieth-century sculpture could make a good shot at dating a piece for which the maker's name and other historical data were withheld. The compound of factors that go to make up this visual style—the visual 'look' or 'feel' of the object—

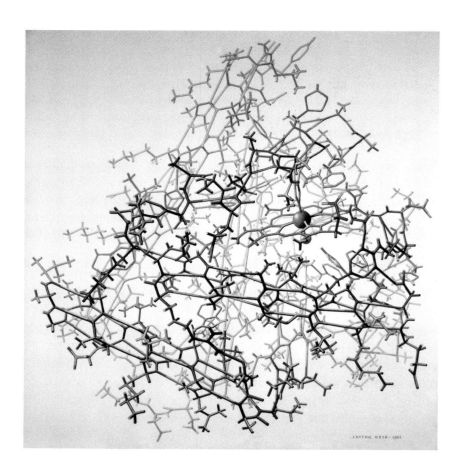

Fig. 97

Irving Geis, *Detail of Sperm Whale Haemoglobin Molecule*, from John Kendrew, 'The Three-Dimensional Structure of a Protein Molecule', *Scientific American*, 1961

include materials, colours, textures, scales, and the vocabulary of the shapes and how these formal elements interact with the underlying conceptual parameters.

But the different modes of model-building are not simply an expression of historical factors of styles of thought and depiction. The problem of 'realism' in the models of things which can only be 'seen' by machines is even more problematic than the depiction of forms visible to our eyes. An atom does not 'look' like anything at all. It is a contradiction in terms to talk of its visual appearance, since its being 'seen' depends upon emissions of a wavelength which lies far outside what can be seen, and the act of 'seeing' can only be defined for us in terms of what we can conceive seeing to be—and this conception is necessarily limited by how we have been equipped to see. We are no more permitted to see a molecule than we can see what an insect 'sees' with its multi-faceted eyes. The best we can do is to take the data from the machine and to translate it into something that we can work with visually. The situation is not dissimilar to the early microscopists' translation of an incomprehensible revelation into the familiar terms of a known item that they saw as having an analogous appearance. The translation in the molecular case involves an even higher degree of selection of what aspect of the data is to be seen and modelled. Any realism is selective, and the 'realism' of molecule modelling stands at the extreme end of the selective range. Are we to concentrate on the format of the links and distances between the atomic nuclei, or are we to envisage that we are looking at the molecule from outside, as if it is a solid object? Do we represent the atoms by marking their position or by showing then as solid balls, with their fuzz of orbiting electrons solidified into components of a constructivist sculpture? And, if we use fat balls, do we leave them as solid spheres or compress them selectively to retain the distances between the nuclei in such a way that they abut with flat planes like clusters of soap bubbles? This is to say nothing of colour and texture.

Now that the building of models is generally done on computer, the questions have become more rather than less complex, because the possibilities presented by computer graphics go beyond those of physical models. Computer programmers have enabled the graphics to simulate full stereo and cinematographic effects, so that models of the space-filling kind wheel in our field of vision like giant, weightless space stations, while 'ball-and-stick' or 'ribbon' models etch the delicate tracery of their geometrical skeletons across a scale-less spatial field (fig. 98). The question is not which is the most realistic model, but which is most 'realistic' for what particular purpose. Just as our

perceptual system has been equipped to extract coherence from sensory data according to our needs as mobile and dextrous creatures of high mental capacity, so the designer of biochemical modelling systems is directed by what properties are regarded as crucial to the function of the model. Thus, if the important consideration is the internal architecture of the molecule, we need a see-through structure, while the envisaging of a new molecule to lock spatially on to the one in view may be furthered by the space-filling modes of construction.

A good instance of how modes of picturing and scientific functionality interact is provided by a space-filling method devised by the chemist, Preston MacDougall, and Christopher Henze, a visualization specialist at the NASA Ames Research Center.[15] Their images (fig. 99) are based on the topological analysis of the distribution of electron probability density, as defined by quantum chemistry. Their models map the hills and valleys and the extrusions and holes in the electron cloud that surrounds each nucleus. A fourth dimension is provided by the colour coding, in which a rainbow colour scale is taken as corresponding to a range of charge concentration, from 'cool' blue depletions of charge to 'hot' red concentrations. The transition from green to yellow corresponds to the border between depletion and concentration, while white denotes the very highest concentrations. Even with this amount of modelled and coloured information, the static image of an elaborate molecule remains frustratingly complex to unravel. The process of visualization is completed by an animated fly-around facility and by an opacity function editor that allows the spectator to focus and re-focus interactively on features of special concern.

Fig. 98

Per Kraulis, Ribbon Model of a Ras 21 Protein, computer imaged in Molscript

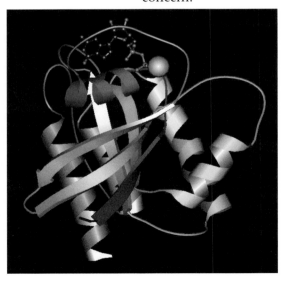

The MacDougall–Henze technique was devised to extend the power of three-dimensional models to predict chemical bonding. Not only do the lumpy configurations reveal very clearly the strong covalent bonding that provides the structural integrity of a molecule but they also denote sites of noncovalent interactions, the weaker links that typically involve hydrogen atoms at the extremities of large molecules. The plastic modelling tool facilitates the identification of reactive sites, and thus predictively assists in the identification of potentially reactive agents, most notably in the context of drug design.

To say that such representations are contrived to achieve pre-defined ends is not to argue, any more than I did when talking about human spatial perception, that the results are arbitrary with respect to properties of things external to us. Rather, the modes of perception and representation are highly structured and filtered for functional ends. It is also readily apparent that the representations have been endowed with visually satisfying qualities, as MacDougall himself is happy to acknowledge.

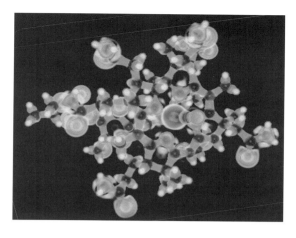

Fig. 99

Preston MacDougall and Christopher Henze, *Space-Filling Model of Vitamin B12 Complex (cyanocobalamin form)*

Seeing the Unseen

The translation of X-ray diffraction images into 3-D models is just one of many perceptual-analytical-representational procedures that have taken image-making much more radically out of our hands than happened even with photography. Many other 'visual' systems—signally characteristic of the twentieth and twenty-first centuries—have found ways to operate with rays that lie immediately outside the visible spectrum, such as ultra-violet or infra-red, or with different kinds of emission, such as sound, heat, radio waves, and electrons. In chapter 2 we briefly saw the electron microscope at work in revealing the miraculous landscapes of the molecular world. More recently, other forms of technological perception and representation, such as those using ultrasound imaging (of, say, the foetus in the womb), positron emission tomology, and magnetic resonance imaging (both of which provide computer-analysed scans of brain activity) have astonished the public with authoritative pictures of the unseeable. Yet we should not loose sight of the way that the conception of the 'seeing' devices is rigged to work within the limits of our accustomed means of viewing and making images. To understand this rigging, it will be helpful to look at two instances, sonar scanning (also mentioned in chapter 2), and recent techniques for scanning the brain.

Sonar scanning is the easier to grasp, since it resides within our normal sensory compass, albeit heard rather than seen. Since no light effectively penetrates below a depth of 200 metres in the sea, an alternative method needs to be found to look at the bottom of the oceans from the surface. In the 1940s and 1950s, adapting technology which had been devised to detect submarines in the Second World

War, sound waves were bounced off the sea bed to a tuned receiver which could register the distance the reflected ray had travelled. If the scan is taken at an angle—a 'side-scan'—a series of highlights and shadows are generated in terms of sound. Bruce Heezen, Marie Tharp, Ivan Tolstoy, and Maurice Ewing used sonar scans of the Atlantic to posit radically new views of the configuration and dynamics of the sea bed. The immediate transcription of the reflected waves is not into visible form, but consists of a series of measurements which can most readily be recorded graphically as a series of peaks and troughs, often exaggerated for the sake of clarity. They can be mapped in various forms, like the surface of the earth, including the underwater equivalent of bird's eye maps (fish-eye maps?) in which a 'physiographic' drawing renders the topography in much the same way as has been done with land masses since the Renaissance, as we noted in chapter 2 (fig. 21). Marie Tharp has described the generation of Heezen's first physiographic map in 1952:

> Heezen . . . seized a piece of paper and within an hour drew in the topography. The physiographic diagram was completed five years later with the actual soundings and profiles. All mapping proceeded with the following principles. First, there was only one way to sketch or to contour the ocean floor and that is to present it as it actually exists as it would be seen if all the water were drained away. But there will never be enough tracks to do this. Thus, hypotheses of ocean floor structure must be used to supplement the often meagre data and only the use of correct hypotheses will result in maps closely approximating nature. Second, what data exists in the several disciplines [involved in surveying the sea bed] must all be put at one scale. Third, sketching proceeds from the shoreline seawards and then from the mid-ocean crest landwards as the policy was to go from the known to the unknown, from the relatively well surveyed areas towards unsurveyed areas. The sketching technique was well suited to portraying sea floor topography since it was very demanding where profiles were available but flexible where there were no data.[16]

She ends this account by noting that 'in 1952 contours were classified by the US Navy'—reminding us of the initial impulse behind the invention of sonar.

The combination of machine 'perception' and hand drawing to produce an image which is both familiar in terms of our knowledge of map types and that works with our taste for spatially effective pictures is particularly revealing of the choices that are made and of the perceptual assumptions underlying those choices. The visual predilections are those which have governed our trust in naturalistic, perspectival images from the time of the Renaissance. As we noted in chapter 1,

physiographic maps, greatly refined in data and technique over the years—involving, amongst others, Heinrich Berann, an Austrian painter of Alpine panoramas—notably resemble historic maps in fictive relief, as exemplified by the sixteenth-century painted topographies designed by Ignatio Danti (fig. 20).

In the case of our second type of scanning, those devised to reveal new data about the brain, the visual choices are even harder to unravel because they are all built invisibly into systems which from first to last are conducted by machines. Let me give a brief account of the three main systems.

We know how X-rays in their original form gave entirely fresh insights into aspects of the interior of the body, but this was only into a few selected aspects, depending on the relative opacity of the various substances of the internal organs. Bones showed up well, but blood vessels barely at all. One way to rectify this shortcoming was to rely upon the selective injection of an X-ray opaque material to provide the necessary contrast, which can further be enhanced by the manual or digital subtraction of unwanted background information by a kind of perceptual filtering. However, the amount of spatial information in the image is still limited, since forms at different depths are inevitably mingled in the see-through view. A radical extension of the use of X-rays to picture the internal topography of the whole body has been provided by computer tomography (CT), in which an X-ray fan beam is received by detectors, and the digitized image is processed to produce complete sectional images of designated thickness. Graphically reconstructed in a sequential series of slices, the data from the sections can present a remarkably complete picture of the plastic configuration of organs, in the manner achieved by earlier sectional anatomies.

A related technique to produce sectional slices is magnetic resonance imaging (MRI) or, in its most recent form, Functional MRI, which exploits a strong magnetic field and radio frequency to detect hydrogen protons in fat and water. The other major new system for the scanning of brains, positron emission tomography (PET), involves the injection of short-lived isotopes into the blood stream. The relative levels of positron emission from cell nuclei are recorded by strategically placed detectors. All three techniques are dependent on the analytical and synthetic power of the modern computer as the programmed 'brain' of the perceiving mechanism.

PET and FMRI scans of the brain serve to register different levels of activity at different sites, providing information about cerebral localization—that is to say, identifying which zones of the brain are particularly active when we perform specific mental functions, such as

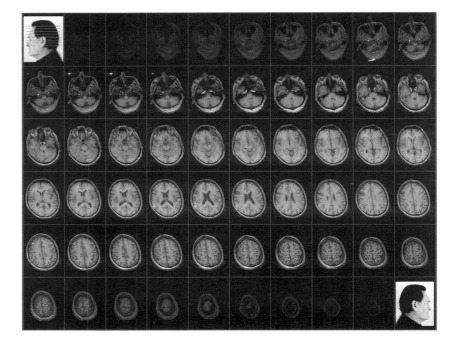

Fig. 100

Functional Portrait of
Martin Kemp by Marta
de Menezes

the detection of movement or facial expression. Computer tomology is used to filter and synthesize the resulting data in such a way that series of sectional images can be generated. The sections do not so much show the morphology of the brain as the dynamic levels of the processes being performed by the neurones. With FMRI the temporal mapping of every kind of cerebral function is potentially possible, ranging from the registering of pain to the laying down of memories, and from watching a dancer to the hearing of orchestral symphonies—or, in the case of the illustrated example, see what is going on when I was looking as best I could from the machine at a not very good reproduction of the painting of *The Ambassadors* by Hans Holbein. The scan was made when I was one of the subjects in the project 'Functional Portraits', by the Portuguese artist, Marta de Menezes. To read the resulting maps effectively requires a good deal of specialized knowledge.

In such scans, colours are typically used to encode levels of activity, with the warmer colours, such as red, unsurprisingly selected to denote 'hot' zones, while the bluer, colder end of the spectrum signals lower levels. White and black generally represent the most active and least active extremes. The detection of patterns of activity can only be accomplished by someone experienced in looking at a wide range of such images and who understands the parameters of the equipment. Our lay viewing tends to rely upon our interpretation of line and colour as corresponding to the shapes of physical structures and to overly

simple ideas about the localization of faculties—much like nineteenth century phrenological theory in its popular guise. Even interpreted by those who know what they are looking for, the localizing of specific mental processes remains distant from an understanding of the tangled complexity of what happens cognitively when different observers look at images of such intricate form and content as Holbein's painting.

One of the characteristics of the use and reception of such machine-made images is the widespread assumption of their authority. The machine seems to promise a non-human precision. In the age of computer graphics, the more technological the image looks, the more it exudes the authority that comes with the highest levels of electronic complexity. But each level of complexity introduces potentially new choices, and we must embed these choices in the machines. We may even be able to construct machines which can devise their own kind of choice, but we must then embed the choice of how to choose the choices. From first to last, the process and design is dependent on our conceptions—their imaginative reach and their constraints. At the most basic level, we define the nature of the task as defined by us at the outset. Ways and means are then devised by us on the basis of what we conceive those ways and means to be. And the whole end of the processes is directed towards something which we can take in through one of our senses, of which sight is the most voraciously demanding in our quest to understand the physical world. At the end of the day, it seems that nothing is in fact taken 'out of our hands'. The danger is that we may either think that the choices are no longer ours—vesting them in the soulless machine—or assigning them to the small bands of specialists who 'know'. The danger is that we fail to recognize that devices are tools—however amazing and wonderful and powerful—and that those who 'know' may have unfathomable knowledge of the tools but have no privileged position in deciding how they should be used. Indeed, those who 'know' should recognize that they carry a burden to educate so that informed choices can be made—to protect their own rights as well as ours.

In conclusion, we may say that the artificial picturing devices examined in this and the preceding chapter do not serve to simplify or eliminate the subjective issues of seeking, knowing and representing that we have repeatedly encountered in the course of the preceding chapters. Rather, by shifting the factors of choice to different parts of the processes by which an image comes into being, they can be used to highlight particular features in the anatomy of those processes. We can also see that, however technologically removed the processes may have become from Renaissance acts of picturing, they have been contrived to

meet familiar visual and intellectual needs, above all by disclosing in two or three dimensions the articulate nature of natural forms and forces. The more I think about acts of seeing and representing, the more awesome seems the dialogue that we conduct between external complexity of almost infinite variety and the pull of our perceptual system towards simple patterns of coherence at every conceivable scale.

NOTES

1. Eadweard Muybridge, *Animal Locomotion: An Electro-Photographic Investigation of Consecutive Phases of Animal Movements*, (Philadelphia: University of Pennsylvania, 1897)
2. Marc Gotlieb, *The Plight of Emulation: Ernest Meissonier and French Salon Painting* (Princeton: Princeton University Press, 1996), p. 177–8
3. Berenice Abbott, *The World of Atget*, (New York: Horizon Press, 1964)
4. Berenice Abbott, *New Guide to Better Photography*, (New York: Crown Publishers, 1953), p. 1
5. *Physics* and *Physics: Laboratory Guide*
6. See Georges Didier-Huberman, *Charcot e l' Iconographie photographique de la Salpêtrière*, (Paris: Macula, 1982)
7. Martin Kemp, *Visualizations*, (Oxford: Oxford University Press, 2000), p. 75
8. *Pall Mall Gazette*, as quoted in Martin Kemp, *Visualizations*, p. 75
9. Christopher Sykes ed., *No Ordinary Genius: The Illustrated Feynman*, (London: Weidenfield & Nicolson, 1994)
10. Dyson as quoted in Christopher Sykes ed., *No Ordinary Genius: The Illustrated Feynman*
11. Dyson as quoted in Christopher Sykes ed., *No Ordinary Genius: The Illustrated Feynman*
12. Max Perutz, *Protein Structure: New Approaches to Disease Therapy*, (New York: Freeman, *c*.1992), p. xi
13. Max Perutz, *Protein Structure*, p. xii
14. John C. Kendrew, 'The three dimensional structure of a protein molecule', *Scientific American*, **205**, n.6, 1961, pp. 68–9
15. Martin Kemp, 'Volumetric Valencies', *Nature*, **412**, 2001, p. 588
16. Marie Tharp, 'Mapping the Ocean Floor—1947 to 1977', in R. A. Scrutton and M. Talwani eds, *The Ocean Floor*, (London: John Wiley and Sons, 1982), p. 22

LOOKING BACKWARDS
AND FORWARDS

One sub-theme of this book has been how we may view the 'style' of images as conveying complex cultural values, whether the representations originate from the sciences or from the arts. I have been inferring that the look of science is no less redolent of cultures and periods than the styles we have come to define in historical studies of the arts. I have been trying to show that the looks of the sciences and arts, both within and across periods and cultures, resonate tellingly when set within the broad history of visual things. And I have tried to show in both the text and the illustrations that there are historically recurrent patterns in ways of looking and representing the phenomena of nature, across varied scales and subjects. Like any historian telling a cultural story—or in my case episodes from a number of fragmentary stories—the differences between periods and cultures are vital. The differences not only chart developing techniques of representation but also show how observers have been able to adopt different perspectives on the witnessing and recording of seen phenomena. But I have also been struck with how persistent are central continuities in image-making in the Renaissance and post-Renaissance worlds. There is no illusionistic trick in the pages of *Nature* or *The New Scientist* that does not have its counterpart in Renaissance art and science. The subjects and technological substance of the modern images are very different, to be sure, but the underlying bag of graphic tricks—perspective, light, shadow and reflection, modulated colour, motion implied by line, and the overall notion that the margins of the image constitute a 'window frame' through which spaces and surfaces of nature are viewed—has

not changed. From my historian's perspective, this continuity of representational means disposes me to think that the 'conventions' of pictorial illusion work at a very deep level with the perceptual and cognitive structures we have acquired to make sense of what lies 'out there'. I recognize that they work better with appropriate cultural attuning, and will only arise as the result of particular sets of historical imperatives, but I do not think the basic mechanisms and visual potentialities are culturally constructed. There is a key difference between cultural construction and cultural realization, and it is the latter in which I believe.

The continuities, or, rather, the recurrences of certain visual strategies also have far-reaching implications for how we understand enduring human ways of articulating our scrutiny of nature. The visual scrutinizers we have studied have regularly traded on intuitions of orders which span nature from the very smallest parts to the very largest wholes. We have witnessed intuitions of how the smallest mechanisms, operating at the most basic geometrical and mechanical levels, can result in organic forms and functions at the very highest levels of complexity. We have also seen, conversely, how complex systems resist reduction to mechanistic parts if they are to be understood at a holistic level. To my mind, the vigorous conflicts between the 'reductionists' and the 'holists' seem overwrought, in that modes of analysis of wholes in terms of parts and of parts as functions of wholes may be considered as exercising complementary powers as tools for our understanding of nature. This is certainly true historically, and it is my intuition that it will continue to be true, since both modes are fundamentally embedded in the apparatus of intuition that we continue to operate at a fundamental human level. And, however much we rig machines to do the jobs for us, it is our apparatus that determines what is to be done and how it is to be accomplished. It is natural that operators of reductionist and holistic methods will believe powerfully in the rightness of their approach, and I suspect that it is the temperamental tuning of each mental apparatus that determines who gravitates to which pole.

I also believe that the complementary nature of 'reductionist' and 'holistic' approaches goes beyond the historical continuities of human cognitive systems. Even in its starkest Neo-Darwinian form, the evolution of morphologies through the combination of blind chance in random mutations and the raw mechanism of natural selection cannot be seen as operating in isolation from the design constraints of physico-chemical laws. This stark formulation, however, oversimplifies to the point of misrepresentation. I believe that a more nuanced theory

is needed if we are to develop a more complete model. The mechanism of selection has inhabited and continues to inhabit a statistical sea of staggering complexity, from the very first moments of life on earth, through the emergence of highly developed organisms, and down to the present. This complexity is at once extreme in its non-deterministic properties and remarkably self-organizing in a non-random way—to such effect that it exercises a shaping role at every level of organic and inorganic form, including the formation of DNA itself as a double helix. No part of the system—gene, natural selection, or self-organized complexity—takes automatic priority in such interactive shaping, any more than the egg takes priority over the chicken. Given this total interdependence, the levels we characterize as 'parts' or 'fundamental units', and those we describe as 'wholes' or 'complexes', are matters of philosophical conviction, practical choice, or personal preference, not scientific demonstration. It is sometimes the case that the less dogmatic, non-programmatic and 'fuzzier' procedures of artists are better at embodying the potential opposites than the analytical presentations of modern science.

I am arguing that 'visual history', as a new discipline in the burgeoning art-and-science industry, has a central role to play in such debates. I believe that it can reveal significant facets of what I am calling 'structural intuitions' in our viewing and representing of nature. Earlier I touched on the work of Andy Goldsworthy in such a context, and I think it will be useful to return briefly to his manner of working to clarify what I am trying to say about the art-science-technology relationships as a central issue in visual history. I am selecting two pieces for discussion, one of which exemplifies his collaboration with the structural principles of static design, while the other operates with dynamic natural processes.

Goldsworthy has, over a number of years, worked with miraculously balanced single rocks, aggregate bodies of stones and slates in various constructional forms, and arches built from diverse natural materials, including compacted snow and rough blocks. Their stability relies entirely upon the inherent resistance of the discrete components in a structure which is subject to complex forces of compression and tension. No artificial adhesive is used to cement the stones together. The adhesive stability is provided by the hidden chains of static forces that act on each individually shaped stone in a unique manner, depending on its precise position in the arch. The role of the block that serves as the keystone at the very apex of the curve is thus very different from that of a stone near the base of one of the arms. The engineering statics of such a structure can be subject to mathematical analysis,

both by theoretical calculation and by the building of models (physical and/or computerized) for the purpose of observation and analysis.

About five hundred years ago, Leonardo posited one mode of quantitative analysis through a kind of engineer's thought experiment, in which he tried to envisage the proportional progression in the weights needed to equal the downward thrust of the individual stones. Today's formulas in statics are a good deal more complicated, but the ideal remains essentially the same. However, people in varied cultures have been building stone arches for centuries with no knowledge of their underlying mathematics. Over the ages, arch and dome constructors—ranging from the makers of 'simple' igloos to the masons of Gothic cathedrals—have worked with a combination of accumulated trial-and-error wisdom, simple geometry, and the kind of somatic-cum-visual feel for structural forms acquired by those who handle natural materials in the operational fabric of their daily life.

Goldsworthy is of course working in an age when high levels of structural knowledge are potentially available to him. His assemblages of blocks would yield many of their secrets to systematic analysis, even if the irregular individuality of the component parts is hardly likely to appeal to an engineer. Indeed, trial-and-(potential)-error testing has been performed on the massive arch that Goldsworthy erected in Montreal. A test arch was tugged with hawsers to ascertain its durability, a precaution that is particularly necessary given its presence as a large construction in a public space. But does he need to acquire personally or borrow the engineer's know-how? The systematic testing of the arch, which has confirmed its resistance to lateral forces significantly beyond those which can be reasonably anticipated, is indicative of a potential and, in this case, actual dialogue with bodies of technological and scientific knowledge. However, even at its most directly engaged, it is a *dialogue*, and very much not a process of deriving information to determine what should be done. At heart, he is exploiting the 'structural intuitions' of the artisan-craftsman, often won over long periods of time. By leaving the identity of the components self-evident in a kind of rough-and ready manner, rather than concealing them in a high-tech vehicle, he artfully exploits our sense of wonder at the endurance of an apparently precarious structure—in a configuration which is at once natural and artificial in feel. The visual tone is that of Diana's grotto in Ovid's *Metamorphoses*, cited in chapter 3 in connection with Palissy. The formation of sheltering stone was, we may recall, 'wrought by no artist's hand, but nature by cunning had imitated art, for she had shaped a native arch of the living rock'.

The other image is made by a non-deterministic process. A series of

canvases, some very large, have been pinned on the ground in fields where sheep are fed. At various places on each canvas, a block of compressed feed has been asymmetrically placed. Drawn to the food blocks, the sheep press into the progressively tighter field of space around the blocks' peripheries, carrying mud and manure on their feet across the pristine surface of very large, white canvases. The patterns of odiferous imprints exhibit an unsurprising increase in density around the centre of the nourishment. The process is neither as free as the chaotic adhesion of particles in DLA, nor is it as regular as might occur if a series of passive bodies were drawn steadily towards a centre by a centripetal force. The wilful sheep walk, jostle, stand, shuffle, and edge away in a manner that exhibits purpose without being predictable in all its manifestations. The soiled canvases are lifted by the artist at a stage when the pattern of hoof prints has sufficient density to be telling but has not become so dense as to obscure all sense of the individual marks.

Mounted on wooden stretchers, they are subsequently hung as 'sheep paintings' on the walls in his studio or an art gallery. In such a context they bespeak of their making, but they acquire an ambiguity that goes beyond any descriptive act. The roughly circular, more-or-less unstained aperture left by the food block becomes a kind of 'sun' or 'nuclear centre' from which radiate emissions in the form of diffusing particles—or it acts as a bright, magnetic attractor towards which a surrounding substance is in the process of being drawn. In either case, exhaling or inhaling as it were, the degrees of dispersal and density look as if they could be subject to mathematical analysis, most notably using the probabilistic sciences of complexity. But such analysis is not the overt purpose of their making nor is it the standard mode of commentary in the art-world context in which they are most likely to be assessed.

Such an example shows how we can see the artist and the scientific investigator of complexity as potentially sharing intuitions, which provide visual itches they may need to scratch, but, at the same time, as embarking on enterprises quite distinct in means and ends. The end of the artist is to provide a field for interpretation, into which the spectator is invited with varying degrees of generosity. The end of the scientist is to provide as complete and unambiguous an interpretation as words and images allow, in which beauty and wonder are allied with precision rather than suggestion.

For the historian of the visual culture at the start of the twenty-first century, one of the most striking commonalities in the structural intuitions of art and science is the fascination with non-deterministic

processes of the kind exploited by Goldsworthy's sheep paintings and Callan's dust-scapes. Why processes with non-predictable outcomes should have assumed such prominence at the same time in art and science is one of the big questions. In our present context, I want to state it as a legitimate issue rather than attempt to explore it in any depth. That attempt has been begun elsewhere, and still has a long way to go.[1]

In this as in all that has gone before, I am not setting myself up as an authoritative critic of the sciences in contemporary society. I am certainly not wishing to place myself automatically in a position hostile to big institutionalized science—a stance which all too readily results from any re-assertion of the humane role of non-rational imagination and poetic insight in any society that wishes to retain its intellectual and material health. If I have been critical, overtly or by implication, of some of the stock claims of current science as they are often broadcast in public, it is because I see as a historian how these claims are just part—albeit a hugely powerful and efficacious part—of the resources we have available to us to locate ourselves with due deference within the world we inhabit. The apparently omnipotent methods of modern science are not just incomplete with respect to non-scientific disciplines such as the arts and humanities, but they are also partial within the broader spectrum of science over the ages. The old ideal in which 'science' was defined more broadly as a rational body of understanding and was set within the framework of 'Natural Philosophy' still has much to recommend it.

I think I can best conclude by returning to the term 'perspective' in its particular usage in the phrase 'from a different perspective'. Any act of articulate viewing inevitably takes place from a particular perspective. Without the frameworks and criteria provided by and from a particular stance we would not be able to draw (in any of the possible senses) anything coherently from the world we see, hear, touch, and smell. All our individual perspectives are different to various degrees, and it is reasonable to suppose that the divergences will become more pronounced the greater are the cultural contrasts between the observers. But I have maintained at various points in the book that from all the different perspectives, however relative they may seem, and however arbitrary it may seem for an individual to be located in one culture rather than another, there are consistently common proclivities at work. The need for a defined viewpoint and the possibilities for shared criteria for seeing are nicely illustrated in one of the 'Calvin and Hobbes' cartoons by Bill Waterson, the American graphic artist whose prolific comic strips have provided such rich veins of 'lay' philosophy.

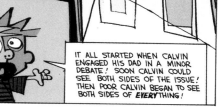
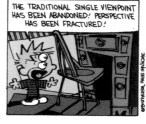
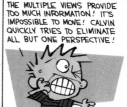

The strip in question is taken from his 1991 collection, *Scientific Progress Goes 'Boink'* (fig. 101).

The ever querulous and preciously smart Calvin (without in this instance the presence of his playmate, the stripy feline Hobbes), has been engaging his Dad in a 'minor debate'. His father's counter-arguments have enabled Calvin to 'see both sides of the issue'. The surrendering of his single perspective is visually accompanied by the dizzy onset of 'neo-cubist' vision in which 'poor Calvin began to see both sides of *every*thing'. Overloaded by alternative views, 'Calvin quickly tries to eliminate all but one perspective', at which point 'the world falls into recognisable order'. Having regained his personal perspective on things, he returns to his father, who has turned to other matters. 'You're still wrong Dad', he announces.

We can sometimes manage to see something from someone else's viewpoint, generally by an act of conscious and temporary repositioning which does nothing to erode our conviction that we see better from our original position. More occasionally, we may actually change our stance in a radical way. The alternative viewpoints involve a switching mechanism through which we successively imagine occupying different positions, rather than suffering from the mingled simultaneity

Fig. 101

Bill Waterson,
Calvin and his Dad in Debate, from *Scientific Progress Goes 'Boink'*, 1991

of perspectives that so bemused Calvin. What is also apparent is that—once restored to their normal visual world—Calvin and his Dad can hold different viewpoints within a world seen in sufficiently shared terms as to make dialogue possible. It is a world in which huge but generally unstated measures of shared and agreed perception exist. They both, for instance, can see a chair as a four-legged thing that occupies a portion of space, know what it is called and understand what it is for. They could both potentially reason as to why two legs would not do, why four is better than three, and why five would create redundancy. They could also both envisage acts through which the chair might be transformed into something else, losing its prosaic 'chairness'—being used for example to prop open a door or to provide a podium from which a speech is delivered to a group of people. This sense of functional transformation, which dislocates the simple taxonomic identity of a 'chair' as a piece of furniture, is what the English artist, Richard Wentworth has called 'Making Do and Getting By'—the title of a set of photo-works of observed situations that testify to the subversively lateral thinking we are all capable of performing (fig. 102). As Joseph Beuys rhetorically over-asserted, everyone is an artist—at least in terms of such inventiveness, untrammelled by the constraints of naming and function. The legendary story of Alexander Fleming's realization that the petri dish inadvertently infected with the mould, *Penicillium notatum*, was of special significance may be regarded as an example of 'making do and getting by' at the highest level of creative insight—whether or not the story is good history of science.

The whole of this book is a plea for visual history as a form of 'making do and getting by'—of seeing that a visual thing known as a 'scientific illustration' or as a 'work of art' can serve functions in zones of history in which the taxonomies behind their conventional naming do not become rigid constraints. It is also a way of saying that the visual qualities of art are too important to be left solely as the prerogative of art professionals and that the implications of the visual worlds of science are too significant to be given over wholly to the scientists. I have a powerful sense that effective art and science both begin at the points where knowledge breaks down. Visual intuitions are one of the most potent tools we possess for feeling our way into the unknown. My final plea is for professionals in each 'field' to exercise

Fig. 102

Richard Wentworth, From the series *Making Do and Getting By*, 2002

generosity and tolerance within the scope of an agenda which decrees open communication with each other, not just in specially staged conferences but also in broader public forums. I believe that we surrender our human 'wholes' to our specialist 'parts' at our peril.

NOTES

1. Martin Kemp, *Visualizations*, (Oxford: Oxford University Press, 2000)

FURTHER READING

Note: a full bibliography would be unmanageably vast. I have therefore provided guidance to some further reading on the main issues (including books by authors advocating stances different from mine), a list of relevant publications by myself which contain fuller sets of references and illustrations, and some literature on particular topics in an order corresponding to their main appearance in the book. Further sources and references are provided by the footnotes, and are not necessarily replicated in the following lists. Since the text was largely complete a longer time ago than I care to confess, more recent literature has exercised less impact than it might, but some recent contributions are included below to assist the reader in taking the topics further. I am conscious that my own reading across this wide territory is rather hit-and-miss. Given the pressures on my time, I have concentrated on primary sources as the highest priority.

GENERAL

Leonardo Amico, *Bernard Palissy: In Search of Earthly Paradise*, Paris and New York, 1996

Wallace Arthur, *The Origin of Animal Body Plans: A Study in Evolutionary and Developmental Biology*, Cambridge, 1997

Brain Baigrie, ed., *Picturing Knowledge: Historical and Philosophical Problems Concerning the Use of Art in Science*, Toronto, 1996

Per Bak, *How Nature Works: The Science of Self-Organized Criticality*, New York, 1996

Phillip Ball, *The Self-Made Tapestry: Pattern Formation in Nature*, Oxford, 1999

John Barrow, *The Artful Universe Expanded*, Oxford, 2005

Gillian Beer, *Darwin's Plots: Evolutionary Narrative in Darwin, George Elliot, and Nineteenth-Century Fiction*, London, 2000

Margaret Boden, *The Creative Mind: Myths and Mechanisms*, New York, 1992

Horst Bredekamp, *The Lure of Antiquity and the Cult of the Machine: The Kunstkammer and the Evolution of Nature, Art and Technology*, trs. Allison Brown, Princeton, 1995

Vicki Bruce, Patrick Green, and Mark Georgeson, *Visual Perception. Physiology, Psychology and Ecology*, 3rd. ed., Hove, 1996

Bruce Clarke and Linda Dalrymple Henderson, *From Energy to Information: Representation in Science and Technology, Art, and Literature*, Stanford, 2002

Enrico Coen, *the Art of the Gene: How Organisms Make Themselves*, Oxford, 1999

I. Bernard Cohen, *Album of Science: From Leonardo to Lavoisier*, New York, 1980

Jack Cohen and Ian Stewart, *The End of Chaos: Discovering Simplicity in a Complex World*, London and New York, 1994

Jonathan Crary, *Techniques of the Observer*, Cambridge (Mass.), 1990

Paul Crowther, *The Language of Twentieth-Century Art: A Conceptual History*, New Haven and London, 1997

Lorraine Daston and Katharine Park, *Wonders and the Order of Nature*, New York, 1988

Richard Dawkins, *The Selfish Gene*, (1976) rev. ed. Oxford, 1989

Adrian Desmond and James Moore, *Darwin*, London, 1991

Sian Ede, ed., *Strange and Charmed: Science and the Contemporary Visual Arts*, London, 2000

Samuel Y. Edgerton Jr., *The Heritage of Giotto's Geometry: Art and Science on the Eve of the Scientific Revolution*, New York, 1991

Michele Emmer, *The Visual Mind: Art and Mathematics*, Cambridge (Mass.), 1993

Robin Evans, *The Projective Cast: Architecture and its Three geometries*, Cambridge (Mass), 1995

Richard Feynman, *QED: The Strange Story of Light and Matter*, Princeton, 1985

Richard Feynman, *The Character of Physical Law*, London and New York, 1992

J. V. Field, *The Invention of Infinity: Mathematics and Art in the Renaissance*, Oxford, 1997

Brian Ford, *Images of Science: A History of Scientific illustration*, London, 1992

Guy Freeland and Anthony Corones, eds., *1543 and All That: Image and Word, Change and Continuity in the Proto-Scientific Revolution*, Dordrecht, 2000

David Freedberg, *The Eye of the Lynx: Galileo, his Friends and the Beginning of Modern Natural History*, Chicago, 2002

Peter Galison and Emily Thompson, *The Architecture of Science*, Cambridge (Mass.) & London, 1999

John Gage, *Colour in Culture*, London, 1993

Ernst Gombrich, *Art and Illusion*, Princeton, 2000

Ernst Gombrich, *A Sense of Order, a Study in the Psychology of the Decorative Arts*, London, 1994

Brain Goodwin, *How the Leopard Changed its Spots*, London, 1994

Steven Jay Gould, *Ontogeny and Phylogeny*, Cambridge (Mass.), 1977

Steven Jay Gould, *The Mismeasure of Man*, London and New York, 1981

Steven Jay Gould, *Hen's Teeth and Horse's Toes*, London and New York, 1983

Steven Jay Gould, *Reflections on Natural History*, London and New York, 1993

Ivor Grattan-Guinness, *The Fontana History of the Mathematical Sciences*, London, 1997

Richard Gregory, *Even and Brain*, 3rd ed. London, 1979

Nina Hall, ed., *The New Scientist Guide to Chaos*, London, 1992

Stephen S. Hall, *Mapping the Next Millennium*, New York, 1993

Stephen Hawking, *The Universe in a Nutshell*, with illustrations by Malcolm Godwin, London, 2001

Linda D. Henderson, *The Fourth Dimension and Non-Euclidean Geometry in Modern Art*, Princeton, 1984

Nicholas Jardine, James Secord, and Emma Spary, *Cultures of Natural History*, Cambridge, 1996

Caroline Jones and Peter Galison, *Picturing Science: Producing Art*, New York and London, 1998

Michio Kaku, *Hyperspace: A Scientific Odyssey Through the 10th Dimension*, Oxford, 1994

Stuart Kauffman, *At Home in the Universe: The Search for Laws of Self-Organisation and Complexity*, London and New York, 1995

Thomas da Costa Kaufmann, *The Order of Nature*, Princeton, 1993

David Knight, *Zoological Illustration; an Essay towards a History of Printed Zoological Pictures*, Folkestone, 1977

Lisbet Koerner, *Linnaeus: Nature and Nation*, Cambridge (Mass), 2003

John Krige and Dominique Pestre, *Twentieth Century Science*, Amsterdam, 1997

James Lovelock, *The Ages of Gaia: A Biography of our Living Earth*, New York, 1988

Benoit Mandelbrot, *The Fractal Geometry of Nature*, Oxford, 1983

Christa Marr, ed., *Iconic Turn: Die neue Macht der Bilder*, Cologne, 2004

David Marr, *Vision: A Computational Investigation into Human Representation and the Processing of Visual Information*, San Francisco, 1982

Renato Mazzolini, ed., *Non-Verbal Communication in Science prior to 1900*, Florence, 1993

Arthur Miller, *Imagery in Scientific Thought: Creating 20th-Century Physics*, Boston, 1984

Arthur Miller, *Insights of Genius: Imagery and Creativity in Science and Art*, New York, 1996

William Mitchell, *The Reconfigured Eye: Visual Truth in the Post-Photographic Era*, Cambridge (Mass.), 1994

Roger Penrose, *Shadows of the Mind: A Search for the Missing Science of Consciousness*, Oxford, 1994

Sidney Perkowotz, *Universal Foam*, New York, 2000

Frank Popper, *Art of the Electronic Age*, London, 1997

Eliot Porter and James Gleick, *Nature's Chaos*, ed. Janet Russek, London, 1990

Ilya Prigogine and Isabelle Stengers, *Order out of Chaos: Man's New Dialogue with Nature*, New York, 1994

Eileen Reeves, *Painting the Heavens: Art and Science in the Age of Galileo*, Princeton, 1997

Robert Root-Bernstein, *The Visual Arts and Sciences*, American Philosophical Society, vol.75/6, 1895, pp. 50–68

Martin Rudwick, 'The Emergence of a Visual Language for Geological Science 1760–1840', *History of Science*, XIV, pp. 149–95

R. A. Scrutton and Manik Talwani, eds., *The Ocean Floor*, London, 1982

Deborah Shafter, *The Order of Ornament: The Structure of Style*, Cambridge, 2003

Lee Smolin, *The Life of the Cosmos*, Oxford & New York, 1997

Barbara Stafford, *Body Criticism: Imaging the Unseen in Enlightenment Art and Medicine*, Cambridge (Mass.), 1991

Barbara Stafford, *Artful Science: Enlightenment Entertainment and the Eclipse of Visual Education*, Cambridge (Mass.), 1994

Philip Steadman, *The Evolution of Designs*, Cambridge, 1979

Ian Stewart, *Does God Play Dice? The New Mathematics of Chaos*, London, 1990

Ian Stewart and Martin Golubitsky, *Fearful Symmetry: Is God a Geometer?*, London and New York, 1993

Elaine Strosberg, *Art and Science*, UNESCO, Paris, 1999

Ann Thomas, ed., *Beauty of Another Order: Photography in Science*, London and New Haven, 1997

D'Arcy Wentworth Thompson, *On Growth and Form*, Cambridge 1917 and 1945; and ed. J. T. Bonner, Cambridge 1992 (Canto ed.) with intro by S. J. Gould

Martin Turner, Jonathan Blackledge, and Patrick Andrews, *Fractal Geometry in Digital Imaging*, San Diego, London, 1999

Conrad H. Waddington, *Behind Appearance, a Study in the Relation between Painting and the Natural Sciences*, Cambridge (Mass.), 1970

Marina Wallace, *Project Eight*, exhibition catalogue, Total Museum of Contemporary Art, Seoul, 1998

Lewis Wolpert, *Triumph of the Embryo*, Oxford, 1993

The Unnatural Nature of Science London, 1992

Semir Zeki, *Inner Vision: An Exploration of Art and Brain*, Oxford, 1999

RELATED PUBLICATIONS BY THE AUTHOR

Since some of the topics in this book draw upon evidence (written and visual) and ideas scattered across my earlier publications, I hope it will be helpful for the reader to indicate some of those which are most directly relevant, and which provide access to a fuller set of references. All were published under the name of Martin Kemp, unless otherwise indicated. They are in chronological order.

'Analogy and Observation in the Codex Hammer', *Studi Vinciani in Memoria di Nando di Toni*, ed. M. Pedini, Brescia, 1986, pp. 103–34

'The Inventions of Nature and the Nature of Invention', *Leonardo: Engineer and Architect*, ed. P. Galluzzi, Montreal, 1987, (in French as 'Les Inventions de la nature et la nature de l'invention'), *Leonardo da Vinci: Ingénieur et architecte*, pp. 141–4

Leonardo on Painting: An anthology of writings by Leonardo da Vinci with a selection of documents relating to his career as an artist, ed. M. Kemp, selected & trs. by M. Kemp and Margaret Walker, London and New Haven, 1989

'Geometrical Bodies as Exemplary Forms in Renaissance Space', *World Art: Themes of Unity in Diversity*, (Acts of the XXVI International Congress for the

History of Art, Washington, 1986), ed. I. Lavin, Pennsylvania and London,
I, 1989, pp. 237–41

The Science of Art: Optical Themes in Western Art from Brunelleschi to Seurat,
London and New Haven, 1990

'Taking it on Trust: Form and Meaning in Naturalistic Representation', *Archives
of Natural History*, XVII, 1990, pp. 127–88

Introduction to *Leon Battista Alberti, On Painting*, (trs. C. Grayson), London and
New York, 1991

' "The Mark of Truth": Looking and Learning in some Anatomical Illustrations
from the Renaissance and the Eighteenth Century', *Medicine and the Five
Senses*, ed. W. Bynum and R. Porter, Cambridge, 1993, pp. 85–121

'Spirals of Life: D'Arcy Thompson and Theodore Cook, with Leonardo and
Dürer in Retrospect', *Physis*, **XXXII**, 1995, pp. 37–54

'Relativity not Relativism: Thoughts on the Histories of Art and Science, Having
Re-Read Panofsky', *Meaning in the Visual Arts: Visions from the Outside*, (Erwin
Panofsky: A Centennial Celebration), ed. I. Lavin, 1995, pp. 225–36

'Temples of the Body and Temples of the Cosmos: Vision and Visualization in
the Vesalian and Copernican Revolutions', for volume on *Picturing Knowledge:
Historical and Philosophical Problems Concerning the Use of Art in Science*,
ed. B. Baigrie, Toronto, 1996, pp. 40–85; and as 'Vision and Visualization in
the Illustration of Anatomy and Astronomy from Leonardo to Galileo',
*1543 and All That: Image and Word, Change and Continuity in the Proto-Scientific
Revolution*, ed. G. Freeland and A. Corones, Dordrecht, 2000, pp. 17–51

' "Wrought by No Artist's Hand": the Natural, Artificial and Exotic in Some
Artefacts from the Sixteenth Century', *Reframing the Renaissance: Visual
Culture in Europe and Latin America, 1450–1650*, ed. C. Farago, New Haven and
London, 1996, pp. 177–96

'Doing What Comes Naturally: Morphogenesis and the Limits of the Genetic
Code', *Art Journal*, ed. B. Sichel and E. Levy, Spring 1996, pp. 27–32

'Seeing Subjects and Picturing Science: Visual Representation in 20th-Century
Science', for *20th-Century Science*, ed. J. Krige and D. Pestre, Amsterdam, 1997,
pp. 361–90

' "A Perfect and Faithful Record": Mind and Body in Medical Photography
before 1900', *Beauty of Another Order*, ed. A Thomas, New Haven and London,
1997, pp. 120–49

'Talbot and the Picturesque View. Henry, Caroline and Constance', *History of
Photography*, **XXI**, 1997, pp. 270–82

Behind the Picture: Art and Evidence in the Italian Renaissance, London and New
Haven, 1997

with Marina Wallace, 'What's it Called and What's it For?', *Interfaces*, **XIV**, 1998,
pp. 9–25

'Palissy's Philosophical Pots: Ceramics, Grottoes and the *Matrice* of the Earth',
Le origini della Modernità, ed. W. Tega, Bologna, 2 vols, 1999, II, pp. 101–32

Immagine e Verità: Per una storia dei rapporti tra arte e sciennza, ed. M. Wallace and
L. Zucchi, Milan, 1999

'The Music of Waves. The Poetry of Particles. Thoughts on the Implicate Order for Susan Derges', in *Susan Derges: Liquid Form*, London, 1999

Introductory essay in *The Physician's Art: Representations in Art and Medicine*, ed. Julie Hansen and S. Porter, Duke University Medical Centre, 1999, pp.13–19

'Art as process. A Baker's Dozen for Gustav Metzger', *Gustav Metzger, Retrospectives*, Museum of Modern Art, Oxford, 1999, pp. 29–43

Visualizations: the Nature Book of Art and Science, Oxford, 2000

with Marina Wallace, *Spectacular Bodies*, exhibition catalogue, Hayward Gallery, London, 2000

'The *Temple of Flora*. Robert Thornton, Plant Sexuality and Romantic Science', *Natura-Cultura: L'interpretazione del mondo fisico nei testi e nelle immagini*, ed. G. Olmi, L. Tongorgi Tomasi, and A. Zanca, Florence, 2000, pp. 15–28

with Debora Schultz, 'Us and Them, This and That, Here and There, Now and Then: Collecting, Classifying and Creating', *Strange and Charmed: Science and the Contemporary Visual Arts*, ed. S. Ede, London, 2000, pp.84–103

Structural Intuitions: The 'Nature' Book of Art and Science, Oxford University Press, 2000

'From Different Points of View: Correggio, Copernicus & the Mobile Observer', *Coming About . . . A Festschrift for John Shearman*, ed. L. Jones and L. Matthew, Cambridge (Mass.), 2001, pp. 207–13

'Looking and Counting. From the Visual to the Non-Visual', *Gregor Mendel: The Genius of Genetics*, eds. C. Albano and M. Wallace, Brno, 2002, pp. 56–63

'Gregor Mendel; the genius of genetics', *Interdisciplinary Science Reviews*, **XXVII**, 2002, pp. 120–4

with Mory Gharib, David Kremmers, and M. Koochesfahani, 'Leonardo's vision of flow visualization', *Experiments in Fluids*, **XXXIII**, 2002, pp. 219–23

'*The Mona Lisa* of Modern Science', *50 Years of DNA*, eds. J. Clayton and C. Dennis, Nature / Palgrave, Basingstoke, 2003, pp. 102–6; also in *The Double Helix—50 years, Nature Supplement*, 23 Jan 2003

'Wissen in Bildern—Intuitionen in Kunst und Wissenschaft', *Iconic Turn: Die Macht der Bilder*, eds. C. Marr and H. Burda, Cologne, 2004, pp. 382–406

with Antonio Criminisi and Sing Bing Kang, 'Reflections of Reality in Jan van Eyck and Roger Campin' *Historical Methods*, **III**, 2004, pp. 109–21

'From science in art to the art of science', *Nature*, **434**, 17 March 2005, pp. 308–9, also as *Supplement: artists on science; scientists on art*

Leonardo, Oxford University Press, 2004

Leonardo da Vinci: The Marvellous Works of Nature and Man, Oxford, 2006

FOR PARTS 1–1V

(Items from the lists above appear in abbreviated form)

I Journey into Space

Martin Kemp, *The Science of Art*, 1990

Field, *The Invention of Infinity*, 1997

<table>
<tr><td>FURTHER
READING</td><td>

Samuel Y. Edgerton Jr., *The Renaissance Rediscovery of Linear Perspective*, New York, 1975

Kemp, 'Temples of the Body and Temples of the Cosmos', *Picturing Knowledge: Historical and Philosophical Problems Concerning the Use of Art in Science*, 1996

J. V. Field, *Kepler's Geometrical Cosmology*, Chicago, 1988

John North, *The Fontana History of Astronomy and Cosmology*, London, 1994

John Shearman, *Only Connect*, Princeton, 1992

David Freedberg, 'Iconography between the History of Art and the History of Science: Art, Science and the Case of the Urban Bee', in Jones and Galison, *Picturing Science . . .*, 1998

Edgerton, *The Heritage of Giotto's Geometry*, 1991

Martin Kemp, 'Relativity not Relativism', *Meaning in the Visual Arts*, 1995

Eileen Reeves, *Painting the Heavens*, 1997

Scrutton and Talwani, *The Ocean Floor*, 1982

Stephen Hall, *Mapping the Next Millennium*, 1993

Lelio Orci and Alain Perrelet on *Freeze-Etch Histology*, New York, Heidelberg and Berlin, 1975

Patrick Moore, *Venus*, London, 2002

James Watson *The Double Helix: A Personal Account of the Discovery of the Structure of DNA*, New York, 1968

James Watson with Andrew Berry, *DNA: The Secret of Life*, London, 2003

Victor McElheny, *Watson and DNA: Making a Scientific Revolution*, London, 2003

Brenda Maddox, *Rosalind Franklin: The Dark Lady of DNA*, London, 2002

Soroya de Chadarevian and Harmke Kamminga, *Representations of the Double Helix*, exhibition catalogue, Whipple Museum, Cambridge, 2003

'The Double Helix—50 Years', eds. Carina Dennis and Philip Campbell, *Nature* (Supplement), **421**, no. 6921

Max Perutz, *Proteins and Nucleic Acids: Structure and Function*, London and Amsterdam, 1962

Edwin Abbott, *Flatland. A Romance of Many Dimensions* by A. Square, (1884, London and New York, 1998 Charles Hinton, *The Fourth Dimension*, London and New York, 1904

Gombrich, *Art and Illusion*, 2000

Bruce et al, *Visual Perception*, 1996

Zeki, *Inner Vision*, 1999

</td></tr>
</table>

II Lesser and Greater Worlds

Martin Kemp, *Leonardo da Vinci*, 2006

Erwin Panofsky, *The Life and Art of Albrecht Dürer*, Princeton, 1955

Kemp, 'The *Temple of Flora*. Robert Thornton, Plant Sexuality and Romantic Science', *Natura-Cultura*, 2000

Ernst Kris, 'Der Stil "rustique": die Verwendung des Naturabgusses bei Wenzel Jamnitzer und Bernard Palissy', *Jahrbuch der Kunstsammlungen in Wien*, **I**, 1926, pp. 137–208

Amico, *Bernard Palissy*, 1996

Horst Bredekamp, *The Lure of Antiquity and the Cult of the Machine: The Kunstkammer and the Evolution of Nature, Art and Technology*, trs. Allison Brown, Princeton, 1995

Kaufman, *The Order of Nature*, 1993

Daston and Park, *Wonders*, 1998

Grattan-Guinness, *Mathematical Sciences*, 1997

John Hayward, *The Virtuoso Goldsmiths and the Triumph of Mannerism*, London, 1976

Peter Bowler, *The Fontana History of the Environmental Sciences*, London, 1992

K. Wettengl, ed., *Maria Sibylla Merian, 1647–1717: Artist and Naturalist*, exhibition catalogue, Frankfurt (1997), 1998

Natalie Zemon Davies, *Women on the Margins*, Cambridge (Mass.), 1995, pp. 140–202

Donald Cardwell, *The Fontana History of Technology*, London, 1994

Judy Edgerton ed, *George Stubbs, 1724–1806*, exhibition catalogue, Tate Gallery, London, 1985

Judy Edgerton ed., *Joseph Wright of Derby*, exhibition catalogue, Tate Gallery, London, 1990

Wilfred Blunt and William Stearn, *The Art of Botanical Illustration*, new ed., London, 1994

L. Koerner, *Linnaeus*, 1999

Charles Darwin, *The Origins of Species*, ed. G. Beer, Oxford, 1998

Desmond and Moore, *Darwin*, London, 1991

Andrew Cunningham and Nicholas Jardine, *Romanticism and the Sciences*, Cambridge, 1990

Jardine et al, *Cultures of Natural History*, 1996

Dawkins, *The Selfish Gene*, 1989

Lovelock, *The Ages of Gaia*, 1988

Cohen and Stewart, *The End of Chaos*, 1994

Bak, *How Nature Works*, 1996

III Discerning Designs

Adolf Zeising, *Der goldne Schnitt*, Halle 1884

Albert van der Schoot, *De ontstelling van Pythagoras—over de geschiedenis van de goddelijke proportie* [The Pythagorean disposition—on the history of the divine proportion], Kampen, 1998

John Onians, *Bearers of Meaning*, Cambridge, 1988

Arthur Crosby, *The Measure of Reality. Quantification in Western Society 1250–1600*, Cambridge, 1997

Grattan-Guinness, *The Fontana History of the Mathematical Sciences*, 1997

Gould, *Ontogeny and Phylogeny*, 1977; *Hen's Teeth and Horse's Toes*, 1983; *Reflections on Natural History*, 1993

Martin Kemp, 'Spirals of Life', *Physis*, 1995

Thompson, *On Growth and Form*, 1917 and 1942

Ruth D'Arcy Thompson, *D'Arcy Wentworth Thompson: The Scholar Naturalist*, Oxford, 1958

Theodore A. Cook, *Curves*; and *Spirals*

Deborah Silverman, *Art Nouveau in Fin-de Siècle France: Politics, Psychology and Style*, Berkeley, Los Angeles and London, 1989

Alan Turing, 'The Chemical Basis of Morphogenesis', *Philosophical Transactions of the Royal Society*, B 237, pp. 37–72

Wolpert, *Triumph of the Embryo*, 1993

Arthur, *The Origin of Animal Body Plans*, 1997

Turner et al, *Fractal Geometry in Digital Imaging*, 1999

N. Hall, *The New Scientist Guide to Chaos*, 1992

Stewart, *Does God Play Dice?*, 1990

Mandelbrot, *The Fractal Geometry of Nature*, 1983

IV Out of Our Hands

Martin Kemp, 'Taking it on Trust', *Archives of Natural History*, 1990

John Hammond, *The Camera Obscura: A Chronicle*, Bristol, 1981

Ilaria Bignamini and Martin Postle, *The Artist's Model*, exhibition catalogue, Nottingham University Art Gallery, and Kenwood, London, 1991

Deanna Petherbridge, *The Quick and the Dead*

Martin Kemp, 'The Mark of Truth', *Medicine and the Five Senses*, 1993

Martin Kemp and Marina Wallace, *Spectacular Bodies*, 2000

R. Ollerenshaw 'The Camera Obscura in Medical illustration: a Belated Reference' *British Journal of Photography* 1977, pp. 815–16

Georges Didi-Huberman, *Invention de l'hystérie: Charcot et l'iconographie photographique de la Salpêtrière*, Paris, 1982

Larry Schaaf, *Out of the Shadows: Herschel, Talbot and the Invention of Photography*, London and New Haven, 1992

Gail Buckland, *Fox Talbot and the Invention of Photography*

Geoffrey Batchen, *Burning with Desire*, Cambridge (Mass.), 1999

Martin Kemp, 'Talbot and the Picturesque View', *History of Photography*, 1997

Helmut and Alison Gernsheim, *L. J. M. Daguerre*, London, 1956

Thomas, *Beauty of Another Order*, 1998

Rebecca Solnit, *Motion Studies: Time, Place and Eadweard Muybridge*, London, 2003

Martha Braun, *Picturing Time. The Work of Etienne-Jules Marey*, Chicago, 1992

Miller, *Imagery in Scientific Thought*, 1984; and *Insights of Genius*, 1996

Clarke and Henderson, *From Energy to Information*

Feynman, *QED*, 1985

James R. Brown, 'Illustration and Inference', in *Picturing Knowledge*, ed Baigrie, 1996, pp. 250–68

James Franklin, 'Diagrammatic Reasoning and Modelling in the Imagination: the Secret Weapons of the Scientific Revolution', in *1543 and All That*, eds. Freeland and Corones, 2000, pp. 53–116

Scrutton and Talwani, *The Ocean Floor*, 1982

INDEX

Note: Page numbers in *italics* indicate illustrations